DRESSMAKING

A MANUAL FOR SCHOOLS AND COLLEGES

BY

JANE FALES

ASSISTANT PROFESSOR OF HOUSEHOLD ARTS, DIRECTOR OF THE DEPARTMENT OF
TEXTILES AND CLOTHING, TEACHERS COLLEGE, COLUMBIA UNIVERSITY

ILLUSTRATED

CHARLES SCRIBNER'S SONS

NEW YORK **CHICAGO** **BOSTON**

PREFACE

THE purpose of this book is to give such instruction in dressmaking—in the broadest meaning of the term—as to make a text-book for both teacher and student in colleges and schools (above the elementary) where sewing or dressmaking is taught.

The *Introduction* considers the fundamental meaning of dressmaking. It traces the development of the art of dressmaking from its simple beginnings to its present elaborate expression—from the time when clothing was represented by painting and tattooing to the present day, when numerous coverings conform to the various requirements of custom, use, and fashion.

Part I presents the development of costume from the standpoint of history and design. This material is necessarily given in an abbreviated form and serves merely as a suggestive outline for further study and research.

Part II considers *Textiles*, the materials which are used in dressmaking, and discusses the economic value of various fibres and fabrics. The general processes of textile manufacture are given to serve as a basis for consideration of the cost and wearing qualities of any fabric. A few suggestions are included for physical tests for fabrics —such tests as do not require a knowledge of chemistry and are possible in the schoolroom or at home.

Part III treats of design and technique in pattern-making and dressmaking. It presents various methods for cutting, fitting, and finishing a garment to meet the demands of art and of convention as affected by fashion.

iii

A knowledge of all fundamental stitches and seams is presupposed and no instruction in elementary sewing is included. Directions are given, however, for any sewing which pertains strictly to dressmaking.

In Part II, *Textiles*, the author is greatly indebted to the generous co-operation of Mr. Edgar H. Barker, chief of the Departments of Woolen and Worsted Yarns of the Lowell Textile School, not only for his valuable constructive criticism, but also for many opportunities for technical verification which his wide experience and vital interest in the subject have made possible.

In Part III, *Dressmaking*, Miss Ruth Wilmot, of Teachers College, has rendered helpful criticism and general suggestions in the chapters dealing with the technique of dressmaking and the problem of design. To Miss Bessie White, of Teachers College, the author is also gratefully indebted for the outline of the chapter on *Embroidery*.

For advice in the plan, scope, and organization of material the author wishes to express her thanks to Doctor Frederick Henry Sykes, president of the Connecticut College for Women, at whose suggestion the book was first undertaken and whose kindly interest has continued throughout its construction.

Lastly, she wishes to record her thanks to Miss Edna Dingwall, through whose untiring and sympathetic assistance the labor of the completion of the book has been appreciably lightened.

CONTENTS

PAGE

INTRODUCTION vii

PART ONE—THE HISTORIC DEVELOPMENT
OF COSTUME

CHAPTER

I. COSTUME I

PART TWO—TEXTILES

II. TEXTILE MANUFACTURE 48

III. TEXTILE ECONOMICS 120

PART THREE—DRESSMAKING

IV. GENERAL SUGGESTIONS AND INSTRUCTIONS . . . 155

V. DRAFTING AND PATTERN-MAKING 172

VI. THE USE OF COMMERCIAL PATTERNS 239

VII. PATTERN-DESIGNING AND DRAPING 250

VIII. WAISTS 313

IX. SKIRTS 373

X. FINISHINGS AND EMBROIDERY 421

BIBLIOGRAPHY 486

INDEX 489

INTRODUCTION

When the various and intricate garments of to-day are donned, there is little thought of why clothes are worn, of what the beginnings of the custom or habit were, or of the evolution of that custom from its simplest expression in the garb of primitive man to its most complex in that of the civilized nations of the present day. But just as it is not possible to study intelligently the art of modern painting or sculpture without some knowledge of its background or history, so it is not satisfactory to begin a study of the art of dressmaking without some consideration of its past and of its evolution from that past.

In very early periods man was unclothed and probably unadorned. The beginnings of clothing have been attributed to various causes: to a feeling of modesty or shame; to a need for protection against climate; but it is generally conceded that coverings were due to and developed from a desire for ornament or for the distinction which decoration or ornament brings.

Clothing was not, originally, due to the demands of modesty. The idea of what constitutes modesty has been expressed very differently by different races. With some tribes of savages coverings can be and are entirely dispensed with, without consciousness, if the body is tattooed or painted. Among the savages in Alaska a woman must never appear without a plug in her lips. Similar variations are found among civilized races. The Mohammedan women satisfy the demands of modesty by covering the face, the Chinese women by concealing the feet. In Western nations a woman has been allowed to wear, without comment, a very décolleté costume at night, but the same garment was not considered appro-

priate for street wear. Recently, however, it is evident that fashion has affected our feeling of what constitutes modesty, for the prohibition has been removed, and convention is not outraged by the décolleté costumes which are constantly seen in the street. Again, both men and women appear for public bathing in costumes which would be considered, at present, highly immodest for either the street or the ballroom.

Westermarck says that the feeling of shame is not the cause but the result of covering the body; that modesty is evidently self-consciousness caused by the unusual—it might be from wearing clothing or from going without it. If custom or convention is followed, no self-consciousness will arise.

That morality has nothing to do with coverings seems proved again by savages. Among rude races immorality is less common than among the more clothed.

Climate has affected and still affects the wearing of clothing somewhat, but it can be in no way held responsible for its first adoption. Many races living in hot countries wear the full amount of clothing, while others, living near Cape Horn, still unaffected by civilization, wear almost nothing. Among civilized nations there is less and less distinction shown in regard to materials appropriate for different seasons. We now see chiffon and fur combined for summer or winter as fashion dictates. The convention of the cities demands a coat for the street no matter what the temperature may be.

According to Carlyle: "The first spiritual want of a barbarous man is decoration." There are peoples destitute of almost everything which is included among the necessities of life, but there are no people so rude as not to possess and take pleasure in possessing and wearing ornaments.

Ornament and clothing signify the desire which has always been present in man to express his personality and attain distinction among his fellows. This desire was first evidenced by the tattooing or painting of the body for decoration. It is suggested that man may have received

scars in battle, which brought him not only glory, and distinction from men, but also sympathy and attention from women. He naturally desired to perpetuate the scar and retain the position gained, so the scar was carefully reproduced in paint.

Hanging ornaments, trophies of battle or travel, were the next step in decoration. They were probably combined with tattooing, and their use may have come from man's innate taste for change; for, while painting was permanent, ornaments could be hung on the body in a variety of ways—the ears, nose, lips, arms, fingers, legs, and waist all served as ornament-bearers. Of these, the waist offered the greatest opportunity for decoration, and it is probably from the girdle or waist ornaments that the earliest form of actual coverings was developed. Aprons or abbreviated skirts appeared, followed in quick succession by a shoulder-covering. Both of these were made of skins of animals or, as the art of weaving became known, of plaited reeds and grasses.

Superstition may have played a part in the use of ornaments. In many cases they seem to have been considered a protection against the dark and evil spirits, both feared by primitive man. Ornaments were donned for protection; they have been continued for decoration. Superstition did not entirely die out with the disappearance of primitive man. From time to time slight evidences of it are found to-day. For example, many children wear amber necklaces as a preventive of sore throat. Can a savage do better than that!

At first, then, ornament or clothing was desired by man because it gave him individuality, distinction, and, as a result, probably a certain social standing. It is interesting to attempt to note in how far the same desire, creating others in its advance, seems to have been at work throughout the succeeding ages in bringing clothing, in its many phases, to the present important position which it unquestionably occupies in the industrial and social world to-day. In studying the gradual development of dress, this desire is so woven into its very foundation that it is

difficult to separate its results from those of other strong influences, many of which were brought to life by it.

To quote Carlyle again: "Society is founded upon Cloth. All visible things are emblems. Hence, clothes are so unspeakably significant." All social distinctions are made more distinct by clothing. What real value have the so-called precious stones except that given them because of their scarcity? Their possession demands great expenditures and consequently indicates the economic status of the wearer. Again, the judge shows his power, the minister the dignity of his calling, by a special kind of covering. And so on through various social strata. Once having established various standards as evidencing social position, convention demanded strict adherence to them, allowing only the demands of that all-powerful factor fashion to change that standard from time to time.

The first coverings worn, even though necessarily simple, must have given much the same satisfaction as hanging ornaments, in that there could be constant variety and increased number. No attempt was made to fit these garments. All skins or furs were flat and materials were woven flat; but the body was of varying contour, and so the materials seem most often to be draped or held around the body by a girdle and some substitute for pins.

As greater technical skill was acquired and the number of garments increased, it was found satisfactory to have the shape of the garments conform somewhat to that of the figure. Once this fashion was established, great interest was shown in the figure and more fitted garments followed. With the fitted garments the question of convenience arose. Clothing must be made to be put on and taken off without difficulty; it must be so made as not to hamper the use of all parts of the body. In addition to cut came the question of materials; only those could be chosen which were sufficiently flexible to permit freedom of action. Otherwise chain armor or steel plate might form a part of clothing for regular wear.

Why was it that distinction was finally made between man's costume and that of woman? In all probability it

was that same factor which is to-day affecting dress—the question of occupation, of utility, which involves the question of suitability to circumstances and environment.

How soon fashion began to affect dress and its development it is difficult to state. There seem to be various explanations for its power past and present. The most potent factor was, without doubt, the desire for variety, the stimulus attendant on change, the universal dramatic quality, the desire to become part of the "passing show"—to be "in fashion."

But to-day a careful analysis shows that the trade influence far outweighs all other factors in the fashion world. The manufacturer has played on the desire for variety to his commercial advantage. In spite of public opinion and the taste of designers, he is practically universally successful in emerging each season with such new fashion requirements as necessitate a constant output of fresh materials.

The first coverings which were made—that is, shaped and sewed—were the products of the home. As they increased in number and were more fitted, the making of the garments became more difficult and demanded the special attention of certain numbers of people, and we have the simple beginnings of dressmaking as an occupation.

In the development of the trade which followed, many changes have been made in the texture and design of the materials used; but in form they have remained a flat web, woven without any effort to conform to the outline of the figure which they are intended to cover. In these same thousands of years of change, the number and characteristics of the garments worn have, in general, been the same, but the variety of style and intricacy of cut have so increased, and with the increase have been included so many other considerations, that dressmaking, which was at first estimated merely as a trade, must now be treated as an art.

Dressmaking, when considered as an art, makes many demands. It requires not only improved methods of con-

struction but an appreciation of the relation of technique to art, to hygiene, to economics. Technique has received more emphasis than have these broader relationships, and consequently its development has been more rapid and complete, and we now have fairly definite rules for sewing and many improved methods for cutting and fitting. To cut a garment satisfactorily and make it fit, according to the demands of fashion and the needs of the human form, is a difficult task; consequently many methods have been devised—such as cutting by patterns made to regular measures, by drafting to individual measures, and by draping on a dress-form arranged to correspond to the desired measures. All of these systems are so much used that they have given rise to extensive business operations which have adapted the systems to the prevailing fashions and brought them to a point nearing perfection.

So greatly has the emphasis been laid on technique alone that hitherto a garment has been adjudged satisfactory if well made. Now, however, a new standard must be met. While it is obviously impossible to formulate definite rules for a complete understanding of this larger scope of the problem of dressmaking, it is clear that beyond a mere knowledge of the method of construction there must also be an appreciation, which shall require for the finished garment not only utility and suitability but definite hygienic, economic, and æsthetic values. In meeting the demand there is necessity not only for a working knowledge of the fundamental principles of hygiene and physiology, textile economics and art, but also for a knowledge of the development of costume through the past centuries—that is, a history of costume, showing the evolution of modern dress.

While these broader relationships may seem at present intangible and difficult to acquire and apply, dressmaking in its fullest meaning must include them, together with perfection in technique. In determining the value of the finished garment, these factors are equally important, and one cannot be stressed at the expense of the other.

In the chapters which follow, an effort has been made

to present the subject of dressmaking from this viewpoint. If this is kept in mind the book—which at first may appear to contain material not now generally considered relevant to the dressmaking problem—will be much more easily understood and prove much more valuable as a text.

It is not possible to present in detail, in the limited space allowed, such important subjects as textiles, historic development of costume, and design. The chapters in which they are included do not aim in any way to survey the subjects completely. They consider only what seems absolutely essential and what may prove suggestive of the fuller possibilities of these subjects in their relation to the dressmaking problem.

DRESSMAKING

PART I—THE HISTORIC DEVELOPMENT OF COSTUME

CHAPTER I

COSTUME

The study of the development of costume throughout the early ages presents many difficulties. Until a fairly recent period fashion books were unknown, and the only records were those found in the writings of the times, in wall carvings and paintings, in sculptures on monuments and tombs, on seals and various gems, and a little later in engravings of various fêtes, royal processions, marriages, etc. All these were not made with the student of costume history in mind, but generally to commemorate some event or to perpetuate the memory of various reigning monarchs, and in consequence they were not always accurate representations of the period they illustrate. Allowance must be made for the vagaries of the artists, the materials in which they worked, and also for the fact that in many cases these monuments were not made until some centuries later than the events they commemorated, when little accurate information existed regarding the costume of the earlier periods. To obviate this difficulty, the costume of the period at which the work was actually executed generally appears.

By the comparison of various records, however, a fairly satisfactory and continuous outline of costume history has been worked out—an outline which in general is sufficiently suggestive to meet the demands of the modern dress designer.

Every fashion and every detail of fashion of the present day may be traced to that of some former period. It

1

is only through contact with the representations of these
fashions that the creative ability so necessary in designing
is awakened; it is only through a knowledge of them that
what is called "originality" is possible. In this connec-
tion originality means the power to adopt and adapt suit-
ably the fashions of the past to the demands of the
present.

It is because the French have this knowledge, because
in their libraries, churches, and museums there are these
records free to all, because for centuries they have ap-
preciated their value and have through constant practice
acquired skill in their use, that all the fashion world looks
to them for inspiration and guidance in design in cos-
tume.

To be of the greatest use an outline history of costume
should include a survey of the costumes of the ancient
Egyptians, the Grecians, and the Romans, as showing the
general type of garment used in early civilizations. These
differ very greatly from the garments worn by the Gauls
at the time of their conquest by the Romans, or from those
of the Franks who later appeared and gradually took pos-
session of Gaul, renamed it France, and established there
the French nation. French costume, as such, may be con-
sidered as beginning at this time, about the sixth century.
From this period no attempt is made here to describe even
briefly the costume of any other nation than the French.
They began at an early period not only to create their own
fashions but to make whatever fashions they borrowed
distinctively theirs by their manner of adoption. Because
of limited space the costumes of men are omitted from this
outline; in Egypt, Greece, and Rome they did not differ
in their main characteristics from those of the women, and
in French costume the same names and many of the same
characteristics persisted until the Renaissance, from which
time there is definite distinction between the garments of
the men and women.

I. Egyptian Costume

Egyptian dress was evidently as much ruled by fashion as is the dress of more modern nations. It was unlike modern dress, however, in that the costume of the men showed more changes than did that of the women and seemed of greater importance. For a period of about thirteen hundred years all Egyptian women, whether princess or peasant, old or young, wore one garment, a simple dress. It was without folds and so narrow that the form was

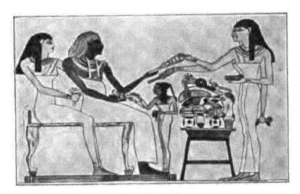

Simple dress of Egyptian women

plainly visible. This garment reached from just below the breast to the ankles and had few variations in style. These were generally in the arrangement of the shoulder straps or braces which served to hold the dress in place. These straps were straight bands and were usually worn over both shoulders. They were, however, sometimes arranged to form a V-shaped neck. Occasionally only one or even no strap was used, in which case the costume was made sufficiently narrow to keep it in place. The usual ornamentation for the dress was a little embroidery at the hem.

Improved commercial relations and greater intercourse with foreign nations affected Egyptian fashions. The same narrow dress was first arranged to cover the left

shoulder and to leave the right one uncovered and the arm free. Later there were various changes, such as the addition of fulness and the use of a short sleeve for the left arm. Over the dress a wide, loosely flowing cloak or mantle was worn. It was fastened over the breast and hung straight down to the feet. The dress and the mantle were made of fine, transparent fabrics. Many other variations appeared from time to time; the most important was an additional thick, non-transparent underdress which fitted the figure closely and somewhat concealed it. The outer dress was given even more fulness which was frequently arranged in plaits. There were also dresses with two sleeves, short mantillas with fringed borders, short aprons, and girdles. Both linen and wool were used for the costumes. They were spun and woven by hand

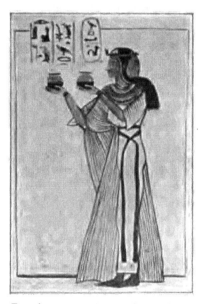

Egyptian costume showing the use of the thick underdress

and dyed in various colors, such as red, saffron, and blue.

While the garments worn by the Egyptian women were simple in texture and arrangement, the accessories with which they completed their costume were elaborate in design and rich in coloring and offer many suggestions for the decoration of modern costume. They included ornaments, head-dresses, shoes, etc. In the early periods women seem seldom to have worn sandals, though they were adopted later. They were chiefly of one form, fairly heavy in the sole, with straps; but they were made of a variety of materials.

In Egypt the care of the head was especially important.

It was a hot country where covering was evidently needed to protect the head from exposure to the sun. The hair of the Egyptian woman was well cared for and elaborately dressed. Wigs were evidently frequently, if not generally, worn. At first the fashion of all classes was a heavy coiffure of straight hair hanging in two tresses over the shoulders. Later the ends of these tresses were made into a fringe, and still later the full length of the hair was divided into a number of locks and braided or curled. In addition to the elaborate hair-dressing there was the head-dress representing a lotus bud, a vulture, an asp, according to the rank and position of the wearer.

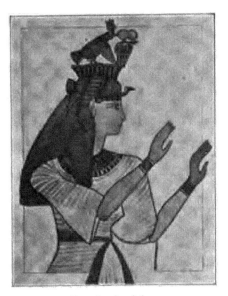

Egyptian head-dress

Ornaments were used throughout all periods. The most valued of these were evidently the colored embroidered necklets or collars which were made of leaves of papyrus or of fabrics and were embroidered in a great variety of interesting designs in gay-colored wools. There were also bracelets, earrings, and anklets which in many cases matched the collars in design and color.

II. GREEK COSTUME

Greek costume of the classic period has given greater inspiration than any other to the designer in the past and in the present.

In Greek costume there were two general classes of garments, the under and the outer, both of which were rect-

angular or square in shape and were draped on the figure
rather than fitted to it. These garments varied somewhat,
from time to time, in size and method of wearing. The
undergarment or dress was called a *chiton*, the outer gar-
ment or mantle a *himation*.

There were two forms of the chiton, known as the Doric
and the Ionic. The exact difference between these two

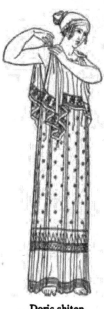

forms has given rise to much discussion.
It was evidently a difference in detail
rather than in general arrangement. The
Doric was of thick material and small in
size. When worn it fell in a few heavy
folds and was without sleeves. The Ionic
was of fine material and large; it fell in
many small folds and was arranged to
form sleeves.

A rectangular piece of material was
used for both. The material for the
Doric was about one foot longer than
the wearer's height and as wide as the
distance from tip to tip of the fingers
with the arms outstretched. For the
Ionic it was much larger, especially in
width. Much of this additional width
was used in forming the sleeves.

In draping, the extra length was usu-
ally turned over along the edge which
was to form the top of the garment.

Doric chiton

The folded-over section was called the *apotygma*. The
entire piece of material was then folded in the centre from
top to bottom edge and placed about the figure with the
opening at the right side. Pins at the shoulder were used
to keep it in place and form the opening for the neck and
arms.

The Doric chiton was arranged by dividing the width
into three fairly equal sections, the centre for the neck,
the others for the arms. With this arrangement only one
pin at each shoulder was required. The central division
of the Ionic was less than a third of the full width. The

extra size was made into sleeves by using pins placed at regular intervals from the shoulder along the opening nearly to the elbow.

After either chiton was attached at the shoulder the girdle was placed about the waist, the wearer standing with arms outstretched to draw the material up into place. The chiton was usually sufficiently long to allow the material to be pulled up through the girdle to form a blouse. The arrangement of the apotygma was varied; it might hang free or be held in by the girdle. Both the chitons made exceedingly graceful costumes. They permitted perfect freedom of movement and gave opportunity for variety in arrangement.

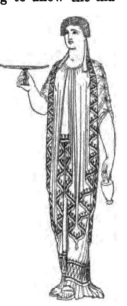

Ionic chiton

The usual mantle, or himation, was a large square or rectangular piece of material, usually wool, which varied in size and in the method of arrangement according to the taste of the wearer. It was draped about the figure rather than fitted, and in many cases it served both as a mantle and a covering for the head. Like the chiton, when well draped it was a very graceful garment and lent itself to an infinite variety of arrangement.

All garments worn by the Greeks were in early times woven in one piece, a garment separate and complete in itself. Wool, linen, and silk were all used. The woolen materials were evidently the most satisfactory. Some were very heavy and firm, others thin and so loosely woven as to be almost transparent, while still others were very much like crêpe. Linen and silk were in general made up into the more elaborate and luxurious garments of later periods. Cotton was used in small quantities. It was yellow in color and too expensive for the larger garments. Greek chitons were of many colors, such as purple,

red, yellow. Designs of birds, beasts, flowers, or emblems were frequently distributed over the entire surface or made to form a border. In many costumes a variety of design was combined, an all-over design with two or three different borders.

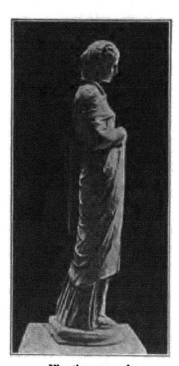

The girdles, which formed an important part of the costume, were often decorated with pendent ornaments and set with gold and silver studs. Their position changed from time to time: in the Archaic period it was at the waist line; in the age of Pericles below the waist, as shown by the maidens of the Parthenon frieze. Later it was much higher, until finally it was practically under the arms.

When out-of-doors the women usually wore either sandals or soles tied on with straps, which were frequently carried part way up the leg. Soft leather boots were also used.

Himation or mantle

The manner of wearing the hair varied very little. It was usually parted and drawn into a knot at the back. Fillets and other ornaments were used in many different ways to bind it up and hold it in place.

The Grecian women were fond of jewelry and wore many different kinds—rings, bracelets, necklaces, earrings, and brooches. The last might be considered as a necessary part of their costume. They had also a variety of hair ornaments, such as pins and metal diadems and fillets.

III. ROMAN COSTUME

The costume of the Roman woman was, in general character, much like that of the Grecian. It was fairly simple in the early history of Rome, but became, under the empire, much ornamented and exceedingly luxurious.

There were three garments—the *tunic*, the *stola*, and the *palla*.

The inner tunic served as an undergarment and was simple in form. It was generally made of wool though sometimes of linen.

The stola was very long and full, like the Ionic chiton of the Grecian women. It did not require sewing, but could be held in place on the shoulders by clasps or brooches. It differed from the chiton, however, in having at the bottom a border or shaped ruffle which was frequently elaborately decorated or embroidered and gave much additional fulness about the feet. The stola was usually arranged to have fairly close sleeves to the elbow. These, like the shoulders of the garment, were fastened with gold or jewelled clasps or buttons. A girdle was worn about the waist or hips through which the stola was drawn up to form a blouse. The stola was the distinctive garment of the Roman matron; the women of the lower classes were not permitted to wear it.

The palla was the outer garment, or mantle. In shape it was rectangular. It corresponded to the Grecian himation and was worn in much the same way, frequently serving as a covering for the head. The material of the palla for women of the higher classes was usually fine and thin. In the early period it was made of wool, but later was frequently of a mixed fabric, such as silk and wool or silk and linen. Occasionally it was of pure silk, which was a great luxury. In addition to the palla the women of the empire wore a garment called a *dalmation*, which was made of wool, linen, or cotton. It was usually decorated, was somewhat shaped, and had sleeves.

Both shoes and sandals of many varieties were worn.

The shoes were generally used out-of-doors, while sandals were more often worn in the house.

In the early days the coiffure of the Roman woman was simple and resembled that of the Grecian, but in the days of the empire the hair was elaborately arranged and was much frizzed, curled, and decorated with ornaments. It was often dyed, and wigs were worn, as fashion demanded a change in the color of the hair. Many ornaments were used, such as bracelets for the wrist and upper arm and rings and necklaces of exquisite workmanship. There was also a great profusion of hair ornaments, hairpins of gold, silver, and ivory, fillets of gold studded with gems, and nets of gold.

IV. Costume of the Gauls, the Gallo-Romans and Early Franks, and the French through the Middle Ages

After the conquest of Gaul by the Romans we have the introduction of a somewhat new style of costume. The costume of the women of Gaul was less elaborate in arrangement than that of the Romans but more barbaric in coloring and ornamentation. They wore two tunics. The under was long and rather straight and reached to the ankle. It usually had long, close-fitting sleeves. The outer was shorter, generally a little fuller, and had sleeves which were flowing and came only to the elbow. With these a girdle was worn about the hips. A long, straight mantle was worn over the tunics and evidently served as a covering for the head. Simply made shoes or sandals completed the costume. The women were exceedingly fond of jewelry, and were able to have it, of a barbaric kind.

This costume was soon made to resemble more closely that worn by the Roman woman. The shape of the tunic was somewhat changed and the sleeves were held in place and decorated with brooches. The long strands or braids of hair were bound up in much the same fashion as that of the Roman women.

The conquest of Gaul by the Franks and the establishment of their kingdom, about the fifth century, may be said to mark the beginning of the Middle Ages. The Franks were barbarians, and their costume, therefore, when they first appeared in Gaul, was not unlike that of the Gauls when they were conquered by the Romans. The women wore two long tunics, an under, which was rather straight, and an upper, shorter, with more fulness. Both were held in by a girdle worn about the hips. They had mantles, and in addition large veils with which they covered their heads. As they mingled with the Romanized Gauls they made gradual changes in their costume. These changes, many of which show a strong Byzantine influence, were not so evidenced in the number and general style of the garments as in the materials and decorations used.

Gallic costume

As late as the end of the tenth century the inner tunic worn was still long and straight, with straight sleeves; while the outer was somewhat shorter and fuller, with wide, short sleeves. Both were confined by a girdle. The outer tunic at this period was usually decorated with a band, or fichu, which was fitted about the neck and extended down the centre front. Bands to match were also used at the wrist and occasionally around the bottom of the tunic. The mantle and veil were still worn; of the latter the Frenchwomen were especially proud.

Gallo-Roman costume

All the garments were covered with embroideries combined with precious stones.

At the end of the eleventh century additional fulness and length were added to both tunics, the outer of which was called a *bliaud*. The heavy veils were replaced by small circular ones which showed the flowing hair. Otherwise, in general appearance, there was little change. The Crusades, which began during this century, had an important bearing on costume. They brought about improved commercial relations with the East and with Italy which resulted in many new fabrics and new fashions for the Frenchwomen. Many Italian artists and artisans were persuaded to come to France and ply their trades there.

In the twelfth century the outer tunic was no longer cut as one garment, but was made in separate pieces, like a waist and skirt, and the waist was fitted about the figure and outlined it. This fitted costume was in marked contrast to the flowing garments of the previous periods, which had concealed rather than revealed the figure. The style of this fitted tunic varied somewhat—there were either two pieces, a long, fitted waist and full skirt, or

Costume of early Franks

three, a waist like a bolero jacket, a yoke or wide girdle, and a full skirt. The first style was evidently the one most worn.

When the short, fitted waist was used it was attached at the centre front by a button or clasp, while the deep yoke at the top of the skirt was laced at the back, making the joining of these two garments impossible. The yoke fitted the form above the waist

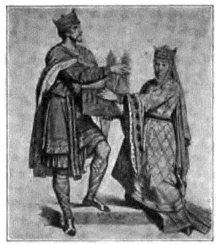

French costume of 9th and 10th centuries

and over the hips, and to it was attached the full, gathered skirt, which was of sufficient length to cover completely the long undertunic, or chemise. The fitted part of the tunic was of pliable material which could be easily drawn into shape to fit the figure, while the skirt was of a soft material which fell in fine folds or plaits.

The sleeves were of two kinds—bell-shaped, with long points falling nearly to the ground, or long and close-fitting, with a large, straight piece which fell free from the wrist to the floor. The bottom of the bell sleeve was often cut on the bias to give a ruffled effect, and at the

Fitted costume of 12th century

armseye it was made to fit closely by a number of fine plaits. The mantles worn with this costume were large and long, and were fastened over the chest with clasps which allowed them to fall apart and show the fitted tunic.

The hair was done in two long braids or interwoven strands which fell nearly to the knees, and over it was the short, circular veil which was held in place by a crown-shaped ornament.

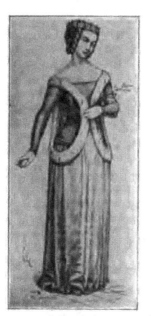

Cotte, surcot, and *garde corps* of 13th and 14th centuries

Quicherat, in his "Histoire du Costume en France," calls the thirteenth century the most brilliant in costume. Great interest was taken in dress, in its cut as well as in the materials used. The Italian artists had become thoroughly established, and many beautiful and elaborate materials were made by them.

A new garment gradually replaced the fitted tunic, or bliaud. It was generally called a *surcot*. It seems to have been, with slight variations in style, the characteristic garment of the thirteenth, fourteenth, and part of the fifteenth centuries. Under it two tunics were worn, the under called a *chemise*, the outer a *cotte*. The material of the surcot was frequently the color of the field of the family coat of arms, and on it were painted or embroidered the armorial bearings, the heraldry of the family.

The first surcots were cut in many different styles, but they were all long, semifitting garments, usually as wide in back as in front, and shaped at the sides to outline the waist and hips. A girdle was not worn over the surcot but over the cotte. Later the waist was made closer-fitting, and from the shoulders down over the hips it had lateral openings which were like an enlarged armseye. Because

of these openings there were no sleeves in the surcot, and the fitted waist, full skirt, and long sleeve of the cotte showed to great advantage, as it was generally of contrasting color and fabric. Many colors, in fact, were combined in the rich fabrics and elaborate embroideries of which the surcots and cottes were made.

Many of the surcots were extremely décolleté and were held up by narrow straps over the shoulders; the skirts were very full. Over these surcots a small fur stole, called a *garde corps*, was worn. This was generally of ermine. At first it was made with a narrow band across the back, along the neck line of the surcot, while in front it covered the chest and fell below the waist in two straight panels which were held together with jewelled clasps. It afforded no protection whatever to the neck of the wearer. The *garde corps* may or may not have been attached to the surcot but seems to have followed its exact neck lines.

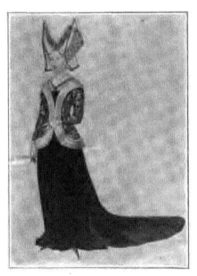

14th-century costume

Later its shape changed and it was cut in narrow bands which outlined the large armseye of the surcot. These bands met at the centre front and were held together by a clasp. The lateral openings of the surcot were so large that practically none of the material showed on the front of the waist. At the back there was still the same narrow band of fur extending from shoulder to shoulder. From it the material fell in long box plaits which lay on the floor and formed a train. This fashion of the long plaits at the back might easily have been the ancestor of those popular eighteenth-century plaits which were called *Watteau*.

The girdle was still worn over the cotte about the hips and showed at the side openings of the surcot.

The coiffure had changed. For a short period the hair was plaited and worn in a knot at the back. A flat band was frequently drawn under the chin and fastened at the top of the head. A circular veil held in place by a band or crown covered the forehead and hair. The veil was sometimes replaced by a cap which, while worn with the band, permitted the knot of hair to show at the back. Later the braids were arranged over the ears and a crown-shaped ornament was added which gave the head a rather square appearance.

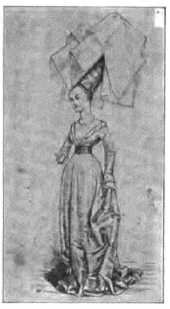

14th and 15th century costume

From the twelfth century there was a gradual change in shoes, which were becoming more pointed. The general tendency throughout the last centuries of the Middle Ages was toward a closer, more fitted garment, and there was also, for a certain period, an affectation in dress which reached the ridiculous.

Many of the garments were parti-colored. This division of color cut the figure practically in half, and on these two differently colored backgrounds various emblems were placed. Ladies of rank placed on the right side the coat of arms of the husband, on the left that of their own family, and, to make the costume still more gorgeous, various significant emblems, such as birds, beasts, and flowers, were added.

Another garment, or dress, appeared during the late fourteenth and early fifteenth centuries. At first it did not take the place of any then worn, but the surcot gradually

disappeared and the *houppelande*, or robe, became the dress for women. Like the surcot, it was a one-piece garment, but varied greatly in shape from time to time. It had a close-fitting waist and an exceedingly long, full skirt which formed a long train. There were two styles of sleeves, one large and bell-shaped, the other long and fitted. The dress was shaped to fit the figure at the waist and hips, and no girdle or belt was worn. The skirt and the bell sleeves were generally lined with fur, and fur lapels outlined the V-shaped neck, which was cut to cover but little of the shoulders. For a few years this garment was frequently worn buttoned straight up to the throat with a standing collar. In general, however, the V-shaped neck was a more popular style. After these dresses had been worn for some time belts at the normal waist line were adopted, and their use immediately gave rise to

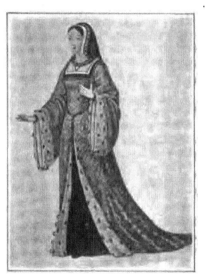

Costume of the transition period

great interest in the size of the waist. A small waist was evidently considered a mark of great beauty, and the belts were worn exceedingly tight, giving the figure a very ugly outline.

Several remarkable head-coverings which were worn in the fourteenth and fifteenth centuries showed more than anything else the caprice of the period. They were round, cone-shaped, heart-shaped, or pointed. They were frequently hung with tissue or they had two wide wings or two horns. They were generally called *hennins*, and varied in height from half a yard to a yard. They completely covered the hair. Many of these head-dresses were cone-

shaped, and to them were attached enormous frames of wire which were covered with gauze and various fine materials. The gauzes were starched and stood out in stiff folds. The hennin lasted about seventy-five years, from 1395 to 1470.

At the last of the fifteenth century and the early sixteenth we have a period of transition during which the eccentric costume of the last of the Middle Ages gradually disappeared and was replaced by one which had a certain claim to elegance and simplicity. Charles VIII (1483–1498) made an expedition into Italy, and as a result French costume was much changed and improved, and there appeared the beginnings of the Renaissance movement which was at its height under Francis I a few years later.

There was a marked difference in the costume of the women; the dress was no longer drawn in at the waist by a belt but fitted the figure easily. The skirt was full, outlining the hips, with the girdle worn low. It was less décolleté, with a square neck rather than the deep V.

The enormous head-dress gave place to a kind of close-fitting cap. This change was evidently due to the queen of Charles VIII, Anne of Brittany, who brought to France the head-dress of her own province of Brittany. She also introduced a new fashion in mourning. Formerly all queens of France had worn white as widows. As the widow of Charles VIII, Anne wore black with a white cord knotted about her waist until she became the wife of his successor, Louis XII.

V. SIXTEENTH-CENTURY COSTUME

One of the characteristics of the Renaissance costume, a fondness for variety of color and richness of material, was not new but might be considered an outcome of the later fashions of the Middle Ages.

The radical change in the costume came as the result of a desire to make the shape of the figure other than it really was. The desired shape was secured by the use

of two garments, which were called the *basquine* and *vertugale*—the basquine, the corset; the vertugale, the hoop-skirt or crinoline. These broke the long lines of the figure which until this period had been felt to exist under the flowing garments, except for the few years of the fifteenth century when the exceedingly tight belt had been worn to make the waist appear small. The squeezing of the waist and the covering of the lower part of the body in a sort of bell-shaped garment seems really to mark the decisive and absolute passing of the antique drapery and the introduction of forms which are known as those of modern costume. The idea of the small waist again prevailed. The methods of acquiring it, however, were new and exceedingly successful. The waist was squeezed with the basquine, or corset, and in addition

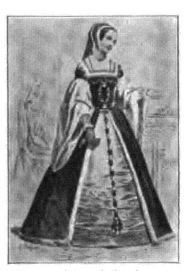

Costume of the early Renaissance

the skirts were widened below the waist so that by comparison the waist appeared even smaller than it actually was.

The undergarment was still the chemise, which was unchanged in general style but fitted the figure more closely. It usually showed at the neck and wrists. Over this was placed the corset, or basquine, which was a·kind of stuffed bust without sleeves. It had no bones, but was made of several thicknesses of heavy material cut and sewed to the desired funnel shape. It held in the waist and moulded the figure.

The hoop, or vertugale, was a stiff skirt in shape like an inverted funnel or the letter A. Like the corset, it was made of several thicknesses of heavy material cut and sewed to the required shape. It added great weight to

the costume. The cotte was no longer a complete under-dress, but merely a piece of rich material stretched over the front of the vertugale from the waist to the floor and forming a panel which showed at the opening of the dress skirt. The same material was frequently used for a panel in the front of the waist and for the full sleeves which were worn under the large fur dress sleeves and were slashed to show the chemise or other decorative material.

A ruff of the Renaissance period

The dress, or robe, which was worn over all these garments had a close-fitting bodice and short, full skirt. The bodice was finished at the top with a square neck line. This line was not straight across the front but curved upward at the centre and dropped as it neared the armseye. The bodice came to the normal waist line, except at the front where it was cut to form a short point. The sleeves were merely caps of the material, to which were attached wide, open, bell-shaped sleeves of fur. Occasionally the caps of the material were omitted, and the sleeve was entirely of fur and so open as to show the full length of the slashed undersleeve. The skirt was of round length and opened at the front to show the cotte. It was gathered at the waist line and its fulness formed tubelike folds which were stiffened to keep them in shape.

There were two or three different kinds of outside garments or mantles; they were large and full and usually had hoods attached; some were made with sleeves. The stockings were made of fine cloth and were of one color, the most popular being scarlet. The shoes, slippers, and pumps were all elaborate. They were no longer ex-

tremely pointed. They were made of leather or of rich materials and were usually slashed to show contrasting colors. The hair was done simply, bound in a knot at the back with a few curls about the face. It was usually covered by a close head-dress so that only a few curls showed at the front. A girdle outlined the waist of the bodice and fell nearly to the bottom of the dress. Various pendent ornaments were attached to it. A great profusion of jewelry was worn over the entire costume. Jewelled collars, all kinds of gems, and chains of gold in garlands enhanced the rich materials of which the costume was made.

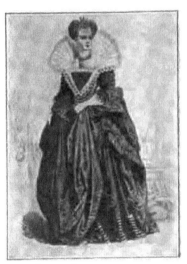

Late 16th-century costume

The materials used were camelot, silk serge, taffeta, satin, damask, velour, cloth of gold, and cloth of silver. There was also much fur and passementerie and elaborate embroidery of pearls and precious stones. All colors were used, and many in one costume, which usually, however, had a dominant harmony. Scarlet seems to have been extremely popular.

This costume remained much the same in general style, with slight variations, until the latter part of the century.

Many women adopted a bodice which buttoned to the throat, and discarded the large oversleeve in favor of a small one which was decorated at the shoulder with epaulets or padded rolls. The ruff played an important part in the costume of the period. It is said to have been brought from Italy to France by the Italian wife of Henry II, Catherine de Medici. It was made in many shapes and sizes and of many materials. Its edges were cut in elaborate shapes or finished with beautiful laces. When it

completely encircled the throat it was frequently wide and flat, although it might also be narrow, full, and standing. If it was standing and attached at the back only, coming just to the ears, it was generally wide and high; it might be full or straight and stretched on a frame. In many cases made of beautiful laces, it formed an attractive background for the face.

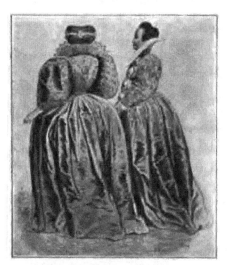

Silhouette of the late Renaissance

As the sixteenth century neared its close and fashion was swayed by the king, Henry III, and his sister, Marguerite of Valois, much of its charm vanished. The silhouette became grotesque. The hoop, which had been funnel-shaped, was now made barrel or drum shaped, and both padding and plaits were frequently added at 'the hips to give more width. This fashion is said to have been introduced to disguise the real shape of the figure of Marguerite of Valois, who was enormously stout at the hips. Over this ungainly hoop both long and short skirts were worn. There were sometimes three skirts made of materials of contrasting color and design. The gathered-in fulness of the skirts was held out from the waist by the width of the hoop and then fell in straight lines to the floor. Many court dresses were made with long trains. The waist was made even smaller in size and the waist line of the bodice more pointed in front. Many of the bodices were widely open at the neck and shoulders and finished with the high, spreading ruffs. To balance the size at the hips the sleeves were frequently made enormous. They were balloon-shaped at the top and stuffed out to give

width to the shoulders; they were long and cut to fit closely at the wrists.

On the whole, the women looked like wasps, with their tiny, extremely pointed waist lines, their barrel-shaped skirts, and their stuffed-out shoulders all topped with the spreading ruffs. The costume was exceedingly ornate and destitute of its early grace and dignity. The hair was drawn up from the forehead and gave the head greater height. The head-dress was usually replaced with hair ornaments.

The fashions were not in any way improved when Marie de Medici became queen, after the divorce of Henry IV and Marguerite of Valois. Various edicts were issued against the extensive use of Florentine and Venetian laces and cut-work, which had been brought into France because of the ruffs. While these edicts did not really prevent the use of lace they led to the use of ribbons, which became popular in the costume of the next century.

VI. SEVENTEENTH-CENTURY COSTUME

In the first years of the seventeenth century there was a gradual decline in the Renaissance fashions which had at that time grown extremely ugly. Awkwardness and heaviness were gradually discarded and a bold and dashing elegance became the prevailing fashion of the century. The wife of Louis XIII was Anne of Austria, a Spanish princess, who brought many of her own countrywomen to France with her. The influence of these Spanishwomen may have had much to do with the changing fashions. The vertugale, or hoop, for which Spain is held responsible by many, left France and returned, strangely enough, to Spain, where it made the costume hideous for some years; the loss of the hoop entirely changed the outline of the Frenchwoman's figure.

The number of garments was practically the same, and the corset was worn as during the Renaissance, but the silhouette appeared quite different because it was no longer affected by the hoop.

In place of the barrel-shaped hoop and the enormous skirts a close underpetticoat was worn with an overskirt which fell in graceful folds with its fulness arranged at the sides and the back. This overskirt opened at the front to show the underskirt. To give some of the size which the hoops had formerly given, the overskirt was often puffed or draped a little at the hips. The under-dress, or petticoat, was of round length, while the overdress

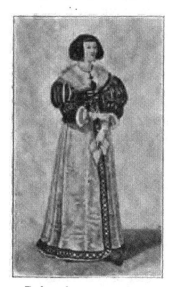

was frequently long and train-ing. Occasionally the under-petticoat was omitted, and the full overskirt was gathered at the waist and fell in straight folds without any opening at the front. If the skirt opened over a petticoat the bodice usu-ally also had a narrow panel which matched in material that of the underskirt.

The neck line of the bodice was more often round than square, as that shape was bet-ter suited for the arranging of the fichu, or collar, which re-placed the ruff. These collars were as varied as the ruffs in shape, style, and material.

Early 17th-century costume

They were not always flat; many were wired; and they usually stood out, away from the head, rather than up, close to it. Waists were still small, though not so exaggerated as in the late Renais-sance. Many of the bodices had a somewhat pointed waist line, while others had one which was raised some-what above the normal waist and had attached to it a kind of peplum, or basque. These peplums were short and usually slashed or cut up in sections to give sufficient flare over the hips. The sleeves were large but no longer padded. They were allowed to fall in natural folds and were finished with deep, turn-back cuffs to match the

collars. They were sometimes slashed and were frequently decorated with ribbon.

Mantles were large and full, and occasionally large hats were seen. On all garments a great profusion of ribbon was used in all forms of decoration, as ornaments on sleeves, bodices, and skirts, in bows, streamers, latticework, etc. Buttons also served for ornaments. The hair, which had been done high, was now curled a little at each side of the face, with a few short curls on the forehead, and rolled or plaited low at the back. The shoes were made of elaborate materials and had very high heels and buckles or rosettes at the instep.

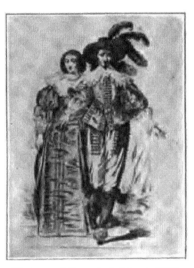

Costume of the period of Louis XIII

These same general lines in costume prevailed throughout the century, but under the sway of Louis XIV (1643–1715) and his extravagant favorites it gradually lost much of its early grace and charm and became again heavy and stiff and more superb than elegant. The heavy richness of materials and the elaborate elegance of their ornamentation gave the costume stiffness rather than beauty. The changes were chiefly in this elaboration of the materials and in the increased amount of drapery or puffings.

The bodices were tighter at the waist, more as the fashion of the early Renaissance had demanded, and the waist lines were more pointed. These bodices were often open in front over panels which were embroidered or decorated with lace. There was greater variety than formerly in the shape of the neck line. The round line was still very popular, but when there was a front panel

in the waist the neck was frequently cut out straight across the panel and was less widely open over the shoulders. The sleeves were now usually short and close-fitting. They came to the elbow and were finished with lawn or lace ruffles.

The outer skirts were long and full but were generally tucked up in puffs over the hips, revealing gorgeous petticoats. The puffings were usually held in place by jewelled clasps or knots of ribbon. While no hoops were worn, nearly the same effect was achieved by having the puffs at the hips and adding some stiff material at the back. It was worn inside and answered the same purpose as the more modern bustle.

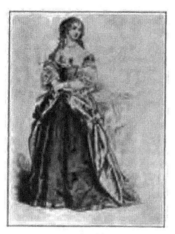

Costume of the early part of the reign of Louis XIV

The large collars and cuffs of lace disappeared, but the jewels which had been worn with them, the string of large pearls at the neck, continued in fashion. It is said that if a woman could not afford real pearls in the large size required by the prevailing fashion she wore imitation rather than the smaller size which was within her means.

A new outer garment was introduced by one of the foreign princesses who came to the court. It was a short cape which protected the shoulders left uncovered by the very décolleté costume. It was called a *palatine* or *pelerine*.

Long gloves of kid or mittens of knitted silk were worn with the elbow sleeves. Shoes were very elaborate; heels increased in height until three inches was not considered unusual. The tight stays which were worn are said to have led to a very general use of fans, which helped to conceal the discomfort of the wearers.

Materials were of the same kinds as before, but were generally much heavier in quality and more decorative. About 1675 some transparent materials became popular. Muslin or lawn, with bunches of many-colored flowers painted or printed on them, were worn over underdresses of bright-tinted moiré satin; or the overdress was plain and the underdress might be of brocade with large flowers in gold and silver on a colored background; or of gold or azure brocade of lacelike tissue. Lace was used in every way, on every part of the costume, from bodice to shoes. It was even mixed with ribbon streamers in the hair. It formed ladders of large bows and floated in every direction. Many small, round muffs of fur were carried.

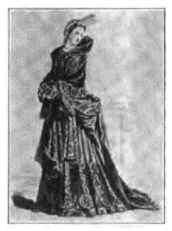

Costume of late 17th century. Showing Fontanges head-dress

The rather simple fashion of arranging the hair which Anne of Austria had introduced lasted, with slight variations, until about 1680. Then a marked change was made. Mlle. de Fontanges, at that time the favorite of Louis XIV, is said to have lost her hat at some festivity and to have used her ribbon garter to fasten her hair. The garter was adorned with a rosette, which proved to be exceedingly becoming to Mlle. de Fontanges. The king expressed approval, and immediately the coiffure à la Fontanges became the fashion, and reigned without a rival until 1710, at which time it had become a towering edifice of lace and ribbon extremely ugly and ridiculous. At the last of the century Louis XIV fell under the restraining influence of his last favorite, Mme. de Maintenon, who has been called an "eminent refrigerator and paragon of virtue." While she did not set any special fashion, costume was in general somewhat affected by her

influence.　There had already been a loss of the early
grace and freedom.　The costume became an exaggeration
of fitted waists and elaborately puffed and plaited over-
skirts, which were widely open to display the heavy, much-
decorated underpetticoats.　The bodices, with their long,
pointed waist lines, were made to look longer and more
pointed by the arrangement of the draperies formed from
the fulness of the overskirt at the hips.　The underskirts
were covered with ruffles or so decorated with appliqué and
embroidery as to look like elaborate upholstery.　These, with
the Fontanges head-dress, gave a most elaborate effect.

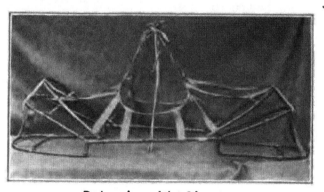

Panier or hoop of the 18th century

VII.　Eighteenth-Century Costume

The costume of the eighteenth century is considered by
many to be, as a whole, more graceful than that of any
preceding period.　At the beginning of the century, about
1711, after an absence of a hundred years, the hoop came
once more into fashion, succeeding the puffings and pad-
dings which had given size to the hips.

It is thought that the hoop was brought to England at
the time of Queen Anne from some obscure German court,
where it had never gone out of fashion.　From England it
came to France, brought there by some visiting English-
women.　It was made in a new way and had a new name
and a new shape.　It was called a *panier* because it was

an open framework made of hoops of straw cord, cane, whalebone, or steel, and fastened together by tapes. It was cupola-shaped at the sides but flat at the front and back. The arches were soon made to spring from the waist outward over the hips so that the wearer could rest her elbows on the hoop. Fulness in the skirt gave the required shape and size at the back. The panier in this shape lasted a long time and attained most extravagant dimensions.

The hoop naturally necessitated many changes in the costume. During the regency (1715–1723) the heavy materials and elaborate decorations of the Louis XIV period were seldom used, and the paniers, probably somewhat on account of their size, were covered by rather plain, full skirts made of stuffs which were

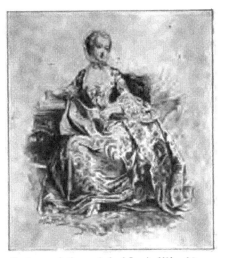

Costume of the period of Louis XV. Mme. Pompadour

light in weight and brilliant in color. Later heavier materials appeared, and there was much decoration, but it was of a lighter, daintier, and more graceful kind.

During the entire century we find the same pointed bodice with the round neck line or with the square neck and panel front. All the sleeves were short. Many were of the fashion which had its beginning in the last reign. These came to the elbow and were finished with deep, wide cuffs, full ruffles of lace, or with fan-shaped tucks of the material of the sleeve. Others were made entirely of ruffles of narrow lace—sewed in rows around the sleeve. Skirts were made with and without panels, but there were no puffings. Both bodice and skirt were much trimmed

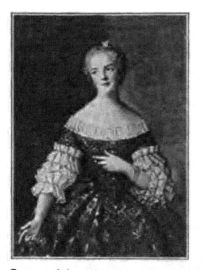

Costume of the 18th century. Daughter of Louis XV, by Nattier

with ribbons, laces, and artificial flowers. There were such materials as thin silks, India cottons, dimity, muslin, and gauze, and with these were used trimmings of lace, ribbon, and taffeta; the latter formed shirrings or was pinked or cut to form flowers or petals. Gathered net or wash blond also became popular as a decoration.

Long mantles, cape-shaped, were worn. Hoods were generally attached to the mantles, but there were also many head-coverings of gauze, net, and batiste. The hair was done simply and often decorated with aigrettes of jewels, of flowers, and ribbon.

About 1730 there appeared those graceful fashions which are generally referred to as Watteau. These did not replace the fashions in vogue but shared the general favor equally with them. There were many variations in the Watteau costumes, but they were generally loose, flowing gowns without a defined waist line. The material was arranged in the back across the shoulders in wide box plaits, which fell unconfined to the floor and usually formed a

18th-century decoration

train. The front was shaped to fit the figure somewhat to the waist line, and below that was cut sufficiently full to cover gracefully the large panier. Girdles were generally worn with the costumes, especially if the bodice was not fitted at the front, but, like the back, was free from the shoulders to the ground. Underpetticoats were frequently worn and were displayed by puffing or draping the overdress at the hips. The dresses were also frequently arranged to open at the centre front and form a panel in both waist and skirt. In these dresses the overskirt was often puffed to form two long, wing-shaped draperies at the back and a shorter one over each hip. Garments of this style were later called polonaise.

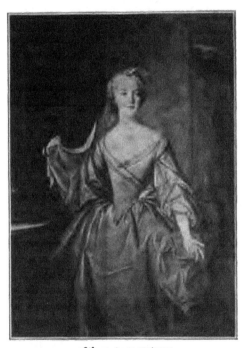

18th-century costume

All kinds of materials and many charming decorations of ribbon and lace were used. The overdress was frequently of flowered material while that of the underdress was plain.

The Louis XV costume is considered by many as at its best from 1750 to 1770, when fashion was chiefly guided by Mme. Pompadour, the favorite of the king. At this period many charming costumes were made in the flowered silks which bear her name. Much decoration was used, but it was dainty and graceful in character and gave no appearance of stiffness or heaviness to the costume. Through-

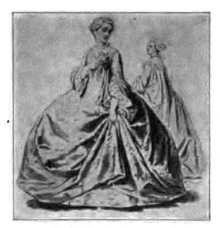

Watteau costume of 18th century

out the entire period the paniers had been steadily increasing in size, until at the end of the reign of Louis XV (1774) skirts were often six feet wide, from right to left, and eighteen feet in circumference.

Because many of the costumes worn over these large paniers were short, much attention was given to both shoes and stockings. White stockings with colored or gold or silver clocks were worn with shoes made of beautiful materials, heavily embroidered, and adorned with jewelled buckles.

For a brief period (1774-1792) a queen of France, Marie Antoinette, was also the queen of fashion. Under her guidance, however, costume seems not to have improved. The two types of dresses were still worn, but they became exaggerated in style and much of their charm was lost.

When the separate skirts and bodices were worn the skirts were very full and much trimmed. They were gathered at the waist and were held out by the large hoops. They seldom had trains.

For the other style of dress, the Watteau, the bodice and the skirt dra-

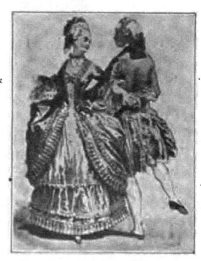

Draped costume of late 18th century

pery were cut in one piece and were worn over an underpetticoat. The edges of the overdress were usually very much decorated, as was the underpetticoat. The overdress was frequently cut to form a train.

All the bodices were made with extremely tight waists; they were also décolleté and generally had an elaborate front panel. In many cases a close-fitting, heavily boned, sleeveless silk underbodice was used. It was decorated at the front or had attached to it a panel decorated with lace or embroidery. This bodice shaped the figure, and over it was worn the dress itself, which had elbow sleeves and was sufficiently open at the front to show the panel.

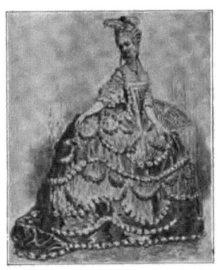

Costume of the period of Louis XVI and Marie Antoinette

Paniers were nearing the end of their reign, and, as if in revenge, they assumed their greatest size; the skirts worn over them were of rich and heavy materials, like brocades, and were made still heavier by wide and narrow flounces, by latticework of lace and ribbon, by plaited frills and scallops, shell-shaped trimmings, bouquets of artificial flowers and fruits, and over all a profusion of lace and ribbon.

Shoes became even more coquettish. They were often made in two colors, embroidered with gold and enriched with jewels. One very popular style of shoe had its back seams garnished with emeralds and diamonds.

The head-dress of Marie Antoinette's reign was as enormous and absurd as was that of the Middle Ages. At first the hair was built up and an enormous bonnet poised

on it. Then, in place of the bonnet came puffs made of
the hair itself and decorated with absurdities of every
sort. Frequently a high cushion of horsehair formed a
foundation over which the hair was drawn. Then row
upon row of puffs was attached. These were made by
using plaits of gauze in the meshes of the hair. Eighteen
yards was sometimes required for one head-dress. On this

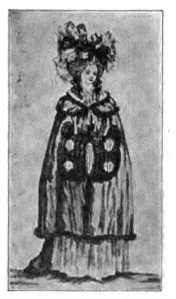
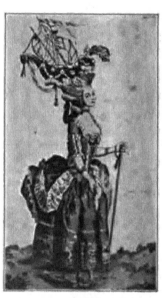

Costume of the late 18th · Head-dress of Marie Antoinette
 century period

erection of puffs was placed a variety of things, represent-
ing, it might be, an English park, a poem, a scene from
an opera, or an important political event. One head-dress,
called *La Belle Poule*, represented in miniature a French
ship which had been victorious in battle. These head-
dresses were so enormous that a woman could not ride in a
carriage unless she put her head out of the door or knelt
on the floor of the carriage.

About 1778 Marie Antoinette and her royal followers
played at farming at the Petit Trianon. An informal cos-

tume was required for this, one less cumbersome than that of the court. The general style of the costume was like that adapted from the Watteau period. The paniers were smaller, the skirts shorter. Dainty overdresses were looped up over puffed and ruffled underskirts, and the fichu, which had already become a popular fashion, adorned many of the costumes. It was made in a variety of shapes, of lace, muslin, gauze, and net. Dainty hats

Head-dress of Marie Antoinette period

were perched on elaborately arranged coiffures, hats which shaded the eyes and stood up from the hair at the back, showing the rows of puffs. Many women, to finish this costume, carried a shepherdess crook.

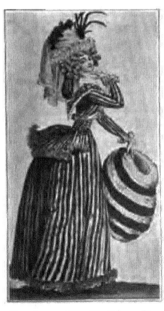

A costume of the English, or Pre-Revolution, period

These fashions were of rather short duration. As the stormy days of the French Revolution approached some of the gay absurdities of the eighteenth-century costume vanished and in place many women wore a costume masculine in general character and little less exaggerated than the other but in a different way. Styles which were called British, or English, were adopted by many, although not by the queen and her followers. The bodices were long and stiff, with small waists and an exceedingly pointed

waist line to which was frequently attached a full peplum. This increased the size of the hips and made the waist appear small. The sleeves were long and very tight. These waists were often ornamented with large metal buttons and topped by full-ruffled fichus which gave to the wearer

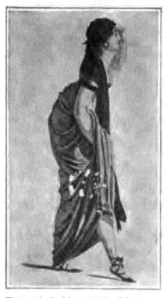

an appearance of absurdity and an abnormal silhouette. If paniers were worn they were small and round and had padding at the back to give the effect of a bustle. The skirts were gathered at the waist and fell in straight folds to the floor. Coats were worn with large lapels and triple collars. They were fitted tight to the figure and were long and straight in the back. An enormous amount of hair was still worn and it was surmounted by an enormous hat with large brim and high crown. These masculine costumes were, strangely enough, made up in bright colors, in silks, satins, and cloths. Such colors as

Eccentric fashions of the Directory

lemon, pink, and apple green were popular, while stripes in black and white, wide and exceedingly conspicuous, were frequently used.

The English fashions gave place to simple fashions and simpler materials. The days of the Revolution (1789–1799) were difficult ones—times were hard, and inexpensive fabrics took the place of the silks and satins. Cotton, India prints, and lawn were used, and such simple materials required rather simple making. Dresses were made somewhat like chemises. They had short waists and the skirts were plain and full with an occasional frill at the bottom. The sleeves were plain and short, and the neck was low. The dresses were adorned with fichus made of gauze or

other cheap material and were held in with sashes which had long ends. Corsets and paniers had disappeared.

This simplicity was followed, in the early days of the Directory (1795-1799), by a sudden reaction. The Revolution, and particularly the Reign of Terror (1794-1795), had practically swallowed up everything, the royal family and its followers, tradition, throne, manners, customs, and dress. With everything swept away and little time for reconstruction, fashions were borrowed, as were some of the laws. The men adopted fashions closely resembling those which were earlier called English; the women, however, worshipped antiquity and went back to either Greek or Roman fashions. Many of the women wore straight gowns bound by a girdle worn high up under the bosom. These gowns were frequently cut to be very short in front and training behind and displayed the feet and legs. Many were slit on one side to the hips or were raised above the knee and fastened with a brooch. These simple garments were made of transparent, clinging materials. They were worn with or without chemises. When no chemise was worn, tights were used. These gowns, in true classic fashion, had very small sleeves or none at all. Cameos, brought from Italy to France by Mme. Bonaparte, were used to attach the gowns on the shoulders, to form short sleeves, and to drape the skirt at the side. The arms were covered with bracelets as were also, in many instances, the legs. The colors were delicate shades of blue,

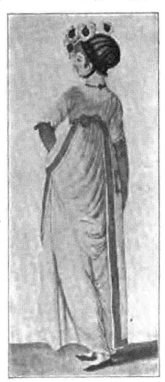

Costume of the Directory

pink, and lemon. In addition to this scanty costume an enormous cravat was often worn about the throat, sometimes covering the chin. This fashion was borrowed from the men. These thin garments were worn in the streets without protection other than the shawls and scarfs which were then coming into great favor.

In arranging the hair many women chose a goddess and copied her coiffures from the statues in the museums. Many coiffures and many toilets were named after some of the various terrible happenings of the Reign of Terror. The head-coverings were of many kinds; they were borrowed not only from the antique but from every other possible source. One fashion much worn later, under the Empire, that of the flat-crowned turban, was said to have been copied from the head-dress of the Turkish ambassador sta-

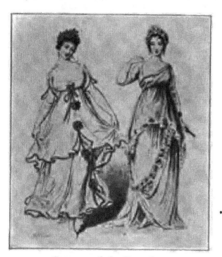

Costume of the Consulate

tioned in Paris. The shoes resembled the sandals worn by the Greek and Roman women. They were frequently red and were held in place by ribbon lacings.

Near the end of the Directory, costume, while still classic in form, no longer showed a tendency toward exaggeration or eccentricity. The materials were not transparent; the shawl, introduced after the Egyptian campaign of Napoleon, was much worn and, when well draped, added to the elegance of the costume.

All the simplicity and charm of line of the directoire costume at its best was maintained throughout the Consulate (1799–1804). The materials were more expensive but cut as simply. They were India mulls, muslins, and

lawns, all of beautiful, fine quality. The skirts were usually longer than before, were sometimes cut with trains, and had much dainty embroidery at the hems. The bodices were frequently embroidered on waist and sleeve to match the skirts and with them were worn fine lace collars. Many of these tiny décolleté bodices were made separate from the long, straight skirts and were of different materials.

The spencer, a tiny coat with short waist and long sleeves, was much worn and became exceedingly popular. It provided the covering which the abbreviated waist and sleeves of the gown frequently lacked. The cashmere shawls of brilliant colors were also very popular. The hair-dressing in general was still copied after that of the Roman women. A few ringlets were worn about the face; the hair was knotted at the back and ornamented with golden fillets and nets embroidered with pearls. Cameos, corals, and mosaics were chiefly used for jewelry.

VIII. Nineteenth Century

The fashions of the Empire (1804–1814) were merely an outgrowth and elaboration of those of the Consulate.

At first the short waists were, if possible, made shorter and more décolleté. Sleeves were close-fitting and either long or short; occasionally they were so short as to be just a padded roll at the shoulder. With many of the waists tiny standing lace ruffs were worn. They were attached at the shoulder, along the armseye line, and extended across the neck line at the back. They were generally for evening wear. The skirts of the dresses were straight, with a little fulness, and were worn both long and short. Strangely enough, many evening dresses were short and much trimmed at the bottom, while those for the day were long and training and less decorated. In 1809 stays began again to creep slowly into favor; they had not been necessary with the exceedingly short waists, when the size of the waist was of no importance. With their reappearance the waist line began almost imperceptibly to drop.

Small kerchiefs, arranged somewhat as the fichus had been, were worn about the shoulders. For a larger wrap the cashmere shawl was still used. Throughout the Empire there was a fondness for all things military. The spencer, still popular, was often adorned with braid put on in military style; one long outer garment, called a redingote, was similarly decorated.

Hats were of many varieties. Some were copied from the head-coverings of the army. They had tube-

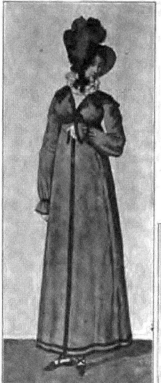

The redingote of the Empire period

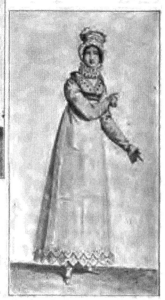

The spencer of the Empire period

shaped crowns, narrow brims, and were trimmed high with feathers and fastened under the chin with strings. Toques and the Turkish turbans were also used.

The greatest change from the fashions of the preceding years came in the materials used. These were usually

Oriental in texture, color, and ornamentation. They were
the results of Napoleon's campaigns. The simple and in-
expensive mulls and muslins gave place to silks and other
fabrics heavily embroidered and spangled. As in the
eighteenth century, artificial flowers were worn in great
abundance. Furs were also much used, and with them, in

marked contrast to the
fashion of the former
period, the women were
well covered.

Napoleon was ban-
ished to Elba and re-
turned for the short
period of one hundred
days. During that
time allegiance to the
imperialists or the
royalists was shown by
the costume worn. For
the followers of Napo-
leon, violets were the
emblem; for those of
Louis XVIII, a dress
of white jackonet with
eighteen tucks in the
skirt.

During the Restora-
tion (1814–1830), which

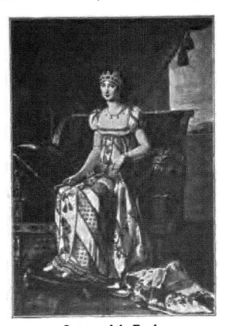

Costume of the Empire

marked the return of the last of the Bourbons, costume
gradually changed from the simple, graceful, although some-
what decorated, Empire fashions to a much more decorated
and less attractive style which in silhouette somewhat
resembles early Renaissance costume. Dresses were still
décolleté and had short waists, although the use of the
stay was causing the waist line to drop. The sleeves
were short and puffed, or they were long with some ful-
ness at the top but close-fitting at the wrist. They were
frequently bound at the wrist by a narrow ribbon which
also held up a short colored kid glove.

Evening dress of the Restoration

The skirts were straight and gathered, with much more fulness than before. They were very much decorated at the bottom, their elaborateness quite outdoing that of the Empire.

These skirt decorations were not only elaborate but varied and in many cases absurd. There were flounces, the edges of which were cut in different shapes, copying leaves and the petals of flowers; there were also garlands of artificial flowers and puffings or twists of material which were evidently padded to give them shape. The skirts were full and appeared very short. This appearance of shortness may have been due to the fulness as well as the increased decoration which held them out away from the figure.

About 1822 the bodices were cut to come to the normal waist line, and interest was at once

Costume of the Restoration

shown in the size of the waist. Belts were frequently worn emphasizing the straight waist line and the smallness of the waist.

The sleeve was greatly increased in size at the top and to it or to the shoulder were attached decorations to match those of the skirt. These gave width to the shoulders, which, with the width and decoration at the bottom of the skirt, made the waist appear, in contrast, even

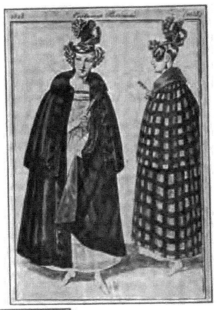

Hair-dressing of the Restoration period

more decreased in size than it really was. The sleeves were usually closefitting from just below the elbow to the wrist. Sometimes deep cuffs were added.

Much attention was given to the arrangement of the hair, which was copied somewhat from the Chinese and was drawn to the top of the head

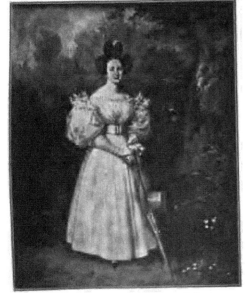

Costume of the Romantic period

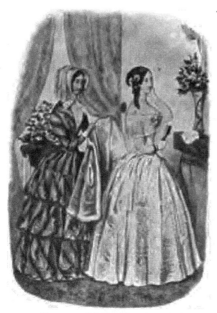

Costume of the Romantic period

and arranged in set loops intermixed with artificial flowers, plumes, etc. Even more interest was shown in the variety and number of the head-coverings. Bonnets and hats were both used. Many of them were military in character, being designed from the caps and hats of the troops. All the hats were very large, with wide brims and high crowns which were overloaded with flowers, ribbons, padded twists of material, ruches, aigrettes, and plumes. Many of the ribbons were in stripes and plaids of bright colors. During the Romantic period (1830–1848) costume again assumed a certain grace, distinction, and originality. The skirts, although full, were much simpler in design and had little decoration; the bodices were still close-fitting with a very low neck, which was cut widely off at the shoulders. The waist line was normal but more becoming because it had a point at the front. The shoulders of the wearer were made to look longer and

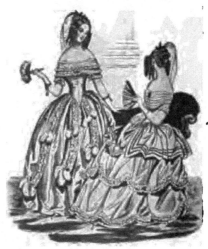

Evening costume of the Romantic period

more sloping by attaching
the sleeve to the waist
much below the normal
armseye line. This fash-
ion continued for some
time. A kind of bertha
in lawn or lace was fre-
quently worn and in-
creased the effect of a long
shoulder. The sleeves
were full at the top, but
as they were not stiffened
in any way they drooped
and did not add width to
the shoulder. The elabo-
rate shoulder decorations
of the earlier period were

Costume of the last of the Romantic period

given up. Many fancy shoulder capes were worn, as well
as many styles of long capes and mantles, some of which
had hoods.

Except for evening the elaborate coiffure was replaced
by a simpler arrangement. The hair was parted and
drawn back into a roll
which was held in place
by a large comb. A
few curls were usually
worn about the face.
There were still many
different styles of head-
coverings. One of the
most popular was a
rather close-fitting
bonnet with a rounded
brim which did not en-
tirely conceal the face
or the row of curls at
each side. Shoes were
low, with an instep
decoration such as a

Fashions of the Second Empire

Fashions of the Second Empire

rosette or bow, and some had no heels. Boots to the ankle were also worn.

There were no radical changes in fashion during the period of the Republic (1848–1852). The skirts were gradually growing larger, and under the Second Empire (1852–1870) they became very full and bell-shaped. They were frequently made up of flounces or had decorations which sim-

ulated them. At first they were held out by stiffened underpetticoats, but the increase in size of the skirt brought about naturally, if slowly, a revival of the wearing of crinoline or hoops. About 1854 crinolines, horsehair, and wire hoops were all used. In general shape they were like the first hoop of the Renaissance. Many who did not adopt crinolines continued to wear the flounced and starched petticoats to secure the desired effect.

Bonnet and shawl of the Empire period

The bodices were close-fitting, with the long shoulder. They were frequently adorned with wide collars or fichus which had long ends. These were sometimes attached or crossed at the waist line and then fell nearly to the bottom of the skirt. An effort was made to raise the waist line and adopt the fashions of the First Empire, but the close-fitting basque, with pointed waist line and full skirt, continued to be popular. Many of the basques fastened straight up to the throat and had narrow turn-over collars of lace. All the sleeves were long; some were close-fitting, while others, called pagoda sleeves, were bell-shaped. Both were set in at the lowered armseye as before.

Many lace jackets were used and many capes. The mantles were large, as were the shawls, like those of the First Empire. Smaller bonnets and small hats were worn. The bonnets were made of straw, of lace and nets, and were usually decorated, as were the hats, with artificial flowers or small plumes.

There was constant opposition to the hoop, and in 1869 its shape was changed and a melon-shaped bustle was added. The skirts worn with it changed in shape necessarily. They were narrow over the hips and were usually called Chinese skirts.

As there are many accessible records of the fashions from 1870 to the present day, and many of those fashions are merely adaptations of some described above, there seems little necessity of an outline covering the period.

PART II—TEXTILES

CHAPTER II

TEXTILE MANUFACTURE

The term textiles is the general designation for the materials of which dresses and the majority of garments are made. To insure a suitable selection of materials for any specific use in the making of dresses and garments a knowledge of textiles is required. This knowledge entails a study of the various standard fabrics as to fibre and general design, also a comparison of the different qualities in which the materials are made and of the different prices at which they may be purchased. Such work must be based on a preliminary study of the processes of manufacture of the four fibres, cotton, wool, silk, and linen, which are most important because most used. These processes vary somewhat according to the fibre used and the finished product desired. There are some processes, however, required for nearly all fibres and practically identical in general principle for each. These processes are:

(a) *Carding*, or some allied process, which prepares the fibre for spinning by converting the tangled mass into a continuous strand.

(b) *Spinning*, which prepares that strand for weaving by making it, through various drawing and twisting operations, into a yarn.

(c) *Weaving*, which makes that yarn into a fabric by interlacing it in various designs.

I. CARDING, SPINNING, AND WEAVING

I. Carding

Carding is the process by which tangled and matted fibres are cleaned, opened up, and arranged in a continu-

ous strand for subsequent spinning. It is probable that the need of this process was not felt until the art of spinning was fairly well known; but when its value was once understood its development paralleled that of spinning.

1. **Hand Carding.**—Carding, like spinning, was evidently first done by the fingers without the aid of tools. Later,

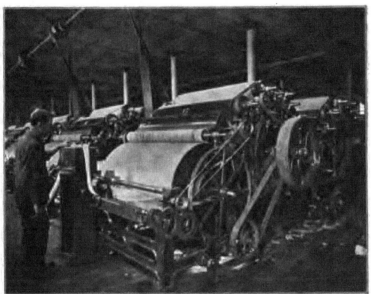

Worsted card

two flat pieces of wood with handles were used. These pieces, called cards, were covered on one side with skin or leather which was set with fine wire points or teeth. The wire was so bent that the points turned toward the handles of the cards. The fibres were placed between the cards, which were so manipulated, one on the other, that the fibres were disentangled, cleaned, and then made to form a soft roll called a sliver which was the length of the cards. In the subsequent spinning these rolls were drawn out and joined to form a continuous strand which was sufficiently fine and strong to be used in weaving.

Carding by this method was obviously a slow process. It is now done with great rapidity by the use of machines which have a large revolving cylinder covered with fine wire points called clothing. This cylinder comes in contact with many small cylinders or with revolving flats, and the fibres are cleaned, opened, and finally delivered continuously in the form of a web, which is in some cases reduced to a soft roll, or strand, called a sliver, and in others to a smaller roll, called a roving.

The first machines invented were fed by hand and delivered the sliver in short lengths as did the hand cards. Through many inventions, however, cards have been evolved which are fed by machine continuously and deliver the fibre in a continuous strand.

2. **Machine Carding.**—There are two general types of carding-machines; those used for wool, which have a large cylinder and several small ones, and those used for cotton, which have a large cylinder and revolving flats.

(1) *Carding-Machines for Wool.*—The carding-machines which are used for the two branches of the wool industry, worsted and woolen, differ somewhat in detail.

(a) *Worsted.*—For worsted (which does not require as much carding as woolen because of the subsequent combing processes) generally only one machine is used. This may be a single or a double cylinder card.

A machine in general use in the worsted industry is made up as follows:

(i) An *automatic feed*, which receives the fibre in bulk and regulates the amount to be delivered to the card. The machine consists of a travelling apron, which receives the fibre and carries it forward; a stripper, a cylinder or comb which works against the apron at the back and removes the surplus fibres; another stripper at the front, which removes the fibres brought forward on the apron and sends them into the card.

(ii) A *series of cylinders or rollers*, each of which is called a licker-in. These are placed in front of the feed and have metallic clothing which takes up the fibre and gently opens and cleans it preparatory to the carding.

(*iii*) *Burr guards*, metal rollers which revolve against the surface of the licker-ins and snap off any burrs in the wool. These burrs are received and held on a tray. (If any burrs and wool hold together the wool is also removed and later used for woolens.)

(*iv*) *First large cylinder*, which follows the licker-ins and is covered with card clothing. This clothing consists of a leather or cloth backing, or foundation, set with fine wire teeth, turned in the direction in which the cylinder moves.

(*v*) A *series of small cylinders*, called workers and strippers, which are also covered with card clothing. The workers revolve against the surface of the large cylinder. The strippers remove the stock from the workers so that it is again taken up by the cylinder and carried forward. There are the same number of workers as strippers, usually three of each for worsted.

(*vi*) A *fancy*, a kind of wire brush which runs into the clothing of the cylinder and raises the fibre to the surface of the teeth.

(*vii*) A *doffer*, a cylinder which is set close to the large cylinder and receives from it the fibre raised by the fancy.

(*viii*) An *angle stripper*, which removes the fibre from the doffer and passes it to the second large cylinder.

(*ix*) *Second large cylinder*, like the first.

(*x*) A *doffer*, like that which follows the first cylinder.

(*xi*) A *doffer comb*, a metal bar with corrugated edges which works against the surface of the doffer and removes the fibre, now made into a·thin web, as it comes up on the doffer.

(*xii*) A *trumpet*, or *tube*, which is placed at one side of the machine. It takes the web as it is delivered by the comb and, condensing it into a roll, passes it through drawing-off rolls.

(*xiii*) *Drawing-off rolls*, from which it comes in the form of a continuous strand, or sliver, and is wound on a ball or coiled in a can ready for the subsequent processes which prepare it for spinning.

(*b*) *Woolen.*—In the woolen industry a set of cards, two or more in sequence, is used. At present each card

is a separate machine, called a *breaker*. Usually there are three—first breaker, second breaker, and finisher. In general principle the breaker is the same as the worsted card, but there is a difference in detail. Usually burr guards are not necessary, as in the majority of cases the fibres have been passed through a separate machine called a burr-picker before coming to the woolen cards. There are generally more workers and strippers on the large cylinder of the breaker—from six to nine of each. The fibre used for the woolen industry requires much more carding than for the worsted, as it is not combed but goes from the breakers directly to spinning.

(*i*) *Feeding the Fibre.*—There are two general methods of feeding the fibre from one breaker to another, the purpose of each feed being to produce uniformity of product.

(*a*) *Traverse feed.* The web is drawn in the usual method from the large cylinder to the side and made into a continuous sliver by a revolving tube and drawing-off rolls. From these rolls it is carried to a travelling apron placed at the back of the second breaker. Here lengths of 'this continuous sliver are so arranged on the bias, side by side, as to form a solid lap. This lap is carried forward by the apron and fed into the second breaker.

(*b*) *Creel feed.* The web is made into a sliver by the side drawing, as in the other machine, and then wound into a ball on a spool. Several of these balls are placed in a creel, or frame, and fed side by side straight into a card. More manual labor is required for this method than for the other.

(*ii*) *Removing the Fibre.*—The method of removing the fibre from the final card, or finisher, differs somewhat from that used with the worsted card. In the finisher there are two ring doffers placed one above the other and working against the surface of the large cylinder. On these the clothing does not cover the entire surface, as in the worsted doffer, but is in narrow strips or rings around the cylinders. As these rings alternate on the two rolls, by working in conjunction, the full width of the web is re- moved. Each doffer delivers narrow strips or ribbons of

the web to a condenser. The condenser is a travelling apron having an oscillating or sidewise motion which reduces each strip, as it passes over it, to a small roll, called roving, or roping. These strands of roving go over guides and are wound side by side ready for spinning on a big spool, generally termed a jack-spool.

(2) *Carding-Machine for Cotton.*—The carding-machine for cotton is simple. The fibre has already been made into a thick lap. This is placed at the back and is fed directly to the card.

In place of the workers and strippers working on the surface of the large cylinder, there are revolving flats, a kind of endless lattice which is supplied with card clothing. The motion of the flats is like that of a travelling apron, continuous. They card the fibre, which is delivered in a thin web from the cylinder to the doffer. This is made to form a sliver by passing it through the trumpet and the drawing-off rolls and is then coiled in a can for the subsequent processes which prepare it for spinning.

The process in detail for all is as follows: If the raw fibre is fed to the card in bulk the amount delivered is regulated by the automatic feed at the back. If a lap is used, as in cotton, no automatic feed is necessary. The fibre passes in a wide sheet to one or more small rollers, and they, in turn, pass it on to the large cylinder, over which it goes, carded by the action of the teeth of the large cylinder and those of the flats, or the small cylinders. The fibres are opened, cleaned, separated, and finally removed by another small cylinder called a doffer, which has its teeth so arranged that it takes the fibre from the large cylinder.

The fibre comes from the doffer of the carding-machine in a wide, thin sheet or web. For convenience in handling, this web is made by various methods into a continuous, untwisted strand which, according to its size, is termed a sliver or a roving.

II. *Spinning*

Spinning is the drawing out and twisting of fibres to form a continuous strand or yarn. It is not known when or how the discovery was first made that certain fibres could be spun; that is, could be drawn out and given enough twist not only to hold the fibres together but to make them sufficiently strong for use.

1. **Hand Spinning.**—When spinning was first mentioned in early records, it had reached a stage of development at which it evidently remained for centuries. At that time the three fundamental processes—drawing, twisting, and winding—were done, with more or less difficulty, by the fingers. The first improvement came with the use of tools, when the spindle and whorl and the distaff supplemented the work of the fingers.

(1) *Spindles.*—The earliest spindles seem to have been merely straight sticks used for the winding of the continuous strand which the fingers had made by drawing out and twisting the fibres. This strand was kept from unwinding by tying it about the stick or fastening it in a notch at one end. Later the spindle was made to assist the work of the fingers in both the drawing and the twisting. After the fibres were attached to it, it was given a twirl and allowed to fall to the ground. In twirling, it twisted the fibres together into a strand, which was drawn out as the spindle fell. After a sufficient length had been twisted and drawn it was wound on the spindle and fastened. The spindle was then set twirling again and the operation repeated.

It was soon seen that the spindle fell more quickly and easily when it had yarn wound on it, so a weight, called a whorl, was added. It was probably, at first, of mud, clay, or stone. Later both spindle and whorl were made of wood, bone, and metal and much ornamented.

(2) *Distaff*, or *rock*. This was also a stick and carried the raw fibre. It was generally tucked under the arm or worn in the belt. This facilitated the work somewhat, as it left both hands free to draw out the fibres and operate the spindle.

2. The Introduction of Spinning-Wheels.—With the appearance of the hand-wheels at the last of the Middle Ages there was greater production. There was also a differentiation of method which still persists in modern spinning-machinery.

(1) *Jersey Wheel.*—The wool, great, or Jersey wheel was first used. It had a large and a small wheel placed on

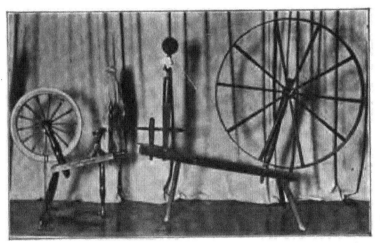

(*a*) Saxony wheel (*b*) Jersey wheel

a standard and connected by a belt. The spindle was attached to the small wheel and both were turned by the revolutions of the big wheel. The worker stood. The motion was intermittent; that is, the twisting and drawing were done together by the turning of the spindle and the receding movement of the spinner. For winding, the motion of the spindle was temporarily reversed in order to bring the yarn into place. When this was done its regular motion was again started, and the spinner advanced toward it, guiding the twisted strand with her fingers.

The process in detail was as follows: One end of the carded roll of fibre was attached to the point of the spindle. This roll was drawn out or attenuated by the worker as she walked back away from the spindle to start the big

wheel. As the big wheel turned the spindle turned with it. The worker held the attenuated strand of fibre out, almost in line with the spindle, so that it could not wind on it but fell from its point at each revolution and in consequence was twisted rather than wound, each revolution of the spindle giving one twist to the strand. After the fibre was sufficiently drawn out and twisted, the big wheel was stopped and its motion reversed to bring the yarn into position on the spindle for winding. The spun yarn was then held at right angles to the spindle and nearer its centre; the wheel was turned in the original direction and the yarn was wound on the spindle.

Bobbin and flyer

(2) *Saxony Wheel.*—The Saxony or flax wheel, which next appeared, was of more complicated mechanism. It also had a large and a small wheel placed on a standard and connected by a belt. These wheels were turned by a treadle which was attached to the big wheel by a rod. The spindle was fastened to the small wheel and turned with it. In addition to the spindle, however, there was a bobbin and flyer.

In spinning, the yarn was wound on a bobbin rather than on a spindle as in the other wheel. The bobbin was a hollow cylinder which was put on over the spindle but not attached to it. It revolved with the spindle in the same direction, but more slowly, as it fitted loosely and was retarded in its motion by the winding of the yarn.

The purpose of the flyer was to twist the yarn. It was

shaped somewhat like a horseshoe but with its ends more spreading. It was attached to one end of the spindle and turned about it and the bobbin at the same rate of speed as the spindle. A series of hooks were placed on each prong of the flyer. These served to guide the yarn as it was wound on the bobbin. In order to bring the yarn into position for winding, it was passed through a hole or eye in that end of the spindle to which the flyer was attached, then carried around one hook in the flyer and fastened to the bobbin.

A distaff to hold the carded fibre was usually placed high at the front of the wheel. As this wheel was operated by foot-power, the worker sat. The motion was continuous; the worker guided and drew out the fibres, which were then twisted by the flyer and wound by the bobbin without interruption.

The process in detail was as follows: The fibre was taken from the distaff by the spinner and drawn out sufficiently to pass through the eye of the spindle. It was then carried over a hook of the flyer and attached to the bobbin. The big wheel was started by placing the foot on the treadle; this in turn started the spindle with its bobbin and flyer. The worker, who had both hands free, took the fibre from the distaff with her left hand and, slightly twisting and drawing it with her right, guided it to the eye of the spindle. The drawing, twisting, and winding went on continuously and followed each other. The drawing was done by the worker, the twisting by the rapid revolution of the flyer, and the winding by the slower revolution of the bobbin. It was not necessary to stop the wheel except for changing the yarn from one hook of the flyer to another in order to wind the bobbin evenly.

The product of these two wheels differed somewhat, the continuous motion of the flax wheel giving a harder-twisted, stronger yarn than the intermittent motion of the wool wheel.

3. **The Development of Spinning-Machines.** — In the latter part of the eighteenth century various spinning-

machines appeared. Their appearance was due to a demand for an improved quality of yarn and for a much greater product than could possibly be supplied by the use of the hand-wheels. Two spindles could be used on a spinning-wheel, but this doubling of the productive power of some wheels did not in any way meet the demand, which was soon still further increased by the invention of a fly-shuttle for the loom. Formerly the two industries, spinning and weaving, were evenly balanced. With this invention, however, more yarn could be woven than could be supplied by the spinners.

The underlying principles of the spinning-machines which were invented seem to have been borrowed from one or the other of the hand-wheels.

(1) *Spinning-Jenny.*—The first important invention was made by James Hargreaves about 1764. His machine was called a spinning-jenny. Its principle was like that of the wool or Jersey wheel. The motion was intermittent; that is, the drawing and twisting were done together, followed by winding.

The jenny had an oblong frame. Across one end of it were (*a*) eight or ten upright spindles. Over the spindles were (*b*) the wires, which could be regulated to place the roving in position for twisting, and later the spun yarn in position for winding, as required. The spindles were operated by (*c*) a big wheel which was at one side of the opposite end or back of the frame. The wheel was connected by (*d*) a belt with (*e*) a cylinder placed in the centre of the lower part of the frame. This cylinder had (*f*) a separate belt or cord for each spindle, and as it revolved with the turning of the wheel the spindles were made to revolve also.

Set near the cylinder in the lower part of the frame was (*g*) a creel which held (*h*) bobbins of the roving to be spun. There were as many bobbins as upright spindles. On the top of the oblong frame, extending from side to side, was (*i*) a carriage which, set on wheels working in grooves made in the framework, could be pushed back and forth the length of the frame. Across this carriage was (*j*) a

holder which could be regulated to allow the roving to pass through it or to be firmly held as desired.

The process in detail was as follows: The carriage was placed in front of and close to the upright spindles; the ends of the roving were brought up from the creel and passed through the holder of the carriage; each end was then attached to one of the spindles. When the roving was fastened to their points the spindles could twist in the turning, as in the big wheel, but because of the guide . wire they could not wind.

To begin spinning, the worker turned the wheel, causing the spindles to revolve. Having thus started the twisting, with the other hand he drew the carriage some distance away from the spindles, letting out a length of roving. When enough roving was delivered the holder on the carriage was closed and held the roving. The carriage was then drawn back the full length of the frame, while the spindles continued turning. As a result, that length of roving was both attenuated or drawn out and twisted. When the carriage reached the far end of the framework, it was stopped and backed a little to loosen the tension of the yarn so the spindles could continue to turn and give a still tighter twist to the drawn-out yarn.

When twist enough had been given, the spindles were stopped and the guide wire was adjusted to press the yarn down on the spindles in position for winding. The turning of the spindles was then continued and, as the carriage was sent slowly back toward the spindles, the twisted and drawn-out yarn was wound on them.

While the operation of this machine was slow and tedious, yet it was an improvement, as it had eight or eleven spindles working at one time in place of the one or two of the hand-wheels. It helped in amount of production, but the yarn it made was softly twisted and not very satisfactory for use as warp.

(2) *Water-Frame.*—Arkwright's water-frame was the next invention, about 1768. It was first run by horse or water power, as it was an exceedingly heavy machine. Later steam was used. Its principle was in general that of

the Saxony wheel. The motion was continuous, the drawing, twisting, and winding being done separately but continuously. ·

In addition to the bobbin and the flyer, which were used for twisting and winding, a series of rollers, called drawing-rollers, were introduced to draw out the roving. The machine had an upright frame, on the top of which, at the back, was placed the roving to be spun. In front of the roving were (*a*) the sets of drawing-rollers revolving at different speeds. Placed somewhat below these, and at the very front of the frame, were (*b*) several upright spindles provided with (*c*) bobbins and flyers.

The process in detail was as follows: The roving passed from its spool, or bobbin, through the two sets of rollers. The set at the back which first received the roving moved slowly; the other set moved much more rapidly. Consequently, as the intake of the second set was greater than the output of the first, the roving was drawn out or attenuated. The roving passed from the .rollers through the hole or eye in the top of each spindle, and over the hooks on the flyer which twisted it, to the more slowly moving bobbin on which it was wound.

The introduction of this machine marked the beginning of successful roller-drawing which is employed in nearly all modern spinning. Formerly, in the wheels and even in the jenny, the amount of drawing which the yarn received was dependent on the worker, and might, in consequence, be very uneven. With the use of rollers the drawing was governed entirely by machinery. As a result the yarn was more even in quality and, due to the continuous motion of the water-frame, harder twisted. It was a more satisfactory warp-yarn than that of the jenny.

(3) *Crompton's Mule.*—A machine which combined the most valuable points of the water-frame and the jenny appeared about 1779. It was the invention of Samuel Crompton. Its motion was intermittent. It was called a mule because of the combination of parts of the two machines, Crompton having used Arkwright's drawing-rollers and combined with them Hargreaves's movable

carriage for more drawing and his upright spindles for the twisting and winding. At the top and back of the stationary part of the machine the roving was placed as in the water-frame, and immediately in front of it were (a) sets of rollers operating at different speeds. The (b) upright spindles were placed on (c) the carriage, which travelled away from and toward the rollers on a track some feet in length. The (d) spindles were made to twist and wind the strands alternately, much as in the spinning-jenny, by their turning and by the use of the (e) guide wires and the movement of the carriage. This machine combined drawing by rollers with drawing by the receding of the carriage.

The process in detail was as follows: The carriage with the spindles was drawn close to the drawing-rollers. The roving from the creel of bobbins at the back was passed through the rollers and attached to the point or end of the spindles, where it was held by a guide wire. As the rollers delivered, the carriage withdrew on its track and the spindles turned, so that the strand was drawn by the rollers and twisted by the spindles at the same time. After the required length of roving had been delivered the rollers were stopped but the carriage continued to recede to draw out the roving still more. When the carriage reached the end of the track it stopped, the tension was loosened by a slight backing of the carriage, the spindles continued to turn to give extra twist, and then they also stopped. Another guide wire placed the yarn in position for winding on the spindles. The motion of the wheel was reversed and the carriage returned to its original place, while the spindles were turning to wind the yarn.

This machine forms the basis of the modern self-acting mules. Even when first invented the mule was more satisfactory and more used than the jenny or water-frame. Various improvements were made from time to time in the various parts of it, but it was not until about 1830 that it was made self-acting.

4. Types of Modern Spinning-Machines.—There are two general types of spinning-machines in use now: the mules

and the upright spinning-frames. Both types have developed from the two hand-wheels through the series of machines just described. The mules are based on the wool-wheel and spinning-jenny, and the spinning-frames on the Saxony wheel and water-frame, both having added rollers for feeding or drawing. The underlying principles have been the same throughout as those of the early wheels, but the modern machines differ in that all the processes of drawing, twisting, and winding are done by complicated machinery, which can operate many hundreds of spindles at one time, while the spinner using the hand-wheels must do some of the work herself and in consequence cannot, at best, manage more than two spindles. In running the modern machine these mechanical contrivances enable the worker to produce probably more than a thousand times as much yarn as can be produced in the same length of time on the wheel.

(1) *Mules.*—There are two kinds of mules, one which is used in the spinning of woolen yarns, the other which is used in the spinning of worsted and cotton yarns. Both are based on the Crompton mule and are alike in general method of procedure. Both have rollers which guide and feed, or draw; upright spindles placed on a movable carriage which travels back and forth on a track averaging from sixty-four inches to seventy-two inches in length; and faller wires which guide and maintain the tension in winding. In both machines the motion is intermittent, the drawing and twisting being done on the outward journey of the carriage and the winding on the return.

In the winding, one section of the bobbin or cop is filled at a time. End-to-end winding is not done as it is on some of the spinning-frames.

(a) *Woolen Mule.*—The roving for this comes from the woolen card and is on a jack-spool, which is placed at the back of the stationary structure of the machine. Directly in front of the roving are the guide rail and feed-rolls. These rollers do not draw, but they are arranged to regulate the tension and guide the roving as it is fed to the spindles. The drawing of the roving is done by the con-

tinued recession of the carriage after the feed-rolls have ceased to deliver. The twisting and winding are alternately done by the turning of the spindles, which are provided with bobbins and guide wires, called fallers, and are so placed in the carriage that they slant a little forward toward the machine. This slant causes the roving to drop off the point of the spindle as it revolves on its outward journey, so that the roving is twisted and not wound.

In detail the process is as follows: The carriage with the spindles is drawn close to the stationary machine. The ends of roving are carried from the jack-spool over the guide rail, through the feed-rolls, and attached to the spindles.

As the carriage withdraws, the feed-rolls deliver and the spindles turn. No drawing is done at first. When about half the journey of the carriage is completed, however, the feed-rolls stop delivering, and as the carriage continues to withdraw, the roving already delivered is drawn out and reduced in size. The spindles are twisting all the time, and even after the carriage has reached the end of the track they continue turning to give additional twist.

While this final twist is put in, the carriage moves back a very little toward the machine to free the tension on the yarn, as it is somewhat shortened in length by the twisting.

When enough twist has been given, the spindles are stopped, the yarn is backed off the top of the spindle and placed in position for winding. The faller wires drop into position, one serving as a guide in the winding, the other maintaining the necessary tension, while the carriage returns and the spun yarn is wound.

(b) *Worsted Mule.*—The roving for this comes from the roving-frame and is generally on shells which are placed in a creel at the back of the stationary machine. Directly in front are the guide rail and drawing-rollers. There are two sets of rollers which draw, and between them are two more sets whose purpose is to guide and maintain an even tension on the roving.

All the drawing is done by the rollers; the recession of the carriage merely gives opportunity for greater length of

gyration in the twisting, which keeps the fibres in better shape and gives a yarn more regular in size and even in twist. The twisting and winding are done alternately by the turning of the spindles, which are provided with tubes, on which the spun yarn is wound, and with faller wires. The spindles are set to slant forward as are those of the woolen mule.

In detail the process is as follows: The carriage with the spindles is drawn close to the stationary machine. The ends of roving are carried from the shells through the guides and rollers and are then attached to the spindles.

The front rollers turn at greater speed than those at the back, and the roving is thus drawn out and attenuated. As the carriage withdraws, the drawing-rolls deliver this attenuated roving and the spindles turn to give it the necessary twist. The carriage moves at a rate of speed which keeps the roving taut while the twisting is going on but which does practically no drawing. Additional twist is put in after the carriage has reached the end of the track. Exactly as in the woolen mule, the winding is done by the aid of the faller wires as the carriage returns.

A mule requires a skilled attendant, as it is an exceedingly complicated machine. Men are usually employed for this work. A man with attendants can take care of two machines. The number of spindles on a machine differs, as does the distance which the carriage travels, both depending on the kind of yarn spun.

A woolen mule generally has about four hundred spindles, a worsted about six hundred, while a cotton may have from six to twelve hundred, according to the size of the yarn.

(2) *Upright Spinning-Frames.*—There are three kinds of upright spinning-frames in general use for the different fibres: the ring, the cap, and the flyer.

These are all based on the Arkwright water-frame and are alike in their method of drawing, but vary in the contrivances used for twisting and winding.

In the original water-frame the twisting was done by a flyer. It did not prove satisfactory, however, for the high

speed necessary in the majority of the modern machines, and other inventions took its place. The flyer is still used, but much of the work in spinning formerly done by it is now done by a ring and traveller or by a cap.

All the spinning-frames have drawing-rollers and upright spindles with bobbins. The motion is continuous, the drawing, twisting, and winding being done separately but continuously. In the winding, the cop may be formed either by filling the bobbins in sections (filling wind) or by end-to-end winding (warp wind).

(a) *Ring Spinning.*—In this process big spools of roving as they come from the roving-frame are placed at the back of the upright frame. Just in front, but on an incline, are arranged the series of drawing-rollers. These differ in their rates of speed, the front set going faster than those at the back in order to draw out the fibre. Below these and at the front of the machine are the spindle and bobbin, which are turned by power. They are enclosed by the ring, which carries the traveller. The spindles are upright and are attached to a stationary rail. They pass through circular openings in another rail or platform, called a lifter, which is so arranged that it moves up and down the length of the bobbin. In the circular openings are placed stationary rings with flanges. Sprung on each flange and revolving on it is a small wire ring called a traveller.

In detail the spinning process is as follows: The roving goes through the drawing-rollers and is attenuated. It is then passed through the traveller and fastened to the bobbin. The spindle with its bobbin revolves rapidly. The tension of the thread between the rollers as they deliver and the bobbin as it revolves rapidly causes the traveller to turn, but, in turning, it lags behind the bobbin, so that in revolving it not only twists the attenuated yarn, which it receives directly from the rollers, but winds it on the more swiftly turning bobbin. The winding is regulated by the movable platform, or lifter, which carries the ring and traveller. It rises and falls, winding the yarn evenly.

The ring is generally used in the spinning of cotton, but is seldom used for worsted except for twisting after spinning.

(*b*) *Cap Spinning.*—The machine for this process differs mainly in having a cap in place of the ring and traveller.

The spindle is upright and to the top of it is attached a metal cap. Both are stationary. On the spindle is a bobbin which is driven by power. This bobbin moves up and down as well as around on the spindle and winds the yarn evenly. In order to wind on the bobbin, the yarn coming from the drawing-rollers must revolve about the cap, the lower edge of which guides it in the winding.

In detail the spinning process is as follows: The roving goes through the drawing-rollers and is attenuated. It is then brought through an eye in a guide rail, down over the cap, and attached to the bobbin. The power turns the bobbin, and by its swift turning the thread is made to balloon rapidly about the cap and in this way is twisted as it is wound.

Yarn which is spun on the cap very frequently has many loose fibre-ends which stand out. This is caused by the speed with which it is whirled through the air about the cap.

Cap spinning is used very largely for worsted.

(*c*) *Flyer Spinning.*—The machine for this process differs in turn from the other two in that its twisting and winding are done by a flyer.

The spindle is upright and has the flyer attached to it and moving with it. On the spindle is a bobbin which is turned, as was the traveller in ring spinning, by the tension of the yarn. It also moves up and down to wind the yarn evenly.

In detail the spinning process is as follows: The roving goes through the drawing-rollers and is attenuated. It is then brought down through the eye of the fly-board, or guide, through a guide called a twizzle in the end of the flyer, and attached to the bobbin. As the spindle is turned by power the flyer turns with it and twists the yarn. The tension of the yarn moves the bobbin, on which, as it revolves more slowly than the flyer, the yarn is wound.

The flyer is used on the spinning-frames for the long fibres, like linen, mohair, alpaca, hemp, jute, and long

wools, when a smooth yarn is desired, and on the so-called fly-frames which by drawing and twisting prepare the cotton roving for spinning.

The upright spinning-frames are much simpler in operation than the mules. The machines are usually so placed that many spindles can be watched at the same time by one attendant.

III. Weaving

Weaving consists in interlacing at right angles two or more series of threads, of which the lengthwise are called warp, and the transverse woof, weft, or filling. In weaving, the warp-threads are always arranged first and the filling threads are then interlaced in various ways, as required by the design. Weaving was at first done by hand, with but little assistance in the way of mechanical devices, and yet the products of the most perfected of the power-looms of to-day have never surpassed the beauty of the texture and design of those hand-made materials.

1. **Hand Weaving.**—The first weaving was, without doubt, exceedingly simple. The warp and filling threads were probably alike, and were of material which could be handled easily, such as grass, reeds, and leaves. The size of the finished product was dependent on the length of these materials. The design was the simplest,—the plain weave,—over one, under one, alternating with each row.

As has been said, in all weaving the warp materials, or threads, are first arranged in parallel order. To interlace the filling, certain of these warp-threads must be lifted by some means, probably at first by the fingers, and the filling passed in and out. Each row as it is put in must be carefully pushed close to the last; otherwise the interlacing will not appear regular and the fabric will not be firm when completed.

The lifting of the warp-threads to open a path for the filling was called shedding, or opening a shed; the passing of the filling through the shed was called picking; while the pushing of the rows of filling into place was called

battening, or beating up. These three fundamental steps or processes are present in all weaving operations, whether of hand or machine, and take place always in the same order. The gradual evolution of the stationary loom and the later use of power-machinery have affected only the exactness and speed of the work, and not the method of procedure.

The first efforts to make weaving easier seem to have been by the use of (*a*) two sticks or beams, to which the ends of the warp were attached. These stretched the warp and kept it in place, so that the interlacing of the filling was less difficult. Later, when materials of greater length were made, these same sticks served still other purposes. On one, called the warp-beam, was wound the extra length of warp to be woven; on the other, called the cloth-beam, was wound the finished fabric.

To facilitate the work further, a stick was put through the warp and so attached to it that all the desired threads could be raised at once, rather than one at a time, as by the fingers, thus making a better shed for the more rapid insertion of the filling. This stick, called (*b*) a heddle, has developed into the complex harness of the modern loom, and has still the same function, that of forming a shed. Another stick, on which the filling was wound and which took the place of the fingers in passing it through the shed, later became (*c*) the shuttle, and carried the bobbin wound with filling. Still another stick, which was called (*d*) a batten, lay, or lathe, and was used to push the filling-threads together to make a firm fabric, is to-day represented in the loom by the reed, which does the beating up or battening.

2. **The Appearance of the Hand-Loom.**—Improvements and changes in all devices led in time to the construction of what was called in Europe the hand-loom, and later, in America, the Colonial loom. This loom had a stationary, square framework which held a revolving beam at the back on which the warp was wound, (*a*) the warp-beam; and another beam at the front which received the finished cloth as it was woven, (*b*) the cloth-beam. Between these

two beams and near the front was (c) the harness for open-
ing the different sheds. There were two or more of these
harnesses, the number depending on the elaborateness of
the design to be woven. Each harness was made up of a
series of healds, or heddles, or cords, suspended between two
flat strips of metal or wood. To form a heddle, a cord was

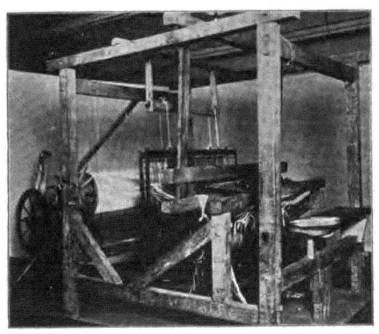

Hand-loom

so knotted as to make an eye or loop at the centre through
which one warp-thread might be passed when the loom was
set up for operation. The harness was suspended from the
top of the frame of the loom by cords and pulleys and was
worked by (d) treadles. In a simple design one treadle
usually operated one harness. In front of the harness was
the lay, or batten, now become (e) a reed, a metal comblike .
arrangement enclosed in a wooden framework. This was
so arranged that it could be moved as required, backward,
out of the way of the shuttle when the shed was open, or

forward to beat the filling into place. The warp-threads were drawn from the warp-beam through the different harnesses, according to the design, and through the reed, and then attached to the cloth-beam at the front. Near the warp-beam two sticks, called (*f*) lease-rods, were interlaced through the warp, to help in keeping the warp-threads taut and to prevent tangling. These sticks were used in the primitive looms, but, unlike the other sticks, their form remained practically the same for the most modern loom. The tools necessary in weaving were (*g*) the shuttle with its (*h*) bobbin, or quill, and a cloth-stretcher, now called (*i*) a temple. Generally the filling-thread was wound on a quill, or bobbin, and placed in the shuttle, which carried it back and forth through the warp for the interlacing. The shuttle was of wood and usually boat-shaped. It is much the same in the power-looms to-day. The temple kept the material at the proper width as it was woven. In putting in the filling-threads it was very easy to make the fabric narrower than intended, by pulling the threads too tightly. To prevent this the stretcher or temple was placed in the material close to the end which was being woven, thus keeping it stretched to the right width. It might be made of wood or metal; its length could easily be changed to suit the width of the material, and at each end were teeth to catch in the cloth. The temple has now been entirely changed in form and become a part of the loom. It is generally a small cylinder set with pins or teeth and placed at each side of the loom near the front. It is turned by the friction of the cloth. Its teeth catch the edge of the material as it is woven and drawn forward to the cloth-beam, or roll, and keep it stretched to the proper width.

To operate the hand-loom for the plain weave—one over, one under—the process in detail is this: Two harnesses are required, through one of which the even threads—2, 4, 6, 8—are drawn; through the other the odd—1, 3, 5, 7. All the threads in regular order—1, 2, 3, 4, 5—are then passed through the reed and carried forward to the cloth-roll and fastened. The warp must be so wound that there is an

even tension on each thread. One treadle operates one harness, which in turn operates the one set of threads passing through it. This opens a shed. To weave, a foot is placed on one of the treadles and it is pressed down. This opens a shed by drawing down or depressing one set of threads. The shuttle carrying the filling is thrown through this opening or shed. The reed is then brought forward and pressed firmly against the filling-thread just put in to beat it into place; the next shed is opened by pressing down the other treadle; the shuttle is thrown back again, and thus the work continues. The later hand-looms had an automatic arrangement for unwinding the warp and winding the cloth as the weaving progressed. The power-loom is essentially the same as the more modern hand-looms.

3. **Inventions.**—The first two important inventions were made in weaving while the hand-looms were still in use. These were the fly-shuttle and the drop-box.

(1) *Fly-Shuttle.*—With the invention of the fly-shuttle in 1733 by John Kay one person could manage an ordinary loom, where before two were needed to send the heavy shuttle back and forth. The arrangement of the fly-shuttle was this: At each side of the loom was a box for the shuttle, and in each box was a driver. These drivers were connected by a cord which had a handle at the centre of the loom. By drawing the handle sharply the driver, in the box containing the shuttle, struck the shuttle and sent it across through the shed.

(2) *Drop-Box.*—The drop-box, invented by Robert Kay in 1760, was an arrangement by which bobbins carrying various colors of yarn could be brought into place and sent through the shed automatically as desired, without stopping the loom, as had been necessary formerly.

4. **The Use of Power-Looms.**—Many attempts were made to operate a loom by power. In 1785 a heavy automatic loom was invented by Doctor Edmund Cartwright. It became the basis for the modern power-loom.

(1) *Plain Harness-Loom Weaving.*—In the power-looms used to-day all the old operations are present but are

now done practically by machinery; and in addition there are various devices for holding and changing shuttles, replacing empty bobbins, and stopping the loom if warp or filling threads break. All power-looms without special devices are limited as to pattern, because the pattern is dependent on the number of harnesses, and only a comparatively small number—about thirty—can be used conveniently in one loom. Each harness can control a large number of warp-threads, but it can open only one shed. After exhausting the number of harnesses which a loom can carry, the weaving can be continued only by repeating the pattern just made by these harnesses.

(2) *Pattern-Weaving.*

(a) *Jacquard Loom.*—The difficulty of repetition of pattern was met by the invention of the Jacquard loom. In this loom the warp-threads may be operated separately rather than in groups, which allows a practically unlimited variety of patterns to be made. Each warp-thread passes through the eye of a harness-cord, which is attached to a hook overhead. Each hook is in turn attached to a horizontal needle and operated by it. All these needles are driven forward by springs, against the face of a cylinder. This cylinder has four sides, and over it go the perforated cards which bear the design to be woven. Only those needles which, when driven forward, go through a perforation in the card affect the pattern. In entering the perforation they carry forward their hooks, which catch on a crosspiece, or griffe, in the loom and are held there; the other needles fall back into place, taking their hooks with them, and the warp-threads which are connected with them are lowered. In this way a shed is formed. As there are many sets of these needles, many sheds may be opened and a very elaborate pattern made. The expense in setting up the loom and in making the design and perforating the cards is somewhat of a drawback to its use.

(b) *Harness-Loom Attachments.*—There have been many devices invented which may be attached to the harness-loom to secure special results.

There are two in very general use which accomplish

somewhat the same results as the Jacquard, with less expense. These are the Dobby and the Head-motion. The Dobby is an English invention. In this attachment the pattern-cards of the Jacquard are replaced by an endless chain of narrow strips of wood, called bars. These have rows of holes in which pegs may be placed according to the design. Each bar opens one shed. The bars move around a cylinder and operate levers which lift hooks. The hooks in turn raise the harness fastened to them and open the shed. The Head-motion is an American invention. In this attachment the pattern-cards of the Jacquard are replaced by an endless chain of rods on which are movable collars, called risers and sinkers, which operate the harness and give much the same results as do the pegs of the Dobby.

Other less elaborate attachments are used to secure special effects. By an attachment called a lappet, which is practically an additional harness set in front of the reed, designs are added to the face of the cloth which give the effect of embroidery. The swivel attachment gives much the same result as the lappet but is more often used in the more expensive fabrics. Terry fabrics, like Turkish towelling, are made by a specially arranged reed which beats up the thread firmly only on every third or fourth pick. This, with an additional warp which is loose, gives the loops which are its characteristic. For warp-pile fabrics there must be added to the regular loom equipment a series of wires, with or without knife-edges, which bring up into loops, at right angles to the foundation warp and filling threads, an extra warp-thread and thus form a pile.

5. **Preparation of Warp and the Threading of the Warp for Hand and Power Looms.**—Preliminary to all weaving are two important processes, the preparation of the warp and its threading into the loom. In general, the method of procedure for both is somewhat the same in the hand and power loom. In the hand-loom the warp is prepared and drawn in entirely by hand. In the power-loom the preparation of warp is by machinery. It is not so in every case with the threading, which, when many harnesses are

used, is a rather difficult operation and requires not only
patience and time but skill.

(1) *Hand-Loom.*—For the hand-loom the processes of
warp preparation and threading are generally as follows:

(a) *Preparation of Warp.*—The number of warp-threads
required and their length depend on the width and length
of the material to be made. The yarn comes wound on
bobbins from the spinning-wheel. In spinning, the amount
of yarn wound on each bobbin is not uniform, and in order
to secure even lengths for the warp the yarn must be meas-
ured. This is done by winding the desired lengths into
skeins on a reel which somewhat resembles a wheel. From
the reel the skeins are put on a swift and wound back on
bobbins, the required length to each bobbin. To transfer
the yarn to the warp-beam of the loom, several bobbins are
placed in a bobbin-frame, and the threads from these are
wound on warping-bars which are of various kinds. This
operation is repeated until enough lengths to give the re-
quired width have been prepared. From the bars the
different groups of threads are transferred by various
methods to the warp-beam of the loom. In this trans-
ferring they pass through the teeth of a comb-shaped
guide, often called a raddle, which is placed near the warp-
beam and helps in keeping the threads separated and in
winding them on the beam evenly and smoothly. Two
people are needed for this operation, one to watch and
guide the threads, the other to turn the beam.

In winding the threads on the warping-bars a cross, or
lease, must be made in them at one end. Through this
the lease-rods are to be placed as the warp is set up in the
loom.

(b) *Threading.*—When the warp is wound on the beam
and the cross is secured by the placing of the lease-rods, the
ends are drawn, as the pattern requires, through the har-
ness and then through the reed. A reed-hook, resembling
somewhat a flattened crochet-hook, is used to pull these
threads through the eyes of the heddles and the dent, or
teeth, of the reed.

The simplest weaving design, the plain weave, requires

two harnesses—one for the odd threads, one for the even. In threading, care must.be taken to keep the threads in the regular order in which they come from the warp-beam. One harness is threaded at a time. In doing it, thread No. 1 goes into the eye of the first heddle, No. 2 goes between the first and second heddles, No. 3 goes into the eye of the second heddle, and No. 4 between the second and third heddle, and so on. This is followed by drawing the even threads, which were passed between the heddles of the first harness, through the eyes of the heddles in the second harness.

The reed then receives both odd and even threads in regular order—1, 2, 3, 4, 5, etc. After the threads are drawn through the reed their ends are tied together in groups. A stick is passed through these knots and is firmly attached to the cloth-roll. The loom is then ready for work.

(2) *Power-Loom.*—For the power-loom the processes in general for the preparation and drawing in of warp are as follows:

(a) *Preparation of Warp.*—By machinery this operation is comparatively simple. It differs somewhat in detail, however, for the different fibres.

As in the hand-loom, the width and length of the material decide the number and length of the warp-threads. All yarn, as it comes from the spinning, is on bobbins, or cops. From the bobbins it is wound on big spools; that is, it is made into larger packages for greater convenience in handling. These packages are placed in frames, or racks, and the yarn wound by different methods on to the warp-beam. In the preparation of some warps for the power-loom it is necessary to add sizing to the yarn in order to strengthen it to withstand better the wear of the weaving-machinery. This is usually done by passing the yarn through a tank of sizing, after which it must be carefully dried. All warp must be evenly wound; otherwise, as the weaving progresses, the warp will not feed with an equal tension on each thread.

If the warp is very fine, as is frequently the case in silk,

thin paper is placed between the layers of thread as it is wound on the warp-beam.

(*b*) *Threading.*—The threading of power-looms is now done both by hand and by machine. The method in general parallels that of the hand-loom. As the threading of any loom takes time and skill, when a warp is no longer of use or its length exhausted, all the threads are carefully tied in groups back of the harness. The new warp is then wound on the beam by the usual methods, and each new warp-thread is twisted or tied to an old one and drawn through the harness. This can be done much more quickly than can the regular threading.

II. Processes of Manufacture for Cotton, Wool, Silk, Linen, and Other Lesser Fibres

There are four general classes of fibres:
(1) *Animal*—wool, silk, and mohair.
(2) *Vegetable*—cotton, flax, ramie, jute, and hemp.
(3) *Mineral*—asbestos and tinsel.
(4) *Artificial*—artificial silk and spun glass.
The four important fibres—cotton, wool, silk, and linen (flax)—are those most used in the manufacture of clothing and consequently are those chiefly discussed here. Cotton, wool, silk, and linen fibres are, when manufactured, suitable for use both in undergarments and in outside garments. In this chapter, however, both the fibres and fabrics are considered only as to their suitability; that is, their wearing quality from the standpoint of dressmaking.

I. Cotton

Cotton is a vegetable fibre. It is the hairs which are attached to the seeds of the cotton-plant. While growing, they are enclosed in the pod formed after the flower dies. The fibre is made up of a single cylindrical cell which collapses as the pod bursts and the air reaches it, and becomes ribbonlike, with thickened edges and an irregular spiral twist. This twist is important, since it assists in the interlacing of the fibres in spinning.

There are many varieties of the cotton-plant. The value of the fibre depends somewhat on the variety, but the desirable qualities—color, length, strength, smoothness, fineness, pliability, and uniformity—are greatly affected by the climate, soil, and cultivation.

1. **Field Picking.**—Cotton must be picked as soon as it is ripe. The picking is done both by hand and by machine, and an effort is made to pick only the ripe fibres, as the presence of the unripe injuriously affects the character of the whole. It is a tedious operation and often badly done because of the great number of people required for the work and the consequent necessity of employing unskilled labor.

2. **Weighing.**—Cotton is weighed after the picking. About two-thirds of its weight is due to the seed which is still attached to the fibre.

3. **Ginning.**—Ginning is the next process; it separates the seed and the fibre. There are two general kinds of gins—the roller-gin, which seems to have developed from primitive methods and is now used chiefly for long-staple cottons, and the saw-gin, which was invented by Eli Whitney and is more generally used but often tears and injures the fibre. In the roller-gins the seed is removed by passing the fibre over a roller against the surface of which a kind of knife operates and separates seed and fibre. In the saw-gin revolving circular saws separate fibre and seed by pulling the fibre from the receiving hopper through a grating which is too fine for the seeds. If the cotton is fed into this hopper too rapidly, knots, or neps, will result and interfere later with the spinning process.

4. **Baling.**—From the gin the cotton is carried to a condenser and then baled. In this process it is subjected to pressure, covered with jute or some similar material, and bound with metal bands. Before transportation the bale is usually subjected to more and greater pressure in the cotton compress. This makes it the required size for shipping, but does not improve its appearance, as the covering often bursts in many places.

These processes—picking, ginning, and baling—might

be called preliminary processes. Those which follow have to do with making the fibre into yarn, and they vary somewhat; that is, the number of processes used and the quality of yarn made, depend on the effect and quality desired in the finished product.

Before giving the mill processes, it is necessary to explain that nearly every mill manager has a different method of procedure. The attempt is made here to show a representative method which includes the number and variety of general processes required and places them in an order followed by many mills. No attempt is made to explain intricate machinery.

5. **Opening.**—After the bales are opened at the mill the cotton is usually mixed to establish a uniform quality. This mixing may be done by hand, but is usually done in a machine called a bale-breaker, which cleans the fibre as well. The cotton from various bales is carried on a travelling apron, or lattice—a feed which regulates the amount—and fed to a beater, after which it is usually sent through a cleaning-trunk and delivered to another beater. In the trunk the fibre is shaken up and carried forward by a draft of air, and the dirt, which is thus removed, settles and the two are separated. The beaters are cylinders set with heavy teeth; these seize the cotton and throw it against a grid through which the dirt goes. The fibre is then taken up by other teeth and thoroughly opened up. By means of condensing-rollers it is delivered in the form of a thick web.

6. **Picking.**—Machines called pickers follow. There are usually three, the breaker-picker, intermediate picker, and finisher-picker. These are in general principle like the bale breaker or opener in that they have beaters and condensing-rolls. In many mills the bale-breaker is omitted and its work done by the breaker-picker.

Each picker has attached to it an automatic feed, which receives the fibre from the previous machine and regulates by pressure the quantity to be delivered to the beater. These pickers remove the dirt, separate the tufts of cotton, and finally deliver it in a lap which is wound into a roll on

a shell and is then ready for carding. The three machines are used, because by repeating the beating and condensing processes the final lap is made much more uniform and the fibre much cleaner.

7. **Carding.**—The roll of lap is next placed at the back of a carding-machine. The purpose of this machine is to separate, clean, and arrange the tangled fibres.

As already explained, the carding-machine has a large cylinder the surface of which is covered with small wire teeth which are turned in the direction in which the cylinder revolves. Above this cylinder and coming in contact with it are revolving flats, a kind of endless lattice with teeth, which are turned in the opposite direction to those of the cylinder. The cotton is fed in between these two sets of teeth, and is straightened and cleaned by them and the poor fibres removed. The cotton comes from the machine in a continuous thin web, is condensed by the trumpet and drawing-off rolls into a narrow band, or roll, called a sliver, and coiled in a can. Double carding is sometimes done. (For detail in *Carding*, see page 53.)

8. **Combing.**—If a fine grade of yarn is required the cotton must next be combed. It is an expensive operation. Practically all mercerized yarns and such as are used for sewing-threads, batistes, and laces are combed. There are a few preliminary processes after carding before the sliver is ready for the combing. (a) Sliver Lap-Machine.—Several slivers from the cards are passed side by side through the rollers of a sliver lap-machine and made into one lap the required width, about ten or twelve inches. '(b) Ribbon Lap-Machine.—A few of these laps are then combined by feeding them to a ribbon lap-machine, which delivers them as one lap more uniform in size than the product of the sliver lap-machine and ready for the comb. (c) Comb. —Some form of nip comb is used. There are several different makes, but the general method of procedure is the same for each. The comb removes from the lap all the short fibres and straightens and parallels those which are fairly uniform in length. There is much waste from this machine, called comber waste. It is used in cheap-grade

cotton fabrics. The combing is done by the action of combs set in cylinders, over which the lap passes, and by an overhead comb. Sections of the lap are held in position by the jaws of a nipper and combed one-half of the length at a time. When thoroughly combed these lengths are again made into a continuous strand, condensed, and finally delivered as a sliver and coiled in a can.

9. **Doubling and Drawing.**—The slivers, either from the card or from the comb, are next subjected to a process called doubling and drawing, the purpose of which is to continue paralleling and straightening the fibres, to make even the sliver, and to reduce it in size for spinning. This is accomplished by feeding from four to eight slivers to a machine called a drawing-frame which has a series of drawing-rollers. These rollers, like those of the upright spinning-frames, revolve at different speeds, the last set going much faster than the first. Because of this difference in speed the sliver is drawn and not only evened but reduced in size. Drawing may be done once, twice, or three times. From the last drawing-frame the fibre is again delivered as a sliver and coiled in a can.

10. **Drawing and Twisting.**—From the drawing-frames the sliver goes to the fly-frames, of which there are four. In many cases only three of these frames are used, depending on the quality of yarn desired. The four are called (*a*) the slubber, (*b*) the intermediate, (*c*) the roving, and (*d*) the fine, or jack frames.

The fly-frames have drawing-rollers, like those of the drawing-frames, but in addition they have a bobbin-and-flyer attachment, as, in these frames, the strand is so reduced in size as to require a twist to give sufficient strength for winding and handling.

One thick end or sliver is fed to the first frame, the slubber. It is drawn out by the rollers and twisted and wound on the bobbin by the flyer. The product of this machine is called slubbing. Several strands of slubbing are united when fed to the different fly-frames which follow. On each a strand still more reduced in size is twisted and wound on a big spool or bobbin. From the last, or

jack, frame it is called a roving, and is sufficiently small and has twist enough to be ready for spinning.

11. **Spinning.**—Spinning may be done on either of the two spinning-machines, the worsted mule or the ring spinning-frame; the latter, for many reasons, is more often used. On these machines the roving is reduced in size by the drawing-rollers and is then given a twist and wound on a bobbin or tube. Two strands of roving may be combined in the spinning. The product from any spinning-machine is a single yarn.

12. **Twisting.**—Many of the single yarns are doubled and combined by more twisting to give strength or to produce special effects in the weaving. Greater strength is more often necessary when the yarns are to be used for warp. The twisting-frames are like the upright spinning-frames except that they have no drawing-rollers.

13. **Weaving.**—For this some preparation of the yarns is necessary.

(*a*) The filling-yarns are wound on bobbins which are suitable for the shuttles. Filling-bobbins are always wound a space at a time and not end to end, as the yarn is thus delivered more easily.

(*b*) The warp-yarn requires more preparation, as it must be sized before it is wound on the warp-beam. The yarn is transferred from the bobbins to spools which are set up in a rack and the yarn wound from them to several warp-beams. From these warp-beams the yarn passes through a machine called a slasher, in which it goes through a tank of sizing and over a big drum for drying. It is then drawn through a guide and is wound, as the design requires, on one warp-beam ready for the loom. This sizing is to give the yarn sufficient strength for the weaving process; it is later removed during the finishing processes.

Cotton yarns are made into a great variety of materials, which include all kinds of weaves from the plain to the very elaborate. These may be made on the plain harness-loom or by special attachments, such as the Dobby and Head-motion, or on the Jacquard. A large number of cotton fabrics have the plain or cotton weave and are given vari-

ety by finishing processes or by a combination of yarns of different color, size, or fibre.

14. **Finishing.**—The final appearance of cotton material depends very much on the finishing processes employed and on the dressings used after the weaving is done. Many materials are alike in weave and the size of the yarn used, yet quite unlike when ready for purchase. For example, long cloth and cambric have the same weave, the plain or cotton; but while the cambric has a somewhat polished surface the long cloth has a dull one which shows a little fluff or fuzz. This difference is made in the finishing.

Many of these finishes are often removed to some extent in the laundry and the appearance of the material decidedly altered. For instance: in some cases loosely woven cotton fabrics are made to feel and look firm and thick by the use of sizing, which is somewhat like starch. Water will dissolve and remove this and leave the fabric as it originally was—sleazy and thin.

(1) *Regular Processes.*—No matter what is desired in the appearance of the finished product, all materials from the loom must be subjected to certain processes. These usually include:

(a) *Inspecting and Marking for Repairs.*—The woven material is drawn over a frame which is placed in a strong light, and its defects are carefully marked. (b) *Repairing.* —All the defects marked must be repaired; all broken threads must be joined and any missing ones replaced, otherwise the design in the finished fabric will not be complete. This is especially important in cotton materials, as the weave is seldom entirely concealed by any finish. (c) *Singeing.*—This is done to one or both sides of the material to remove the many short fibre-ends which show on the surface. The material is passed through gas flames with such rapidity that only the loose fibre-ends are affected. To prevent any burning, however, the material is immediately washed and dried. (d) *Starching, wet or dry.*—All materials have some starch or sizing added during the finishing. In many cases a loose weave and poor quality of fibre are concealed by sizing, thus necessitating

a larger quantity. (*e*) *Spraying.*—This is done by forcing water on the fabric, much as sprinkling is done in laundry work preparatory to ironing. (*f*) *Calendering.*—All materials are pressed with heavy rolls. The detail of this process differs somewhat according to the finish required. For example: for ginghams and long cloths, which do not have polished surfaces, cold rollers are used in the calendering, as merely rolling contact is required to give the desired result; for cambrics, which do have polished surfaces, hot rollers revolving at different rates of speed are used as heat and friction are required to give polish. (*g*) *Bleaching, Dyeing, or Printing.*—If material is to be white, it is necessary to bleach it. If it is to be colored, and the raw stock or yarn was not dyed, it is dyed in the piece. Many materials have a design printed on the surface of the fabric by some of the usual methods rather than woven in. Such fabrics usually require a preliminary bleaching.

(2) *Special Processes.*—Cotton, by special treatment, may be made to look like silk, linen, or wool.

(*a*) The general method of giving cotton the appearance of silk is by mercerization—a process in which the cotton is subjected under tension to a concentrated caustic alkali bath. As a result, the fibre becomes round, full, and rod-like and reflects the light sufficiently to give a lustrous surface. This can be more satisfactorily done to the yarn than to the woven fabric, but it is done to either.

(*b*) Many methods are used to make cotton cloth look like linen. None of the methods are permanently successful, because of the marked differences in the fibres, especially in the length and lustre. Much dressing is usually required, followed by beetling, or some allied process, and pressing. These give the fibre all the lustre and firmness it is possible to secure.

(*c*) Various methods are even more frequently employed to give a woolen or worsted effect; the most common is that of raising a nap on the surface of the fabric by using cylinders with napper clothing. The result gives such materials as outing flannel, flannelette, duckling-fleece, and blankets.

Cotton is the cheapest and the most used of the four important fibres. Because of its cheapness there is no need of adulteration; but, as has been said, it can be made to look like various other fibres, and in consequence is often used as a substitute. A few years ago cotton was said to supply nine-tenths of the material employed in the manufacture of clothing. That includes, of course, materials which are all cotton and many which are shown on the shop counters as all wool, all silk, or all linen.

The character of the various cotton fabrics manufactured is discussed under *Fabrics*.

II. Wool

Wool and hair are the most important of the animal fibres. They come from sheep and other similar animals, such as the angora goat, the camel, and the alpaca. Both wool and hair are used in manufacture and are subjected to much the same general processes. Chemically, they are the same, but in appearance they differ somewhat. Hair is generally rather stiff, straight, and lustrous. Wool is soft, flexible, elastic, and wavy.

Each wool fibre is formed from a series of cells in the skin of the animal. These cells are grouped about each other and are filled with a fluid which evaporates as the cells force their way, in series, through the cuticle into the air. The evaporation of this fluid allows the cell walls to collapse, one on the other, and as they are gelatinous they form a continuous stalk which is the fibre. On the surface of this fibre are scales or serrations, sawlike edges, which are made by one cell's overlapping another, as they collapse on reaching the air. These serrations and certain other characteristics, such as its cellular structure, give to the wool the shrinking, felting, or matting quality which is so valuable in manufacture.

There are many varieties of wool, depending chiefly on the breed of the sheep. There are also many different grades on any one sheep. As a result, wool fibres differ greatly as to length, strength, fineness, softness, elasticity,

lustre, number of serrations, and waviness. All these qualities cannot be combined in any one fibre, but in proper combination they have much to do with the value of the wool.

The wool industry as a whole includes two important clothing industries: *woolen* and *worsted*, both of which are not usually carried on in the same mill. The different processes necessary in the manufacture of each require different types of machines.

Almost from the first the wools intended for the two branches need quite dissimilar treatment. In the sorting and blending the method in general is the same, but it is done with a different result in view for each. The dusting and drying, on the contrary, are the same in method and result for both. Beyond the drying the processes differ very much.

The difference between a woolen and a worsted yarn is in the mechanical arrangement of the fibres in the finished thread.

The fibres in the worsted yarn are straightened and paralleled. All the processes in its manufacture, especially the spinning with its roller drawing, work toward that result. In many cases the beauty of the finished fabric depends on the twisting of the yarn and the clearness of the design and weave, and all the finishing processes applied are to aid in emphasizing that effect. Worsted fabrics include serges, whipcords, albatross, Bedford cord, etc.

The fibres of the woolen yarn, on the contrary, are as intermixed and interlaced as possible. The yarn in the spinning is always spindle-drawn, and in general the weave is chosen to give firmness as well as design to the finished fabric. Woolen fabrics include such materials as broadcloth, tweed, melton, and beaver.

1. **Preliminary Processes for Worsted and Woolen.**

(1) *Shearing.*—Sheep are sheared by hand and by machine. The wool, in the shearing, comes off in a whole sheet, called a fleece. Each fleece is tied up separately, and about forty are packed in a bag together for shipping. Paper twine is very generally used now for the tying, in

place of sisal and jute, from which the fibres are easily rubbed off and intermixed with those of the wool.

(2) *Grading.*—Wool grading is often done by the middleman before the wool is finally sold to a mill for manufacture. The qualities are determined without untying the fleece and depend in general upon the cleanness of the wool, as affecting its shrinkage in the scouring, and the length and diameter, or fineness, of the fibre.

Following these two processes, shearing and grading, come those of the mill in which the wool is first prepared for manufacture by sorting and scouring and is then manufactured by various processes into yarns.

The kind of yarn and its quality affect the number and kind of processes necessary. As with cotton, an attempt is made here to show a representative method which includes in their regular order the number and variety of general processes required.

(3) *Sorting.*—This is the first process at the mill. Woolsorters are trained to detect the various qualities and can quickly divide a fleece into parts, the number of parts depending entirely on the use to which the wool is finally to be put. A fleece, in general, is divided according to length, fineness, and suitability of fibre. While the various required qualities are being separated, the undesirable parts of the fleece are also determined and assembled for other uses. Some wools, usually those from the Far East, are opened on tables provided with screens and having a downward draft of air which prevents the dirt from rising.

2. **Special Processes for Worsted.**

(1) *Blending or Mixing.*—Blending is done to secure a desired price and quality in the finished product. After the various mixtures are chosen they are spread out on the floor, in the right proportion, layer upon layer. In using, care is taken to secure the complete mixture by taking from the side of the mass rather than from the top.

(2) *Dusting.*—The purpose of the duster is to take out as much as possible of the loose dirt and sand. Dusting is not always considered necessary. If the wool has much sand and dust in it, however, soap is saved in the scouring,

which is to follow, by sending the loose fibres through the duster first. Generally, a machine called a cone duster is used. It has a cone-shaped cylinder made of wood or metal arms set with heavy pins, or teeth. The fibre is fed in at the small end of the cylinder, is carried by its revolutions to the big end, and thrown out at the back. There is a screen and fan at the top which takes away some of the dust, and a grid at the bottom against which the fibre is beaten and through which the dirt drops.

(3) *Scouring.*—The scouring or washing is to remove the chemical and mechanical dirt; that is, the grease, or yolk, a skin secretion, and any sand and loose dirt. These are found in all wools. The scouring must be carefully done or the fibre may be injured. Soap, with carbonate of potash, or carbonate of soda—depending on the wool—is generally used and followed by careful rinsing.

The wool-washer has (*a*) a self-feed which delivers a regular amount at regular intervals. The fibre is placed in the hopper of the feed and taken up by a revolving spiked apron. At the back of the apron is a stripper which knocks the surplus wool back into the hopper; at the front there are revolving drums which strike off all the wool, allowing it to pass over the apron and delivering it to be washed. (*b*) A series of tanks, three or four in number, as required. Each tank has a false bottom, or screen; this keeps the wool away from the dirt which settles to the bottom. In each tank there are rakes or harrows which take up the wool as it enters the tank and carry it slowly forward through the water, cleaning it and preventing felting or matting.

Between the tanks are squeeze rolls which act as wringers. They have an immense pressure and remove much of the liquid as the wool is passed forward through them. These rolls are placed over screens, and the liquid runs down into other large tanks and, after settling, is used again.

The first two or three tanks through which the wool passes contain some detergent; the last, pure water for rinsing.

(4) *Drying.*—Drying must follow scouring and may be done in various ways, but, whatever the method, care must be taken to maintain the correct amount of heat and moisture. A drier may be attached to the washer or it may be a separate machine.

One type of drier frequently used has a self-feed and a chamber which is kept at a certain temperature by steam-pipes, an inlet for fresh air, and an outlet for hot, moisture-laden air. In this chamber is a travelling wire apron with a fan underneath. The feed delivers the wool in regular amount to the apron, which carries it as a rather thin web forward through the heated chamber and dries it.

(5) *Oiling.*—Wool loses its natural oil in the scouring, and some must be added to make the fibre sufficiently soft and pliable and prevent static electricity, so that it will go through the remaining processes without injury. The oil is applied either by hand or by a simple spraying apparatus attached to some machine. Different oils, but usually olive-oil, are used in different mills.

(6) *Carding.*—*Preparing.*—After the drying and oiling the fibre is put through a carding-machine or a set of preparers. The choice of the machine used depends on the kind of fibre to be manufactured; that is, the cards are used for the medium and fine wools, the preparers for the longer wools, twelve inches or fourteen inches, and for mohair and alpaca, for which the cards are not suited.

About nine-tenths of all the worsteds are carded. The purpose of both the cards and the preparers is the same. They separate and clean the tangled fibres and deliver them in a continuous strand called a sliver.

(a) *Cards.*—A single or double cylinder card may be used. The double-cylinder card differs from the single only in having two large cylinders rather than one. These are connected by a doffer and an angle-stripper, which pass the fibre from the first to the second cylinder. The fibre is first delivered by an automatic feed to cylinders called licker-ins, which begin the opening and cleaning. On the licker-ins are burr-guards which knock off any burrs left in the wool. The large cylinders with their sets of workers and

strippers do the carding. The second cylinder is provided with a doffer and doffer-comb which removes the carded fibre. The fibre comes in a thin web from the second cylinder to the doffer and is taken off by the comb. It is then made into a continuous strand called a sliver by passing through a tube or trumpet and through drawing-off rolls, after which it is coiled in a can or wound on a ball. (For detail in *Carding*, see page 50.)

(*b*) *Preparers.*—The general result of the set of preparers is the same as that of the card, plus the work of machines called gill-boxes, which must always follow the card. The action and principle of the preparers, however, differ from those of the cards and are like those of the gill-boxes. At the back of the preparers is an apron-feed which delivers the fibres to rollers. These in turn pass the fibres forward to movable bars set with parallel rows of upright pins—a kind of comb, called fallers. These fallers automatically come up in front of the rollers, receive the fibre, and, moving forward faster than the rolls, comb the wool and then deliver it to two rollers at the front. These front rollers are moving at a faster rate of speed than the fallers, and they draw the fibre as it is delivered to them by the fallers and thus assist further in the straightening and drawing.

Usually five or seven of these preparers are used in sequence; from the last two or three the fibre is passed through a hole and condensed into a sliver and coiled in a can. When the sliver leaves the last preparer it goes directly to the comb.

(7) *Gilling.*—This process, which is a kind of combing and much resembles the preparing, *must* follow the card but is *not* used after the preparers. The work is done in a machine called a gill-box, which has drawing-rollers and fallers like the preparers. It continues the arranging of the fibres for the comb.

In this machine doubling and drawing are done as well as the preliminary combing. Several slivers, the number depending on the quality of the product required, are fed to the back rollers of the gill-box. From the rollers the slivers are carried forward by the fallers and delivered to

the more rapidly moving front rollers. The fallers are set with pins much finer than those of the preparers. After leaving the front rollers the fibre is made into a sliver and coiled in a can or wound in a ball.

For the fine and medium wools, after the double-cylinder card there may be generally two operations of gilling, one machine following the other, before the sliver is ready for the comb.

For coarser wools a single-cylinder card and one operation of gilling sometimes precede the comb.

(8) *Combing.*—The fibres in the sliver which results from any one series of the preceding processes are fairly well straightened and paralleled, but they are of uneven length. Both long and short are combined in one strand. To remove the short fibres and further straighten the remaining long ones, they are put through a rather complicated machine called a comb.

The Noble comb is most frequently used for worsteds, though the work can also be done by a nip comb.

For use in the Noble comb the slivers are arranged by winding in a punch or ball-winder. This machine has a plate with four holes for the sliver to pass through, two rolls in front of the plate which guide and keep an even tension, and a revolving spindle on which the winding is done. Four ends, or slivers, from the last gilling or preparing operation are passed through the holes and guide-rolls and wound side by side into a ball. The spindle is withdrawn from the balls and eighteen of these are placed in the comb.

The Noble comb is circular in shape. It has one large circle set with concentric rows of steel pins; the coarser pins are on the outside rows, the finer on the inside. On each side of the machine are two smaller circles; these are set inside and practically touch the big circle at one point. These small circles are also set with concentric rows of steel pins, but on these the fine are outside to be next the fine of the large circle and the coarse ones inside. The big circle and the two small circles revolve, and as they revolve there is always a point of contact between each small circle

and the big one. At this point of contact the strand of fibre is fed in and pressed down, or dabbed, into the teeth of the big and small circles. As the two circles revolve, the points at which they were in contact separate and the strand of fibre is drawn through the teeth of both circles and combed as they continue separating.

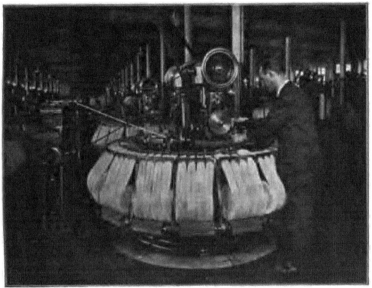

From a photograph, copyright by American Woolen Co., Boston

Noble comb

The short fibres, called noils, are removed by a knife. These are frequently, though wrongly, included in the list of wool substitutes. Noils are used in the manufacture of woolen fabrics, as they give many short ends which are useful in the teazling and gigging processes to raise the nap. The long fibre is taken from the circles by rolls, carried by travelling leather aprons, and finally delivered, a united strand, through a trumpet or tube which gives it a false twist, to a can in which it is coiled. It is called a sliver.

(9) *Spinning Systems.*—From this point either of two different methods of procedure in the manufacture of the

yarn may be followed, according to the kind of yarn desired; that is, worsted yarn may be drawn and spun (*a*) by the *Bradford* system, which gives a smooth, lustrous, level yarn, or (*b*) by the *French* system, which gives a soft, rather fuzzy yarn.

These two systems differ in an operation called back-washing, which removes any oil from the wool, and in the drawing operations.

In manufacturing the wool fibre it is necessary to add oil frequently to facilitate the carding and combing processes. If the wool is to be Bradford-spun no effort need be made to remove the oil except: (*i*) If top dyeing is to be done the oil must then be removed by back-washing and later applied. In the end the same result is accomplished. (*ii*) Back-washing may be done from choice to give the top a very good appearance, if, for instance, the wool is to be sold in the top. The oiling must then be done later before the manufacture of the top can be continued.

Back-washing is not an absolutely necessary process, except for the tops to be used in the French system of drawing and spinning.

(*a*) *Bradford System.*—For the Bradford system the following operations are required:

(*i*) *Gilling.*—Two operations of gilling follow the comb, the first in a can gill-box, the second in a balling gill-box. The principle of these machines is the same as of those which precede the comb. The fallers are generally provided with finer pins. In the first gill-box fourteen to eighteen ends of sliver from the comb are united into one and run into a can. In the second four to five ends from the first gilling are united into one and wound into a ball, called a top.

(*ii*) *Doubling and Drawing.*—In the drawing-boxes, of which there may be from five to nine, the top is converted into roving. The drawing-boxes have a series of drawing and guide-rollers and a bobbin-and-flyer attachment. At the back of the drawing-boxes are frames which hold several bobbins of slubbing or tops. The slubbing passes through the drawing-rollers and is then given a slight twist

by the bobbin-and-flyer attachment. This twist is put in merely to facilitate the handling of the strand in carrying it from one machine to another. When the slubbing passes through the rollers the twist is removed. The real function of the drawing-boxes is drawing. The last drawing-box is called a roving-frame, and delivers the strand much reduced in size and slightly twisted.

(*iii*) *Spinning.*—This is the last process in forming the yarn. For this system it may be done on the cap, flyer, or ring spinning-frames.

(*b*) *French System.*—For the French system the following operations are required:

(*i*) *Gilling.*—One operation of gilling, in a can gill-box as with the Bradford system, follows the comb.

(*ii*) *Back-Washing.*—The sliver is next passed through a machine called a back-washer. This has two bowls for the washing-liquor at the back, a series of drying-cylinders, and a gill-box with the usual fallers. The slivers are washed free of oil in the bowls, are dried by passing over the drying-cylinder, and straightened and united into one end in the gill-box.

(*iii*) *Gilling.*—Another operation of gilling, in a balling gill-box as with the Bradford system, follows. This straightens the fibres, winds the strand, and makes a back-washed top, also called a dry top.

(*iv*) *Doubling and Drawing.*—In the drawing-boxes, of which there are nine or ten, the slubbing, or top, is made into a roving. Several strands are made into one, much reduced in size. The drawing-boxes differ from those used by the Bradford system in that (*a*) they have, in addition to the usual series of drawing and guide rollers, a small cylinder set with pins, called a porcupine, which acts much as do the fallers in the gill-boxes in keeping the fibres straight as the strand is reduced in size; and (*b*) in place of the bobbin-and-flyer attachment they have two oscillating aprons which receive the strand as it is delivered by the rollers and condense it, but do not twist, as the oscillating apron of the woolen card-condenser does not twist.

At the back is the creel, or rack, for the slubbing, several

strands of which pass through a guide-plate to the guide and feed rolls, then over the porcupine and through the front rolls. All the drawing is done between the porcupine and front rolls. By these rolls it is delivered to the two oscillating aprons, from which the strands are passed through guides and wound on spools placed side by side.

(*v*) *Spinning.*—This is the last process in forming the yarn. For this system it is generally done on the worsted mule but may be done on the ring spinning-frame.

3. **Special Processes for Woolen.**—Fewer processes are required for woolen yarn than for worsted.

(1) *Scouring.*—This operation is the same as for worsted.

(2) *Drying.*—This operation is the same as for worsted.

(3) *Burr-Picking.*—The work of scouring and drying does not extract the burrs, which are in most wools. As they cannot be allowed to remain, the wool is put through a burr-picker. This has an apron-feed, a picking-cylinder, and one or more burr-cylinders with burr-guards. The picking-cylinder, revolving rapidly, lashes the wool into the burr-cylinders and the burrs are struck off by the burr-guards.

(4) *Mixing.*—This process is for various purposes: (*a*) to secure a desired color; (*b*) to secure uniformity of fibre; (*c*) to regulate the cost of the finished product by introducing inferior grades of wool, shoddy, etc.

The mixing is done on the floor. Various layers in the right proportions are made. In feeding this mixture to the picker, care is taken to remove the material from the side of the pile to secure all the different kinds of fibres. The mixing-picker is in general action like the duster. It has cylinders, which are set with hooks rather than teeth. The mixed fibre is delivered to the machine by feed-rolls, and after the cylinders have done their work the fibres are thrown into a chamber called a gauze-room. The picker is always used, even if no mixture is to be made, as it prepares for carding by opening up and shredding the fibres. Oil is applied from overhead to the wool at this time, to facilitate the carding operation. More oil is used for woolen than for worsted, but the object is the same.

(5) *Carding.*—The fibres for woolen yarn go from the mixing process to a set of cards of which there are usually three. These are called breakers—first and second breaker and finisher. Their purpose is to open and clean the fibres. The principle is in general like that of the worsted card, but there are various differences in the detail. The breakers have more workers and strippers, and consequently each machine does more carding, which is a necessity, as the fibre goes directly to spinning from the cards.

The fibre is delivered by an automatic feed to the first breaker, passes over the big cylinder, and is delivered by side drawing as a sliver. It may be fed to the second breaker and to the third by either of two methods: the traverse, in which it travels without winding, or the creel-feed, in which it is wound. Both methods are to produce uniformity of product. The ring doffer is used on the finisher. This doffer, with the condenser (an oscillating apron), delivers the fibre in a small roll, without twist, called roping, or roving. The ends are wound on a big spool called a jack-spool and are ready for spinning. (For detail in *Carding*, see page 51.)

(6) *Spinning.*—The woolen-mule is usually employed for spinning woolen yarn which requires spindle-drawing.

4. Final Processes for Worsted and Woolen.

(1) *Twisting.*—Twisting, if used, follows spinning. The general method is the same for all yarns, both worsted and woolen, but different twisting attachments are used. The twisting-machines are like the upright spinning-frames except that they are without drawing-rollers. The cap, the flyer, and the ring attachments are all used, the choice depending on the kind of yarn. In the twisting operation one or more single yarns from spinning are combined for strength or to secure some special effect.

(2) *Weaving.*—The preparation of the warp and the filling for the loom and the process of weaving are in general the same for both worsted and woolen.

(a) The filling yarns require no special treatment. If they are not on bobbins suitable for the shuttles they are rewound and are then ready for spinning. Filling-bobbins

are always wound a space at a time rather than end to end, as the yarn is thus delivered more easily.

(b) The warp requires more preparation. The bobbins from the spinning or twisting are set in a frame. From them the yarn is wound as desired on a big spool called a dresser-spool. From the dresser-spool the yarn is drawn through two guides resembling reeds, the second guide finer than the first. It is then wound in sections on a big reel. These sections are in turn wound on the warp-beam as the design requires. Tension, rather than a guide, is used in this winding. The warp-beam is turned by power and the tension on the yarn turns the reel, which delivers the yarn evenly. An even tension is exceedingly important in winding a warp-beam.

(c) The weaving may be done in the plain harness-loom, in those having attachments, or in the Jacquard, as the design demands.

Woolen and worsted yarns are made into a great variety of materials, which include all kinds of weaves from the plain to the very elaborate. The different twill weaves are much used for both, because they give the beauty of design which is required by worsteds as well as the firmness which is needed in the finishing of the woolens.

(3) *Finishing.*—Great variety is possible in the finishing of both woolens and worsteds. Each finish requires many processes, certain of which are necessary for all materials. Beyond these certain necessary processes the number and kind employed depend entirely on the effect the manufacturer desires and the amount of time and expense which can be given to securing the desired effect.

Worsted fabrics depend for beauty on the yarn and the weave, and much attention is given to enhancing the merits of both. In woolen fabrics both the yarn and the weave are frequently entirely concealed by a surface finish, toward the securing of which all processes are directed.

(a) *Perching, or Inspecting.*—After any material is taken from the loom it is carefully inspected by being drawn over a perch in a strong light and all its defects are marked.

(*b*) *Burling.*—Most materials have knots and bunches of threads where ends have been joined. These are drawn to the wrong side by the use of burling-irons.

(*c*) *Mending.*—All the defects marked must be repaired, all broken threads must be joined, and any missing threads replaced; otherwise the design will not be complete. Woolens require less careful mending than worsteds, as the defects are usually covered by the finishing. Any specks of vegetable matter which may have got in during manufacture are looked for and removed.

(*d*) *Fulling.*—The chief characteristic of wool is its quality of felting. This quality is made use of in the finishing of both the woolens and the worsteds. In general, the processes to which either kind of fabric is subjected for felting are much the same, though they do not serve the same purpose for both and are done in a different degree for different materials.

(*i*) In the worsted industry felting is used for the fabrics called unfinished worsteds. The chief purpose is to give softness to the weave and flexibility and firmness to the cloth. Worsteds felt less than woolens because their fibres have been straightened and paralleled. They are also subjected to the fulling process for a much shorter time than woolens.

(*ii*) In woolens the purpose in felting is to make the cloth sufficiently strong, firm, and thick to stand successfully all the finishing processes required, such as napping or gigging and cropping. Woolens have great felting quality because their yarns are softly twisted and their fibres are interlaced. They are subjected many hours to the fulling process. Woolens are woven much longer and somewhat wider than is required for their finished size. Occasionally a woolen material is made to shrink half its length. As they shrink in length and width they naturally become much thicker. For this reason woolens are usually woven rather loosely; otherwise, as the fulling takes place they become boardlike.

Fulling is done in a large machine which is fitted with rollers and a trap to regulate the shrinkage in length. The

shrinking of the fabric is caused by the action of warm, soapy water on the fibres and their subsequent compression. The warm water softens the fibres, they become more interlaced, and are pressed closely together by the action of rollers. In woolen the fabric is so solid that its weave is practically concealed. Very many times, if a woolen fabric is made of a poor yarn and loosely woven, flocks—wool waste from some of the finishing processes—are added to the back while the fulling is going on. This gives weight and sufficient substance to make a good surface. If carefully done it does not impair the value of the goods, but it is too often resorted to in order to cover an inferior foundation, in which case the flocks usually drop out and leave a very shabby surface.

(*e*) *Washing.*—Fulling is followed by washing and rinsing to remove all the milling agents which have been used. The ends of the material are sewed together and careful scouring done.

(*f*) *Gigging and Shearing.*—This is a process in which the fibres by various means are brought to the surface to form a nap or pile. The amount of nap raised depends entirely on the effect desired. Unfinished worsteds when ready for market usually show but little nap, while woolens often have their surface completely covered with nap. Wire gigs, brushes, and teazles are all used. The teazle is a vegetable growth which it is difficult to imitate successfully in metal. Revolving cylinders are set with teazles, wire pins, or brushes, and as the material passes over another cylinder, placed at the right distance, the exposed surface of the material is continuously brushed by these and the nap evenly raised. The gigging or teazling is followed usually by careful brushing which in turn is followed by shearing or cropping to secure the required length of nap. This is done by a shear which has revolving knives and is followed by brushing to remove the stray fibres. Many materials are napped several times and have generally a corresponding number of shearings and brushings.

(*g*) *Steaming, 'Crabbing, Brushing, and Pressing.*—All these processes are used to give the desired finish to ma-

terials. The steaming and boiling methods which give lustre are accomplished by the use of steam or hot water and rollers. For either method the material is stretched tightly over the rollers. If it is to be steamed the rollers have perforations through which the steam is blown. If it is to be boiled the material passes through boiling water as it is wound from one roll to another, or it stands while rolled for several hours in the boiling water. To all these finishes much brushing and pressing may be added. These give additional lustre and more careful finish.

(*h*) *Tentering.*—In drying, the material must be made to conform to a certain width and must also be carefully stretched smooth and straight. This is done by tentering. For instance, broadcloth has a regulation width of fifty-four inches; it may come from the milling process uneven in width. To remedy this it is, while still wet, stretched into shape on a frame. It is attached to this frame by hooks which catch in the selvage. The selvages of many materials show evidence of this process in the small holes made by the hooks.

(*i*) *Inspecting.*—All materials are very carefully inspected after the finishing processes.

5. **Usual Finishing Processes for Worsted.**—The following processes may be required in the finishing of a worsted fabric: inspecting; burling; mending; scouring; fulling (for unfinished worsteds); washing to remove the soap; crabbing (the cloth is wound on a roll and placed in the crabbing-machine; it is passed through rollers, through boiling water, and is wound again; by this process the cloth is set); dyeing (if it is to be piece-dyed); crabbing again; tentering; steam-brushing (the material is wound on a perforated cylinder and steam is blown through both cylinder and material); specking (cutting off any specks); shearing on face and back; pressing by rollers; dewing; water blown on it (somewhat like sprinkling of laundry); drying; inspecting.

6. **Usual Finishing Processes for Woolen.**—The following processes may be required in the finishing of a woolen fabric ("face goods"): inspecting; burling; mending; fulling in grease; washing; rolling and stretching through

water (left to stand twelve or eighteen hours to remove
creases, much like crabbing for worsted); drying; napping
to raise pile (by wire gig); shearing; napping and teazling;
blow-steaming (wound on a perforated cylinder and steam
blown through to set the fibre); cooling (while stretched);
dyeing (if it is to be piece-dyed); wet-gigging or brushing
wet; extracting (water taken out); brushing (wet or dry
—wet gigging may be done); tentering; steam-brushing
(steam warms it); shearing (double or single—depth can be
regulated); steam-brushing; sanding and polishing; press-
ing (a press acts like an iron); inspecting.

Besides these there are special finishings, some of them
employed in making a woolen look like a worsted and vice
versa. Methods of finishing change constantly as fashion
changes and requires new effects in materials.

7. **Substitutes Used in the Manufacture of Wool.**—
There are various substitutes which are used both with
and in the place of good wools in the manufacture of so-
called wool materials. These are used because there is not
enough good wool produced to supply the great demand for
wool fabrics of all kinds. If only good wool were used the
supply would be so limited and the prices so great that the
materials could be had by only a few and those the very
wealthy. This use of inferior grades and substitutes les-
sens very materially the expense of manufacturing fabrics
and makes possible the furnishing of woolen materials at
prices within the reach of the general public. The adulter-
ation of wool is, like the weighting of silk, frequently over-
done.

The substitutes are (1) *cotton;* (2) *wool*—reclaimed wool,
fibres from materials like shoddy, and waste wool.

(Noils from the combing process, flocks from the finishing
processes, and pulled wool, which is taken from slaughtered
sheep, are sometimes included in this list but should not be.)

(1) *Cotton.*—Because of the cheapness of the cotton fibre
and the fact that in manufacture it can be made to resemble
wool it is much used—

(a) *In wool materials*, in combination with wool of vari-
ous grades. It may be introduced in the fibrous state dur-

ing blending or used in the yarn form, either by itself or combined by twisting with wool yarns. Cotton yarn is frequently used as warp. For example, it is always used in mohair and alpaca fabrics both because of the difficulty of weaving mohair warp and filling and because it gives a less harsh fabric.

(*b*) *In cotton materials* which have the appearance of wool and are frequently called wool. Many materials, such as outing flannel, duckling fleece, canton flannel, and the cheaper blankets are made entirely of cotton fibre but are given the wool surface by teazling and gigging.

(2) *Wool.*—The wool substitutes are frequently classified in different ways—

(*a*) *Shoddy.*—This term includes all the materials which are to be remanufactured and used in the woolen industry. It is really the shredded fibre ultimately obtained by subjecting various kinds of rags, cloth, and yarn to a shredding or tearing-up process. The materials used may be either old or new and are, in general, all kinds of rags, materials which have been worn and discarded, clippings of new materials, and those which come from cuttings in tailors' shops, etc.

The term *wool extract* is frequently applied definitely to the fibres coming from rags and waste which are made of both cotton and wool. In order to obtain the wool the material must be carbonized to destroy the cotton. This process is used when necessary with all shoddy.

Preparation of Shoddy.—All the fabrics which are to be used again in wool manufacture must be reduced to a fibrous state. These fibres are used alone or they may be mixed with the clean wool in the blending process. Shoddy is used only in the manufacture of woolen yarns. It cannot be used for worsted yarn, but a woolen yarn made of shoddy may be combined with a worsted yarn.

(*i*) *Sorting.*—Before any manufacturing process is attempted all the shoddy materials must be sorted according to color and to kind; that is, new or old. The different kinds may require slightly different treatment.

(*ii*) *Washing.*—This frequently follows sorting.

(iii) Carbonizing.—When carbonizing is required it is usually done in rag form. In this process all the rags which have any cotton mixture are subjected to acids which extract the hydrogen and oxygen from the cotton and leave carbon to be dusted out. Several different operations are required.

The material is put in a cage and placed in a tank containing acid and water. It is soaked from ten to thirty minutes, according to the kind of material. From the cage it goes through three or four operations which extract the liquor and dry the material. The first is the hydro-extractor. This takes out the excess liquor, which is saved for use, and leaves the rags somewhat moist. The second machine is a drier, in which more water is dried out at low heat. In the third machine there is intense heat, which concentrates the acid and removes the water. Neutralizing follows to remove all acids.

(iv) Oiling.—All materials should be oiled and then left in piles to soften. This applies to all rags whether carbonized or not.

(v) Picking.—The machine for this operation is called a shoddy-picker. It has a travelling-apron, feed-rolls, and a picking-cylinder. In it the rags, both old and new, are torn to shreds; that is, they are practically reduced to a fibrous form. Several layers of rags are placed in flat, thin sheets on a travelling-apron which carries them to the feed-rolls. The feed-rolls pass them on to the picking-cylinder which is set with steel and iron pins. The feed-rolls go at a slower speed than the picking-cylinder, and because of this and the action of the pins the rags are shredded and reduced to a fibrous condition.

(vi) Dusting.—The carbonizing duster follows. It has the same general principle as the regular duster. It removes the dust or carbon from the fibres which were subjected to the carbonizing process while in the form of rags. After leaving the duster the fibres, by a blending process, are mixed in the desired quantity with the raw wool fibres and then pass through all the steps of manufacturing required in the making of a woolen fabric.

(*b*) *Waste Wool.*—This includes two kinds of wool fibres: first, from the worsted industry, those which are so mixed with burrs that they are thrown out by the burr-guards on the licker-ins of the worsted cards; second, from the woolen industry, the waste wool mixed with burrs which comes from the burr-picker.

(*i*) *Removing Burrs.*—The burrs in both kinds of fibre are reduced to powder or carbon by crush-rolls. Carbonizing and neutralizing as for shoddy are necessary for some kinds of waste wool—when the vegetable matter cannot otherwise be removed.

(*ii*) *Dusting.*—The carbonizing duster follows. It is the same as that used for the fibre of carbonized rags or cloth. After leaving the duster the fibres are ready for the mixing or blending process.

The character of the various woolen fabrics manufactured is discussed under *Fabrics*.

III. Silk

Silk, like wool, is an animal fibre. It comes from the cocoon of the silkworm, of which there are for manufacturing purposes two general kinds—the cultivated, called the *Bombyx mori*, and the wild, such as the *Tussah*. The cultivated worm feeds on the leaves of the mulberry-tree, the wild on the leaves of the oak. The fibre of the silkworm is unlike any other fibre in that it is several hundred yards in length and so does not have to be joined and twisted to make thread of sufficient length to use in weaving. Several strands are twisted together, however, to give more strength and thickness. The silk fibre consists of two parts—the inner or true fibre, called fibroin, which is not soluble in water, and the gum coating, called serecin, which is readily soluble in hot water and soap. The important characteristics of the fibre are its softness, fineness, elasticity, lustre, and endurance.

The life of the silkworm is short and busy. The eggs, usually laid in summer, are kept for some time in a cool place and hatched in the spring when the leaves of the mul-

berry-tree are green and tender. The worm at birth is about one-eighth of an inch long but begins eating at once and increases rapidly in size. During its life great care must be taken as to food, temperature, cleanliness, and unusual noise. As it continues eating and growing it sheds its skin. This occurs four times in its short life of thirty or thirty-six days, until the worm is finally about three inches long and much lighter in color. At the end of the moulting period its hunger lessens; it shows signs of restlessness and a desire to climb. Twigs are provided, and soon the worm finds a desirable spot to which it attaches itself by throwing out a little silk which hardens or dries and holds the worm in place. Spinning now begins. By a waving motion of the head and a circular motion of the body, as if making the figure eight, the worm begins throwing out from two openings underneath its mouth two thin threads of silk which unite and form one. This gradually encloses the worm and forms the cocoon. The outside threads of the cocoon are usually rough and broken but the inner is a long double thread varying from five hundred to thirteen hundred yards. The spinning takes three days, and as it ceases the worm gradually changes into a chrysalis, which if allowed to live would become a moth and escape, injuring the silk. To prevent this the cocoon is fumed; that is, it is heated sufficiently to stifle the chrysalis. After fuming, if care is taken, the cocoon may be kept indefinitely.

Before any manufacturing processes are begun, cocoons are usually sorted and classified for color, texture, and general condition. Each cocoon has two kinds of silk—the long, inner, continuous fibre, called raw silk, and the outer, shorter, and often rougher fibre, called spun or waste silk. These require very different treatment in manufacture.

1. **Processes for Raw Silk.**

(1) *Reeling.*—Usually over one-half of the silk in a cultivated cocoon is reeled into skeins, or hanks. Preparatory to this the cocoons are put in soap and water sufficiently warm to soften the gum and are then brushed. This brushing removes the short outer floss and finds the end

of the long filament. Several of these filaments, according to the size of the thread desired, are united, passed through guide-eyes, and wound on a reel. The water must be kept at even temperature throughout the process to keep the gum softened. Hand reeling is a simple process, but steam filatures are generally used in which the reels are run by power. Care must be taken in uniting the filaments, which are not·of equal size their entire length, in order to make as even a thread as possible.

(2) *Throwing.*—The next process for raw silk, after reeling, is called throwing. It includes various operations which convert the raw silk into threads suitable for warp and filling for weaving.

(*a*) Several different kinds of silk thread may be made in the throwing process. (*i*) *Singles*, used for either warp or filling in thin materials. They are made by twisting a single strand from the reel to make it stronger and firmer. The amount of twist given depends entirely on the finished product intended. Chiffons, for instance, require a hard twist. (*ii*) *Tram*, used generally for filling, is made by slightly twisting two or more single untwisted reeled threads together. Usually there is just enough twist given to hold the strands together. This keeps the strand soft and makes a bulky, lofty filling and produces lustre. (*iii*) *Organzine*, used for warp, needs strength, and consequently it is made by combining with a left-hand twist several single strands which have already received a right-hand twist or vice versa. The number of threads and the amount of twist depend on the required strength of the thread and the desired appearance of the finished product. There are usually fourteen or sixteen turns to the inch in the singles used, of which two or more are combined. In this combining more than three twists must be used. (*iv*) *Twist*, which is made in the same general way and closely resembles organzine but has fewer twists.

(*b*) The operations included in the throwing process are as follows:

(*i*) *Washing or Soaking.*—Most of the silk to be thrown is first soaked to soften the gum.

(*ii*) *Drying*.—Drying is done by placing the skeins first in a hydro-extractor and then hanging them for drying in a room heated by hot air or steam.

(*iii*) *Winding*.—The silk is prepared for doubling and twisting by transferring it to bobbins. This is done by means of a machine resembling a swift or reel. In winding, care is taken to make the thread smooth and of even size. To accomplish this it is passed from one bobbin to another through a cleaning-machine which removes any irregularities.

(*iv*) *Doubling and Twisting*.—These processes depend on the kind of thrown silk required; for instance, singles are not doubled but go directly to the spinner, which does the twisting with the bobbin-and-flyer attachment; tram, on the contrary, is made by combining silk from several bobbins on the doubling-machine, and is then twisted; while organzine is twisted, doubled, and then twisted again in the opposite direction.

After the throwing, if the silk is to be skein-dyed, it must be wound from the bobbins into skeins and boiled to remove the gum.

2. **Processes for Spun or Waste Silk.**—This term includes all silks which cannot be reeled and are not suitable for throwing—the silk around the outside of the cocoon, which was used to hold the worm to its twig; it is strong, uneven, and rather lustreless; the outside layers of the cocoon; the first silk spun, which it is impossible to reel; the last spun, which is too fine and weak; short fibres from pierced and damaged cocoons; and waste from reeling and throwing.

(1) *Mixing*.—Because of the varying quality of the waste silk it must be carefully mixed to get an even product.

(2) *Boiling and Schapping*.—Raw silk can go through all the processes of manufacture except dyeing without having its gum removed; waste silk cannot. There are various ways of freeing the silk of its gum. The two generally used are boiling, the English method, and fermentation, the Continental method.

By the first method, boiling, the waste silk, in open mesh

bags, is put into a soapy water which is allowed to come
to the boiling-point. Constant stirring is necessary. The
gum is softened and passes out through the meshes.
Another bath, with less soap, follows, and the silk is dried.
By this method very little gum is left and the silk is much
lighter in weight. In schapping, the silk is put into vats
of tepid water and allowed to remain without motion for
several days. A process of fermentation takes place and
the silk is practically freed of its gum. This leaves a cer-
tain quantity of gum in the silk, which is an advantage
for some materials such as velvets. Washing and drying
follow, as in the boiling method.

The processes of manufacture for waste silk are similar in
many ways to those used for cotton.

(3) *Inspecting and Cleaning.*—Because much of the waste
is gathered up in mills and from the surface of the cocoons,
it has mixed in it straws, hairs, and grasses. It is looked
over and these are picked out by hand.

(4) *Conditioning.*—After the gum is removed the silk is
very dry and a certain amount of moisture must be added;
otherwise the necessary processes are not possible without
breaking the fibre.

(5) *Beating and Opening.*—The beating opens up the fibre,
softens it, and makes it flexible; the opening straightens
and parallels the fibres for the combing.

(6) *Combing.*—In this process the short fibres and any
foreign matter which may still be mixed with the fibre are
removed, and at the same time the fibres are somewhat
straightened and paralleled. The waste silk fibres are of
different lengths. Before they can be combed satisfactorily
they must be made regular in length by some method.
There are two general ways of doing this. The first is by
choosing and grouping the fibres of even length. This
method requires time but saves any waste of fibre. In
the second method the fibres are wound on a grooved cylin-
der, the grooves being as far apart as the desired length of
the fibre. After the winding is completed a knife is slipped
into the grooves to cut the fibre. This gives even length
but many short waste ends.

The actual combing is done in a machine which has a comb and several book-boards. These latter are two-hinged boards which close like a book. Half the length of the fibres is enclosed in the book-boards; the other half hangs free so that it comes in contact with the combs. After it is combed the fibres are reversed and the other half combed. This removes the short fibres, which are called noils, and further parallels the long ones, which are called tops. Noils are combed twelve or thirteen times. Each time the combing produces both top and noils, the fibres of which with each combing are shorter. Those fibres nearly equal in length are combined for each of these combing operations.

(7) *Preparing and Drawing.*—From the combing the silk is fed to gill-boxes. These work like the worsted gill-boxes which have drawing-rollers and fallers. The rollers are often set farther apart, since the silk fibre is longer than the wool. By them the silk is made into a continuous sliver, which goes on to the drawing-machines, where several slivers are made into one and sufficiently attenuated to form roving.

(8) *Slubbing.*—The roving-machine has rollers and a bobbin-and-flyer attachment. The roving is drawn out and given a sufficient twist to prepare it for the spinning.

(9) *Spinning.*—This is done, as in cotton or worsted, by the mule or by the cap or the ring spinning-frames, the choice of machine depending on the kind of yarn desired. The mule and ring are in most general use.

(10) *Doubling and Twisting.*—In these processes two or more threads from the spinning are combined and given twist enough to hold them together. The machines used are like the upright spinning-frames but have no drawing-rollers.

(11) *Gassing.*—This process removes any loose fibres from the twisted yarn by running it through a gas flame or through a platinum V-shaped slot electrically heated. After this is done the yarn is wound, according to use, on bobbins if for warp; on quills or small bobbins if for filling.

3. **Processes for Both Raw and Spun Silk.**

(1) *Weaving.*—This is the same for both raw and spun silks. For it some preparation is necessary.

(*a*) The filling yarns are wound on bobbins suitable for use in the shuttles.

(*b*) The warp yarns are transferred by various steps from the bobbins to the warp-beam. In this transferring, sizing is generally added to strengthen the yarn. If fine yarn is used thin paper is very frequently placed between the different layers as it is wound on the warp-beam. This prevents tangling and assists in maintaining an even tension when the warp is unwound during weaving. Silk warp yarns are frequently printed with a design before they are woven. This is done as on the woven fabrics by roller-printing, in which a different roller is necessary for each color. In the weaving a plain filling yarn is used, resulting in softer colors and a somewhat blurred design. This method is very frequently used for ribbons. A great variety of weave is found in silk fabrics, from the plain, in such materials as taffeta and China silk, through the twills and satin weaves, to the brocades, which are the product of the Jacquard loom. Many corded materials, such as the poplins and bengalines, have the plain weave and are frequently a combination of yarns of two different fibres. Cotton is used in the cheaper qualities for filling, while wool is sometimes used to give the desired weight and effect.

(2) *Finishing.*—The same general methods are employed for both kinds of silk. Many times the yarns are finished partially before weaving; the processes are in general to give strength, weight, smoothness, and gloss to the yarn.

Before raw silk is dyed, whether in piece or skein, the gum must be removed from the fibre by boiling. In this process the silk loses weight. To make up for this loss weighting is usually added, the kind used depending chiefly on the color of the dye. For much of the weighting metallic salts are used, salts of tin or iron. If used in excess they affect the wearing quality of the silk, as they are themselves affected by light, air, and time. Some crystallize when exposed to the air and light and cut the silk fibre so that it breaks easily.

For the woven material there are many finishings, mechanical or made by the use of dressings: the pressing and

calendering for good silk, the dressing or sizing for poor silk. There is also that larger class of special finishings, such as moiréing or embossing and polishing, which also includes dressings of many kinds. These special finishings change with fashions, new ones appearing each year. The character of the various silk fabrics manufactured is discussed under *Fabrics*.

For artificial silk, see *Other Lesser Textiles*.

IV. Linen

Linen is a vegetable fibre. It is expensive, and consequently adulterants and substitutes are often used. They are, however, because of certain properties of the linen, less satisfactory in the case of this fibre than in many others.

Linen comes from the stalk of the flax-plant. It is the bark which lies between the inner woody core and the outer bark and because of this is called a bast fibre. The fibre is long, varying from twelve to twenty inches. It is straight and has a long, cylindrical tube with lengthwise markings which look like fine black lines. At intervals there are also cross-markings which help slightly in keeping the fibre together in the spinning. It is composed of cells held together by a vegetable gum called pectin. In addition to length the fibre has various other valuable qualities such as strength and lustre.

Flax is pulled and not cut, as in this way greater length of fibre is obtained. This is done by hand, since no suitable machine has yet been invented. In preparation for manufacture it requires entirely different treatment from that given cotton, wool, or silk. The beginning processes are for the purpose of (*a*) breaking up and removing the bark and woody tissue and (*b*) separating the short fibre, called tow, from the true fibre, called line.

i. **Processes for the True, or Line, Fibre.**

(1) *Rippling.*—When flax is pulled it has all its leaves and seed-pods, which, after the plant dries, must be removed. This is done by hand, by drawing the ends of the stalks through big combs.

(2) *Retting.*—This is one of the most important processes, and if not well done it may injure the fibre. It begins the freeing of the bast fibre from the bark and the woody core by decomposing the resins which unite them. There are various ways of doing this; the most usual are by dew or cold-water retting. (*a*) *Dew Retting.*—The fibres are spread on the grass, exposed to sun, rain, and dew. From two to five weeks are required for the decomposing of the gum. This method is used chiefly in Russia. (*b*) *Cold-Water Retting.*—For this there are two general methods: the use of stagnant water, in which the flax is placed and left for several days or weeks undisturbed, and the use of slow-running water—a less offensive method—not always possible to secure but giving a good result. The latter method is much used in Belgium, to which country the flax of other countries is frequently brought for retting. Retting is sometimes done twice. (*c*) Other methods, which have been tried to shorten the length of time required, include the use of hot water or chemicals. None of these have been successful to the present time.

(3) *Drying.*—After the retting the flax is dried in the open air, then tied in bundles and left standing in the air until the time for breaking and scutching.

(4) *Breaking.*—After the retting has decomposed the uniting gums the woody matter must be broken up and removed. The breaking, which was formerly done by hand, by a series of slabs, is now usually accomplished by several fluted rollers moved by machinery through which the flax passes.

(5) *Scutching.*—The broken material is removed by placing the flax within reach of a revolving wheel in which wooden knives or beaters are mounted. These knives strike off the woody part and begin the separation of the bast tissue into fibres. Aside from the long fibre, which is a product of this process, there is a certain amount of waste or short, tangled fibres, called scutching tow, which is used for cheaper threads and strings. At this point the work of the farmer is finished and the product is sold.

(6) *Hackling.*—This is a process closely resembling the combing of other fibres. It cleans, disentangles, combs, and

parallels the fibres, separating the long, or line, fibre from the short, which is also called tow. It splits what seems one fibre into several and produces fibres of uniform diameter as well as of uniform length. Hackling is done by hand or machine, or both. There is usually a certain amount of hand hackling or roughing before the fibre goes to the machine. The process is generally repeated many times. Finer combs are successively used as the fibre becomes finer and cleaner. Hackling by hand is expensive and is more often used when the finer qualities of yarn are required. When done by machine the strands of fibre are held in place and combed by needles which are set in revolving aprons. The tow catches in the needles and is held by them until brushed off.

(7) *Sorting or Classifying.*—Before preparing for spinning the flax must be arranged according to quality. This is done by hand. In doing it machines like the hand hackles are used. More short fibres are removed and the longer ones paralleled, subdivided, and cleaned; the product is often called dressed line. In this process, if fine linen is to be made, the fibre is sometimes cut to secure the best section for the yarn.

(8) *Gilling.*—After securing the line fibre the first process in preparing it is done by a machine called a spread-board. In this machine the fibre is paralleled, subdivided, and joined to form a continuous strand. The spread-board is like the gill-boxes already described as used for other fibres; that is, there are feed-rolls, fallers, and draft-rolls. The process is rather more difficult for flax because of the greater length of the fibre and its stiffness and irregularity. The flax is fed to the machine in tresses, which differ in thickness and width according to the desired product. A usual width is about four inches. The ends of the flax are overlapped, and by the drawing of the rollers and the action of the fallers, which keep the fibres straight, a continuous sliver is made which is run into a can.

(9) *Doubling and Drawing.*—This is done in a series of drawing-boxes. The series is frequently composed of a machine called a doubler, three drawing-frames, and a

roving-frame. The first machines used are much like the gill-boxes; they attenuate and even the slivers which come from the gilling process by uniting and drawing out from two to ten or twelve of them. These slivers are fed from the different machines into cans. The roving-frame, the last machine in the series, has the rollers and fallers, but in addition it has a bobbin-and-flyer attachment. The sliver is still further reduced and attenuated by the rollers and fallers and is also given a slight twist by the flyer and wound on the bobbin.

(10) *Spinning.*—The fibre is now ready for the actual spinning. Fly-frames are used because of the smooth straightness of the flax. The spinning may be done in one of three ways: in dry frames, damp, or wet. These fly-frames are like the old machines, with rollers and the bobbin-and-flyer attachment. They have the bobbins at the back, which deliver the roving to the two sets of rollers, the receiving and the draft going at different speeds. From the rollers the drawn-out roving is twisted by the flyer and wound on a bobbin. For dry spinning the feed and draft rollers are set about one foot apart and the work proceeds in the usual way. If the spinning is to be damp the strands, after being drawn out by the receiving and draft rollers, come in contact with a roll turning in cold water which moistens the yarn. If, however, wet spinning is to be done, the drawing-rollers must be set close together—the distance between being shorter than the length of the fibre—and the roving must actually pass through water almost boiling before coming to these drawing-rolls. This softens the fibres and makes them more supple. It also gives a smoother yarn, as the vegetable jelly in the fibre is softened by water, hardens again, and forms an outside coating. Too hot water, however, is injurious. All yarn spun by damp or wet spinning must be made into hanks or skeins and dried at once. The wet spinning is generally used for the finest yarns, the damp for the next grades, and the dry for the coarsest.

(11) *Twisting.*—This process may follow spinning in preparation for weaving. Wet or dry twisting may be

done; the wet makes a smoother yarn. For this the ring
and the bobbin-and-flyer attachments are used. The spin-
ning-frames give single yarns which are usually combined
by twisting to give more strength or to secure some special
effects in the weaving. Greater strength is more often
necessary when the yarn is to be used for warp.

(12) *Weaving*.—Weaving for flax is more difficult than
for cotton because the fibre is not elastic and breaks easily.
The warp yarns are sized to make them smoother and give
them strength for the drawing in and weaving. All vari-
eties of looms are used, and we find a corresponding variety
of weaves from the plain of dress linens through the geo-
metric designs of huck and bird's-eye to the elaborate
damasks.

(13) *Finishing*.—There is much less variety in the finish-
ings used for linens than for the other fibres. Those used
are chiefly to add lustre by polishing and weight by sizing
or dressing. For polishing, a liquid like starch is applied
and the material passed over hot rollers. Other finishes
are given by pressing, calendering, and mangling. There is
also a process, called beetling, by which the threads are
beaten flat and softened. The yarn frequently goes through
this process before weaving to soften it for any subsequent
processes. Beetling, whether done in the yarn or on the
fabric, gives a closer weave and increased lustre. The sur-
face of the fabric is smoother because the threads are flat-
tened and are less distinct and separate. It gives a leathery
feel to the fabric.

The best class of linens need very little dressing. Some
of the cheaper grades—those in which the weave is poor or a
substitute is introduced—are rather heavily sized to cover
defects and thus appear a better quality than they are.

Many linens are left their natural color and are stronger.
Bleaching, unless very carefully done, weakens the fibre.
Linen may be bleached or dyed in the yarn or in the fabric;
sometimes in both. Linens do not dye easily and do not
hold dye particularly well.

2. **Processes for the Short Fibre, or Tow.**—The short
fibre, or tow, is separated from the long during the scutch-

ing and hackling processes. It is used by itself and in combination with the long fibres. The processes of its manufacture are somewhat different from those of the long fibre. It is beaten and shaken in a beater, to clean and open it up, and then carded to disentangle the fibres and continue the cleaning. The card has the same big cylinder and workers and strippers as are used for wool, but the card clothing is heavier and coarser, owing to the coarseness of the tow. The carding-machine delivers the tow in the form of a sliver. This is doubled and drawn and made into roving ready for spinning by the drawing and roving frames, as is the line fibre. The spinning is also the same as that of the long fibre. It may be dry, damp, or wet and is done by the bobbin-and-flyer attachment.

The character of the various linen fabrics manufactured is discussed under *Fabrics*.

V. *Other Lesser Textile Fibres*

1. **Ramie.**—Ramie is a vegetable fibre. It comes from the stalk of a plant belonging to the family of stingless nettles. It is a bast fibre, is strong, long, lustrous, and non-elastic, like linen. The plants are cut, not pulled, and the leaves and branches are removed. The different countries in which ramie is grown have different methods for its preparation. Sometimes the bark is stripped off while the stalk is green; sometimes the plant is allowed to dry and the bark retted by dew or water.

Before the fibre is ready for spinning it must be put through several processes. First, decorticating, a process for removing the bark while it is still wet; second, degumming, which requires care, as the gum can be removed only by the use of chemicals. When carefully degummed it is soft, lustrous, and silky. The fibre, after being immersed in the chemical, is boiled, washed, dried, and sometimes bleached. To soften the fibre it is passed through fluted rollers which make it flexible without breaking it. It is then put through gill-boxes and made into what is called filasse. The gill-boxes disentangle and straighten the fibres

ready for combing. Combing gives two kinds of fibres, as in worsted: the long fibre, called tops; the short, called noils. Both of these are spun, but the tops make the finest and strongest yarn and a better grade of material.

The use of ramie has been tried in the manufacturing of a great variety of materials; it is generally combined with other fibres. Efforts have been made to improve its processes of manufacture, but as yet its use has not become varied. To date it is not generally successful except for Welsbach burners. As a fibre for dress materials it is found that it does not stand twisting and does not wear well.

2. **Jute and Hemp.**—Such fibres as jute and hemp need be considered only by those interested in house furnishing, as they have, so far, proved too heavy for use in dress materials.

3. **Mineral Fibres.**—The mineral fibres, *asbestos* and *tinsel*, are so little used as to deserve but passing notice. This is especially true of asbestos. Tinsel, made into fine wires, is, however, introduced into dress fabrics. It is frequently seen in novelties and in gauzes which are used for trimmings and for evening wear.

4. **Artificial Silk.**—There are various kinds of artificial silk, nearly all of which are made from cellulose. The principal varieties are nitrocellulose, cuprammonium, and viscose. There are others, but they are not now widely enough used to warrant discussion here. Artificial silks resemble real silks in appearance but their properties are quite different. Until recently they have had serious disadvantages: they have been difficult to dye, were likely to disintegrate in washing, and were inflammable. Improvements have been and are constantly being made, however, and most of these difficulties have been practically corrected.

One general process of manufacture is this: cellulose is dissolved by treatment with chemicals and forced through capillary tubes into another chemical which hardens or sets it. Other processes are being attempted and may prove equally successful.

Artificial silks have high lustre but are brittle and inelastic. They do not cover in weaving as well as real silk and are much heavier. They are inexpensive as compared to real silk and are coming more and more into use. They are made into hosiery, underwear, and sweaters, and also into a variety of dress materials, all of which include many kinds of weaves. They are found in combination with wool, cotton, and silk. In many materials they are woven in small dots or figures to form the design.

5. **Spun Glass.**—The use of spun glass in wearing apparel has been attempted but has not been considered successful.

III. Bleaching, Scouring, and Dyeing

Both yarns and fabrics may be bleached, scoured, or dyed, according to the requirements of the finished product.

I. *Bleaching and Scouring*

All fabrics are scoured or washed after leaving the loom and before the finishing is done.

Bleaching and scouring sometimes precede dyeing to remove any objectionable substance in the fibre. If materials are not to be dyed the bleaching and scouring is much more carefully done, as its purpose is then to give good color to the product.

Bleaching, as it is generally done to-day, requires the use of chemicals and consequently weakens the fibre somewhat; for this reason unbleached cotton and linen fabrics are stronger than the same quality of fabric bleached. Linen is more affected than cotton. Fabrics bleached by continued exposure to the weather are not injuriously affected.

II. *Dyeing*

Dyeing is the art of coloring textile and other materials in such a way that the colors cannot be readily removed by the influences to which they are likely to be subjected; that is, water and other cleansing materials, wear, light, and sun.

In dyeing, the coloring matter is first soluble and becomes insoluble while it is being absorbed by the fibre.

(1) Dyeing may be done at different periods or stages in the manufacturing of the fibre; that is, (*i*) in stock—in the loose state after washing and before any of the mechanical processes; (*ii*) in the slub—during the mechanical processes, the exact stage differing with different fibres; (*iii*) in skein— after the spinning; or (*iv*) in piece—after the weaving. The time of dyeing depends on the fibre and on the kind of product desired. When dyed in stock the colors are thoroughly absorbed by the fibres and are considered permanent. Skein-dyeing is used for specific purposes. It is less often done than stock or piece dyeing. Piece-dyeing is for materials of solid colors.

(2) Of the four most important fibres, wool dyes most readily, in general, and gives to the color depth and fulness. Silk follows, and because of the smoothness and transparency of the fibre its color is more lustrous than that of any other. Cotton does not dye readily and its colors usually lack brilliancy or depth. Linen is even more difficult to dye; while its colors are richer than those of cotton they are not usually lasting.

(3) Cotton, wool, silk, and linen do not react in the same manner in the dyeing processes; consequently different methods and different kinds of dyes are used for different fibres. The same fibre often requires a variety of treatment, differing according to the color used. For much of the dyeing a mordant is necessary. This is a substance which has an affinity both for the coloring matter and the fibre. It varies, depending on colors and fibres. It prepares the fibre so that the dyestuff may be precipitated into it in insoluble form.

(4) Dyestuffs may be divided into two general classes: (*i*) artificial, which includes coal-tar products, and (*ii*) vegetable, of which madder and indigo are well known.

(5) There are special kinds of dyeing, such as resist, cross, and discharge dyeing.

(*a*) Resist dyeing is the process which treats part of the yarn so that it will remain unchanged when subjected to

another dye bath. This is used often in striped material. (*b*) Cross dyeing is done in the piece in materials which have both cotton and wool fibres. Cotton will not take wool dyes; in consequence it may be used to give a white stripe or plaid in colored materials. (*c*) In discharge dyeing the material is also piece-dyed a solid color; then some of the color, in the pattern desired, is removed by chemicals.

CHAPTER III

TEXTILE ECONOMICS

Textile fabrics have design, color, and finish and are made up of one fibre or a combination of fibres. In judging any fabric to determine its value and wearing quality it is necessary to take all these factors into consideration. All materials, whether of cotton, wool, silk, or linen, should be so made as to conform to certain requirements or standards, these standards to be regulated for the purchaser by the quality claimed for the materials and the prices charged. At present, however, no definite standards exist, and wise selection must depend to a large extent on the knowledge of the purchaser.

In selecting materials the purchaser should know not only what quality or grade of material may be demanded for a certain price but be able to determine as well whether that quality has actually been secured on payment of the price. For instance, if damask sixty-six inches wide and sixty-nine cents a yard is bought, the purchaser has no right to expect good linen fibre firmly woven. The fabric of that width and price must necessarily have either poor linen fibre or linen and cotton combined with a loose weave and concealed with much sizing. If, on the other hand, a bengaline silk twenty-seven inches wide is purchased for two dollars a yard, it can scarcely be claimed that proper value is received if the fabric is found to be two-thirds cotton.

In order to select materials wisely both knowledge and experience are required.

First, it is necessary to know—

(a) The characteristics of the various fibres used in the manufacture of the materials, their feel, appearance, strength, their similarities and differences before manufacture and after, and the manner in which they respond to various tests.

(*b*) The general processes of manufacture required to make various standard kinds of fabrics from these fibres. Without some knowledge of the many operations necessary it is difficult to have a just appreciation of the value of the finished product.

(*c*) What substitutions or adulterations are possible in manufacturing the fibres into fabrics. (*i*) The various operations by which one fibre may be made to resemble another or one fibre may be concealed when combined with another for the purpose of adulteration. (*ii*) Simple tests by which these substitutions and adulterations may be detected.

Second, based on this ascertained knowledge there should be unlimited experience in the handling and testing of the materials themselves for comparison of quality and price. Facts, unless supplemented by experience, are of little value in judging materials. Discrimination in selection can result only from the experience which is gained by the constant use of both eyes and hands in a careful study and comparison of materials. In beginning such work, standard materials should be chosen rather than novelties, and as a starting-point or basis for comparison of any kind of material a good quality of that material should be used. The necessary qualifications for such a material are as follows:

(*a*) It should be woven of well-spun yarn which is not only made of a uniformly good quality of fibre but is sufficiently twisted to give the required strength to the fabric. Because of the finishing, short and imperfect fibres and substitutes may not show in the new fabric unless it is very carefully examined, but they will appear after the material has been worn a short time.

(*b*) The yarns for warp and filling should be well balanced to prevent the unequal strain or wear of one set and their consequent breakage. This balance is usually secured (*i*) by having the yarns of warp and filling of comparatively the same size, weight, and twist, or (*ii*), if either warp or filling yarn is finer, by having a sufficient number of the finer to give the required strength. This latter

method is not satisfactory in every case. Any dimity which
has a few heavy lengthwise cords with a fine, tightly twisted
filling and no heavy crosswise cords is an excellent illustra-
tion of lack of balance. The heavy cord, because of the
extra strain of its weight, has practically a cutting action
on the finer crosswise or filling threads, which, with wear and
laundering, soon break.

(c) To permit the developing of any desired finish from
the fabric itself, without the aid of any applied fibres in the
finishing processes, the yarn should be of such weight and
quality and so woven as to give the fabric a sufficiently
firm foundation or structure. For instance, many fabrics,
particularly those made of wool, have the ends of the fibres
brought to the surface to form a thick pile or nap by the
use of teazles or wire gigs. If the foundation—the stock—
of the cloth is too poor to supply these fibre ends it is
necessary in the fulling process to add material to give
substance enough for this finish. Good materials properly
applied during manufacture do not injure the finished
product, but in too many cases cheaper qualities are used
and so carelessly added that with wear they drop out and
reveal the lack of substance in the woven foundation.

(d) The weave should have strength and endurance.
The weaving should be so firmly done that sizing is not
necessary to give the material the substance and appearance
of a good fabric. The kind of weave chosen should depend
on the use for which the material is intended. Designs
like the basket have æsthetic but not economic value and
consequently should be avoided in fabrics of which wearing
quality is demanded. There are many others, however,
such as the twills, which are good in design and are unri-
valled from the standpoint of wear.

(e) The material should have a true finish, one which can
be brought up from the fibre by the pressing of the fabric
rather than one which is artificially made by the application
of various polishing and finishing mediums. The first is
permanent; the latter disappears with little wear or laun-
dering. Such finishes are difficult to recognize because of
their great variety, but they may be found in many of the

cotton, wool, silk, and linen fabrics. There are also many designs which are made by pressing down sections of the surface of the material with engraved rollers and then treating those sections with a starchlike substance which holds them in place temporarily but is quickly rubbed off with wear. These designs are most frequently seen in novelty cotton fabrics. Because of their finish they often command a price much above their actual value.

(*f*) When possible the color of the material should be lasting for the use required of it; that is, the color of a cotton fabric is subjected generally not only to the test of wear, but of laundering as well, and must be made to meet both tests. Usually the color of a wool fabric has merely that of wear to withstand. Few colors are really "fast" to all treatment but may be to some. Constant improvements are being made in dyes, especially those used on cotton fabrics where fast colors are most necessary. Effort should be made to obtain the names of firms who guarantee fastness to certain colors.

I. Comparison of Fibres

As has been said, all testing of materials for fibre or fibres should be based on a comparative knowledge of the characteristics of the different raw fibres and the manner in which each fibre responds to certain physical tests. Although the fibres may be somewhat changed in the manufacturing operations, they are essentially as before and respond in the same general way when similar tests are applied to them in the fabric.

The four important fibres—cotton, wool, silk, and linen—differ from each other in various ways, many of which may be detected without using even a simple microscope or linen-tester. In comparing various grades and qualities of the same fibre, however, such as good wool and remanufactured wool, little can be determined accurately even by an expert with the use of a powerful microscope. In identifying fibres by physical tests the following factors should be considered:

(*a*) Appearance; (*b*) length; (*c*) feel; (*d*) tensile strength; (*e*) elasticity; (*f*) behavior in burning.

Before considering these, however, it is necessary to establish a foundation by knowing as much as possible concerning the structure, the composition, the hygroscopic quality, and the behavior toward dyestuffs of these fibres. These are not facts which can be determined by physical tests; they have, however, been worked out and proved by chemical and microscopic analysis and are recorded in books which are easy of access to the majority.

Cotton is a vegetable fibre. It is a flat, ribbonlike band with thickened edges and a slight spiral twist. Unripe or dead cotton has no twist and does not spin well. It has its inner canal closed and does not take dye. Cotton is largely made up of cellulose; it absorbs from six to eight and one-half per cent of moisture without evidence of dampness. It does not dye easily.

Wool is an animal fibre with a scalelike surface. It is made up of flattened and overlapping cells which form a series of scales called serrations. These serrations help to give to wool its shrinking or felting quality. Kemp is the diseased fibre. It is solid and without cellular formation. It has the same structure throughout as the scales of the fibres. It is short, stiff, brittle, and large in diameter. It does not spin and does not take dye. It cannot be improved by any process of manufacture. Wool is a protein substance composed of oxygen, hydrogen, carbon, nitrogen, sulphur, and phosphorus. It can absorb from twelve to nineteen per cent of moisture without evidence of dampness. It usually dyes easily and the color is quite lasting.

Silk fibre is a smooth, structureless filament with a transparent lustrous surface. It has an outer coating of gum called serecin. This encloses two combined filaments of silk or fibroin which is a protein substance. Silk can absorb eleven per cent of moisture without evidence of dampness. It dyes easily.

Linen is a vegetable fibre made up of cylindrical cells. Its surface shows lengthwise fine lines and crosswise markings like breaks in the fibre. It is cellulose and can absorb

eleven per cent of moisture without evidence of dampness. It does not dye readily nor hold its color well.

Based on these facts, a comparison of the fibres may be made as follows:

(1) *General Appearance*

Cotton: Fine, fluffy, straight, dull.

Wool: Wavy, fuzzy, rather wiry, bright. The wool fibre varies—the long is usually lustrous, the short is soft and has less lustre.

Silk: Fine, smooth, straight, shining.

Linen: Smooth, stiff, straight.

(2) *Length*

Cotton: ¾″–2½″; 1″–1⅛″ average length.

Wool: 1″–14″.

Silk: 500 yds.–1,300 yds.

Linen: 12″–36″; 18″ average length.

(3) *Feel*

Cotton: Matted, unresponsive, inelastic, soft.

Wool: Springy, spongy, elastic, harsh.

Silk: Smooth, soft, elastic, cool.

Linen: Wiry, harsh, cold, inelastic.

(4) *Tensile Strength*

Cotton: Third in strength.

Wool: Generally weakest, but varies greatly.

Silk: First in strength.

Linen: Second in strength.

(5) *Elasticity*

Cotton: Third, very slightly elastic.

Wool: Second, very elastic.

Silk: First, most elastic.

Linen: Fourth, inelastic.

(6) *Behavior in Burning*

(a) *Odor:*

Cotton: Like burning paper or wood (cellulose).

Wool: Like burning hair (animal oil).

Silk: Much like wool.

Linen: Much like cotton (cellulose).

(b) *Rapidity:*

Cotton: Burns rapidly, brightly, and steadily; does not extinguish easily.

Wool: Smoulders, burns slowly, with difficulty; extinguishes often.

Silk: Burns rapidly, darting flame.

Linen: Burns rapidly, like cotton, but is not so inflammable; has more oil.

(c) *Appearance:*

Cotton: Steady yellow flame, leaves gray ash without residue.

Wool: Blue, unsteady flame, leaves oily globule, gummy residue.

Silk: Leaping flame, leaves oily globule.

Linen: Much like cotton, leaves ash.

II. DESIGN

Textile design is produced in many ways, all of which may be grouped under two general heads: structural design, that which is made during the formation of the fabric, and surface design, that which is made after the formation of the fabric.

I. *Structural Design*

Structural design is by far the larger class. In general, it may be said to have more effect on the wearing quality of a fabric than do the majority of surface designs. Structural designs are made while a fabric is being woven. The design may depend entirely upon the character of the weave—the way in which the warp yarn is interlaced by the filling yarn; or, in addition to weave, there may be variety in the threads or yarns used.

1. Design by Yarn.

(1) *Yarns Made of Different Fibres.*—Combinations of yarns of different fibres are seen in wool materials in which there is a silk stripe; in wool brocades which have the figures in silk; in lansdowne, in which silk and wool are evenly combined; in silk ginghams, in which silk and cotton are used; in mohair, alpaca, etc., in which mohair filling is combined with a cotton warp; in such materials as Tussah Royal, in which mohair and wool are used and give to the surface a crinkled appearance due to the different shrinkage of the two fibres; in many upholstery materials, in which jute or hemp is combined with plain or mercerized cotton.

(2) *Yarns Having Different Twists.*—Various materials are given an irregular or pebbly surface by combining yarns of different twists. The warp and filling yarns may have different twists, or different twists may alternate in both warp and filling. *Crêpe de chine* and *Georgette crêpe* are illustrations of different-twisted yarns.

(3) *Colored Yarns.*—The use of colored yarns gives a great variety of design.

(a) *Solid Color.*—Materials in which the warp and the filling are always alike, as in galatea, sateen, nun's-veiling, or wool batiste, and panama cloth.

(b) *Changeable.*—Materials which have a warp of one color and filling of another. Chambray is an excellent example, as this characteristic really distinguishes it. True chambray always has white filling and colored warp yarns, with the exception of a few white warp yarns added at each edge to keep the selvage white.

(c) *Stripes.*—Materials in which colored yarns may be introduced warpwise, with warp varied and filling solid, or fillingwise, with filling varied and warp solid. Stripes are more generally seen lengthwise than crosswise, unless to meet an occasional demand for novelty. They are found in a variety of materials—in gingham, in madras, and in silks and wools.

(d) *Checks and Plaids.*—Materials which have both warp and filling striped—evenly for checks, unevenly for plaids.

This kind of pattern is seen in Irish poplins and shepherd's plaids. Checks and plaids are also found from time to time in wools, such as serges and broadcloth, and in silks, such as taffeta and surah, but are not characteristic of them.

(4) *Yarns of Different Sizes and Weights.*—Pattern is frequently made by the use of heavier yarns. These yarns may be introduced into either warp or filling, forming stripes, or into both, forming checks or plaids. Dimity is given its chief characteristic by the heavy yarns which, according to their placing, form stripes, checks, and plaids. The heavy yarns introduced fillingwise give to poplins and a large class of silks, such as bengaline, eolienne, and faille, the corded surface which makes them distinctive.

(5) *Yarns of Different Sizes and Weights Combined with Colored Yarns.*—Many materials are given more decorative surfaces by having the stripes, checks, or plaids formed by the colored yarns outlined by heavy cords. Such effects are frequently seen in ginghams and madras.

(6) *Novelty Yarns.*—These are generally made in the final process in the manufacture of the yarn, that of twisting. Yarns of the same or different fibres may be combined. Novelty yarns have been much used recently in materials both of wool and cotton, which were sold under the general names of *ratine* or *éponge*. Nearly all such materials may be classed under the general term of novelties. They change constantly because of their dependence on passing fashions.

(7) *Yarns at Different Tension.*—Some materials are given a crinkled surface by the use in weaving of warp yarns at different tension. This necessitates the use of two warp-beams to carry the two distinct sets of threads. These may be arranged to give the entire fabric an irregular surface or may be made to form stripes of regular or different widths. This kind of design is most frequently seen in such cotton fabrics as crêpe and seersucker, which do not require pressing after laundering.

2. **Design by Warp Printing.**—Many materials are given a design by the printing of the warp yarn after it is practically prepared for weaving. A plain filling is used,

resulting in a less pronounced design and softer colors. Dresden ribbon and taffetas are made in this way. The method of printing is described under *Surface Design*.

3. **Design by Weaves.**—In studying weaves there are two lines of yarns or threads to consider: the warp, or lengthwise, threads—those which are put on the loom first and which may be said to form the foundation upon which the pattern is worked out; and the filling threads—those which cross the warp at right angles and make the pattern simple or elaborate by the manner of their interlacing. In the finished fabric the warp-threads are usually called ends and the filling threads picks, particularly in trade, and in any comparison of material for fineness and strength the number of picks and ends to an inch is considered.

(1) *Classification of Weaves.*—The various weaves which are used in materials offer an interesting and by no means difficult study once a general classification has been arranged. The one given here is simple and easily understood. (a) Plain and its variations: derivatives, basket and rib; (b) twill and its variations; (c) satin and its variations; (d) figure: damask, brocade, huck, diaper, granite, etc.; (e) double cloth; (f) pile; (g) lappet and swivel; (h) gauze; (i) leno.

(2) *Method of Making Weaves.*

(a) *Plain Weave.*—The simplest weave, and one which is important because of the large number of materials in which it is used, is the plain weave, also called tabby, cotton, homespun, or taffeta. It is found in cotton materials—muslins, cambrics, percales, and batistes; in wools—nun's-veiling, panama, voile, and challie; in silks—taffeta, China, and India silks; in linen—chintz, handkerchief linen, and sheeting. The plain weave requires two harnesses, through one of which all the odd threads (1, 3, 5, 7) are drawn; through the other all the even (2, 4, 6, 8). If the harness holding the odd threads is raised in opening the first shed, the shuttle on its trip through the shed goes under all the odd threads and over all the even; that is, the first warp-thread is up, the second is down, and so on across the fabric. When the next or second shed is open and the

shuttle is sent through, just the reverse happens: the odd threads are covered by the filling and the even are on top. In this the first warp-thread is down and the second is up. This completes the design, and when the third shed is opened it is a repetition of the first, the fourth is a repetition of the second, and so on until the fabric is finished. The filling passes under one and over one in regular order, alternating in each row.

This weave, while giving a strong and firm material, is not particularly close because the threads do not pack as compactly as those of some other designs. A material woven in this way, if held to the light before any finishing is done, will usually show openings between the threads; these are filled with sizing sometimes, if the holes are large and the fabric inexpensive. Shrinking or fulling during finishing helps to make the threads lie closer. The plain weave is often made more decorative by the use of the methods already referred to as forming designs; that is, the introduction of colored yarns, of heavier yarns, of yarns at different tension, etc.

Plain weave

There are several weaves which are usually called derivatives because they are based on another with a slight variation. From the plain weave we have the basket and rib weaves.

(*i*) *Basket Weave.*—The basket weave is found in cotton materials, such as monk's cloth; in wools and linens, called basket cloth; and in silks, such as louisine.

In the simplest basket weave only two harnesses are necessary, as in the plain weave, but they are not used and arranged as for the plain. The more elaborate weaves re-

quire more harnesses, but the method of making is in general the same. The threads are woven in in groups of two or more to form squares. For instance, for a group of two one harness has threads 1 and 2, 5 and 6, 9 and 10, while the other has 3 and 4, 7 and 8, 11 and 12. Instead of opening first one shed and then the other the same shed is opened twice in succession; that is, the first two picks are alike. The first two warp-threads are up in the two rows, the second two are down in the two rows, and so on across the fabric. The second shed is opened twice also and its two picks are alike. In this the first two warp-threads are down in two rows and the second two are up in the two rows. The filling goes under two and over two, making a trip over and back through each shed. To hold it at the edges of the material the filling is interlaced with the threads which form the selvage. This method of weaving gives a design in squares and makes a very attractive fabric but one not satisfactory for wearing quality. The threads slide over each other, do not pack closely, and cannot stand the least strain. Many basket weaves have an additional warp-thread which is introduced between each square or group and is interlaced in such a way as to keep the threads from sliding. This gives strength to the material.

(*ii*) *Rib Weaves.*—There are two kinds of rib weaves, warp rib and filling rib. In the first the warp yarns form the face of the material, in the other the filling. Both are a combination of the plain and basket and require only the two harnesses. *Warp rib.* In the warp rib the first two picks are alike, but, unlike the basket, they go under one and over one. The first warp-thread is up in the two rows, the second one is down in the rows, and so on across the fabric. The second two are also alike and go over one and under one. In this the first warp-thread is down in the two rows and the second one is up in the two rows. This makes a rib effect across the material. It is difficult to distinguish this weave from the plain weave with a heavy filling, as the effect is practically the same. *Filling rib.* In the filling rib the pick goes through each shed only once, but in going it passes under two and over two threads of the

warp. This makes a rib lengthwise with the selvage. The cross rib formed by the warp is more often seen.

(*b*) *Twill Weave.*—The twill weaves are practically equal in importance to the plain weave because they are used in so many materials and with such variety of effects. Twills are found in cotton materials—canton flannel, drillings, jean, outing flannel; in wools—serges, whipcords, cheviots, broadcloths; in silks—plain foulards, surah, silk serges; in linen—diagonals and some kinds of towelling. In the twill

Twill weave

the warp and filling threads intersect, so that they produce a diagonal line or rib across the fabric either to right or to left. The regular twills have an angle of forty-five degrees. All twills are a progression of one; that is, instead of alternating, as is done in plain weaving, the filling moves forward in each row, one thread to right or left of the crossing of the first line, and in this way makes the diagonal.

There is a great variety of twills, their names sometimes indicating the number of harnesses necessary for the weaving. There are even and uneven twills. In the even equal quantities of warp and filling yarn show on the surface of the material, as in the common, or plain (two warp up and two warp down), twill. In the uneven one yarn shows much more than the other, as in what is frequently called the prunella, or three-shaft (one warp up and two warp down), twill. Besides the twills already mentioned there are many others, among them the corkscrew, broken, pointed, and fancy.

One of the simplest twills is the three-shaft or three-leaf (uneven). It may be either warp or filling face and re-

quires three harnesses. For a filling-face fabric in the first shed warp threads 1, 4, 7, 10 are lifted; the filling passes under one (1), over two (2 and 3), under one (4), and so on. In the second shed 2, 5, 8, 11 are lifted, and in the third 3, 6, 9, 12, giving a progression of one in the lifting of the warp in each row. For a warp-face fabric the filling passes under two (1 and 2), over one (3), under two (4 and 5), over one (6), and so on.

All of the twill weaves make exceedingly attractive surfaces, and for this reason they are used in many materials like the worsteds, which do not have their weaves concealed by any finishing process. They also give firmness and bulk to material, as many threads can be used and packed firmly. Because of this the twill is used for materials like broadcloth which, in the finishing, have fibre ends brought to the surface to form a nap. In many materials twills form the only decoration; in others they are merely the background for elaborate figures.

(c) *Satin Weave.*—The satin weave like the twill has a progression in each pick in the lifting of the warp, but it is a progression of two or more rather than one as in the twill. It might be called a broken or irregular twill. The terms satin and sateen are both used for this weave: satin to indicate a surface formed by the warp, as in satins, in Venetian cloth, in prunella, and in galatea, which have the floating threads running lengthwise of the material; sateen, a surface formed by the filling, as in sateen, which has the floating threads running across the material.

The satin weave gives a smooth, lustrous fabric, since the surface—because of the kind of weave used—appears unbroken and consequently reflects the light to the best advantage. As has been said, the surface may be formed by warp or filling threads. In either case, whether warp or filling, these surface threads are longer than in any other weave, as they are carried under one intersecting thread and over several, and they are so closely packed that the few intersecting or cross threads over them scarcely show. This weave is found in cotton materials—sateen, galatea;

in wools—Venetian cloth, prunella; in silks—satin, messaline, *peau de cygne*, and *charmeuse;* in linen—damask. An odd number of shafts is usually found; that is, five or seven shafts or even a greater number.

For a five-shaft, filling-face satin, as the name implies, five harnesses are necessary. When the first shed is opened the filling passes under one warp thread (1), over four (2, 3, 4, 5), under one (6), and so on; in the second row, to make the progression it passes over three warp threads

Satin weave

(1, 2, 3), under one (4), over four (5, 6, 7, 8), under one (9), and so on; in the third row over one (1), under one (2), over four (3, 4, 5, 6), under one (7), over four (8, 9, 10, 11), and so on; in the fourth row over four (1, 2, 3, 4), under one (5), over four (6, 7, 8, 9), under one (10); in the fifth row over two (1, 2), under one (3), over four (4, 5, 6, 7), under one (8); then the pattern is complete and the sixth row is like the first.

The satin weave is very frequently used in materials in which there is a combination of fibre, as in cotton-backed satins, where the silk threads floating on the surface cover entirely the few cotton threads which intersect them. The result is a silk face and a cotton back with irregular twill effect. Skinner's satin is a well-known illustration of this. Many of these materials are less expensive than all silk and prove satisfactory in wearing quality. If the threads have too long a float on the surface, as frequently happens in some foulards, they are likely to catch and pull, and thus destroy the face of the fabric, especially if there is a colored design. Some satin-face materials in dark colors have the disadvantage of becoming shiny with wear. Generally

speaking, however, the satin weave is satisfactory and gives many beautiful fabrics.

(*d*) *Figure-Weaving.*—Figure-weaving is closely allied to the satin and twill weaves, many of the designs being really a combination of the two. Figure-weaving is done on the Jacquard loom, or by some special attachments like the Dobby or Head motion, which may be added to the harness-loom. In this class the most frequently used are the damask, brocade, huck, diaper, and granite weaves, which are found in practically all kinds of materials.

Damask and brocade are terms often confused, but there is a distinct difference. In damask the design or pattern is complete on each side of the fabric and is, in consequence, reversible; there is no definite right or wrong side. In general, on one side the background is satin with the figure showing the twill; on the other the figure is satin and the background has the twill effect. Damask is often woven with a sateen background and satin figure or vice versa; this gives a crosswise twill to one on the back and a lengthwise twill to the other.

Figure weave

In brocade there is a decided right and wrong side. The design shows very indistinctly on the wrong side, as no effort is made to have it complete. The threads which form the pattern on the right side are woven in on the wrong side when not in use or left floating to be cut off later. The damask and brocade weaves are used in a variety of materials, the damask principally for table linen, which may be made either of cotton or linen or a combination.

Such weaves as the huck, diaper, and granite are much simpler in construction and do not require necessarily the

Jacquard loom. The diaper and huck weaves are used chiefly in linens and cottons; the granite weave in linens and wools, most often in materials called granite or crêpe cloth.

(*e*) *Double-Cloth Weave.*—Under this general heading may come materials of various kinds: (*i*) Cloths which are backed. The extra backing is usually done by warp-threads which give additional weight without in any way changing the appearance of the face of the fabric. In many cases the materials added to give weight are of decidedly inexpensive quality. (*ii*) Cloths which are reversible. In the reversible materials two warps or two filling threads may be used and interchanged in such a way as to make the designs alike or unlike on the two sides of the material. (*iii*) Cloths which are figured with extra materials. These frequently have two distinct sets of warp and filling and are reversible. (*iv*) Cloths which are really double or compound. Many double cloths are made with two sets of warp and of filling, which are so interlaced at intervals as to make the two fabrics inseparable; or there may be a double warp, double filling, and an additional warp which binds them together. Fabrics made in this way may easily be pulled apart. In this general class come many heavy suitings, coatings, steamer rugs, novelties, polo cloth, and silence cloth.

(*f*) *Pile Weave.*—The pile weave differs from others in that it does not have all the warp and filling threads in lengthwise and crosswise parallel lines, but has some threads of either the warp or the filling so raised in loops as to become vertical.

Under the general head of pile weave come several classes of fabrics: (*i*) those in which the pile is formed by the warp, as in good velvets and plushes; (*ii*) those in which the pile is formed on the two sides of the fabric by the use of a movable reed and two warps, one at loose tension, as in Turkish towelling; (*iii*) those in which the pile is formed by the filling, as in velveteen and the cheaper velvets; (*iv*) those in which two distinct fabrics are made at once and later cut apart.

(*i*) *Warp-Pile—Cut or Uncut.*—Warp-pile fabrics are of great variety, as they may be plain or figured, the latter a combination of cut and uncut pile. When the pile is formed by the warp there are two sets of warp to one of filling. Both the ground and pile warp are interlaced by the filling threads, but at short and regular intervals one set of warp-threads passes over an inserted wire which pulls the threads up to form loops. In making cut-pile fabrics the wire is provided with a knife at one end which cuts the loops as it is withdrawn. If a warp-pile fabric is to be given a design by a combination of cut and uncut pile, the pile is not cut in the weaving but during the finishing processes.

(*ii*) *Warp-Pile—Uncut.*—Turkish towelling and some novelty materials are made by using two sets of warp-threads one of which has a very loose tension. The regular loom is used, but the reed is so regulated that it does not beat each row of filling regularly; that is, two rows of filling are put in and beaten very lightly. After the third row, however, they are all firmly beaten into place. As a result the loose warp is pushed both up and down and forms a loop on both sides of the material.

(*iii*) *Filling-Pile.*—When the pile is formed by the filling there are two sets of filling threads and one of warp. One set of filling interlaces with the warp regularly and forms a firm groundwork; the other set floats over the woven surface for some distance and is intersected and bound to the fabric by the warp at regular intervals. After the weaving is finished this floating thread is cut in the centre and rises to form the pile. As there are a great number of these threads, a uniform and well-covered surface is formed. Velveteen and corduroy are woven in this manner, also many cotton velvets.

(*iv*) *Double-Pile Weaving.*—This method of weaving is sometimes employed for plushes. The weaving is done somewhat as in double cloth, but the two fabrics are far enough apart to give the requisite length of pile. The pile threads pass from one fabric to the other and are interlaced and kept in place by the filling threads. These pile threads

are later cut half-way between the upper and lower fabrics, giving two distinct materials.

If a pile fabric is poorly made, with few threads or the threads insecurely fastened, the surface soon pulls out or wears off and an ugly background is left.

(g) *Lappet and Swivel Weaving.*—By the use of attachments—either the lappet or the swivel—decorative figures may be woven over the surface of a fabric without affecting the groundwork weave. The effect is somewhat that of embroidery. Many figured muslins, such as the dotted swiss, are made in this way. When the figures are continuous the wearing quality of the material is in no way affected by the decoration, which enhances its beauty. If an intermittent design is used, such as a dot, the long threads connecting the dots on the wrong side must be cut. These ends may pull out if the material is not closely woven.

Frequently these designs are imitated; that is, similar effects are produced in inexpensive materials without using any attachment. Dots are a favorite method of decoration, but without the attachment each dot is not made of a continuous thread. They are put in by an extra bobbin, which carries the filling back and forth across the full width of the material, letting it appear on the surface to form the dot. Each thread of the dot is a separate thread. The back of the material is covered with the long lines of floating threads between the dots, which must be cut in order not to catch. With very little wear the short threads which form the dots soon pull out. Many of the designs in cotton materials are made in this way.

(h) *Gauze Weave.*—In the gauze weave we have an openwork effect obtained by a crossing of the warp-threads. Grenadine and marquisette are the best-known illustrations of this.

While gauze fabrics are light and open they are exceedingly firm, more so than any other fabric in proportion to the quantity and quality of material used. An even number of warp-threads is used, and between every two filling threads two warp-threads entwine to right and left alternately; the warp-thread, which is on top in the crossing,

passes under the filling and vice versa. This occurs regularly, because of the alternating of the warps to right and left, and gives firmness to the material.

(*i*) *Leno Weave.*—Leno is a name usually given to a variation of the gauze, a combination of gauze and plain weaving. Many cotton curtain materials have this combination.

II. Surface Design

As the name indicates, this kind of design is applied after the fabric itself is made. The majority of fabrics having a surface design have also structural design, as, with but few exceptions, fabrics are formed by weaving. Surface design may be applied in various ways, some of which are not of sufficient importance here to require more than passing mention.

In many of these designs the decoration is made by the application of color in various ways. In others it is made in the finishing processes by pressing with special rollers without the use of color. It may also be made by hand or machine embroidery, when the pattern may be in a contrasting color or may not.

1. **Design with Color.**

(1) *By Hand.*—There are two or three hand methods, the best known of which are block-printing and stencilling.

(*a*) *Block-Printing.*—Block-printing is the method in which the design is applied by blocks, a separate block being necessary for each color. The blocks are applied one at a time.

(*b*) *Stencilling.*—In stencilling, the pattern is cut out of stout paper or metal and the color applied to the fabric through the interstices of the pattern.

(2) *By Machine.*—There are different machine processes, the best known of which are block-printing and roller-printing.

(*a*) *Block-Printing.*—When block-printing is done by machine the general principles are the same as in the hand method. In the machine method there are at present limitations not found in the hand work as to the number of colors and the size of the pattern.

(*b*) *Roller or Machine Printing*.—The most important method of textile printing is roller, cylinder, or machine printing. The majority of surface designs are made by this method.

When fabrics are properly printed the color applied in this way becomes a part of the fibre and resists both washing and friction. In general, for machine-printing there is (*i*) a large cylinder covered with several thicknesses of material called lapping, over which passes the cloth to be printed. Against this large cylinder there is (*ii*) a smaller cylinder which is the engraved copper printing-roller. This copper roller in revolving touches (*iii*) another roller which supplies it with color. To keep the copper roller free from the lint of the material and to regulate the amount of color on it there are (*iv*) two knives which are so set as to operate against its surface and keep it clean.

In roller-printing a different cylinder is required for each color. These different copper cylinders, to the required number, are placed around the central cylinder and print one after the other. Various methods are employed in engraving the copper rollers and there are also many different finishing processes for setting and bringing up the color.

2. **Design without Color.**—The design without color, made by pressing rollers, gives many different results which are determined by the surface finish of the rollers.

(1) *Design on Plain Weave.*—A material with the smooth surface which a plain weave gives may have a design made by using embossed rollers. In this method the background, which is pressed flat, is often treated with a finishing gum or paste which further accentuates the difference between the flattened background and the raised pattern. Such fabrics belong to no special class and are generally termed novelties. Many of the cotton ratines are finished in this way. Various crêpe effects are given to fabrics having a plain weave by the use of special rollers. The crinkled surface of albatross is made in this way.

(2) *Design on Pile Weave.*—Many pile fabrics have designs made in much the same way. They may be made with uncut-pile background and cut-pile design or vice

versa. The method is the same for both. The design is
made on the uncut-pile material by using engraving or em-
bossing rollers as in the plain weave. When the design is
made, if the background is to remain uncut it is pressed flat
and treated with a paste to keep it flat during the next
process, which is that of shearing or cutting the pile left
standing. The material is then washed, a process which
removes the paste and releases the background pile. The
result is a light background of uncut-pile with a design in
a darker shade which is given by the cut-pile. The op-
posite effect is secured by pressing the design and cutting
the background.

(3) *Moiréing.*—Another method of securing design with-
out color is the moiréing process. The surface of the ma-
terial used is generally slightly corded. This cording is
made by having the threads which form the filling heavier
than those of the warp. The material is folded face to face
along its lengthwise centre and a paper inserted; it is so
pressed and dampened that some of the cords are flattened
and its surface given the watered effect which is seen in
many materials, such as percaline, moreen, moiré antique,
moiré velour, etc.

III. TESTS FOR FABRICS

Before beginning any tests on fabrics it is necessary to
know the various processes required in their manufacture
and, with this information as a basis, to establish familiarity
with the raw fibres and with the ordinary designs, by care-
ful and constant observation and comparison of fibres and
materials. In the materials many weaves are concealed
by the finishes, and the fibres are combined with various
substitutes, adulterated by weighting, and covered with
sizing, thus greatly increasing the problem of identifica-
tion.

As has been said, in the beginning it is much wiser to ap-
ply all tests to good fabrics—those which are sold as good
by reliable firms at fair prices. If the first testing is done
on cheap materials it is a discouraging task, as there are

usually more difficulties to be met in the way of poor fibres, substitutes, sizing, and weighting. A knowledge of good materials—of all that the term *good* implies—should when possible be made the basis of all textile testing.

Some of the same tests may be applied to fabrics as to fibres, and while any one test may not give absolute results by itself, in combination with others it will help to determine, in a general way, the character of the material. Many tests require the unravelling of the threads of the material until the fibres are so separated that they can be examined. These tests may be left until various others have been used for such factors as the strength, finish, and color of the material itself.

1. **General Comparison of Fabrics.**—A comparison of the four general classes of fabrics—cotton, wool, silk, and linen—may be made, but is valuable only to a limited extent, as each class includes so great a variety of fabrics which differ widely in appearance, feel, strength, etc.

(1) *Appearance.*—Because of the perfection of the art of finishing, the general appearance of many fabrics counts for comparatively little, except to the expert, in indicating the structure of the fabric and the exact quality and combinations of fibres used.

(2) *Feel.*—Many fabrics, however, frequently have somewhat the same feel as the fibres of which they are made.

(a) Cotton material: unresponsive, soft, inelastic. (It may be made to look and feel somewhat like wool, but it still retains these characteristics.)

(b) Wool material: springy, harsh, elastic. (When combined with much cotton or with much shoddy it is less elastic and springy.)

(c) Silk material: smooth, elastic, cool. (When weighted or adulterated it has less elasticity.)

(d) Linen material: firm, stiff, smooth, cold, inelastic. (When adulterated it loses somewhat its firmness and smoothness.)

(3) *Strength.*—No comparison of the strength of the different classes of materials can be made based on the strength of the respective fibres. Two materials made of the same

fibre differ absolutely in strength, as the strength depends on the size and quality of the yarn and the kind and quality of the weave. For instance, wool fibre, which is weak in tensile strength, makes generally a strong material.

(4) *Burning.*—Burning a small section of cloth gives practically the same results for materials as for fibres, with the exception that the quickness with which any fibre burns may be somewhat affected by the firm twisting of the yarn and the closeness of the weave.

(5) *Tearing.*—The tearing of material sometimes helps in a general way in determining the kind of fibre as well as the strength of the material itself.

(*a*) Cotton tears easily, with a shrill sound, and the ends of the fibres along the tear curl up and are fuzzy.

(*b*) In a wool fabric the weight of the thread and the firmness of the weave have much to do with the way in which it tears. Ordinarily, however, it tears with difficulty and the sound is dull and muffled. If much cotton is present it facilitates the tearing, and the ends of the cotton fibres are unlike those of the wool.

(*c*) Silk, unless it has a special design, such as very heavy filling or cording, tears easily, with a sharp, shrill sound.

(*d*) Linen is difficult to tear; the ends of the fibres are straight and smooth. If cotton and linen fibres are used in one fabric the tearing test may indicate such a combination because of the difference in the torn ends. It proves little or nothing, however, as to the proportion.

2. **Testing for Strength and Color in Fabrics.**—The tests used for determining strength and color are practically the same for all fabrics.

(1) *Tests for Strength.*—The strength of a fabric has much to do with its wearing, but it can have no fixed standard. Each material should be strong enough for its intended use. If the warp and filling threads are not well balanced, if one is much finer than the other, the fabric breaks or tears along the line of the heavy threads. Dimity, with its heavy lengthwise cords, is the most obvious illustration of this. With wear and laundering the filling threads break along the cord. No matter what design is chosen the

weaving should be well done; that is, there should be enough threads and they should be closely enough packed to give firmness and body to the cloth.

To judge the strength of a fabric it should be held firmly in both hands, with the fingers underneath and the thumbs on top, and pulled straight out, first warpwise, then filling-wise. The weaker threads, whether warp or filling, will break easily and quickly unless there are so many of them used that they acquire sufficient strength to balance the other stronger threads. Later, when the material is un-ravelled, the respective strength of warp and filling may be tested more accurately by breaking and by comparison for size, firmness, twist, etc.

Many materials which seem strong as far as quality and size of yarn are concerned are woven in a design which al-lows the threads to slip out of place easily where there is the slightest strain, especially in the seams. This fault in the material may be detected by attempting to push the threads apart with the finger-nail. Many fancy weaves, like the basket, do not usually stand this test.

(2) *Tests for Color.*—There are several ways of testing for fastness of color, because color is affected by various factors—chiefly by washing, boiling, and the use of strong soap, by pressing with too hot irons, by wearing, by ex-posure to sun and air, and by friction.

It is, in general, the cottons and linens which must be tested for laundering. This can be done only by obtaining a sample and subjecting it to the ordinary rubbing and soap-ing which must be used in cleansing such materials. It is well to keep part of the sample for comparison to know the exact loss of color. Some colors which a few years ago faded almost immediately are now, if special dyes are used, absolutely fast.

Many materials, particularly those worn next the skin, must have sufficiently fast color to withstand friction. This can sometimes be fairly well determined by rubbing the fabric with another which is white.

For sunlight tests it is best to expose a sample for a num-ber of days, having half of it carefully covered with some-

thing which will exclude the light. By this method easy and accurate comparison may be made.

3. **Testing for Fibres and Finish in Fabrics.**—The tests used for determining fibres and finish differ for the different fabrics.

(1) *Cotton Fabrics.*—In cotton fabrics it is not necessary to consider substitutes; they are not used, because the cotton fibre is cheaper than any other fibre which could take its place. The length and quality of the fibre in the material may vary greatly, however, the weaving may be loose, and much sizing may be used. These are facts which must be considered in determining the soundness and wearing quality of the material.

(a) *Fibres.*—Good cotton fibres are blunt at the end which was attached to the seed, while the other end tapers, and the centre is a little larger than either end. The entire fibre shows a strong uniform twist. The dead or unripe fibres have practically no twist; they do not dye or spin satisfactorily, but usually they are not present in great numbers. In untwisting the cotton yarns to identify the fibres, the general appearance of the yarn itself should be observed as to uniformity of size, evenness of twist, smoothness, etc. Care should be taken not to break the separate fibres. Only an experienced worker with the help of a good microscope can secure satisfactory results in identifying the fibres. This work is, in consequence, not possible for general use.

Any experience which is gained in examining the different qualities of cotton fibres in cotton fabrics assists materially, however, in detecting cotton in various wool and linen fabrics where there are distinct differences in the different kinds of fibres.

(b) *Finish.*—The plain weave is more frequently used in cotton materials than any other. The twill weave is also found, especially in such fabrics as canton flannel and outing flannel, which are made to look and feel somewhat like wool fabrics by having a nap raised on one surface or on both.

The twill weave gives firmness and bulk to material, but

the plain weave, while strong, is not particularly close. If the weaving is not well done, openings or spaces can be seen between the different threads.

Many cotton fabrics have both poor quality of fibre and loose weave concealed with a sizing which is put on while the material is being finished. This sizing, which is somewhat like starch, fills in all the spaces between the warp and the filling threads, giving weight to the material and providing a surface for the desired finishing processes, such as pressing and polishing. There are various ways to detect this sizing. Rubbing between the hands or, if there is a great deal of sizing, tearing the material or flecking its surface sharply with the finger-nail will cause a fine dust or powder to rise. Soaking in warm water will usually dissolve at least a part of the sizing and leave the material sleazy. By moistening the fabric with the tongue a sticky, starchy taste may frequently be detected. These tests are not possible if it is a fabric from which a sample cannot be taken, but something may be learned from its appearance and feel. If it is loosely woven and much sizing is present, the sizing will probably show between the threads when the material is held to a strong light. It will also give the material a feeling of harshness which cotton does not otherwise have.

The wearing quality of many surface designs, especially those in which either the design or the background is pressed flat and held there by starchy preparations, can easily be determined by rubbing the fabric between the hands. In many cases a little rubbing destroys the design entirely by removing the paste or starch.

(2) *Wool Fabrics.*—The problem of identification for so-called wool material is a difficult one. It is possible to use a greater variety of substitutes for good wool and conceal them more successfully than in the case of any other fibre. Wool cannot be adulterated in worsteds, but in some cases cotton may be combined. This is not generally done in suitings, however. In woolens there is a great variety of substitutes possible, as cotton, shoddy, and wool wastes may all be used. A variety of weaves may be employed

for both. The twill weave is frequently used because it is attractive and gives the necessary background or foundation for any desired surface finish.

(*a*) *Good Fibres and Substitutes.*—Good wool fibres show a series of scales on their surface the number and size of which depend on the variety of wool. These scales give a sawlike edge to the fibre which is also kinky and wavy. This waviness must be distinguished from the twist of the cotton fibre. In untwisting yarns to determine the fibres present the general appearance of the yarn should be observed, as in the cotton, as to uniformity of size, evenness of twist, smoothness, etc.

The substitute fibres may be divided into two classes:

(*i*) *Vegetable*, which includes cotton, ramie, and jute. Of these cotton is most frequently used, not only because of its cheapness but because of the ease with which it may be made in its manufacture to resemble wool.

(*ii*) *Animal*, which includes waste wool and the remanufactured, reclaimed, regenerated, or recovered fibres from materials like shoddy. This class is the more important of the two.

Waste wool comes from both the worsted and woolen industries and includes the fibres which are so mixed with burrs that they cannot be freed by the burr-guards or burr-pickers.

The remanufactured wools, as all the terms imply, have already been manufactured and many of them have been worn. In passing through the various processes of the first manufacture and in the tearing up preparatory to remanufacture the physical structure of the wool fibre has been somewhat changed and damaged. In general, all the remanufactured wools are included in the term "shoddy," but by some authorities they are divided into distinct classes, such as shoddy, mungo, and wool extract, varying in quality and in the use to which they may be put.

In testing for different fibres all the vegetable fibres in a wool fabric are easy to detect because they respond to the burning test as when in the raw state. For instance, in burning a material which has cotton in one direction and

wool in the other the cotton disappears, leaving only ashes; the wool is but slightly burned; the odor is unmistakable, and each wool fibre shows the usual gummy residue on its burned end. If cotton and wool threads exist in both warp and filling or if the fibres are combined in the yarn itself, it is necessary not only to unravel the material to test the yarns separately but to untwist the yarns for the individual fibres.

It is, however, very difficult—in fact, for the majority impossible—to identify the different qualities and kinds of animal fibres which may be used in one wool fabric. They all respond in the same way to the burning test or to chemicals, and even under a compound microscope the very expert cannot always detect them. Occasionally the presence of shoddy may with care and patience be discovered. It is frequently confused with noils, however. The wool fibres in shoddy may be of many colors, and both dyed and undyed fibres may be found. There may also be no uniformity in the size, length, or general condition of the fibres.

(*b*) *Finish.*—When wool fabrics reach the finishing process extra materials, such as noils, flocks, and waste wool, are often added to conceal defects or to give the desired weight or surface which has not been supplied in the making of the yarn or in the weaving. Noils come from the combing. Flocks come from the various finishing operations, such as clipping the nap of woolen fabrics. The waste wool is swept up in the mill and is frequently of more value than flocks. All these may be of fairly good quality or of very poor, depending on the amount of good wool or shoddy used in the various materials from which they come. They are usually added while the material is being fulled or felted. If they are of good quality and carefully applied, so that they do not wear off or drop out, the material is not injured. If they are poor, carelessly added, and rub off with a little friction, the weave itself is soon exposed and, on account of its lack of substance, cannot stand wear.

It is generally difficult to detect these added fibres except when the fabric is unravelled and its substance examined with the microscope. There are some exceptions,

however. If a large enough sample can be secured its surface can be tested by hard brushing with a stiff brush. Some fuzz always comes off, but if in large quantity the material should be avoided. Occasionally inexpensive materials, such as chinchilla and imitation zibelines, are found from which the entire fancy surface can practically be removed by pulling and rubbing.

Too high a polish on an inexpensive quality of material should be avoided. This is particularly true of broadcloth. Because of the number of processes necessary in its making and finishing, to be well made and of good-quality fibre it must be expensive. A cheap broadcloth with a high polish soon loses its lustre and wears unsatisfactorily. Good wool responds to pressing and steaming and takes a beautiful lustrous finish which is lasting. Cheap wool, which must of necessity be present in cheap fabrics, may be given a temporary lustre, but wearing soon removes it. Tests for water-spotting should be applied to all wool fabrics. It is not wise to make up even expensive wool materials until they have been sponged.

(3) *Silk Fabrics*.—In silk fabrics it is necessary to consider the use of both substitutes and weighting. Raw silk fibre is sometimes combined with wild silk; with waste silk, which is a shorter fibre; with cotton, mercerized and unmercerized; and with artificial silk, which has the same basis as cotton. It is also frequently filled or weighted with salts of tin or iron.

Many kinds of weaves are found in silk fabrics; those most used are the plain, the satin, and the rib, or the plain with a rib or corded effect made by the use of a heavy filling. Of the three named, the last usually proves least satisfactory for wear. Such silk as the bengalines and poplins are of this kind and are frequently woven with heavy cotton fillings. The cords which the filling forms frequently have their silk coverings, the warp-threads, worn off by slight friction or rubbing, and the beauty of the material is entirely gone.

If materials made in this way become soiled or faded they cannot be redyed, as the silk and cotton yarns do not

dye alike. The silk, unless of very good quality, is apt to mat and separate in the dyeing and thus leave the cotton filling exposed. The result is extremely unsatisfactory.

(*a*) *Good Fibres and Substitutes.*—Good reeled silk fibre is long, strong, elastic, and lustrous. It differs in appearance from its substitutes. In untwisting yarns to determine the fibres present the general appearance of the yarn should be observed.

The substitute fibres may be divided into two classes:

(*i*) *Animal*, which includes wild silk and spun or waste silk. The wild silk fibres are generally coarse, broad, thick, and flat; they have lengthwise markings. The spun or waste silk differs from the raw silk principally in being much shorter. This shortness of fibre may make a fuzzy thread or yarn, which will affect the surface of the fabric, just as cotton fabrics, because of the shortness of the fibre, have a tendency toward fuzziness. This fuzziness may be avoided by careful manufacture or it may be concealed by a surface finish which is more or less temporary.

(*ii*) *Vegetable*, or cellulose, fibres, which include all cotton fibres and the artificial silk. Cotton fibres are short and without lustre; even when mercerized the lustre does not equal that of silk. They also lack elasticity and strength. Artificial silk has almost too much lustre. It has not the strength and elasticity of silk, is apt not to dye well—that is, evenly—and at present it does not stand constant moisture well. Its specific gravity is great, and all artificial-silk fabrics are heavy, as the yarns do not cover well and in consequence a large quantity must be used.

Any silk material in which a quantity of cotton or artificial-silk fibre has been introduced lacks the elasticity and spring of the all-silk fabric. As a result it wrinkles much more when used.

(*b*) *Weighting.*—Silk fibre is often weighted with salts of tin or iron, the adulteration chosen depending somewhat upon the color of the material. Weighting, if done to excess, seriously affects the wearing quality of the silk and makes it much more unsatisfactory than are the various substitutes. The metallic weightings used are variously affected;

for instance, some crystallize when exposed to air and light and act as ground glass would; they cut the silk fibres and absolutely destroy the strength of the silk. Bargains in silks should be avoided, as after they have remained on shop-counters for any length of time they are apt to disintegrate rapidly when subjected to any use.

In testing for the different fibres the waste or spun silk is the most difficult to identify as it is in general structure like the reeled silk. It is, however, shorter and the yarn made from it is frequently much fuzzier. When cotton and artificial-silk fibres are combined with raw silk they are easy to detect because the response to the burning test is the same as with combinations of cotton and wool; that is, there is present the combination of animal and vegetable fibres. Artificial silk, like cotton, is cellulose and burns in the same way with the same results.

When weighted to any extent silk fibre, which ordinarily burns quickly and with a darting flame, burns much more slowly and the framework of weighting remains.

(3) *Finish.*—Various kinds of dressing, such as glues, starches, and waxes, are used in silk finishing to produce various results. They are exceedingly difficult to detect. They may make the silk stiff, soft, lustrous, waterproof, or fireproof; but they may also give poor quality of fibre the appearance of good. Dressings are not in general nearly as injurious as are weightings. While they frequently make a fabric appear what it is not they do not destroy any silk fibre that has been used.

If appearance and feel of silk are to be relied on in purchasing, in general it is wise to avoid stiff silks. The soft-finished, such as *crêpe meteor* and *charmeuse* of good quality, wear exceedingly well. In darker colors the satin surfaces sometimes take on an unattractive, rather greasy, polish after they have been worn some time. Good *crêpe de chine*, which has a closer-twisted thread than the others and is fairly evenly balanced in warp and filling, wears well and usually washes satisfactorily. As has been said, silks with heavy fillingwise cords generally do not wear well, as the floating threads on the surface of the cords wear off. Bed-

ford cord is, however, an exception; its cords are length-wise and are made with a woven surface rather than with floating threads. It gives excellent service.

(4) *Linen Fabrics.*—In linen materials the use of sub-stitutes must be considered. As linen is an expensive fibre, imitations are frequently attempted. Linen fibre is often combined with tow, with cotton, and with ramie.

A variety of weaves may be found in linen fabrics. Those most frequently used are the plain and damask, or figured. As in cotton, the weaving may be loosely done and much sizing used.

(a) *Good Fibres and Substitutes.*—Good linen fibres are long, strong, and have a slightly transparent lustrous ap-pearance. In untwisting the yarn the general·appearance should be observed. All the fibres which are used as sub-stitutes are vegetable, as is the linen, and in consequence they are rather more difficult to distinguish.

Tow, the short linen fibre, is frequently used with the long or line fibre. It generally makes a somewhat rougher thread and consequently a less even and less desirable fabric.

Of all the substitutes, cotton is more frequently used than any other because of its cheapness and the fact that it can by manufacture be made to resemble linen temporarily. It lacks the lustre, strength, and length of linen.

Ramie is a long bast fibre like linen. It has strength, an even higher lustre than linen, and is exceptionally white in color. It is difficult to manufacture and cannot withstand the test of wear as the linen does. It cracks and easily becomes fuzzy. It is not easy to identify when used with linen.

The burning test is useless in identifying any of these fibres, as, being vegetable, they all respond in practically the same way. A linen fabric usually burns more slowly than a cotton fabric, because its fibres, being longer and smoother than the cotton, give a smoother surface which is more resistant to the flame.

When linen yarn is tested for the presence of cotton, the linen fibres in comparison with the lustreless white of

the cotton show a slight transparent yellowness. If material is torn or threads are broken the torn ends of the two fibres are dissimilar; the linen-fibre ends are straighter and smoother than the cotton, the ends of which are fuzzy and have a tendency to curl. Much of the cotton fibre used with linen is mercerized and is thus given additional lustre and strength.

A test which is frequently used to distinguish pure linen from a cotton or a cotton-and-linen mixture is the dropping of water on the fabric. If it is pure linen the water spreads quickly and rather unevenly along warp and filling and dries quickly. For a similar test ink and glycerine also are sometimes used instead of water. The use of the latter gives a particularly good result as the linen shows a transparency which is not seen in the cotton.

(*b*) *Finish.*—Linen fabrics may be treated in finishing much as are cotton, with the difference that the sizing is used in many cases to conceal not only a loose weave but the presence of substitutes as well. The amount of sizing in a linen fabric may be tested, as in cotton, by rubbing, flecking with the finger-nail and soaking in water. Both cotton and tow give a fuzzy surface if used in linen materials. This fuzz may be temporarily concealed by sizing. In the wearing, however, it reappears and destroys the beauty of the fabric. The presence of cotton fibres affects the strength of a material as well as its beauty, as the cotton fibre has much less strength than the linen.

Probably there is more difficulty experienced in the purchase of damask than in that of any other linen material. Good linen, because of the natural lustre of the fibre, is easily given a lustrous surface in finishing. The weave used for damask adds to this gloss, and but little sizing, if any, is required. As has been said, cheaper qualities of linen and combinations of linen and cotton may be given much the same appearance temporarily by the use of sizing and much polishing. The sized linen, however, has not the feel of good linen; it is harsh, while the good is strong and leathery though soft and flexible. The expert depends as much upon the feel as upon the appearance of a fabric in

selecting linen. For the ordinary purchaser much experience in comparing qualities and prices is necessary.

All the tests suggested here are exceedingly simple and require no apparatus. Even these are impossible, however, if samples cannot be secured of a size to give sufficient length to both warp and filling yarns when unravelled.

When these tests are not effectual, as in identifying different qualities of wool in a fabric, the purchaser must give the most careful consideration to a comparison of the appearance and feel of fabrics of varying qualities and prices, in order to establish a basis for judgment and a relation between quality and price.

PART III—DRESSMAKING

CHAPTER IV

GENERAL SUGGESTIONS AND INSTRUCTIONS

In making a costume there are many factors to be considered each one of which plays its relative part in making the completed garment a success. Some of these—they might be called preliminary—such as the selection of material for color and wearing quality and the choice of design from an æsthetic and economic standpoint, are discussed in other parts of this volume. They are referred to here only as showing their relative position in the whole problem. The 'matters discussed in detail in this chapter are the various factors which determine good technique, such as accuracy and sequence, the use of good tools, the preparation of material, a few general rules for cutting, marking, fitting, and the taking of accurate measures.

I. CHOICE OF MATERIAL AND DESIGN

When a dress is to be made there are two initial steps to be taken: choosing the material and choosing the design. The material may be purchased first and a suitable design made, or the design may be selected and the material suited to it. To result in a satisfactory combination the two must be chosen with reference to each other and not as individual units. If the fabric is chosen first, the immediate consideration should be suitability to purpose, and at once the interdependence of all parts of the problem is evident. For on this question of the use of the costume depends also the choice of design, of color, and often of the wearing quality of one textile against the beauty of another. In the fashion world it is the textile which determines the

155

design. The manufacturer produces new fabrics, and designs which seem best suited to these are worked out by the dressmakers. Many hours are spent by the dress-designers in the perusal of past fashions for suggestions and in modelling and draping in the materials themselves on living models. For this reason, as new fabrics appear on the shop-counters fashions simultaneously appear to which they seem well suited. Aside from these fabrics, some of which may be called novelties, there are also the many standard materials always on sale which change little from year to year. These are not definitely related to the passing fashions and easily lend themselves to a variety of designs.

II. Technique

When the preliminary choice of material and design has been made, the actual execution of the technical part of the problem may be approached. Good technique has certain essentials which cannot be overemphasized, such as accuracy, system or sequence, simplicity of construction, and the use of good tools. A knowledge of "dressmaking-sewing" might be included in the list; this differs from the others, however, in that it requires skill and is the *result* of experience; while, on the other hand, accuracy and system are necessary in *acquiring* proper skill and experience. It is too often thought that a careful or good sewer must be also a good dressmaker. The terms are by no means synonymous. A knowledge of dressmaking-sewing appears to consist chiefly in appreciating where to "slight" and where to sew carefully; in regular sewing there is no slighting; there is a fixed standard of excellence.

Accuracy in following directions, in cutting, in fitting, in finishing—in fact, accuracy in all details, no matter how trifling—is indispensable.

The temptation is great to attempt saving time and labor by short cuts, by omitting certain steps which at the time seem scarcely necessary. Only a careful observance of sequence—of the required order—however, really saves time and labor and gives a satisfactory result.

Simplicity of construction is necessary for the comfort of the wearer. In making a design the openings for a garment are often not indicated. It is then the task of the dressmaker to work out a scheme of construction which will place all openings and fastenings so that they do not detract from the symmetry and charm of the design and at the same time are convenient and easy for the wearer to manage. Simplicity in design—good taste shown in simple decoration—is discussed elsewhere in this volume (*Designing, Part III*).

III. Tools

Good tools are absolutely necessary for good work. By tools are meant such things as sewing-boxes, sewing-machines, thimbles, scissors, pins, needles, emeries, tape-measures, pincushions, tracing-wheels, tailor's chalk, white and colored cottons, sewing-silk, and a skirt-rule or square, or both.

It will save time and thought if, while sewing, all the tools which are used frequently are conveniently placed on the table near the worker and always kept in the same relative position.

1. **Sewing-Boxes.**—A rather shallow sewing-box is very useful; all the smaller tools may be kept in it in fairly good order. A convenient size is 9″ long, 6″ wide, 2½″ high. At present, in red cloth, these cost from $9 to $12 per hundred.

2. **Sewing-Machines.**—While the elaborate dresses intended for afternoon and evening wear require little machine stitching except for the linings, there is a larger class of garments of all materials which is dependent for finish, and often for decoration, upon good machine work. Many of these, even though well cut, well fitted, and in good taste, are not successful because of poor stitching. This may be the fault of the worker or of the machine used. Of the two general kinds of machines manufactured—the automatic, or single-thread, and the double, or two-thread—only one kind is suitable for dressmaking; that is, the two-thread machine. As far as possible it is wise to buy machines of

standard make which have a recognized quality tested by
years of constant use. This is particularly true of machines
for school use, which are obviously subjected to rather
severe treatment. There are a few well-known machines,
used the world over, which are simple in construction, can
readily be understood and managed, and are not easily put
out of order. They have an established standard of quality
to maintain and are found much more satisfactory than
the machine of unknown or only locally known make.
While the initial price of the latter machine may be small
it frequently proves expensive in the end. To make its
cost correspondingly small it must necessarily be made of
materials which are not of the best quality and do not
stand wear.

3. **Thimbles.**—Celluloid is a good material and not ex-
pensive. Many inexpensive thimbles and also many of
those which have had much wear are rough. They should
be discarded because they will catch and pull the threads of
the material and often ruin its appearance.

4. **Scissors.**—It is convenient to have both scissors and
shears but not absolutely necessary. If only scissors are
used, however, they should have fairly long blades in order
to cut an even, straight edge. The blades should be kept
sharp and without any catches in their edges. If the blade
has one small place which will not cut, the threads of the
material will be pulled each way several inches and much
damage will be done.

5. **Pins.**—Fine pins, about one inch in length, with sharp
points, are best for general use. If the pins are large they
make holes in the material; if too short they are difficult to
manage. Steel dressmaking pins are excellent, but they
must not be left in the work, as they rust easily and quickly.

6. **Needles.**—Two kinds of needles, one for sewing and
one for basting, are a convenience. The size for sewing
depends, of course, on the material, but for ordinary use
the papers of sevens to nines are best. For basting, mil-
liner's needles, sevens to nines, are satisfactory.

7. **Emery.**—Needles require frequent smoothing, which
necessitates an emery in every sewing equipment.

8. **Tape-Measures.**—Since tape-measures vary greatly in quality and occasionally in length of inch, they should be selected with care. Double measures, numbered on each side, are a necessity. The numbers should begin at opposite ends on the two sides; then either end may be used. The brass clips at the ends are not desirable even in good measures; they soon drop off, the unprotected ends fray, and the first inch is shortened. If there is no brass clip the end is made strong enough to stand wear.

9. **Pincushions.**—Pincushions are made in various styles. Small ones with a tape for attaching to the belt or waist are good. They should be filled with curled hair and covered with material through which the pins slip easily. Wool material, like broadcloth or serge, is excellent. A convenient pincushion is one made in the shape of a crescent, with its points connected by a band long enough to allow the cushion to slip over the hand. When this cushion is worn on the back of the left hand it is always within easy reach. It is especially useful in fitting. If cushions are not used the worker quickly acquires the very bad habit of holding pins in the mouth.

10. **Tracing-Wheels.**—Tracing-wheels must be selected with great care. Even the best cannot be used with all materials; poor ones should always be discarded and no attempt made to use them even by experienced workers. A tracing-wheel is intended merely to mark the surface of the material; yet in many cases, because it is poor or because too much pressure is used, it cuts the threads enough to weaken the material so that when worn it soon breaks or tears.

11. **Tailor's Chalk.**—Tailor's chalk is used in making corrections after fittings and particularly in indicating the line of turning for skirt hems. In many instances it takes the place of the tracing-wheel, where the wheel is not safe or will not show.

12. **Basting-Cotton.**—Regular cotton, white, the size depending on the weight of the material, is best for basting. Basting-cotton, as it is at present made, should not be used; it is generally coarse and uneven and leaves a mark when

pulled out, even if care is taken in cutting the stitches and removing short lengths at a time. Alterations after fitting are marked with colored cotton to distinguish them from the original basting-lines. Red should not be used, as it does not hold its color and light materials are marked by it. Light blue, yellow, and tan are generally safe.

Many materials, such as soft silks and velvets, should be basted with fine sewing-silk and greater care than usual taken when the bastings are removed. Taffeta silks, even a good quality, frequently present as difficult a problem as these others, because not only do they show marks of basting but all pinholes as well. Fine needles for pinning and fine needles and sewing-silk or No. 120 cotton for basting give the best results.

13. **Skirt-Rules and Squares.**—In drafting, a square is indispensable, as it is difficult to strike a true angle with a skirt-rule. All squares are not true, however, and should be tested. If true at first they easily get out of order unless stayed at the corner with a metal brace. This should be remembered when purchasing.

Skirt-rules sixty inches in length are often a great convenience but are not a necessity. They are more expensive and not always so easy to get as the regular yard-sticks.

IV. Preparation of Materials

Most materials need some preparation before being made into wearing-apparel. In general, all wash materials, cottons and linens, need shrinking; all wool materials need sponging.

1. **Shrinking.**—Shrinking includes soaking in water, drying, and usually pressing. With few exceptions all cotton and linen materials should be subjected to this process to remove the sizing which is usually added in the finishing. Practically no linen or cotton materials are sold which have not had some sizing applied; it may be very little, merely to aid in finishing, or it may be a large quantity to conceal a loose weave and poor fibres. In shrinking, the water softens or dissolves the sizing. The threads

of the material, freed from the stiffening which was applied while they were under tension, close up, particularly the filling threads, and the material shrinks. The shrinkage is usually much greater in length than in width.

The shrinking of a material requires a little time and care but is very simple. If the material is placed in the water, folded together in yard lengths as when purchased, it is much easier to manage and wrinkles less. The water should be lukewarm at first; warmer water should be added later and then be allowed to cool. If the material is not wrung in any way, but hung, still in its folds, it will dry without wrinkling and require little or no pressing. The drying may be done in the open air or in a warm room. The more care taken in hanging the material evenly the better condition it will be in and the less pressing it will require. If there are wrinkles, however, they should be pressed out. In doing this the iron should always follow the threads of the material straight across or up and down with the selvage. If, in pressing or hanging, the material has been stretched out of shape, it is almost impossible to place a pattern on it and have the straight or grain of the material run as it should. This straight of material is most important in dressmaking, for if the threads do not run correctly the garment will not fit properly and cannot be laundered satisfactorily.

2. **Sponging**.—Practically all wool fabrics are sponged to prevent water-spotting. They usually shrink slightly in the process. This is an advantage when the material is to be made into garments requiring frequent pressing; less shrinkage then occurs when the pressing is done. Sponging is not difficult to do at home unless there is a great quantity of material. If possible, a table should be used, as the ordinary ironing-board is not large enough to be convenient. The table should be covered with enough material to give a fairly soft, though firm, surface. For the outside cover heavy unbleached muslin is excellent; it is strong and has no lint on its surface. The coverings must be fastened so that they will keep perfectly smooth, as the wrinkles will mar the surface of the material.

In working, the material is placed face down on the iron-ing-table, a wet cloth is laid over it, and a fairly hot iron used. After enough pressing has been done to make the cloth nearly dry it should be removed and the material itself should be pressed. Throughout the pressing care must be taken not to rub the iron along the material in any direction, but in moving to lift it slightly, otherwise the material will follow it and wrinkle. If the material has a nap the pressing must go with the nap. Only a small section of the material should be dampened and ironed at one time, as otherwise sections of it may dry before they can be pressed. If double-width material is to be used it can be left folded, with the right side inside. The wet cloth placed on one side is usually sufficient to steam through both thicknesses of the material unless it is very heavy. Both sides should have a final pressing, however, in order to have the full width of the material thoroughly dry and smooth. Many fabrics are said to be sponged before they are put on sale, but unless this fact can be verified it is wise either to have them sponged at the store or to do it at home. There are few tailors and dressmakers who do not sponge all the materials they use.

3. **Pressing.**—Much of the pressing which is required in the finishing of garments is done in practically the same way as the pressing for sponging.

When possible, all material should be pressed on the wrong side. Frequently the heat and weight of the iron is not sufficient to press the seams and hems in heavy fabrics as flat as is desired. A damp cloth should then be placed over the material while it is pressed. The steam from the cloth moistens the material slightly, and when the cloth is removed and the material pressed dry it will be perfectly flat.

As in sponging, an iron must never be pushed or dragged over material. In many cases the material will follow the iron and become so wrinkled that it is practically impossible to make it smooth even by much subsequent pressing. The iron should be lifted from place to place until the surface to be pressed has been covered.

If, in the process of making any garment, some of the pressing must be done on the right side, the material should be carefully covered so that the iron will not touch it, as it usually leaves a slight polish. Heat will occasionally change the color of a material, more especially silk; for that reason it is wise to test the effect first on a small sample. Generally in this case the use of a cool iron will obviate the difficulty and press the material satisfactorily.

Silk should be pressed as little as possible, as heat takes the life from it; it requires no preliminary sponging or shrinking. To press the necessary seams and hems in silk they should be drawn with as much tension as possible over the surface of a not-too-hot iron. For pressing velvet—except panne and mirror velvet—a special kind of board is used, the surface of which is covered with small, flexible wire points. The pile of the velvet is pressed into these points by the use of an ordinary iron, the wrinkles are removed, and the velvet is made to look like new. Mirror velvet may be made from ordinary velvet by pressing. A damp cloth should be used on the right side of the velvet and the iron should follow the nap.

V. CUTTING

There are several general rules to be observed in cutting. Most materials with a nap must be cut so as to have the nap run down. Ordinary velvet and corduroy are, however, generally exceptions to this rule. If the richest effect possible is desired, the velvet can be made with the pile running up. The objection to this is that as the pile is standing up it catches the dust easily and is difficult to keep clean. Panne velvet should have its pile running down. Many materials which have no nap, such as henrietta and cashmere, show a difference in color if the pattern is not laid on so that the material all runs in one direction. A test for difference in color can easily be made by putting the two cut ends of the material together and holding them up. In that way the top and the bottom of the material

are side by side, and it is easy to determine whether they catch and reflect the light in the same way.

For the inexperienced it is always a good plan to cut all patterns first in inexpensive material, such as cambric, unbleached muslin, or calico, and have them tested and fitted.

In cutting, the two corresponding pieces or sides of any garment should be cut together; that is, two fronts of a shirt-waist or two sleeves, for otherwise two pieces may be cut for the same side. There are occasional exceptions to this, as, for instance, when the amount of material is limited and by cutting the pieces singly they may be more economically placed and material saved, or when the material has a decided up and down, because of nap or pattern, and must be cut separately to look and wear well. It is, in general, more economical if, in placing a pattern for cutting, its wider sections are placed at the cut end of the material. For instance, with a shirt-waist pattern the fronts are usually placed first, with the bottom of the pattern at the cut end of the material. This gives opportunity, if there is no up and down, to slide the second piece of the pattern by the first and so save material. A similar plan may be adopted satisfactorily in cutting skirts.

VI. Marking

In cutting a garment from any pattern the garment should be carefully marked, wherever necessary, with a tracing-wheel, tailor's chalk, or tailor basting. The lines to be marked depend, of course, on the kind of garment. Seam-lines should always be indicated as a guide in basting for fitting, and such lines as the neck, armseye, waist, hip, and hem, which are needed not only for a guide in basting but for the actual making.

(1) *The Tracing-Wheel* will mark two thicknesses at once and is, for that reason, especially convenient. It cannot, however, be used on all materials. For instance, in soft fabrics and those with fancy surfaces the markings will not show.

(2) *Tailor's chalk* marks only one surface at a time, and there is always danger of its being erased during the basting, etc.

(3) *Tailor basting* is in general a most satisfactory method of marking. It may be done through two thicknesses; it stays in place as long as it is needed and does not injure any material. It requires, however, more time than either of the two other ways. When the cutting is done the seamlines are frequently marked with tailor's chalk, which serves as a guide for the tailor basting. In making this basting a long double thread is needed. The sewing is done through both thicknesses, using first a short, then a long stitch. The thread is not pulled through tightly, as in the regular basting, but each long stitch is loose enough to form a loop. After the basting is finished the two pieces of material are carefully pulled apart as far as the loops will allow, and the stitches which hold them together are cut between the two layers of material. If this is correctly done there will be stitches enough on each piece of material to indicate the line perfectly.

VII. FITTING

Generally only one side—the right—is fitted, either for waist or skirt, and the other side is altered to correspond. There are exceptions to this as to every rule. If, for instance, the right shoulder or hip differs greatly from the left it may be necessary to fit the entire garment. The alterations should not be so great, however, as to accentuate the differences in the two sides.

VIII. TAKING MEASURES

The taking of measures is a very important preliminary to dressmaking—for drafting, for modelling, or for the use of commercial patterns. Individual measures are necessary in constructing the drafts and in modelling. They are also necessary in testing the commercial patterns, which are all made to regulation measures and may need slight adjusting. Measures must be accurate, otherwise all the

patterns will be wrong, and, as they are rather difficult to take because of the varying outline of the figure, it is necessary to prove them by repetition. Much subsequent time and labor are saved in the testing and fitting of patterns if this is done. Measures should always be taken over the dress. Before taking the measures a band or tape should be closely pinned about the waist at the normal waist line. The tape should be a very little lower in front than in the back to give a good line. All the lengthwise waist measures are taken to the lower edge of this tape, which is resting on the waist line.

In taking measures a regular order should be maintained and a record of the measures kept in a book. It is usual to take (*a*) the waist measure first, then (*b*) the sleeve and (*c*) the skirt. In measuring, as in fitting, all the work should be done on the right side.

I. *Waist Measures*

(A) *Length Measures*

(1) *Length of Back.*—This is taken from the little bone at the base of the neck straight down to the lower edge of the waistband.

(2) *Length of Front.*—This is taken from the centre of the hollow at the base of the neck straight down to the lower edge of the waistband—an easy—that is, fairly loose—measure.

(3) *Depth of Dart.*—This measure is required in all the fitted garments but is not used in the shirt-waist. It is taken from the base of the neck at the centre front in a slanting line down to the point of the bust. It averages 8 to 9 inches.

(4) *Length of Underarm.*—It is very easy to have this measure too long or too short. One simple way of preventing this is to fold the tape-measure over a fairly long lead-pencil, which is then placed under the arm. The number of inches from the top of the pencil to the lower edge of the waistband in a straight line will give the correct measure. In taking this measure the shoulder must be kept in a natural position and the arm held down close to the figure. The tendency is to raise both shoulder and arm. In the normal figure the height of underarm equals one-half the length of back. In shirt-waist drafting this measure—one-half the length of back—may be used with safety, as the armseye is always made large.

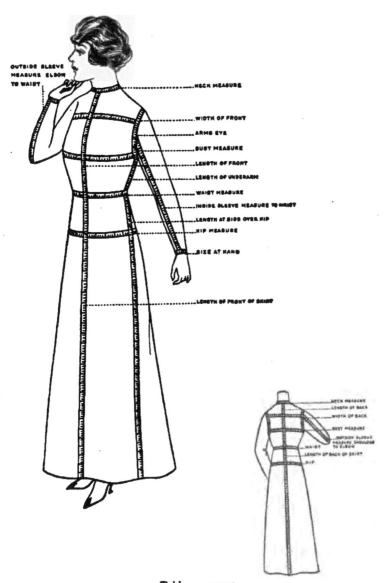

OUTSIDE SLEEVE
MEASURE ELBOW
TO WAIST

NECK MEASURE

WIDTH OF FRONT

ARMS EYE

BUST MEASURE

LENGTH OF FRONT

LENGTH OF UNDERARM

WAIST MEASURE

INSIDE SLEEVE MEASURE TO WRIST

LENGTH AT SIDE OVER HIP

HIP MEASURE

SIZE AT HAND

LENGTH OF FRONT OF SKIRT

NECK MEASURE
LENGTH OF BACK
WIDTH OF BACK
BUST MEASURE
OUTSIDE SLEEVE
MEASURE SHOULDER
TO ELBOW
WAIST
LENGTH OF BACK OF SKIRT
HIP

Taking measures

(B) Width Measures

(1) *Width of Back.*—This is taken one-quarter of the distance down, between the neck and waist, across the back from armseye to armseye. It is an important measure, especially in the drafting, as other measures are based on it. It must be neither too wide nor too narrow. On its correctness depends the fit of the entire waist. It is difficult to take, as the armseye line is rather intangible. No dependence can be placed on that line in the waist worn when the measure is taken, as armseyes vary greatly in shape and size. A tape placed around the armseye may assist in determining it accurately. This should extend in a fairly straight line from the top of the shoulder down and under the arm. Another method of determining the armseye is to place the thumb close up under the arm and let the fingers extend upward and mark the armseye line.

(2) *Width of Front.*—This is taken 1½″ or 2″ below the hollow at the base of the neck, across the widest part of the chest, from armseye to armseye. This measure should not be too wide; it may also be guided by the tape around the armseye.

(3) *Bust.*—In taking this measure it is necessary to stand behind the person who is being measured. It should be an easy measure over the fullest part of the bust, rather high under the arms and straight across the back. For a very thin person it is often wise to add an extra inch.

(4) *Waist.*—This measure may be taken along practically the same line as that used for guiding the length measures. It should, however, be a perfectly straight line, without any drop at the front, and a close measure. It will do for both waist and skirt.

(C) Neck or Collar Measures

Five measures should be taken:

(1) *Base of Neck.*—This should be a close measure, as it is used both for the neck of the waist and for the bottom line of the collar. If there is too large an opening at the neck of a waist it is almost impossible to adjust a good collar. If the neck is small it can easily be cut out.

(2) *Top of Neck.*—This should be a close measure.

(3) *Height at Back.*—This is taken from above the bone at the base of the neck to the height required.

(4) *Height at Front.*—This is taken from the hollow at the base of the neck to the height required.

(5) *Height at Side.*—This is taken just back of the ear. It is measured from the base of the neck to the height required. It should not be more than ¼″ or ⅜″ higher than the back.

(D) *Armseye*

This is taken at the joining of the arm and body, under the arm and up over the shoulder-bone, making a good curve in front and an almost straight line at the back. This also should be a fairly close measure.

II. *Sleeve Measures*

Four measures should be taken:

(1) *Length Inside.*—This is taken along the inside of the arm, from the little muscle where the arm joins the body to the bend of the elbow, and to the wrist at the base of the thumb.

(2) *Length Outside.*—Shoulder to elbow; elbow to wrist. This is taken along the outside of the arm from the place where the width-of-back measure ended to the point of the elbow (with the elbow bent so that the hand will rest on the chest); from that same point to the wrist ending just beyond the bone at the wrist.

(3) *Size at Elbow.*—The tape-measure is placed in the bend of the elbow; the elbow is then bent and the measure taken rather closely over the point.

(4) *Size at Hand.*—This measure is taken very closely over the knuckles with the thumb held in to the palm and should be the smallest through which the hand can be passed.

III. *Skirt Measures*

(1) *Waist.*—This measure has already been taken.

(2) *Hip.*—Two hip measures are necessary; the first is taken over the fullest part of the hip, usually about 6″ below the waist; the other is taken over the fullest part of the thigh, about 10″ below the waist. These two should be parallel. The second measure is chiefly used in testing the patterns and is usually from 4″ to 6″ larger than that taken at the 6″ point. The tape-measure should be placed about the hips and the thigh in a perfectly straight line, parallel to the floor, and free measures taken.

(3) *First Depth of Dart.*—This is taken from the waist line to the first hip line, directly over the hip.

(4) *Second Depth of Dart.*—This is taken from the waist line to the second hip line, directly over the hip.

(5) *Length of Front.*—This is taken from the waist line to the floor, exactly at the centre front.

(6) *Length of Side.*—This is taken from the waist line to the floor over the hip.

(7) *Length of Back.*—This is taken from the waist line to the floor, exactly at the centre back.

It is most important to take the last three measures to the floor, no matter what the desired finished length of the skirt may be, and to have the tape-measure fall in a perfectly straight line.

In order to simplify the work in dressmaking, which is given in the succeeding chapters, a definite division has been made between the *making of patterns* and the *making of garments*.

In Chapters V, VI, and VII all the effort is directed toward securing satisfactory patterns—satisfactory not only from the point of view of fit but, as far as possible, from that of design as well. The work deals not only with the various methods of making the patterns but also with their perfecting by fitting, testing, and altering. It includes directions for the drafting of patterns to individual measures and their fitting, the testing and altering of commercial patterns, and, based on experience in these first two methods and aided by a knowledge of design, the making of more elaborate patterns in paper and on the dress-form.

In Chapters VIII, IX, and X all the work is directed toward the making of the dress itself. Because of the limitless variety of design and finish possible in the making of a garment and the constant change demanded by fashion, it is possible to give in this section only general rules, which must be adapted by the worker to the requirements of specific problems as they present themselves from time to time. The work deals with the various steps involved in the method of procedure: that is, the cutting, which includes the correct placing of the pattern on the material and the various methods of tracing and marking the material; the basting; the fitting, which includes altering and rebasting; and the general finishings, which include the foundation embroidery stitches.

As has already been said, in making any garment time

and effort should be saved as far as possible. To do this, before beginning work all required materials and tools should be collected and conveniently placed and a general method of procedure decided upon. In order to secure satisfactory results the work must be carefully planned and the plan followed step by step, with no details omitted. "Short cuts" should be avoided by all except the experienced.

CHAPTER V

DRAFTING AND PATTERN-MAKING

The drafting system presented here has two marked advantages: the lack of expense connected with its use and the simplicity of its method. Both must be considered in teaching, especially in public schools.

Many systems include a large number of complicated measures and numerous directions, most of which are arbitrary and consequently must be largely a question of memory. In addition, there are various expensive charts, curves, squares, etc., required. In this system few measures are taken, and the attempt is made to show, as far as possible, not only a definite reason for the directions given but their relation to the proportions of the figure for which the pattern is to be made. There is but little memorizing, and all the tools necessary are a square, a tape-measure, drafting-paper, a soft pencil, and a good eraser.

The garments drafted include:

 I. Shirt-Waist.
 II. Shirt-Waist Sleeve.
 III. Foundation Skirt.
 IV. Tight-Fitting Waist and Collar.
 V. Tight-Fitting Sleeve.
 VI. Kimono Waist.

The same general construction lines form the basis for the shirt-waist, tight-fitting-waist, and kimono-waist patterns. As these are intended for foundation patterns from which any desired style may be developed, no marked changes in the drafting directions need be made to meet a change in fashion. The construction lines of the skirt pattern are based on the hip measures of the wearer and the width desired at the bottom of the skirt. By changing the second measure—that of the width of the skirt—according

to the demand of fashion the pattern may be given any desired amount of fulness without changing the general method of its construction.

Like all drafting systems and all commercial patterns, this drafting system is not infallible. It will not fit unless the measures are accurately taken and the directions carefully followed, and even with care it may not always suit the unusual figure. Directions for possible changes are included which, it is hoped, will help to solve some difficulties.

The practicability of drafting is sometimes questioned. As a basis for pattern-making and dress-designing, however, it is invaluable to the student. It is seldom used by dressmakers, except to acquire a set of foundation patterns of regular measurements, with good proportions and good lines, from which other patterns of varying measures are made as required. The designers in good dressmaking establishments have usually already acquired so much skill by experience that they do not need more of the preliminary drill which drafting gives. Many students and teachers sew well but they have little opportunity to become skilled through practice in the designing which is the important factor in all good dressmaking. The appreciation for good line and proportion which is given by drafting and the subsequent pattern-making would seldom if ever be acquired by them in using patterns made by others which would require no thought on their part. The ability to make any desired pattern gives an independence which is invaluable and usually arouses greater interest and enthusiasm in the worker than does the use of a ready-made pattern.

For beginners it is always wise to draft to regulation measures first, as it gives practice without any of the complications which may arise when individual measures are used. Regulation measures are given with each draft. All the drafts illustrated in this book are worked out according to regulation measures and, except those for the skirt and kimono waist, to a one-quarter-inch scale. The size of these necessitates the use of a one-eighth-inch scale.

The shirt-waist is generally given as the first problem in drafting because it is simple and because, whether cut from a commercial pattern or a draft, it is most often the first garment made. In making a dress, however, the logical procedure seems to be to cut the skirt first, if both the skirt and the waist are to be made from the same piece of material, as the skirt usually requires uncut lengths while a waist may often be made from pieces. There is no law governing the order of drafting, and, as each draft is a complete problem in itself, the order of procedure may safely be decided by the worker with reference to her dressmaking course as a whole.

I. Shirt-Waist

I. Drafting the Pattern

REGULATION MEASURES

Length Measures—
 (1) Length of back............................15″
 (2) Length of front...........................15½″
 (3) Length of underarm.......................7½″

Width Measures—
 (1) Width of back............................14″
 (2) Width of chest...........................14½″
 (3) Bust....................................38″
 (4) Waist...................................26″
 (5) Neck....................................13½″
 (6) Armseye ⎫ (test measures) ⎧..............16″
 (7) Shoulder ⎭ ⎩...............5¾″

Individual measures are taken as described in the preceding chapter.

The shirt-waist pattern is composed of two pieces, one half the back and one half the front. These may both be made, side by side, on one sheet of drafting-paper about 36″ in length. The back is drafted first.

BACK

In the upper left-hand corner of the paper two lines at right angles and of indefinite length should be drawn. The work then proceeds as follows:

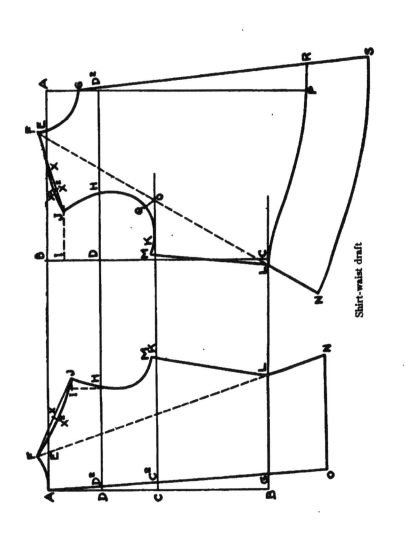

Shirt-waist draft

(1) *To Determine the Foundation Lines:*

AB = Length of back, marked on the vertical line.

B = Draw a line at right angles to the line AB to indicate the waist line.

AC = ½ of the line AB. Draw a line at right angles to the line AB to indicate the bust line.

AD = ½ of the line AC. Draw a line at right angles to the line AB to indicate the width of back line.

(2) *To Determine the Neck Line:*

AE = ⅙ of the neck measure, marked on the horizontal line from point A.

EF = ¾″ above point E, a dotted line drawn at right angles to the line AE.

AF = Connect these points with a curve to form the neck line.

(3) *To Determine the Centre Back Line:*

BG = 1″ measured in on the waist line B.

AG = New centre back line. Connect the points A and G and extend the line indefinitely (about 5″).

On this line mark the points of intersection at point D and point C as D^2C^2 and use these points in measuring all widths.

(4) *To Determine the Shoulder Line:*

D^2H = ½ the width of back.

HI = AE, which is ⅙ of the neck measure, a dotted line drawn at right angles to the line D^2H at point H.

IJ = ⅜″ to the right from point I, a dotted line drawn at right angles to the line HI.

FJ = Connect these points to form the shoulder line.

(5) *To Determine the Underarm Seam:*

C^2K = ¼ of the bust measure, minus 1″.

GL = ¼ of the waist measure.

LM = Underarm measure, plus ½″, drawn from point L through point K. The end of this line is marked point M.

(6) *To Determine the Armseye:*

JHM = Connect these points with a good curve to form the armseye.

(7) *To Determine the Basque:*

LN = 4″ measured down from point L with the ruler placed on points FLN.

GO = 4″ measured down from point G on the indefinite line already drawn through points AG.

NO = Connecting line to form the bottom of the waist.

(8) *To Determine the Curve of the Shoulder Seam:*

FX = ½ of the line FJ, the shoulder line.

XX² = ¼″ down from point X, a dotted line drawn at right angles to the line FJ.

FX²J = Connect these points with a slightly curved line to form the shoulder.

FRONT

Extend the line A of the back of the waist across the sheet and draw a line at right angles to it in the upper right-hand corner. The work then proceeds as follows:

(1) *To Determine the Foundation Lines:*

AB = Amount secured by deducting C²K, the bust measure of the back, from one-half the whole bust measure and adding 1″ to the result, marked on the horizontal line from point A.

BC = Length of back, drawn at right angles to the line BA.

BD = ¼ of the line BC.

AD² = BD. Connect points DD². This line is a continuation of the width of back line DH.

(2) *To Determine the Neck Line:*

AE = ⅕ the neck measure plus ⅜″, marked on the horizontal line AB.

EF = ½″ above point E, a dotted line drawn at right angles to the line AB.

AG = ⅙ the neck measure, marked on the vertical line from point A.

FG = Connect these points with a curve to form the neck line.

(3) *To Determine the Width of Chest:*

D²H = ½ the width of chest on the line D²D.

(4) *To Determine the Shoulder Line:*

BI = ⅓ of the line BD.

I = Dotted line of indefinite length drawn at right angles to the line BD. This serves as a construction line for the shoulder.

FJ = Shoulder line, which should be ¼″ shorter than the shoulder line of the back. The square is

placed on point F and swung until the desired
length of shoulder touches the line I. This es-
tablishes point J.

(5) *To Determine the Underarm Seam:*

 K = ¼″ to the right of the vertical line BC on the ex-
tension of the bust line C of the back of the waist.

 CL = ¼″ to the left of the vertical line BC on the ex-
tension of the waist line B of the back of the
waist.

 LM = Underarm measure plus ½″, drawn from point
L through point K. The end of this line is
marked point M.

(6) *To Determine the Armseye:*

 FLN = Connect points FL with a straight dotted line
and continue it 4″. The end of this line is
marked point N.

 O = At the point of intersection of the line FL with the
extension of the bust line C of the back of the
waist mark point O.

 GP = Length of front measured down from point G on
the centre front line A.

 POQ = ¾″ measured up from point O with the ruler
placed on points POQ.

 JHQM = Connect these points with a good curve to form
the armseye.

(7) *To Determine the Waist Line:*

 PR = 1¾″ out from point P, a dotted line drawn at
right angles to the line GP.

 LPR = Connect these points with a slightly curved line
to form the waist line.

(8) *To Determine the Centre Front Line:*

 GRS = Connect points GR with a straight line and con-
tinue it 4″. The end of this line is marked
point S.

(9) *To Determine the Basque:*

 NS = Connect these points with a slightly curved line
to form the bottom of the waist.

(10) *To Determine the Curve of the Shoulder Seam:*

 FX = ½ of the line FJ, the shoulder line.

 XX^2 = ½ of the line XJ.

 X^2X^3 = ⅛″ up from point X^2, a dotted line drawn at
right angles to the line JF.

JX^2X = Connect these points with a slightly curved line
to form the shoulder.

XF = Remains unchanged.

This draft gives a foundation or plain shirt-waist with but little fulness at the waist line.

II. *Fitting the Pattern*

After the drafting is finished there are certain directions to be followed preliminary to the cutting of patterns in material for fitting.

(1) *Testing the Draft.*—The draft itself should be carefully tested to the measures used and, if necessary, corrected.

(a) The length of back must be exact and the width of back and the bust lines in proper position.

(b) The length of the underarm should equal the underarm measure plus ½″.

(c) The size of the bust—that is, the sum of C^2K, the bust line of the back, and AB, the amount of the bust measure used for the front—should equal one-half the whole bust measure plus 1″.

(d) The width of back and the width of chest must correspond to the measures taken. These should be measured for both front and back on the line D^2H.

(e) It is important to measure the neck of the front and back carefully. In measuring any curved lines the tape-measure should be held upright; that is, on edge, with the numbered edge on the paper.

If any of these measures vary much from the required size there has, without doubt, been a mistake in following the drafting directions. In this case the pattern should be redrafted and the mistake rectified before proceeding with the work.

(2) *Seam Allowances for a Paper Pattern.*—In general, it is simpler to use a paper pattern which is cut out exactly along the drafted lines than one which has the necessary allowances added to it for all seams. For the use of the inexperienced, or for those who have become accustomed to commercial patterns which have seam allowances, it is sometimes thought necessary to add the allowances to the drafted pattern before cutting it out. This should be avoided when possible, as it really complicates the use of the pattern and adds to the difficulty of the student. Without indicated seam allowances a garment is occasionally cut exactly the size of the pattern, without any thought on the part of the worker of the necessity for seams, and the garment is, in consequence, spoiled.

The required seam allowances for a paper pattern are as follows: $1''$ at underarm and shoulder seams; $\frac{1}{4}''$ at the neck and armseye.

(3) *Marking the Paper Pattern.*—After the paper pattern is cut out, if the seam allowances have been added to it, it is wise to trace with a wheel the exact seam-lines for the shoulder, underarm, neck, and armseye, as these lines are very important in all the subsequent work on the waist, and the pencil-marks indicating them on the draft may be erased. In addition, the waist line should be carefully traced and cross-marks made at X^2 of the back shoulder and X of the front. If, as is general, the paper pattern has been cut out exactly along the seam-lines, the only tracing necessary is that for the waist line and the cross-marks of the shoulder.

(4) *Placing the Paper Pattern on the Material and Cutting.*—Economy of material should always be considered in placing a pattern. The complete shirt-waist must be cut in order to give a satisfactory fitting. Half the pattern does not give sufficiently exact results. When possible, all pieces of the pattern should be cut at the same time, with corresponding ones together. This saves confusion and duplication of pieces. The centre-front line of the front of the waist must be on a lengthwise straight of the material and the centre-back line of the back on a lengthwise fold. In cutting this pattern, in general, the economical method is to place the bottom of the shirt-waist fronts to the cut end of the material. This brings the smaller or top part of the pattern into the body of the material and gives extra space for the placing of the back.

After the pattern is arranged with attention to the straight of the material the seam allowances should be measured and the pattern pinned in place and cut.

The seam allowances for the cloth pattern are the same as those already suggested for the paper; that is, $1''$ at underarm and shoulder seams and $\frac{1}{4}''$ at neck and armseye. In addition, however, there should be $1''$ added at each centre front in order to pin the waist together in the fitting.

(5) *Marking the Cloth Pattern.*—The cloth pattern should be marked to indicate the exact size of the pattern as drafted, to give the correct seam-lines. A tracing-wheel may be used, supplemented where necessary by colored bastings. A tracing should be made to indicate: (*a*) the centre-front line, for pinning the waist together; (*b*) the seams and cross-marks of the shoulder and underarm, where the waist is to be joined by basting; (*c*) the neck line; (*d*) the armseye line; (*e*) the waist line; (*f*) the centre-back line.

In addition to these tracings colored bastings should be placed in the centre-front and centre-back lines, the waist, neck, and arms-

eye lines. They prevent the loss of these important lines during work, as the marks of the tracing-wheel are not permanent; they also aid in indicating the direction of the neck and armseye very distinctly during the fitting. The position of these lines is especially important, as they determine the location of the sleeve and the collar-band.

(6) *Basting the Pattern.*—All seams should be basted with white thread and not with colored, which is used only in making alterations and in marking. Seams should be pinned together before basting.

(a) For the underarm seam the waist and armseye lines are matched and both the pinning and basting are done between these two points and continued 1″ below the waist line.

(b) For the shoulder seam, the neck lines, the cross-marks at X² of the back and X of the front, and the armseye lines are matched and pinned. As the front shoulder seam is ¼″ shorter than the back, it requires stretching between these points to give it sufficient length. After it is stretched it should be basted, holding the back shoulder toward the worker. The stretching of the front shoulder along the seam-line makes the waist spring better into the curve of the shoulder of the wearer.

(7) *Fitting the Pattern.*—Before the waist is ready for a fitting some further preparation is necessary.

(a) *Making a Belt.*—For this, non-elastic tape ¼″ in width may be used or a band of the material itself. The material should be cut about 2″ in width and 2″ or 3″ longer than the waist measure to allow for lapping and pinning at the centre front. On the two lengthwise edges and across the two ends ¼″ should be turned in and creased. When the piece is folded lengthwise in the centre it makes a band about ¼″ wide and the desired length. As a guide in attaching to the waist, the centre of the band should be marked with colored basting.

(b) *Gathering the Waist.*—As the pattern is drafted to have extra fulness at the waist line in the back, one row of gathering should be put in at the waist line from underarm seam to underarm seam. This makes the arrangement of the fulness into the belt a very simple matter in the fitting.

The fulness at the front may also be gathered into the belt if desired. If it is left free, however, the laundering of the waist will be much simpler.

(c) *Fitting the Waist.*—For the first fitting the waist is put on right side out and only one side, the right, is fitted, unless the right and left sides of the wearer vary greatly. In this case time is saved by fitting the entire waist at once.

The waist should first be settled to the figure and pinned at the centre front exactly on the indicated lines. The shoulder and underarm seams should be turned to the front. The belt is then put on with its lower edge just at the normal waist line of the figure, even though the line of gathering in the waist may not be correctly placed. The centre mark of the belt should be placed exactly at the centre-back line of the waist and pinned. The fulness is regulated after the direction of the underarm seam is determined. This seam should appear to be a continuation of the shoulder seam and should fall from the centre underarm straight down to the waist. If the back of the wearer is very wide its appearance is sometimes improved by having these seams slant very slightly toward the back. After the belt is pinned to the underarm seam the fulness may be arranged to suit the figure. It is usually a good plan to distribute the gathers across the back to within about 2″ of the underarm seams, to avoid an evidence of much fulness. If the waist is bloused slightly it gives a straighter and more becoming line to the back.

In fitting the waist it is important to observe the following:

(*i*) In general the collar line should run from the bone at the base of the neck in the back in a good line or curve to the hollow in front, just above the two small bones. The line should be rather high at the side, just under the ear. The shape of the neck or it's length may affect this line slightly; that is, for a long neck the line should be as high as possible in front and for a short neck low. If the neck is too high or too tight it may be improved by slashing a little. The shoulder seam should be taken up if the neck is too large.

(*ii*) The draft, like the commercial pattern, is made for the shoulder of regulation height; in consequence, if the shoulders of the wearer are very square or very sloping changes are required.

If the shoulders are square they lift the waist too much at the point or end of the shoulder and there will be a wrinkle running across the waist. This should be remedied by taking up the shoulder seam near the neck and cutting out the surplus material, which is thus brought up around the neck. If the shoulders are very sloping the waist drops at the end of the shoulder and the wrinkle will extend downward from the neck toward the armseye. To change this the shoulder seam is taken up at the point of the shoulder, and the armseye cut out at the underarm seam. (For further details, see *The Use of Commercial Patterns.*)

(*iii*) After such changes have been made care must be taken to re-establish a good neck line and shoulder seam. The direction of the

neck line has already been given. The shoulder seam should be about 1″ back of the highest part of the shoulder and, as has been said, in line with the underarm seam. If this seam is too far back it gives a narrow appearance to the back of the waist. If, on the other hand, it is too far front it may give the appearance of round shoulders.

(*iv*) The armseye line is one of the most important in the waist. It should extend from the point of the shoulder down over the little muscle where the arm joins the body in front and, coming up as high under the arm as is perfectly comfortable, form a nearly straight line up the back to the shoulder.

(*v*) If the waist is too tight over the bust it may be made a little larger by letting out the underarm seam. Too much cannot be let out, however, or the armseye will be too large. Difficulty of this kind usually means that too small a bust measure was taken.

(*vi*) A shirt-waist should not be overfitted. There should not be any wrinkles at the neck or shoulder; the seam-lines should be good and the waist should fit well but loosely. Before the waist is taken off it should be carefully inspected as a whole and all the necessary changes indicated by pins, tailor's chalk, or pencil.

(8) *Altering the Pattern.*—After removing the waist all required changes should be marked on the side just fitted, with the tracing-wheel or with colored cotton. Care should be taken to keep the original lines sufficiently distinct to have them serve as guides in marking the unfitted half of the waist. All the seams should then be opened and the two sides of the waist placed together with the original lines matching. They should be pinned and correspondingly marked.

If a new neck, armseye, or waist line has been made, colored cotton should be used to indicate it. The tracing-wheel may be used for changing the seam-lines, unless they can be too easily confused with the old tracings and rebasting made difficult. All changes should be indicated on the paper pattern, which is to be kept for future use.

(9) *Rebasting the Pattern.*—If many and important alterations have been necessary the waist should be rebasted, following all the directions given for the first basting; the belt should be attached and the whole should be put on for final inspection.

(10) *Refitting the Pattern.*—In refitting, the waist should again be put on right side out. The underarm and shoulder seams should be turned to the front. If the left side requires any changes because of the unevenness of the figure they should be made now and the waist again generally inspected for fit and for seam-line.

(*a*) If the shirt-waist sleeve has been drafted and cut in material it may be basted into the waist and fitted at this time. (For directions, see *Shirt-Waist Sleeve*.) (*b*) A collar-band may also be made, basted to the waist, and fitted. This is a good plan for tailored shirts which require a neck-band. It need be only a straight band, unless the neck is much smaller at the top than at its base. (*i*) To prepare this, a strip is cut on the lengthwise of the material 2″ in width and the size of the neck plus 1″ in length. On the two lengthwise edges ¼″ should be turned in and creased and on each end ½″. When the piece is folded lengthwise in the centre it makes a band ¾″ wide and the correct length to meet at the centre front without lapping. As a guide in attaching to the waist, the centre of the band should be marked with colored basting. (*ii*) The neck of the waist may be slipped into it, pinned evenly, and basted. The lower edge of the band should lie along the line of basting which indicates the correct neck line. If the worker is inexperienced this band will help to keep the neck of the waist from stretching while it is being handled.

II. SHIRT-WAIST SLEEVE

I. Drafting the Pattern

REGULATION MEASURES

(1) Armseye....................................16″
(2) Length inside............................18½″
(3) Girth of arm.............................11″
 (Taken over the muscle of the upper arm,
 with the arm bent.)
(4) Size at hand.............................7½″

Individual measures are taken as described in the preceding chapter.

The shirt-waist sleeve pattern is composed of only one piece. To make the pattern in one piece it is necessary to have the lengthwise centre of the sleeve drafted on a fold of paper. If a piece of paper 27″ in length and 24″ in width is folded along its lengthwise centre it will be large enough for any pattern.

After folding the paper the work proceeds as follows:

(1) *To Determine the Top of the Sleeve:*

UPPER

A = 8″ down from the top of the paper. Locate this
 point on the folded edge.

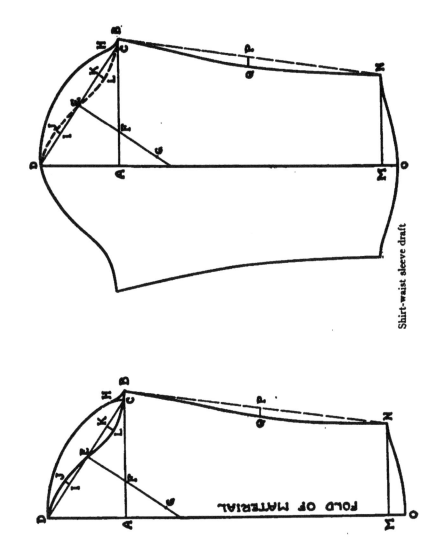

FOLD OF MATERIAL

Shirt-waist sleeve draft

AB = ½ the required width of the sleeve; that is, the girth of the arm plus the fulness desired. Draw a line at right angles to the folded edge at point A.

BC = ½″ measured in from point B on the line BA.

AD = ¼ of the armseye measure plus ¾″, measured up from point A on the folded edge.

DC = Connect these points with a straight line.

DE = ½ of the line DC.

F = From point E, at right angles to the line DC, draw a line extending to the folded edge of the paper. At the point of intersection of this line and the line AB place point F.

FG = 3″ below point F on the extension of the line EF mark point G. If point G does not fall on the paper the point of intersection of the line EF and the folded edge of the paper may be used instead.

DC = With point G as a pivot and the distance from point G to point D as a radius, swing a curve from point D to point C.

H = Measure up 1″ from point C on this curve and place point H.

HB = Connect points H and B with a slight inward curve.

DHB = Curve for the upper part of the top of the sleeve.

<div align="center">UNDER</div>

DI = ½ of the line DE.

IJ = ¼″ above point I, a dotted line drawn at right angles to the line DE.

EK = ½ of the line EC.

KL = ½″ below point K, a dotted line drawn at right angles to the line EC.

DEB = Curve for the under part of the top of the sleeve. Connect with a curved line points DJELC and continue to point B on the straight construction line.

(2) *To Determine the Bottom of the Sleeve:*

This is the same for the upper and the under parts of the sleeve.

AM = The inside length of the sleeve minus the width of the cuff, measured down from point A on the folded edge of the paper.

MN = ½ the length of the cuff plus 1″, or the desired amount of fulness, drawn from point M at right angles to the line AM.

MQ = 1″ measured down from point M on the folded edge of the paper.

NO = Bottom of the sleeve. Connect these points with a curved line, starting at point N and making the line nearly straight for 1″.

(3) *To Determine the Side Seam:*

This is the same for the upper and under parts of the sleeve.

BN = Connect these points with a straight dotted line.

BP = ½ of the line BN.

PQ = ½″ in, to the left of point P, a dotted line drawn at right angles to the line BN.

BQN = Connect these points with a curved line to form the side seam.

This draft gives a plain shirt-waist sleeve with little fulness.

II. *Fitting the Pattern*

After the drafting is finished there are certain directions to be followed preliminary to the cutting of patterns in material for fitting.

(1) *Testing the Draft.*—The draft itself should be tested to the measures used for (*a*) length of sleeve and (*b*) widths and all necessary corrections made.

(2) *Seam Allowances for a Paper Pattern.*—In general it is much simpler to use a paper pattern which is cut out exactly along the drafted lines than one which has the necessary allowances added to it for all seams. If it is thought necessary to add them, however, they should be as follows: 1″ on the lengthwise seams; ¼″ at the top; ¼″ at the bottom.

(3) *Marking the Paper Pattern.*—Before the paper pattern is cut out some tracing is necessary to make the complete sleeve.

(*a*) With the paper still folded as for drafting, the underarm curve, DJELC, the line at the bottom, ON, and the side-seam line, BN, should all be traced through to the under half of the paper. When the paper is opened the complete outline of the sleeve is indicated and the pattern may be cut out. (*b*) Marks should also be made to indicate the points between which gatherings are to be placed at the top and bottom of the sleeve to regulate the fulness. (*i*) For the top J and H indicate the points between which gatherings are required. (*ii*) For the bottom the position of the

placket should first be marked. This is 1ʺ in from the folded edge
on the under side of the sleeve, point R. From this point the
gatherings are made around the entire bottom of the sleeve.

(4) *Placing the Paper Pattern on the Material and Cutting.*—
Economy of material should always be considered in placing a
pattern. When possible the two sleeves should be cut at once.
For a pattern, however, only one sleeve is necessary.

The centre line of the sleeve indicated by the fold of the pattern
should be placed on the lengthwise straight of the material.

The seam allowances necessary for fitting should be measured
and the pattern pinned in place and cut.

The allowances for the cloth pattern are the same as those al-
ready suggested for the paper; that is, 1ʺ on the lengthwise seams;
¼ʺ at top; ¼ʺ at bottom.

(5) *Marking the Cloth Pattern.*—The cloth pattern should be
marked to indicate the exact size of the pattern as drafted, to give
the correct seam-lines. A tracing-wheel may be used. The entire
sleeve should be traced and the location of the placket and the
marks for the gathering at the top should be indicated.

(6) *Basting the Pattern.*—The sleeve should be laid on a table
and folded along its centre line. If it is correctly drafted its trac-
ings match. They should be pinned together and basted, begin-
ning at the wrist. The basting should be done with white thread
and the stitches need not be short, as there is no strain.

(7) *Fitting the Pattern.*—Before the sleeve is fitted it should be
gathered at the top and bottom and basted into the waist, as its
general fit and hang cannot be otherwise determined. It is not
necessary to add a cuff; the bottom of the sleeve may be drawn
up to the required size and the gathering-thread held by a pin
during the fitting.

(a) *Gathering the Sleeve.*—The first row of gathering at the top
should be ¼ʺ in from the edge, which is also the line of basting.
The other should be ⅛ʺ in from that, to hold the gathers in place.

(b) *Pinning and Basting the Sleeve to the Waist.*—In pinning and
basting a sleeve to a waist the position of the work is important.
The following rule may be observed for placing the sleeve in the
correct position in the waist. Using a point 1ʺ back of the shoul-
der seam, the armseye of the waist should be folded in half and the
opposite point marked. This point indicates the location of the
sleeve seam. The sleeve is then ready to be pinned in and basted.
In doing this: (i) The waist should be held with the wrong side and
the underarm toward the worker. (ii) The sleeve should be drawn
up into the armseye and the seam pinned to the point indicated.

(*iii*) The ungathered or underarm part of the sleeve should be pinned to the underarm of the waist, matching the armseye tracings of the waist and the sleeve. (*iv*) With the waist still toward the worker, the gathering-threads should be drawn up around the upper part of the sleeve until the sleeve fits the armseye. (*v*) With the waist still in the same position, but with the shoulder turned back so that the upper part of the sleeve can be more easily seen, the gathers should be adjusted. (*vi*) The centre of the sleeve and the largest amount of the fulness should fall over the shoulder-bone, which in most cases is from ¾″ to 1½″ forward of the shoulder seam. (*vii*) The rest of the fulness should be eased off to the front and back toward the points which indicate the end of the gathering.

(*c*) *Fitting the Sleeve.*—The fit of the sleeve depends somewhat on the position of the line of the armseye at the shoulder. This changes as the shoulder of the waist is long or short, according to the demands of fashion. If the shoulder is short more length may be required from point A to point D. The curve from point D to point C may be too full in proportion to the length from point D to point A and cause a bulge in the sleeve just in front of the shoulder.

The sleeve should be put on right side out, with the armseye seam turned up on the shoulder. (*i*) The straight thread of the material should fall in a straight line down the arm from the bone in the shoulder. If the fulness is not so arranged as to do this the location of the gathers should be changed. (*ii*) If the sleeve is too large or too small it should be changed on the lengthwise seam. Shirt-waist sleeves should not be too tight. (*iii*) The length should be observed; there should be enough extra length over the elbow to prevent the sleeve's pulling up at the back and away from the wrist when the elbow is bent.

(8) *Altering the Pattern.*—After the fitting and before removing the sleeve from the waist it should be so marked that it may be put in again without difficulty, with the proper arrangement of fulness. When the sleeve is taken out and the seam opened, all required changes should be indicated with the tracing-wheel or colored cotton and the paper pattern altered to correspond. The paper pattern is to be kept for future use.

(9) *Rebasting the Pattern.*—If many alterations have been necessary, the sleeve should be rebasted and placed in the waist, following the directions given for the first basting.

(10) *Refitting the Pattern.*—In refitting, the waist and sleeve should be put on as before, with the armseye seam of the sleeve turned to the shoulder. The sleeve should again be observed as to fit and hang and any required changes made.

III. Foundation Skirt

I. Drafting the Pattern

REGULATION MEASURES

- (1) Waist..26″
- (2) Hip (first measure)..........................38″
 - (6″ down.)
 - Depth of dart, 6″.
- (3) Hip (second measure)......................43″
 - (10″ down; from 4″ to 6″ larger than first hip measure.)
 - Depth of dart, 10″.
- (4) Length of front...............................40″
- (5) Length of side.................................41″
- (6) Length of back................................41″

Individual measures are taken as described in the preceding chapter.

The skirt draft is based on the hip measure and the width of the skirt at the bottom. No matter what these measures may be, the method of procedure is practically the same for all, but the results differ as the skirts are narrow or full; that is, for a narrow or straight skirt the curve of the waist line is large and has little depth, and as the skirt increases in width at the bottom the curve of the waist becomes shorter and deeper. The two drafts shown here illustrate this point. The regulation measures have been used; the first skirt is about 60″ in width at the bottom, the second is a few inches less than three yards.

In drafting a skirt which is to measure less than two yards around the bottom, 2″ should be added to the full hip measure. This augmented measure is then used in the construction and testing of the draft. The 2″ is removed later in the fitting by the use of darts or gores.

This change in the hip measure is not required for full skirts, as their width at the bottom gives sufficient size at the hip.

For making the draft, a piece of paper the length of the skirt plus 10″ is needed. In the upper left-hand corner of it two lines at right angles should be drawn. The work then proceeds as follows:

(1) *To Determine the Rectangle Which Forms the Foundation for the Draft:*

> AB = ½ the first hip measure (taken 6″ down) marked on the horizontal line.

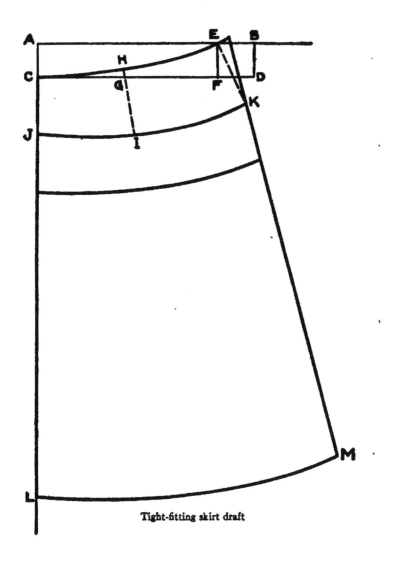

Tight-fitting skirt draft

AC = $\frac{1}{10}$ of $\frac{1}{2}$ the desired width at the bottom of the skirt, marked on the vertical line. While the size of a skirt at the bottom is, in general, determined by the prevailing fashion, it cannot be an arbitrary amount, but must be regulated by the hip measure in order to suit the figure of the wearer. This is especially true when narrow skirts are worn. For a narrow skirt a little more than $1\frac{1}{2}$ times the hip measure may be used. This may be increased to $1\frac{2}{3}$, 2, $2\frac{1}{2}$, and 3 times the hip measure, as fashion demands the wider skirt.

ABCD = The complete rectangle.

(2) *To Determine the Waist Line:*

BE = $\frac{1}{8}$ of $\frac{1}{2}$ the desired width at the bottom of the skirt, measured in on the line BA from point B.

EF = A line drawn parallel to the line BD. Point F is on the line CD.

CG = $\frac{1}{2}$ of the line CF.

GH = The difference between the length of the front of the skirt and the length of the side, measured up from point G, a dotted line drawn at right angles to the line CF.

CHE = Connect these points with a curve to form the waist line of the skirt.

(3) *To Determine the Hip Line:*

This hip line does not parallel the waist line.

HI = The first depth of dart, 6″, measured down from point H. The line HI should be drawn at right angles to the waist line CH.

CJ = The first depth of dart measure, 6″, less the difference between the front length and the side length of the skirt. The line CJ should be measured straight down from point C, a continuation of the line AC.

EK = HI, the first depth of dart measure, 6″, measured down from point E. A dotted line drawn at right angles to the line EH. This line is not permanent in length or direction; it is used to determine the general direction of the hip line. Any difference between the length of the side and the length of the back of the skirt must be

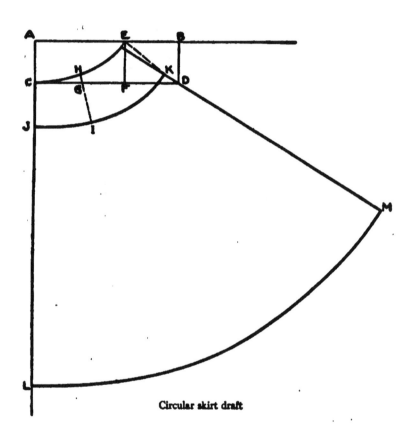

Circular skirt draft

regulated later by changing the length of this line, by raising or lowering the waist line at point E.

JIK ― Connect the three points with a curved line to form the hip line. The line JI does not parallel the line CH. The line IK must parallel the line HE, as the lines HI and EK are equal in length. On this line, JIK, measure ½ the hip measure, or the augmented hip measure if that has been used, from point J through point I and locate permanently point K.

(4) *To Determine the Line at the Bottom:*
This line at the bottom parallels the hip line.

CL ― The full length of the front.

LM ― The line for the bottom of the skirt. To get the direction of this line, measure the line JL. Using that amount, measure down from point I and from point K, keeping the skirt-rule at right angles to the hip line, JIK. Indicate these lengths by dots. From point L, through these dots, measure ½ the width of the bottom of the skirt. The end of this line is marked point M. This makes the hip line and bottom line parallel.

EKM ― The line for the centre back. This line must pass through point K to give the required hip size, even though in doing this it does not meet the waist line at point E. If it falls at the right or left of point E, the length of CHE, the waist line, can be regulated later by darts. Before locating this line, EKM, permanently, the width of the skirt at the 12″ hip measure should also be tested, especially if the skirt is narrow, in order to insure sufficient fulness at that point.

(5) *To Correct the Length of the Line KE and Locate Permanently the Waist Line, HE:*
In determining the line at the bottom of the skirt the length of back and the length of side measures were made equal below the hip line. In consequence, if the full length of back measure differs from the full length of side measure as taken, the difference must be adjusted either by adding to or subtracting from the centre-back

line above the hip line, measuring up from the point K. When KE has been made the right length the waist line should be adjusted by gradually raising or lowering it, as required, from point H toward point E to give the desired curve.

The hip line, as has been said, should always parallel the line at the bottom of the skirt, and all changes in length should be made above it. It is above the hip line that the contour of the normal figure varies.

This draft gives a foundation-skirt pattern of any desired width without gore divisions.

II. *Testing the Foundation-Skirt Pattern*

Before proceeding beyond this point it is wise to test this foundation skirt to the measures used to be sure that no mistakes have been made in drafting.

(1) *Hip Lines.*—The hip line 6″ down should be, for a straight skirt, 2″ more than the correct hip measure; for a full skirt, the correct hip measure; at 10″ down, for the straight skirt, it should be the required size; for a full skirt it will probably be more, but should never be less, than the required size.

(2) *Lengths.*—The full lengths at centre front, centre back, and side (over the hip) should correspond with the measures taken. These lengths at centre front, centre back, and side should measure exactly the same below the hip line. All differences in length should be adjusted and indicated above that line.

(3) *Waist Line.*—In all skirt patterns less than two yards or two and a half yards at the bottom there is extra width at the waist line. In fitting the foundation pattern this extra width must be regulated by darts, which will extend from the waist line below the 6″ hip line and take out the 2″ added there. Most skirts measuring two and a half or three yards at the bottom require small darts, if any, because their width gives them a short and curving waist line.

The exact amount to be removed at the waist is determined by subtracting one-half the correct waist measure from the waist measure of the draft. This amount will vary as the relative size of the waist and hip varies. A waist small in proportion to the hip will require longer and deeper darts than a large one. It is more satisfactory to use several small darts than one large one. These darts must be carefully placed to give good shape to the pattern. The largest, in depth and length, is always made over the hip because of the greater curve of the figure at the hip. The other somewhat smaller darts should be placed at the side front and side back.

In placing the darts the work is found to be much simplified if some gore division, such as the four or six gore, is first indicated on the pattern. If this is done the darts should then be so arranged as to give good seam-lines and good proportions to the gores. Before any gore divisions are made the pattern should be cut out, for convenience, along the drafted lines.

III. *Dividing the Foundation-Skirt Pattern into Gores*

All the directions given in skirt cutting are for measures which are approximately regulation. While it may not be possible to follow them absolutely where individual measures vary greatly from the regulation, they will serve to indicate, as do the directions for gore divisions, a general method by which to work.

Directions for the division of skirts into gores are very difficult to give, because the amount of fulness used in a skirt varies frequently, as fashion demands, and with each variation requires a change in the size and number of the gores. The directions given here are merely suggestive and as such may serve as a foundation for required variations.

In dividing a plain skirt into gores, divisions are indicated at the hip line and at the bottom. The points showing these desired divisions are connected by lines which are continued to the waist line, where all additional fulness is later taken out by the darts.

In all gore divisions the width of a gore at the bottom should bear a certain proportionate relation to its size at the hip. As the width at the bottom increases the proportion increases, or vice versa.

(1) *Four-Gore Divisions.*—For a skirt which is at the bottom $1\frac{1}{4}$ to $1\frac{2}{3}$ times the hip and is to have a front gore or panel, a back gore or panel, and a side gore with dart at hip.

(a) *Front Gore or Panel.*

(i) At the hip line: $\frac{1}{6}$ of $\frac{1}{2}$ the hip measure.

(ii) At the bottom: $1\frac{1}{4}$ times the width at the hip.

(iii) Connect the points at the bottom and the hip with a line which extends to the waist line.

(b) *Back Gore or Panel.*

(i) At the hip line: $\frac{1}{6}$ of $\frac{1}{2}$ the hip measure.

(ii) At the bottom: $1\frac{1}{4}$ times the width at the hip.

(iii) Connect the points at the bottom and the hip with a line which extends to the waist line.

(c) *Line for Direction of Dart at the Hip.*

(i) At the hip line: divide the remaining amount of the hip line in half.

Six-gore division

(*ii*) At the bottom: divide the remaining amount at the bottom in half.

(*iii*) Connect the points at the bottom and the hip with a dotted line, which extends to the waist line.

(*d*) *Darts to Remove Fulness at the Waist Line.*

(*i*) Front gore or panel: ¼″ from the side seam.

(*ii*) Side gore: ¼″ from the front edge; ½″ to ¾″ from the back edge.

(*iii*) Back gore or panel: ¼″ to ⅜″ from the side seam.

(*iv*) Dart at the hip: the remaining amount of extra fulness is taken out on each side of the dart line in such proportion that the sum of the front panel and half the side gore will equal the other half of the side gore plus the back panel.

(2) *Six-Gore Divisions.*—A skirt with six gores may easily be made from the four-gore skirt, which has the front and back panel and the side gore with a dart. To do this the wide side gore is made into two gores by extending the dart to form a seam the direction for which is already determined.

(3) *Five-Gore Divisions.*—For a skirt which is at the bottom 1½ or 1¾ times the hip and is to have a back gore or panel, a side gore, and a side front gore.

This gives a seam at the centre front which is very satisfactory for wash skirts.

(*a*) *Back Gore or Panel.*

(*i*) At the hip line: ⅓ of ½ the hip measure.

(*ii*) At the bottom: 1½ times the width at the hip.

(*iii*) Connect the points at the bottom and the hip with a line which extends to the waist line.

(*b*) *Front and Side Gores.*

(*i*) At the hip line: divide the *whole* hip line in half and mark 1″ to the front.

(*ii*) At the bottom: divide the *remaining amount* from the back gore to the centre front in half and mark 1″ to the front.

(*iii*) Connect the points at the bottom and the hip with a line which extends to the waist line.

(*c*) *Darts to Remove Extra Fulness at Waist Line.*—These vary according to the proportion of the waist to the hip and the width of the skirt at the bottom.

(*i*) Back gore or panel: ¼″ to ½″ from the side seam.

(*ii*) Front gore: 1½″ to 1¾″ from the back edge.

(*iii*) Side gore: ¾″ to 1¼″ from the front edge; ¼″ to 1¼″ from the back edge.

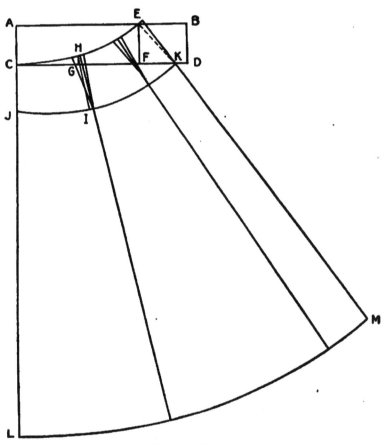

Five-gore division

(4) *Two-Gore Divisions.*—A skirt with two gores, having a seam at the side, may be designed from the five-gore pattern. The side seam is placed as in the five-gore skirt and all the fulness at the waist is taken out there.

(5) *Seven-Gore Division.*—For a skirt which is at the bottom 1½ or 1¾ times the hip and is to have a front gore or panel and three side gores.

This gives a seam at the centre back and three side seams.

(a) *Front Gore or Panel.*

(i) At the hip line: ½ of ¼ the hip measure.

(ii) At the bottom: 1½ times the width at the hip.

(b) *Gores.*—Divide the remaining space in thirds at the hip and at the bottom.

(i) First gore: [a] At the hip line: add ½". [b] At the bottom: add 1".

(ii) Second gore: (This has lost ½" at the hip and 1" at the bottom. To make it equal in size to the first gore, twice as much must be added to it as has been added to the first gore.) [a] At the hip line: add 1". [b] At the bottom: add 2".

(iii) Third gore: This is formed by the remainder.

By this division the two side-front gores are equal in size, while the third gore is smaller. This gives less width to the figure at the back.

(c) *Darts to Remove Extra Fulness at the Waist Line.*—These vary according to the proportion of the waist to the hip and to the width of the skirt at the bottom. In making darts to remove the extra fulness, the larger amounts should be taken out on the seams falling nearest the hip, where there is the greatest curve of the figure; the least should be taken out near the front, except for a figure which is very large there. A medium amount should be taken out in the back, depending on the curve of the figure.

IV. Fitting the Pattern

After the drafting is finished and the gore divisions made there are certain directions to be followed preliminary to the cutting of patterns in material for fitting.

(1) *Testing the Draft.*—The draft is already carefully tested and, where necessary, corrected. As a result:

(a) It should be the correct size at the waist, hip, and around the bottom.

(b) The hip line should parallel the bottom line of the skirt.

(c) In addition, if there are gores, they must now be tested and

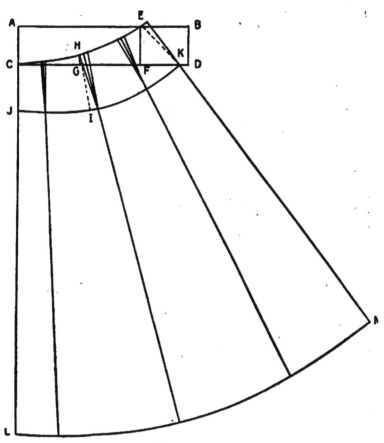

Seven-gore division

their lines trued. As has been said, in drafting a skirt all its lengths are made the same from the hip line to the floor, but above the hip they vary. In dividing a skirt into gores and removing the extra fulness at the waist by the use of darts, all the seam-lines of the gores are necessarily made more uneven in length, because they are given curves which vary according to the location of the seam and the consequent size of the dart; the larger the dart the more curved the edge of the gore. In making these lines true either the 6″ or the 10″ hip line is used as a guide, depending on the point where the dart lines meet. With the point where the two side lines of the dart meet at the hip line as a pivot and with the distance from this point on the hip line to the waist line measured on the original dividing line of the two gores as a radius, an arc should be swung cutting the two side lines of the dart. The points determined in this way give the correct length of those lines.

(2) *Seam Allowances for a Paper Pattern.*—In general it is much simpler to use a paper pattern which is cut out exactly along the drafted lines than one which has the necessary allowances added to it for all seams. This is especially true of a skirt pattern which is cut into gores and may be used as a foundation for the making of many designs. In such work seam allowances would be found a great inconvenience.

If it is thought necessary to add them, however, they should be as follows: 1″ on all lengthwise seams; ¼″ at the waist line.

(3) *Marking the Paper Pattern.*

(a) *For a Plain Skirt with Darts.*—The hip line should be traced with the wheel and all dart lines should be distinctly indicated, but the darts should not be cut open. If seam allowances have been made the waist line and the seam-lines should be marked.

(b) *For a Skirt with Gores.*—The pattern must be cut apart into gores for use. Before this is done (i) the hip line should be carefully traced with the wheel. It is necessary in basting the gores together and in fitting the pattern. (ii) Each gore should be marked with numbers to indicate its position in the skirt, and corresponding edges should be marked with corresponding notches. The grain of the paper is not a correct guide in placing the straight and bias edges. If seam allowances are desired in the pattern these gores must be placed on paper and new gores traced and cut.

(4) *Placing the Paper Pattern on the Material and Cutting.*—Even though these patterns are to be cut in inexpensive materials for the first fittings, attention should be paid to the economy of material by careful placing. Half the pattern is never satisfactory for fitting. The complete garment, carefully cut, traced, and basted, is

absolutely necessary for good results. When possible, all pieces of the pattern should be cut at the same time with corresponding ones together. This saves confusion and duplication especially when there are many gores.

(*a*) In general, the wide end of a gore is placed to the cut end of the material. This brings the top of the gore into the body of the material, and by placing the second gore on in the opposite way its narrow end will slip by that of the first and thus length of material is saved.

(*b*) In cutting the plain skirt there may be a seam at the centre front and centre back. The centre front must be on the straight of the material. The centre back then falls on the bias.

(*c*) In the skirts with gores there are two suggestions which may be found helpful:

(*i*) All centre-front and centre-back panels usually have their centre lines placed on a straight lengthwise fold of material.

(*ii*) The front edge of all other gores generally falls on the straight of the material, below the hip line; that is, below the curve made by the dart.

· After the pattern is arranged with attention to the straight of the material, the seam allowances necessary for fitting should be measured and the pattern pinned in place and cut.

The seam allowances for the cloth pattern are the same as those already suggested for the paper; that is, $1''$ on all lengthwise seams; $\frac{1}{4}''$ at the waist line.

No allowance need be made for a hem in the pattern, as the skirt measures were taken to the floor and the skirt drafted that length. If the skirt is cut exactly like the pattern $2''$ at least of its length may be used for a hem.

(5) *Marking the Cloth Pattern.*—The cloth pattern should be marked to indicate the exact size of the pattern as drafted, to give the correct seam-lines. A tracing-wheel may be used, supplemented, where necessary, by colored bastings.

(*a*) For the plain or foundation skirt with darts a tracing should be made:

(*i*) Around the pattern, to indicate the waist line and the seam-lines.

(*ii*) Through the hip line.

(*iii*) Through any gore divisions which are already indicated in the pattern as an aid in fitting and in locating the necessary darts.

(*iv*) To indicate all darts (which, as has been said, are not to be cut).

In addition to these tracings colored bastings should be placed

in the hip and waist lines. They prevent the loss of these lines and also aid in indicating their direction during the fitting.

(*b*) For all skirts with gores a tracing should be made:

(*i*) Around each gore, to indicate the waist line and the seam-lines.

(*ii*) Through the hip line of each gore.

(*iii*) To indicate any darts (which are not to be cut) where there are not seams, as in the four-gore skirt.

In addition to these tracings colored bastings should be placed as in the plain foundation skirt, and marks should be made to indicate the position of the gores in the skirt.

(6) *Basting the Pattern.*

(*a*) All seams and darts should be basted with white thread, as colored is needed to indicate the hip and waist lines and later alterations.

(*b*) Seams should be pinned together before basting. In joining any seams the hip lines should be carefully matched and the pinning done from that point, up and down. If the seam-lines have been trued they will be of equal length; but in any case the hip lines must match.

(*c*) While basting, the work should be placed on a table and kept there until finished. Long seams cannot be satisfactorily pinned or basted if held in the lap.

(*d*) In joining gores:

(*i*) An edge which is straight below the hip and an edge which is bias frequently fall together, as in the five-gore skirt, in which the straight front edge of the side gore is joined to the bias back edge of the front gore.

In pinning such seams together the bias edge must be held toward the worker; that is, the gore with the straight edge is placed on the table and the gore having the bias edge is then placed on it. In this way the bias is not stretched.

(*ii*) Two bias edges may fall together, one more bias than the other, as in the five-gore skirt, in which the slightly bias edge of the back gore or panel is joined to the more bias back edge of the side gore. In pinning such seams together the more bias edge must be held toward the worker.

(*iii*) Two equally bias edges may fall together, as is often seen in the centre-back seam or in two-piece skirts having a seam at the side. In joining such seams care must be taken to join them evenly and not to stretch the edges.

(*e*) In basting darts:

In both pinning and basting the work should begin at the end

or point of the dart and go toward the waist. Care must be taken to baste smoothly without fulness along either line. The dart, when basted, should form on the right side of the skirt an outward curve to correspond with the curve of the figure. Darts must not be cut open until after the fitting, as they often require altering.

(*f*) Basting plackets:

A 12″ opening is a regulation length. Additional length may be required if the skirt is made for a stout person.

(*i*) If the placket is in the centre-back seam, both edges should be turned back along the seam-line and basted flat.

(*ii*) If the placket is at one side of a panel, the panel edge should be turned back along the seam-line and basted flat. The edge of the gore should be allowed to extend and its seam-line should be distinctly marked.

(7) *Fitting the Pattern.*

(*a*) For the first skirt-fitting it is wise to use a skirt with but few indicated seams or gores, such as the plain foundation pattern or the six-gore pattern. (*i*) If the foundation pattern is used it may be cut with seams at the centre front and centre back and may have the four-gore divisions indicated on it in pencil. The centre-front and centre-back seams give an even division of the skirt which simplifies fitting. The placket may be placed in the centre-back seam. The indicated lines of the four-gore division—which is one of the simplest—determine the position and direction of the darts without difficulty. (*ii*) If the six-gore skirt is used it may be cut with a centre-front and a centre-back panel and a side seam. The placket may be at the left side of the back panel.

(*b*) In the first fitting the fit and hang of the skirt should be given the most attention; in the second fitting the direction of the seams and the general proportion of the gores in relation to the figure should be observed and altered as required.

(*c*) Before any fitting is done it is necessary to have a belt made, to which the skirt may be attached either before or during the fitting. It is usually more satisfactory to join the belt to the skirt during the fitting, as in the directions here, but it may be done before if desired. Cotton belting ¾″ or 1″ wide may be used for a belt. It should be cut 2″ longer than the waist measure. To prepare it, the extra 2″ is turned to the wrong side, 1″ at each end, to serve as a foundation for the necessary fasteners. Hooks and eyes should be used and so placed as to make the belt, when finished, the correct size. To do this the hooks should come to within ⅛″ of the end and the eyes should extend just enough beyond the other end of the belt to fasten easily, about ⅛″. The centre

of the belt should be marked with a colored thread to serve as a guide.

(*d*) In fitting, the belt is first adjusted; it should be put on right side out, with its lower edge exactly at the normal waist line, from which all lengthwise skirt measures were taken. Its opening must be placed to correspond with the placket of the skirt. The skirt should also be put on right side out. All darts and gore divisions are more easily seen and their general directions appreciated if the seams are on the inside, though they may not be as easy to adjust if any changes are necessary. After the skirt is settled to the figure the placket should be pinned up exactly on the indicated lines.

(*e*) Only one side of the skirt, the right side, should be fitted. The other is altered to correspond after the skirt has been taken off. Exceptions to the above directions may be necessary, however. If the right and left sides of a person vary greatly both sides of the skirt should be fitted.

(*f*) In attaching the skirt to the belt it should be pinned to it at the centre front, centre back, and at each side. Even though but half of the skirt is to be fitted, it must be carefully attached to the belt all the way around. The traced waist line of the skirt should fall exactly along the lower edge of the belt. When all this is done the skirt is ready for inspection.

(*g*) No alterations should be made until the general fit of the skirt has been observed.

(*i*) The darts or seams should extend at right angles to the waist line. Even though the skirt fits well, [a] if the seams run toward the front as they near the bottom of the skirt they give a very ugly appearance and should be altered; or [b] if the darts are not in good direction and well placed their position should be changed.

(*ii*) The skirt should fit smoothly from waist to hip and, below the hip, fall straight to the floor.

(*iii*) The skirt should not poke out from the figure in an ungainly way at the front, back, or side.

(*iv*) The line around the bottom should parallel the floor.

(*k*) In fitting, care should be taken lest too much be done, as is the tendency especially with the inexperienced.

(*i*) The hip line and the line around the bottom should parallel the floor and each other. If the hip line does not parallel the floor a new one should be established. A hip line which drops at the back may cause the whole skirt to drop at the back. This usually, by throwing the fulness forward, makes the skirt stand out at the centre front. The skirt should be raised a *little* at the centre back;

this may necessitate opening the dart to regulate the amount of fulness included in it, or changing the seam at the side back, to alter slightly its direction. Too much lifting must not be done, as it spoils the general hang of the skirt. If the skirt is raised or lowered at the waist line it must be very carefully readjusted to the belt and a new waist line indicated.

(*ii*) Very often a wide, flat figure with rather prominent hip bones will cause a skirt to pull up and stand away from the figure at the side. This may usually be remedied by freeing the skirt from the band and dropping it a little just over the hips to give extra length. After making this change the direction of the hip line must be corrected and also the line around the bottom.

(*iii*) If the skirt is too tight or too loose at the waist it may easily be regulated by changing the darts or seams, taking care to keep their general direction good. As has been said, all dart lines must run at right angles to the waist line. The darts must also taper to a point at the hip and be of sufficient length to give the skirt good shape.

(*iv*) If the skirt is too tight or too loose below the hips the fitting may be done in the seams, usually at the centre back in the plain skirt and in the side-back seam of the six-gore skirt.

(*v*) If the line around the bottom is not good the skirt must be rehung. This may be done by a variety of methods. A small skirt-marker which carries chalk, a square, or a stiff card notched to the correct depth may be used. As has been said, 2″ from the floor is a satisfactory length for a pattern. In marking a skirt the wearer should stand in her ordinary position, and, if possible, on a table or stand, to lessen the task of the worker.

(*vi*) After the fitting is finished but before the skirt is taken off all the necessary changes must be plainly indicated by chalk, pencil, or pins to insure satisfactory alterations.

(8) *Altering the Pattern.*—In taking off the skirt, if the direction of the placket has been changed the pins should be left in one side to indicate the change of line.

After the skirt is removed all the changes, no matter how trifling, must be marked in the fitted side with the tracing-wheel or colored cotton. If colored cotton is used it should be unlike that already used for waist and hip lines. The tracing-wheel requires less time and is as satisfactory as the cotton (for all except waist and hip), unless the new tracings cannot easily be distinguished from the original, in which case the basting must be done. Pins are not satisfactory to indicate alterations, except temporarily, as they so often drop out.

The waist and hip lines must be marked with cotton if any change has been made. None of the old lines should be lost, as they are needed as guides in placing the two sides of the skirt together to make corresponding alterations.

The care with which the alterations are marked has much to do with the final success of the pattern.

In the plain skirt all the darts should be opened so that the two sides of the skirt may be placed together, with the original hip and waist lines matching. In the gored skirt all seams which have been changed should be opened and the gores placed on corresponding ones, with the original waist and hip lines matching. All necessary corrections may then be indicated on the unfitted side, but before rebasting all changes should be indicated on the paper pattern, which is to be kept for future use.

(9) *Rebasting the Pattern.*—If many alterations have been necessary the skirt should be rebasted along the new lines, following the directions given for the first basting. In addition, the skirt should be attached to the belt for the second fitting. In doing this the work should be held over the hand with the belt inside the skirt and away from the worker, so that the skirt may be eased to it. Care must be taken to have the two sides of the skirt even.

(10) *Refitting the Pattern.*—For refitting, the skirt should again be put on right side out. There may be a few changes necessary on the left side if it differs materially from the right. These should be made and the same points observed as in the first fitting.

In addition, the gore divisions should be much more carefully considered as to the general direction of line and the proportionate size of the gores.

Directions cannot be given for any corrections or changes which may be required in this, as it depends on the figure of the wearer and also somewhat upon the taste of the wearer and the demands of the current fashion.

Appreciation for good proportion can be gained only by work in design, by observation, comparison, and discrimination.

After the pattern has been satisfactorily fitted it is an excellent plan to use it as a basis for different gore divisions and, as suggested under *Designing*, for various more elaborate designs.

IV. Tight-Fitting Waist and Collar

I. *Drafting the Patterns*

REGULATION MEASURES

(1) WAIST

Length Measures—
 (1) Length of back.............................15″
 (2) Length of front............................15½″
 (3) Depth of dart...............................8½″
 (4) Length of underarm........................7½″

Width Measures—
 (1) Width of back.............................13½″
 (2) Width of chest............................14″
 (3) Bust......................................37″
 (4) Waist....................................25″
 (5) Neck.....................................13″
 (6) Armseye..................................15″

(2) COLLAR

 (1) Base of neck..............................13″
 (2) Top of neck...............................12½″
 (3) Height at back.............................2¾″
 (4) Height at front............................2¼″
 (5) Height at side.............................3″

Individual measures are taken as described in the preceding chapter.

TIGHT-FITTING WAIST

This waist pattern is composed of five pieces: the centre front, side front, underarm, side back, and centre back. These may all be made, side by side, on one sheet of drafting-paper about one and a half yards in length. The foundation lines are practically the same as for the shirt-waist. The centre and side back are drafted together and the centre and side front, while the underarm is placed in a separate rectangle.

The centre and side back are drafted first.

Centre and Side Back

In the upper left-hand corner of the paper two lines at right angles and of indefinite length should be drawn. The work then proceeds as follows:

(1) *To Determine the Foundation Lines:*

> AB = Length of back, marked on the vertical line.
>
> B = Draw a line at right angles to the line AB to indicate the waist line.
>
> AC = $\frac{1}{2}$ of the line AB. Draw a line at right angles to the line AB to indicate the bust line.
>
> AD = $\frac{1}{2}$ of the line AC. Draw a line at right angles to the line AB to indicate the width of back line.

(2) *To Determine the Neck Line:*

> AE = $\frac{1}{6}$ of the neck measure, marked on the horizontal line from point A.
>
> EF = $\frac{3}{4}''$ above point E, a dotted line drawn at right angles to line AE.
>
> AF = Connect these points with a curve to form the neck line.

(3) *To Determine the Centre-Back Line:*

> BG = $1'$ measured in on the waist line B.
>
> AG = New centre-back line. On this line mark the points of intersection at point D and point C as D^2C^2 and use these points in measuring all widths.

(4) *To Determine the Shoulder Line:*

> D^2H = $\frac{1}{2}$ the width of back.
>
> HI = AE, which is $\frac{1}{6}$ of the neck measure, a dotted line drawn at right angles to the line D^2H at point H. For sloping shoulders subtract $\frac{1}{4}''$ from the line; for square shoulders add $\frac{1}{4}''$ to the line.
>
> IJ = $\frac{3}{8}''$ to the right from point I, a dotted line drawn at right angles to the line HI.
>
> FJ = Connect these points to form the shoulder line.

(5) *To Determine Side Lines of Centre Back and Side Back:*

> C^2K = $\frac{1}{4}$ of the bust measure minus $2\frac{1}{4}''$.
>
> GL = $\frac{1}{20}$ of the waist measure on the waist line B.
>
> FM = $\frac{1}{2}$ of the shoulder line FJ.
>
> ML = side line of the centre back.
>
> LN = $\frac{3}{4}''$ measured to the right from point L on the waist line B.
>
> MN = Line of the side back. This line coincides with the line ML from M to the point of its intersection with the line C^2K.
>
> NO = $\frac{1}{8}$ of the waist measure on the waist line B.

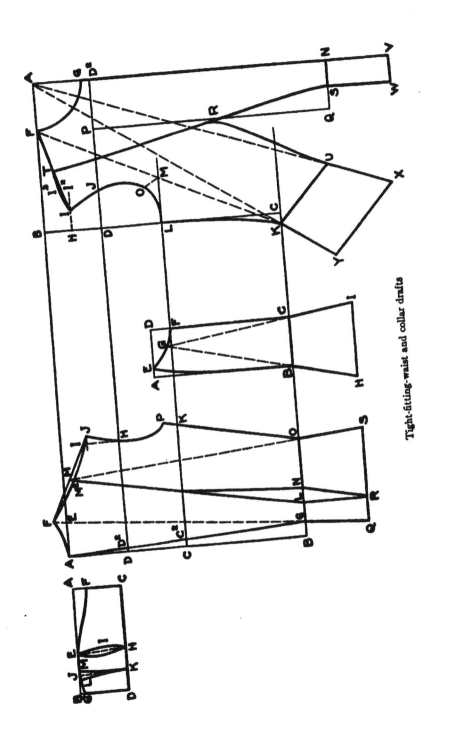

Tight-fitting-waist and collar drafts

OP = Underarm measure plus 1¼", drawn from point
O through point K. The end of this line is
marked point P. This seam falls a few inches
back of the centre underarm and must, in con-
sequence, be longer than the underarm meas-
ure.

(6) *To Determine the Armseye:*
JHP = Connect these points with a curve to form the
armseye.

(7) *To Determine the Basque:*
GQ = 4" measured down from point G with the ruler
placed on points FGQ.
LR = 4" measured down from point L at right angles to
the waist line B.
NR = Line connecting these points.
OS = 4" measured down from point O with the ruler
placed on points MOS.
QRS = Connecting line to form the bottom of the basque
for the centre and side back.

(8) *To Determine the Curve of the Shoulder Seam:*
MM² = ¼" down from point M, a dotted line drawn at
right angles to the line FJ.
FM²J = Connect these points with a slightly curved line
to form the shoulder.

Underarm

Extend the waist line B to form the waist line of the underarm.
The work then proceeds as follows:

(1) *To Determine the Foundation Lines:*
AB = Underarm measure plus 1¼", drawn at right
angles to the waist line B.
BC = ⅛ of the waist measure on the waist line B.
ABCD = Complete the rectangle. The line DC parallels
the line AB.

(2) *To Determine the Back and Front Lines:*
AE = ½" measured in from point A on the line AD.
EB = Connect these two points with a curved line
starting from point E, meeting the line AB half-
way down, and continuing straight to point B.
CF = Underarm measure on the line CD, measured up
from point C.

(3) *To Determine the Armseye:*
> EF = Connect these points with a curve to form the armseye.

(4) *To Determine the Basque:*
> EG = ½ of the curved line EF.
> BH = 4″ measured down from point B with the ruler placed on points GBH.
> CI = 4″ measured down from point C with the ruler placed on points GCI.
> HI = Connecting line to form the bottom of the basque for the underarm.

Centre and Side Front

Extend the line A of the back of the waist across the sheet and draw a line at right angles to it in the upper right-hand corner for the centre-front line of the pattern. The work then proceeds as follows:

(1) *To Determine the Foundation Lines:*
> AB = The difference between one-half of the bust measure and the sum of the centre-back, side-back, and underarm pieces at the bust line C, marked on the horizontal line from point A.
> BC = Length of back, a line drawn at right angles to the line BA.
> BD = ¼ of the line BC.
> AD² = BD. Connect points DD². This line is a continuation of the width of back line DH.

(2) *To Determine the Neck Line:*
> AF = ⅙ of the neck measure plus ½″, marked on the horizontal line AB.
> AG = ⅙ of the neck measure plus ¾″, marked on the vertical line from point A.
> FG = Connect these points with a curve to form the neck line.

(3) *To Determine the Shoulder Line:*
> BH = ½ of the line BD.
> H = Line of indefinite length drawn at right angles to the line BD. This serves as a construction line for the shoulder.
> FI = Shoulder line, which should be ¼″ shorter than the shoulder line of the back. The square is placed on point F and swung until the desired

length of shoulder touches the line H. This establishes point I.

(4) *To Determine the Underarm Seam:*

D²J = ½ the width of front, measured in on the chest line D²D from the centre-front line A.

CK = ½″ measured out, to the left, from point C on the waist line.

CL = The height of underarm, measured up from point C on the line CB.

KL = Underarm line. Connect these two points with a curved line starting from point K, meeting the line CL half-way up, and continuing straight to point L.

(5) *To Determine the Armseye:*

FK = Connect these two points with a dotted line.

M = At the point of intersection of the line FK with the extension of the bust line C of the back of the waist mark point M.

GN = Length of front, measured from point G on the centre-front line A. Extend this line 4″ below point N for the basque.

N = Draw an indefinite line at right angles to the line GN to indicate the waist line.

NMO = 1¼″ measured up from point M with the ruler placed on points NMO.

IJOL = Connect these points with a curve to form the armseye.

(6) *To Determine the Side Lines of the Centre Front and Side Front:*

D²P = ½ of the line D²J, the width of front, minus ¼″, measured from point D².

PQ = Line drawn from point P, at right angles to the line JD², and touching the waist line N at point Q.

R = Height of dart, measured from point G, touching the line PQ at point R.

NS = ½ of the line NQ. This is the waist line of the centre front.

FT = ½ of the shoulder line FI.

TRS = Side line of centre front. Draw a straight line from point T to point R and a slightly inward curving line from point R to point S.

KU = Waist line for side front. It equals the difference
between half the waist measure and the sum of
the waist measures of the centre back, GL, the
side back, NO, the underarm, BC, and the cen-
tre front, NS. As a guide for the direction of
the trial line, place the square on point K and
touch on the centre front line about 4" below
point N.

RU = Side line of the side front. Beginning 1" above
point R on the line TR, draw a curved line in-
side point R to point U. The line KU should
now be so drawn that the line RU is ¼" longer
than the line RS.

RU = RS plus ¼".

(7) *To Determine the Basque:*

NV = 4" measured down from point N.

SW = 4" measured down from point S at right angles to
the line SN.

UX = 4" measured down from point U with a ruler
placed on points AUX.

KY = 4" measured down from point K with a ruler
placed on points AKY.

WV = Connecting line to form the bottom of the centre
front.

YX = Connecting line to form the bottom of the side
front.

(8) *To Determine the Curve of the Shoulder Seam:*

$I I^2$ = ½ of the line IT, which is ½ the shoulder.

$I^2 I^3$ = ⅛" up from point I^2, a dotted line drawn at right
angles to the line IT.

$I I^3 T$ = Connect these points with a slightly curved line
to form the shoulder.

TF = Remains unchanged.

The lengthwise seams may now be slightly curved near the
waist line or it may be done when the pattern is cut.

This draft gives a fitted waist without fulness, which serves as
a foundation or lining.

COLLAR

The collar pattern is composed of one piece, one-half the collar.
It may be made on the same sheet of drafting-paper with the
tight-fitting waist or on a small piece by itself.

Two lines at right angles and of indefinite length should be drawn. The work then proceeds as follows:

(1) *To Determine the Foundation Lines:*

AB = ½ the size at the base of the neck, marked on the horizontal line.

AC = Height of neck at the side, marked on the vertical line.

ABCD = Complete the rectangle. The line BD parallels the line AC.

(2) *To Determine the Top Line of the Collar:*

AE = ⅙ of the line AB plus ¼", measured over from point A.

CF = Height of the neck at the front, measured up from point C.

DG = Height of the neck at the back, measured up from point D.

FEG = Connect these points with a curved line to form the top of the collar.

(3) *To Determine the Darts:*

CH = ⅙ of the line CD plus ½", measured over from point C.

EH = Dotted line connecting these two points to give the direction of the dart.

EI = ½ of the line EH. Measure ¼" to the right and ¼" to the left of point I and draw curves from E to H through these two points. (These two curves must be regulated by the curve of the neck.)

EJ = ⅓ of the line EB.

HK = ⅓ of the line HD.

JK = Dotted line connecting these two points to give the direction of the dart.

LM = Difference between the size at the bottom and at the top of the collar. Half this amount must be taken out each side of point J.

LK = Connect these two points to form the curved side line of the dart.

MK = Connect these two points to form the curved side line of the dart.

Both these lines should curve outward from the line JK to fit the inward curve of the neck.

This draft gives a plain fitted collar.

II. *Fitting the Patterns*

After the drafting is finished there are certain directions to be followed preliminary to the cutting of patterns in material for fitting.

(1) *Testing the Draft.*—The drafts should be carefully tested to the measures used and, if necessary, corrected.

(a) *Waist.*

(*i*) The length of back must be exact, and the width of back, and the bust lines in proper position.

(*ii*) The size of the bust should equal the measure as taken, measuring all pieces of the waist on the bust line.

(*iii*) The waist line should equal the measure as taken, measuring all pieces of the waist on the waist line.

(*iv*) The width of back and the width of chest must correspond to the measures taken.

(*v*) The two seams of the underarm piece should match the seams to which they will be joined in the basting of the waist.

(*vi*) It is important to measure the neck of the front and back carefully. In measuring any curved lines the tape-measure should be held upright; that is, on edge, with the numbered edge on the paper.

(*vii*) The two side-front seams should correspond; that is, RU of the side front should equal RS of the centre front plus $\frac{1}{4}''$.

If any of these measures vary much from the required size there has, without doubt, been a mistake in following the drafting directions, in which case the pattern should be redrafted and the mistake rectified before proceeding with the work.

(b) *Collar.*—The testing of the collar is comparatively simple. (*i*) The size at top and bottom should be measured and (*ii*) the heights at centre front, centre back, and side.

(2) *Seam Allowances for a Paper Pattern.*—In general, it is simpler to use a paper pattern which is cut out exactly along the drafted lines than one which has the necessary allowances added to it for all seams. If it is thought necessary, however, to add them they should be as follows:

(a) *Waist:* $1''$ on all lengthwise seams; $1''$ on the shoulder seam; $\frac{1}{4}''$ at the neck and armseye.

(b) *Collar:* $1''$ at the centre back; $\frac{1}{8}''$ at the top and bottom edges.

(3) *Marking the Paper Pattern.*

(a) *Waist.*—The pattern must be cut apart for use. Before this is done it is wise to mark with corresponding notches or trac-

ings the edges which are later to be joined. In addition to this (*i*) the waist line on the five pieces, (*ii*) the width of back, (*iii*) the width of chest line, and (*iv*) the depth of the dart, point R, on the centre and side fronts, should all be distinctly marked. If seam allowances are desired in the pattern all the pieces except the underarm must be placed on paper and new pieces traced and cut.

(*b*) *Collar.*—The whole collar pattern should be cut. This is done by folding the paper at the centre front and tracing the outline of the collar. The centre and side lines of the darts should be indicated.

(4) *Placing the Paper Pattern on the Material and Cutting.*

(*a*) *Waist.*—Economy of material should always be considered in placing the pieces of this pattern. The complete pattern must be cut in order to give a satisfactory fitting. When possible, all pieces of the pattern should be cut at the same time, with corresponding ones together. This saves confusion and duplication. In placing this pattern on the material the following lines should be used as guides and placed on the straight crosswise threads of the material: the width of back line for the centre and side backs, the chest line for the centre and side fronts, and the waist line for the underarm. After the pattern is arranged with attention to the straight of the material the seam allowances should be measured and the pattern pinned in place and cut. The seam allowances for the cloth pattern are the same as those already suggested for the paper; that is, 1″ on all lengthwise seams; 1″ on the shoulder seam; ¼″ at neck and armseye; no allowance is needed at the bottom.

(*b*) *Collar.*—The whole collar should be cut, as in the paper. In placing it on the material the centre-front line AC should be on a crosswise thread and the bottom line on a lengthwise thread of material. After this is arranged the seam allowances should be measured and the pattern pinned in place and cut. The size at the bottom should correspond to the neck measure and the size of the neck in the waist pattern as well. The seam allowances for the cloth pattern should be the same as those already suggested for the paper; that is, 1″ at the centre back of the collar; ½″ at the top and at the bottom.

(5) *Marking the Cloth Pattern.*

(*a*) *Waist.*—The cloth pattern should be marked to indicate the exact size of the pattern as drafted, to give the correct seam-lines. A tracing-wheel may be used, supplemented where necessary by colored bastings. A tracing should be made to indicate: (*i*) all seam-lines, the centre-front, the side-front, the two underarm, the side-back, the centre-back, and the shoulder; (*ii*) the neck line; (*iii*) the

armseye; (*iv*) the waist line; (*v*) the depth of dart point on both the centre and the side front seams.

In addition to these tracings, colored bastings should be placed in the neck, armseye, waist, and centre-back lines. They prevent the loss of these lines and also aid in indicating their direction during the fitting.

(*b*) *Collar.*—A tracing should be made around the entire collar and through the centre and side lines of the darts. The centre front and centre backs should be indicated by colored bastings.

(6) *Basting the Pattern.*

(*a*) *Waist.*—All seams should be basted with white thread, as colored is used for marking and alterations. Fine stitches should be used and the thread well fastened. Seams should be pinned together before basting.

(*i*) For the lengthwise seams tracings should be matched at the neck, at the waist, at the shoulder, and at the armseye, and both the pinning and basting should be done between the points. As the waist is to fasten at the centre back, that seam should not be

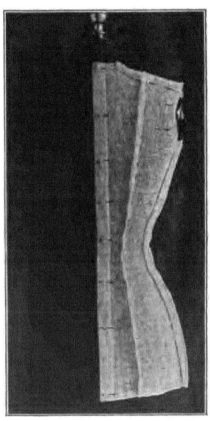

Correct seam-lines for the tight-fitting waist

basted, but the seam allowance should be turned in and basted flat.

Exception.—In basting the centre front and the side front together the more bias edge of the side front should be toward the worker, and care should be taken to stretch the bias edge of the side front from 1 ″ below the waist line to the bust. This helps to spring the lining into the curve of the waist. The shoulder and waist lines should be matched and pinned. The pinning should then be done from

the shoulder down toward the bust and from the waist up toward the bust. In this way the extra fulness of the side-front seam is brought near the bust. The placing of this fulness is very important; it should be distributed very carefully, about 1″ above and 1″ below point R, the depth of dart.

(*ii*) For the shoulder seam, the neck and armseye lines and the two dart seams are matched and pinned. As the front shoulder seam is ¼″ shorter than the back, it requires stretching to give it sufficient length. After it is stretched it should be basted, holding the back shoulder toward the worker. The stretching of the front shoulder along the seam-line makes the waist spring better into the curve of the shoulder of the wearer.

The material for the seam allowances on the side-front and side-back seams should not be caught down when the shoulder is basted.

(*b*) *Collar.*—In preparing the collar the darts should be basted from the bottom of the collar upward, taking care to fold them exactly on their centre lines. The ⅛″ allowance at top and bottom should be turned and basted, but the 1″ allowance at the centre back should be left free for the fitting.

(7) *Fitting the Pattern.*

(*a*) Before putting on the waist each lengthwise seam should be notched to within ¼″ of the basting at the waist line; otherwise the waist will not fit in to the curves of the figure.

(*b*) For the first fitting the waist is put on right side out and but one side, the right, is fitted, unless, as has already been suggested, the right and left sides of the wearer vary greatly. In this case time is probably saved by fitting the entire waist at once.

(*c*) The waist should be settled to the figure and pinned together at the centre back exactly on the turned-in edges. These should be pinned first at the waist and at the neck, matching the lines, and then at intervals between, using enough pins to hold the seam together closely. To hold the waist in place during the fitting, it should be pinned just below the waist line to the corset, at the centre front, the centre back, and under the arm. The whole waist should be carefully inspected before any fitting is done. There are various important things to observe and do.

(*d*) In fitting any seam of a waist there are three methods of procedure. (*i*) An equal amount may be taken up on each side of the seam. This means pinching the seam exactly along its line. (*ii*) An unequal amount may be taken up on each side; that is, one piece may need more taken from it than the other, in which case the original seam does not lie along the centre of the amount pinned up. (*iii*) The entire amount may be taken up on one side

of the seam. This should be so done that the row of pins taking up the amount to be removed is directly along, or practically on, the original seam-line. In making any alterations the pins must be put in on a line with the original seam to maintain the correct direction.

(e) If the entire waist is large or small and there is much fitting to do, care should be taken to observe the direction of the lines and the proportion of the pieces in their relation to the figure. The original lines and proportions of the draft should be maintained even though it is necessary to increase or diminish the size of the whole waist. Too much fitting should not be done. The waist should be made to fit easily and without wrinkles. If the lengthwise seams wrinkle a little near the waist it is of no importance. In a lining these wrinkles may be removed, by boning the seams.

(f) This draft, like the commercial pattern, is made for the shoulder of regulation height; in consequence, if the shoulders of the wearer are very square or very sloping, changes are required. If the shoulders are square they lift the waist too much at the point or end of the shoulder and there will be a wrinkle running across the waist. This should be remedied by taking up the shoulder seam near the neck and cutting out the surplus material, which is thus brought up around the neck. If the shoulders are very sloping the waist drops at the end of the shoulder and the wrinkle will extend downward from the neck toward the armseye. To change this the shoulder seam should be taken up at the point of the shoulder and the armseye cut out near the underarm seam. After any required changes are made a good shoulder line should be established. The shoulder seam should be about 1″ back of the highest part of the shoulder. It is not in a direct line with an underarm seam, as this waist has an underarm piece. If this seam is too far back it gives a narrow appearance to the back of the waist; if, on the other hand, it is too far front it may give the appearance of round shoulders.

(g) The waist should fit very closely over the chest. Usually it is necessary to take up the waist on the centre-front seam to give the required curve from the neck toward the bust line.

(h). The armseye line is one of the most important in the waist. It should extend from the point of the shoulder down over the little muscle where the arm joins the body in front and, coming up as high under the arm as is perfectly comfortable, form a nearly straight line up the back to the shoulder.

(i) If the armseye is full at the front a little above the underarm seam, it is often an excellent plan to make a small dart rather

than to attempt removing the fulness by taking up either the shoulder or the underarm seam. The dart is occasionally necessary at the back.

(*j*) If the colored basting indicating the direction of the waist line does not correspond to the normal waist line of the wearer a new line should be indicated. This may best be done by placing a tape-line around the waist and marking its lower edge with a row of pins.

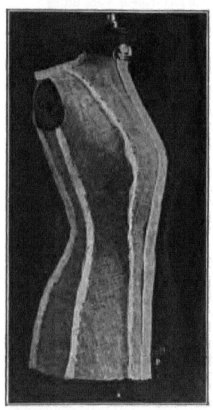

(*k*) In general, the neck line should run from the bone at the base of the neck in the back in a good line or curve to the hollow in front just above the two small bones. The line should be rather high at the side just under the ear.

The shape of the neck, or its length, may affect this line slightly; that is, for a long neck the line should be as high as possible in front and for a short neck low. If the neck of the waist is not right the necessary fitting should be done and a new line indicated. If it is too high or too tight it may be slashed. If it is too low the shoulder seams may be taken up a little.

Correct seam-lines for the tight-fitting waist

When the necessary changes have been made the collar should be attached to the waist. The centre-front line of the collar should be pinned to the centre-front line of the waist at the neck line. The lower edge of the collar should then be stretched around the base of the neck to the centre back and pinned up the centre back, taking care to have this line on the thread of the material. It should then be carefully pinned to hold it in place around the

neck. All changes in the size of the collar at the top should be made in the darts.

The front dart should be about in line with the shoulder seam and end a little back of the ear. The second dart is half-way between the front dart and the centre back. After the collar is pinned in place and fitted, any desired change may be made in its height.

Exception.—For a person whose neck varies greatly in size at top and bottom it is sometimes necessary to change the direction of the centre line and shape it in a little at the top. This should be avoided when possible.

Before the waist is taken off it should be carefully inspected as a whole and all necessary changes in it and in the collar plainly indicated by pins, tailor's chalk, or pencil.

(8) *Altering the Pattern.*—After removing the waist all the required changes should be marked on the side just fitted, with the tracing-wheel or with colored cotton. Care should be taken to keep the original lines sufficiently distinct to have them serve as guides in marking the unfitted half of the waist. The collar should be taken off, all the seams should be opened, and the two sides of the waist placed together—with the original lines matching—and correspondingly marked.

If a new neck, armseye, or waist line has been made, colored cotton should be used to indicate it. The tracing-wheel may be used for changing the seam-lines, unless they can be too easily confused with the old tracings and so make the rebasting difficult. All changes should be indicated on the paper pattern, which is to be kept for future use.

(9) *Rebasting the Pattern.*—If many alterations have been necessary the waist and collar should be rebasted along the new lines; the collar should be basted on, following all the directions given for the first basting, and the whole should be put on for final inspection.

(10) *Refitting the Pattern.*—In refitting, the waist should again be put on right side out. The shoulder seams should be turned to the front. If the left side requires any changes, because of the unevenness of the figure, they should be made now and the whole waist generally inspected again for fit and for seam-lines.

The general fit of the collar and the direction of the neck line should be carefully observed. As has already been said, the direction of the line at the base of the neck should depend on the length of the neck of the wearer. In order not to emphasize a long neck, the line may be slightly raised at the front, or for a short neck it may be lowered. A neck line should not be too low at the back no matter what the length of the neck.

If the tight-fitting sleeve has been drafted and cut in material it may be basted into the waist and fitted at this time. (For directions, see *Tight-Fitting Sleeve*.)

V. TIGHT-FITTING SLEEVE

I. *Drafting the Pattern*

REGULATION MEASURES

(1) Armseye....................................15″
(2) Length outside, shoulder to elbow.............13″
(3) Length outside, elbow to wrist................10″
(4) Size at elbow.............................11½″
(5) Size at hand.............................. 7½″

Individual measures are taken as described in the preceding chapter.

The tight-fitting-sleeve pattern is composed of two pieces, the upper and the under sleeve. The upper is drafted first and the under is based on it and drawn inside it. A piece of paper 27″ in length and 18″ wide is necessary.

In the upper left-hand corner of the paper two lines at right angles and of indefinite length should be drawn. The work then proceeds as follows:

UPPER

(1) *To Determine the Top of the Sleeve:*

AB = ½ the armseye measure, marked on the horizontal line.

B = Line drawn at right angles to the line AB, paralleling the vertical line A.

AC = ⅓ of the line AB. Draw a line at right angles to the line AB, paralleling the vertical lines A and B.

CD = ¾″ above point C, a dotted line drawn at right angles to the line AB. (This amount varies with fashion. If sleeves are large the amount should be larger.)

AE = ⅕ the length of the line AC, measured down on the vertical line from point A.

EF = ¾″ out, at the left of point E, a dotted line drawn at right angles to the line AE.

BG = BC, measured down on the vertical line from point B.

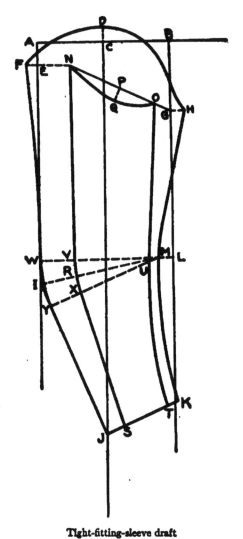

Tight-fitting-sleeve draft

GH = ¾″ out, at the right of point G, a dotted line
 drawn at right angles to the line BG.

FDH = Connect these points with a curved line to form
 the top of the sleeve.

(2) *To Determine the Outside Seam:*

EI = Length of sleeve from the shoulder to the elbow,
 marked on the line A.

FI = Line curving from point F, meeting the line A half-
 way down and continuing straight to point I.

IJ = Length of sleeve from the elbow to the wrist.
 The direction of this line is determined by
 placing the corner of the square on the line C,
 with the inch-mark for the correct length fall-
 ing on the vertical line A at point I.

(3) *To Determine the Line at the Bottom:*

JK = With the square in the same position, measure
 to the right from point J, half the hand meas-
 ure plus 1″, and mark the point K.

(4) *To Determine the Inside Seam:*

GL = ½ of the line GK, marked on the line B.

LM = 1″ in, to the left, from point L, a dotted line
 drawn at right angles to the line BL.

HMK = Connect these points with a curve to form the
 inside seam-line.

UNDER

(1) *To Determine the Top of the Sleeve:*

EN = ½ of the line AC, a dotted line measured in at
 right angles from point E.

NG = Connect these two points with a straight line.

GO = 1″ in, to the left, from point G on the line GN.

NP = ½ of the line NG.

PQ = ¾″ down from point P, a dotted line drawn at
 right angles to the line NG.

NQO = Connect these points with a curved line to form
 the top of the sleeve.

(2) *To Determine the Outside Seam:*

IM = Connect these two points with a straight line to
 indicate the line of the elbow.

IR = EN, measured in, to the right, on the line IM.

JS = 1¼″ measured in, to the right, from point J on
 the bottom line JK.

NRS = Connect these points to form the outside-seam
line.

(3) *To Determine the Line at the Bottom:*

KT = ¼″ measured in, to the left, from point K on the
bottom line KJ.

ST = Bottom line of the under part of the sleeve.

(4) *To Determine the Inside Seam:*

RU = Remainder of the elbow measure; that is, the
line RU equals the elbow measure minus the
line IM.

OUT = Connect these points with a curve to form the
inside-seam line.

This draft gives a plain two-piece sleeve with little fulness.

II. Fitting the Pattern

After the drafting is finished there are certain directions to be
followed preliminary to the cutting of patterns in material for
fitting.

(1) *Testing the Draft.*—The draft itself should be tested to the
measures used: (*a*) for the full length of the sleeve on both the out-
side and inside seams; (*b*) for the length of the sleeve from the
shoulder to the elbow on the outside seam; (*c*) for the size at the
top in relation to the size of the armseye; (*d*) for the size at the
elbow and the wrist. If these do not correspond to the measures
taken they should be corrected as necessary.

(2) *Seam Allowances for a Paper Pattern.*—In general, it is much
simpler to use a paper pattern which is cut out exactly along the
drafted lines than one which has the necessary allowances added
to it for all seams. If it is thought necessary to add them, how-
ever, they should be as follows: 1″ on all lengthwise seams; ¼″
at the top; ¼″ at the bottom.

(3) *Marking the Paper Pattern.*—The use of the pattern is much
simplified if, in cutting it out, the under sleeve is traced on another
sheet of paper so that the two pieces of the sleeve are entirely
separate. Before doing this, however, tracings and marks should
be made to indicate the proper direction for the straight thread of
the material, the arrangement of fulness at the top and at the elbow
of the sleeve, and the point of joining on the inside seam of the
sleeve. (*a*) The vertical line C in both the upper and under sleeve
indicates the direction for the straight thread of the material and
should be distinctly traced. (*b*) In the top of the sleeve the gather-
ing should extend from point F around the top of the upper part of

the sleeve to within 1⅛″ of point H. Marks should be made to indicate these two points. (*c*) The outside-seam line, FIJ, of the upper is longer than that, NRS, of the under; the extra length is arranged at the elbow. To indicate the points at which these seams should be joined at the elbow, radiating lines are drawn from point M touching both seam-lines. The exact direction of these lines is found by measuring up from point R 1″ and marking point V, and measuring down from point R the same distance and marking point X. Lines are then drawn from point M through these points and continued to touch line FIJ. These points may be marked W and Y. Marks should be made on the paper pattern to indicate the four points VW and XY. (*d*) Points M and U should also be marked on the inside seams of the sleeve to show the point of joining there.

(4) *Placing the Paper Pattern on the Material and Cutting.—* Economy of material should always be considered in placing a pattern. When possible, the corresponding pieces of the two sleeves should be cut at once. For a pattern, however, only one sleeve is necessary.

Both the upper and the under should be placed on the lengthwise straight of the material. After the sleeve is arranged with attention to the straight of the material the seam allowances should be measured and the pattern pinned in place and cut. The seam allowances for the cloth pattern are the same as those already suggested for the paper; that is, 1″ on all lengthwise seams; ¼″ at top; ¼″ at bottom.

(5) *Marking the Cloth Pattern.—*The cloth pattern should be marked to indicate the exact size of the pattern as drafted, to give the correct seam-lines. A tracing-wheel may be used. Both pieces of the sleeve should be traced around and the elbow marks on all four seams and the points for gathering indicated.

(6) *Basting the Pattern.—*As has been said, for this fitting only one sleeve, the right, is necessary. The fit of a sleeve depends very largely on the way it is put together. The inside seam should be basted first. The two pieces of the sleeve should be placed flat on the table, with the under next the worker and the inside seams together. These two seams should fall together without difficulty. Points U and M at the inside elbow should be matched and pinned and the seam pinned from this point up and down.

In basting the outside seam the sleeve should still be kept flat on the table; the upper sleeve is turned over until its seam lies along the seam of the under. This seam should be pinned at the elbow first, matching point V with W and Y with X. This holds

in the additional fulness of the upper. The wrist and the top should next be pinned, working from the elbow up and down.

When these two lengthwise seams are finished the sleeve should lie flat and smooth without twisting; if it does not, the drafting and cutting have not been correctly done and should be tested again. It is useless to try fitting a sleeve which, when basted, does not lie perfectly flat.

(7) *Fitting the Pattern.*—Before the sleeve is fitted it should be gathered at the top between the indicated points and basted into the waist. Its general fit and hang cannot be otherwise satisfactorily determined.

(a) *Gathering the Sleeve.*—The first row of gathering should be ¼″ in from the edge and the second ⅛″ in from that, to hold the gathers in place.

(b) *Pinning and Basting the Sleeve to the Waist.*—This is done in much the same way as for the shirt-waist sleeve.

For placing the sleeve in the waist the same rule should be observed. Using a point 1″ back of the shoulder seam, the armseye of the waist should be folded in half and the opposite point marked. This point indicates the location of the inside seam. The sleeve is then ready to be pinned in and basted. In doing this (i) the waist should be held with the wrong side and the underarm toward the worker. (ii) The sleeve should be drawn up into the armseye and the seam pinned to the point indicated. (iii) The under part of the sleeve should be pinned to the underarm of the waist, matching the armseye tracings of the waist and the sleeve. (iv) With the waist still toward the worker, the gathering-threads should be drawn up around the upper part of the sleeve until the sleeve fits the armseye. (v) With the waist still in the same position, but with the shoulder turned back so that the upper part of the sleeve can be more easily seen, the gathers should be adjusted. (vi) The centre of the sleeve and the largest amount of the fulness should fall over the shoulder-bone, which in most cases is from ¼″ to 1½″ forward of the shoulder seam. (vii) Any remaining fulness should be eased off to the front and back to the points which indicate the end of the gathering.

(c) *Fitting the Sleeve.*—The sleeve should be put on right side out, with the armseye seam turned back on the shoulder. The fit of the sleeve depends somewhat on the position of the line of the armseye at the shoulder. This changes as the shoulder of the waist is long or short, according to the demands of fashion. If the shoulder is short, more height in the sleeve may be required. This is secured by raising point D. The curve from point D to point H

may be too full in proportion to the length and cause a bulge in the sleeve at the front of the shoulder.

(*i*) If the sleeve is too long or too short, care must be taken in changing to make the alteration so that the proper position of the elbow is kept. Too short an elbow makes an uncomfortable sleeve. (*ii*) If the sleeve is too large around or too small, changes are easily made in the outside seam. In general, the inside seam of a sleeve is not touched; all alterations should be made on the outside seam.

(8) *Altering the Pattern.*—After the fitting and before removing the sleeve from the waist it should be marked so that it can be easily basted into the waist again with the proper arrangement of fulness. When the sleeve is taken out and the seams opened all required changes should be indicated with the tracing-wheel or colored cotton and the paper pattern altered to correspond. The paper pattern is to be kept for future use.

(9) *Rebasting the Pattern.*—If many alterations have been necessary the sleeve should be rebasted and placed in the waist, following the directions given for the first basting.

(10) *Refitting the Pattern.*—In refitting, the waist and sleeve should be put on as before, with the armseye seam of the sleeve turned to the shoulder. The sleeve should again be observed carefully as to fit and hang and any necessary changes made.

VI. Kimono Waist

I. Drafting the Pattern

REGULATION MEASURES

Length Measures—
 (1) Length of back.............................15″
 (2) Length of front...........................15½″
 (3) Length of underarm........................ 7½″

Width Measures—
 (1) Width of back..............................14″
 (2) Width of chest...........................14½″
 (3) Bust.......................................38″
 (4) Waist......................................26″
 (5) Neck.....................................13½″

Length of Sleeve—
 (1) Neck to wrist.............................28½″
 (2) Neck to elbow............................18½″
 (3) Size at elbow............................11½″
 (4) Size at hand............................. 7½″

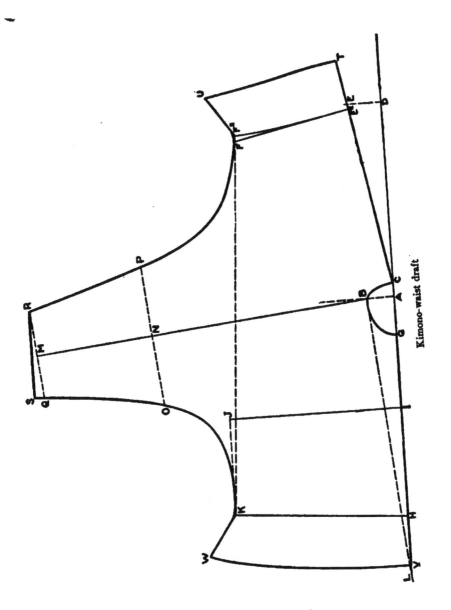

Kimono-waist draft

Individual measures are taken as described in the preceding chapter.

The kimono pattern is composed of one piece, which forms one-half the front and one-half the back and one sleeve. This should be made on a sheet of drafting-paper about one and a half yards in length.

Along the lengthwise edge of the paper, parallel to the worker, an indefinite line should be drawn. This horizontal line should be at least 45″ long, as both the back and the front are to be drafted on it. The work then proceeds as follows:

A = centre point of the horizontal line. From this point at right angles to the horizontal line draw a short dotted line.

BACK

(1) *To Determine the Neck Line:*

AB = ⅙ of the neck measure, marked on the dotted vertical line from point A.

AC = 1″ to the right of point A, marked on the horizontal line.

BC = Connect these two points with a curve to form the neck line.

(2) *To Determine the Centre-Back Line:*

CD = Length of back, measured to the right on the horizontal line from point C.

DE = 3″ in from point D. A dotted line drawn at right angles to the line CD. (The location of this point determines somewhat the length of the kimono over the shoulder from waist line to waist line. For a sloping shoulder the measure should be at least 4″.)

CE^2 = Length of back measure, a line drawn from point C toward point E. This forms the centre-back line.

(3) *To Determine the Waist Line:*

E^2F = ½ the width of back plus its one-half (that is, ½ of the result), a line drawn at right angles to the line CE^2.

FRONT

(1) *To Determine the Neck Line:*

·AG = ⅙ of the neck measure plus 1″, measured to the left of point A on the horizontal line.

BG = Connect these two points with a curve to form the neck line.

CBG = Complete neck line.

(2) *To Determine the Waist Line:*

GH = Length of front, measured to the left on the horizontal line from point G.

AI = ½ of the line AH. Draw a line at right angles to AH to indicate the bust line.

IJ = ¼ of the bust measure plus its one-half; that is, ½ of the result.

JK = The underarm measure plus ½", a dotted line drawn, to the left, from point J at right angles to the line IJ.

HK = Connect these two points to form the waist line.

(3) *To Determine the Sleeve:*

BL = With the corner of the square on point B and the 24" mark on the square touching an extension of the horizontal line AH at point L draw a dotted line.

BM = Length of sleeve from the neck line to the wrist, a line drawn from point B at right angles to the dotted line BL.

BN = Length of sleeve from neck line to elbow, measured from point B on the line BM.

ONP = Desired width of the sleeve at the elbow. A dotted line drawn at right angles to the line BM through point N, with an equal amount each side of point N. The line ON at the left of BM must equal the line PN at the right.

QMR = Desired width of the sleeve at the wrist. A dotted line drawn at right angles to the line BM through point M, with an equal amount each side of point M. The line QM at the left of BM must equal the line RM at the right.

KFF² = Connect KF with a straight dotted line and continue ½" beyond point F. The end of the line is marked point F². This line serves as a guide for the curving underarm seams.

E²F² = Connect these points with a slightly curved line to form a new waist line for the back.

F²PR = Connect these points with a curved line to form the underarm and sleeve seam of the back.

KOQ = Connect these points with a curved line to form the underarm and sleeve seam of the front.

QS = Extend the line KOQ ½″, ¾″, or 1″, to point S, so that the line connecting the points S and R, which form the bottom of the sleeve, will lie on the straight of the material.

SR = Connect these two points to form the line for the bottom of the sleeve.

(4) *To Determine the Basque of the Back:*

E^2T = 4″ measured down from point E^2 with the ruler placed on points CE^2T.

F^2U = 4″ measured down from point F^2 with the ruler placed on points BF^2U.

TU = Connect these points with a line to form the bottom of the back of the waist.

(5) *To Determine the Basque of the Front:*

HV = 4″ measured down from point H on the horizontal line.

KW = 4″ measured down from point K with the ruler placed on points BKW.

VW = Connect these points with a slightly curved line to form the bottom of the front of the waist.

In cutting the neck a new line should be made just inside point B to give a better curve.

When the bust is large in proportion to the width of back, the curve KOS will become too short for F^2PR. In this case increase the width of E^2F (the waist line of the back) to make the curves more nearly equal in length.

This draft gives a foundation or plain kimono waist with fulness at the waist and armseye.

II. *Fitting the Pattern*

After the drafting is finished there are certain directions to be followed preliminary to the cutting of patterns in material for fitting.

(1) *Testing the Draft.*—The draft itself should be carefully tested to the measures used and, if necessary, corrected. The following measures should be exact:

(a) Size of neck.

(b) Length of front and back.

(c) Full length of sleeve.

(d) Length of sleeve to elbow and to wrist.

(e) Size at elbow and wrist.

If any of these vary much from the required sizes, there has been a mistake in following the drafting directions which should be rectified before any more work is done.

(2) *Seam Allowances for a Paper Pattern.*—In general, it is much simpler to use a paper pattern which is cut out exactly along the drafted lines than one which has the necessary allowances added to it for all seams. If it is thought necessary, however, to add them they are as follows: 1″ on the underarm and sleeve seam; ¼″ at the neck.

(3) *Marking the Paper Pattern.*—After the pattern is cut out, if the seam allowances have been added to it, it is wise to trace with a wheel about the pattern to show the exact size of the draft. In addition, the waist lines should be carefully traced. If, as is general, the pattern has been cut out along the seam-lines, the only tracing necessary is that to indicate the waist line.

(4) *Placing the Paper Pattern on the Material and Cutting.*—Economy of material should always be considered in placing a pattern. The complete kimono waist must be cut in order to give a satisfactory fitting. Half the pattern does not give sufficiently exact results. The centre front should be placed on a lengthwise fold of the material, which brings a slightly bias edge at the opening of the waist at the centre back.

After the pattern is arranged with attention to the straight of the material the seam allowances should be measured and the pattern carefully pinned in place. The seam allowances for the cloth pattern are the same as those already suggested for the paper; that is, 1″ on the underarm and sleeve seam; ¼″ at the neck. In addition, however, there should be 1″ added at each centre back in order to fasten the waist for fitting. When these allowances have been measured the waist may be cut out.

(5) *Marking the Cloth Pattern.*—The cloth pattern should be marked to indicate the exact size of the pattern as drafted, to give the correct seam-lines. A tracing-wheel may be used, supplemented, where necessary, by colored bastings.

A tracing should be made to indicate: (a) the centre-front line, to aid in fitting; (b) the underarm and sleeve seam; (c) the centre-back lines; (d) the waist line; and (e) the neck line. In addition to these tracings, colored bastings should be placed in the centre-front line, waist, and neck lines. These bastings emphasize the direction of important lines during the fitting and aid in determining their correct location.

(6) *Basting the Pattern.*—All basting should be done with white thread and not with colored, which is used only in making altera-

tions and in marking. There is but one seam, the underarm and sleeve. It should be pinned at the waist line and wrist and any surplus fulness should be arranged at the elbow and directly under the arm. The centre-back lines should be turned on the tracings and basted flat.

(7) *Fitting the Pattern.*—Before the waist is ready for a fitting it must be gathered at the waist line and a belt prepared.

(a) *Gathering the Waist.*—Two rows of gathering should be put in around the entire waist, one just at the waist line and another about ¼" above. This makes the arrangement of the fulness into the belt a very simple matter in the fitting.

(b) *Making a Belt.*—For this, non-elastic tape ¾" in width may be used, or a band of the material itself. It should be cut 2" or 3" longer than the waist measure to allow for lapping and pinning at the centre front.

(c) *Fitting the Waist.*—This waist is an exception to the general rule of fitting all garments right side out. Because the seam is very much curved, the fitting is simpler with the seam outside. Consequently, for the first fitting, the waist is put on wrong side out. Only one side, the right, is fitted, unless the right and left sides of the wearer vary greatly. In this case time is saved by fitting the entire waist.

The waist should first be settled to the figure and pinned together at the centre back, exactly on the indicated lines. The belt is then put on with its lower edge just at the normal waist line of the figure, even though the line of gathering in the waist may not be correctly placed. The centre mark of the belt should be placed exactly at the centre-front line of the waist. The fulness is regulated after the direction of the underarm seam is determined. This seam should fall from the centre underarm straight down to the waist. Occasionally it is better if it is allowed to slant slightly toward the back.

The extra fulness at the waist may be placed somewhat as desired. There are general directions, however, which it is wise to follow. In front the gathers should be spread rather than drawn together at the centre in order to give width. It is a good plan to distribute the gathers across the back to within about 2" of the underarm seams, to avoid an evidence of much fulness. If the waist is bloused slightly it gives a straighter and more becoming line to the back. In attaching the belt to the waist sufficient length of material should also be left under the arm to allow free movement of the arm. This should be tested before pinning too carefully.

In fitting a kimono waist fewer changes can be made than in

a waist of any other design, because the shoulder seam, which usually plays an important part in the fitting, is lacking.

(*i*) *Shoulder.*—In general, a kimono waist is not becoming to a very sloping shoulder, and for such a figure it cannot easily be made to fit well. In the majority of patterns and drafts there is too much fulness over the shoulder, and, once the kimono is cut, but little of this fulness can be removed. As suggested in the draft, this defect may be somewhat remedied by lengthening the line DE, thus making the back more bias and giving a waist with less length over the shoulder. Sometimes a little fulness may be removed from the shoulder, at the back, by drawing the material toward the centre back and taking out the surplus by changing slightly the centre-back line. Care must be taken not to twist the sleeve and pull it out of place.

(*ii*) *Underarm.*—Fulness under the arm is a different matter and may generally be removed by changing the line of the underarm and sleeve seam. Here, also, care must be taken, as, if too much material is removed, the waist is too narrow through the bust line.

(*iii*) *Sleeve.*—The length of sleeve is easily adjusted; it should be given ample length, as in movement it is somewhat drawn up from the hand.

(*iv*) *Neck.*—A standing collar or collar-band is practically never used on a kimono waist. In consequence, the line of the neck should be carefully considered and cut to be becoming to the shape of the face and neck of the wearer. A round line, close to the neck, is generally unbecoming. All kimonos, when worn, have a tendency to drop away at the back of the neck and at the shoulder. In cutting, the line should be high at these two points and then shaped to a point or square or curve as desired at the centre front. If the waist draws at the neck it may be necessary to slash it slightly to allow it to settle to the figure better and prevent a slight drawing toward the shoulder.

The kimono should not be overfitted; its success lies in its freedom of line and in the ease of its fit.

Before it is taken off it should be carefully inspected as a whole and all the necessary changes indicated by pins, tailor's chalk, or pencil.

(8) *Altering the Pattern.*—After removing the waist all required changes should be marked, on the side just fitted, with the tracing-wheel or with colored cotton. Care should be taken to keep the original lines sufficiently distinct to have them serve as guides in marking the unfitted half of the waist. The seams should then be opened and the two sides of the waist placed together, pinned, and the corresponding sides marked.

If a new neck or waist line has been made, colored cotton should be used to indicate it. The tracing-wheel may be used for changing the seam-line, unless it can be too easily confused with the old tracing and rebasting made difficult. All changes should be indicated on the paper pattern, which is to be kept for future use.

(9) *Rebasting the Pattern.*—If many alterations have been made the waist should be rebasted, following the directions given for the first basting; the belt should be attached and the whole should be put on for final inspection.

(10) *Refitting the Pattern.*—In refitting, the waist should be put on right side out. If the left side requires any changes, because of unevenness in the figure, they should be made now and the waist again generally inspected for fit and for line.

CHAPTER VI

THE USE OF COMMERCIAL PATTERNS

One method of making patterns has already been discussed, that of drafting to regular or individual measures. There are two others: one, modelling on the form, or designing; and the other, the method very frequently used, that of cutting from ready-made or commercial patterns.

There are many different makes of patterns on the market to-day. ·Some are undeniably poor; others are uniformly · good. It is always wiser to purchase from a maker who is well known and whose patterns, tested by long use, are constantly being improved and changed to meet the demands of fashion.

I. GENERAL PRELIMINARY DIRECTIONS

Before a pattern is cut in material there are certain things to be done, such as the careful reading of directions, the testing to individual measures, and the preliminary fitting.

1. **Reading Directions.**—Many patterns are discarded as useless merely because the directions either were not read or were not understood. While patterns and the directions for their use may vary with different makes, they all indicate such necessary details as the number of pieces, the amount of seam allowance, notches for joinings, and perforations for straight of material. All the pieces of the pattern should be carefully looked over and a general idea formed of the way in which they go together before any further steps are taken.

2. **Testing Patterns.**—The pattern must next be tested and altered to individual measures. Good patterns are no longer drafted to a "perfect" size, but are based on what are estimated to be average measures. This average is

secured by the careful taking and comparing of the measures of very many different figures. In spite of this, however, the patterns often need at least slight alterations.

If a pattern is tested to individual measures and altered before it is cut in material, it frequently saves much time, trouble, and material. If cut in material first there are often necessary alterations which cannot be made, even by the most skilful fitting, without affecting the appearance and style of the whole garment. For this testing accurate individual measures are necessary.

Some patterns give a list of the regulation measures to which they are cut; if so, these may be used to compare with the required individual measures; otherwise the pattern must be measured before the necessary alterations are made.

3. **Fitting Patterns.**—There may be in a pattern one or two necessary changes which the testing will not show. For instance, the slope of the shoulder is planned for the average shoulder, but there are very sloping and very square shoulders. To the experienced the general shape of the pattern at the shoulder will mean much; to the inexperienced it will mean nothing; neither will any necessary change be shown in a comparison of measurements. Therefore, in addition to the test by a comparison of measurements any pattern which is used for the first time should be cut in inexpensive materials for a preliminary fitting.

4. **Cutting and Placing All Patterns.**—In cutting any garments the corresponding notches in the patterns, which usually show points or seams to be joined, should never be made in the material, but their position should be marked by a few colored threads or tracings. Too generous notches, sometimes made by a slip of the scissors, may make serious difficulty. In placing the pattern on material great attention should be paid to the tracings or series of marks which are used to indicate the "straight of material" or the way in which the pattern is to be placed on the cloth. This is exceedingly important, as no garment can be made to fit well or hang correctly which has been cut without proper attention to the direction of the threads of the fabric.

All seam-lines should be marked, according to the material, with tracing-wheel, chalk, or bastings and the seam allowance added in the cutting. The traced seam-lines indicate the line of bastings and, consequently, play an important part in the fitting.

II. Special Directions

1. **Shirt-Waist Pattern.**—Shirt-waist patterns are purchased according to the bust measure. This is not always an indication, however, that the neck, armseye, and length measures will correspond to the required individual measures. The alteration of a pattern is usually very simple. There are three pieces to consider: the front, back, and sleeve. Any other pieces, such as collar-band, cuffs, and plackets, are determined later by the choice of the wearer or are dependent for size on the changes made in the waist itself.

(1) *Testing.*

(a) *Waist.*—To test the pattern the shoulder seams of the back and front should be pinned together on the tracings. The neck should be measured and if found too large the line may be altered by raising it slightly; that is, by making a smaller curve. It is better to make it too small than not small enough, as it can easily be cut out a little in fitting. With the seam still pinned, the armseye should next be tested. If it is too large it can be changed by raising the line under the arm on both the front and back of the waist. It is better to add more to the front than the back. If it is not quite right then, it can be changed still more by taking in at the underarm seam in fitting. If the neck and the armseye of the pattern are too small they can be satisfactorily altered in the fitting and no preliminary change need be made. The width of chest and back must be tested. Although the bust measure is correct, these widths may be incorrect. They can vary greatly with different individuals. If the back of the wearer is wide or a little round, more width is often needed in the pattern. A too narrow back in a waist gives an ugly arms-

eye line and a pinched look to the figure. This may be remedied generally by straightening the line from the shoulder toward the underarm to give added width at the armseye.

If the waist is too wide either at the front or the back, the bust full, and the shoulder long, it may easily be changed by taking a tuck from the centre of the shoulder to the bottom of the waist. On the other hand, if the waist is too narrow, width may be added by opening the pattern along the same line and inserting a piece. It is seldom wise, however, to try to use a pattern which has a small bust measure. All the measures will probably be correspondingly small and require much changing. It is important to realize that there should never be any attempt to make alterations at the centre front or back in a waist which is too small or too large in the bust. As suggested, it must be done on the shoulder; otherwise it will change the neck size and cause difficulties which fitting cannot remove.

The waist line of the shirt-waist may be regulated when the belt is put on in the fitting or it may be established in the testing.

(*b*) *Sleeve.*—The shirt-waist sleeve, like the shirt-waist, is not difficult to alter. Fulness may be taken out by laying a plait or tuck its full length in the upper side of the sleeve, as that will not affect its fit; or, if the sleeve is too small for the prevailing style, it may be opened along the same line and fulness added. In either case the curve at the top of the sleeve should be corrected. It may be shortened or lengthened in the same way, taking out or putting in material above or below the elbow according to the length measures of the arm.

(2) *Fitting.*—When the testing has been done and the changes made, the patterns should be cut in material for the trial fitting. In the fitting the results of the testing may be seen and other necessary changes made.

One change which is often necessary and has already been mentioned is the adjusting to square or sloping shoulders. Drafts and patterns are made to fit shoulders of medium

height. If shoulders are square the waist will wrinkle across the front and back from shoulder to shoulder. Letting out the shoulder seam near the armseye will remedy this, but it will also enlarge the armseye; consequently it is not safe to do this. The correct change is to take up on

Adding fulness to a shirt-waist sleeve and correcting
its curves

the shoulder seam at the neck. This makes the neck too small, but it may be cut out both at the front and at the back. This will remove the wrinkle without changing the fit elsewhere.

If the shoulders are sloping the wrinkle will run from the neck at the shoulder seam slanting to the armseye. For this the shoulder seam should be taken up at the point of the shoulder where there is too much material and the

armseye, which is usually made too small, cut out near the underarm.

For an exceedingly full bust, waists are often improved by lowering the front a little, perhaps an inch, at the underarm seam and sliding the front shoulder seam on the back shoulder seam so that it extends beyond it at the point of the shoulder. This change makes the front of the waist too low at the neck and too low under the arm, but arranges the fulness over the bust to better advantage. As can easily be seen, this change must be made in a fitting where trial material is being used. It necessitates adding material to the front of the waist under the arm and also at the neck.

2. **Tight-Fitting-Waist Pattern.**—Tight-fitting-waist patterns are purchased according to the bust measure. For a fitted lining more changes may be required, and, as the pattern is complicated by having more pieces, the changes may not seem quite as simple but are not in reality difficult. There are seven pieces in the pattern if the sleeve is included—the centre and side fronts, the centre and side backs, the underarm, and two sleeve pieces, the upper and the under.

There are four changes which may be necessary in this waist pattern in addition to those already suggested for the shirt-waist. These are as follows: to increase or decrease the size at the waist line—this is very important, as the waist must fit closely; to lengthen or shorten the length of waist; to increase or decrease the size of the bust; to increase or decrease the length of the back for round shoulders or for a very short, straight back. The necessity for the majority of these changes may be determined in the testing.

(1) *Testing.*

(a) *Waist.*—The neck and armseye lines and the width of chest and back are tested in this as in the shirt-waist.

(i) *Size at Waist Line.*—If the waist requires alterations at the waist line the changes are evenly made on each seam unless the proportion of the pieces is not suited to the individual, in which case an uneven amount may be removed.

(*ii*) *Length of Waist.*—In testing a pattern for length it is necessary to use the individual measures for length of front, length of back, and underarm. It is usual to take out or add length to a waist below the bust line, about

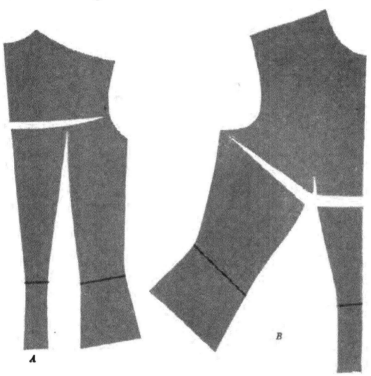

Adding length to (*A*) the back and (*B*) the front of a tight-fitting waist

2½″ or 3″ above the waist line. If the pattern is, for in-stance, 2″ longer than the required measure, a plait 1″ wide should be laid in each piece. This will take up the surplus 2″. If it is 2″ too short the waist may be opened on the same line and 2″ added. It may sometimes happen that the difference in length is above the bust and that the underarm measure is correct; in this case the change should be made only on the centre and side fronts about 2″ below the neck line.

(iii) Size of Bust.—If the individual is between sizes, and it is necessary to increase or decrease the bust measure to make the entire waist larger or smaller, the changes are made evenly on each piece. It is wise, however, before doing this to test quite carefully for width of back to determine if more or less fulness is needed at the back or front.

To change for an extra-large or a small bust is a different matter. This does not mean increasing or decreasing in size around the pattern; it means adding or taking away fulness in the length of the front at the bust line.

To add length, the centre front is opened at the bust line and the two sections separated the necessary amount, while the side front has a bias slash which runs from the bust line toward the armseye but does not reach it. As the slash does not completely divide the side front, the pattern is swung out a little toward the armseye to open the slash and the material added in that way. If there is a tendency to stoop, or the bust is small, the fulness is removed over the bust by tucks which are taken in the same way. The tuck in the side front tapers to nothing as it nears the armseye.

(iv) Length of Back.—Practically this same kind of change is occasionally needed in the back of the tight-fitting waist for a person who stoops or stands too erect, whose back is consequently too short or too long. For the round shoulders material is added by having the centre back opened straight across about one-third of the way down and the side back slashed and opened from the same point nearly across to the armseye seam. For the short back the material is removed by laying tucks along these same lines.

After these tucks or slashes have been made in any part of the patterns the edges of the pieces should be straightened and corrected so that a satisfactory pattern could be cut for a fitting.

(b) Sleeve.—The fitted sleeve is treated in the same way as the shirt-waist sleeve for alteration, both in length and fulness, except that more care must be exercised as to the exact change above and below the elbow. The elbow of a tight sleeve must be correctly placed to wear well, look

well, and feel comfortable. Many arms are short from the elbow down and of average length to the shoulder, or vice versa. In such cases the sleeve may need changing in only one place, which must be ascertained by a careful comparison of measures.

(2) *Fitting.*—When the testing has been completed and the changes made, the patterns should be cut in material for the trial fitting. In the fitting the results of the testing may be seen and other necessary changes made. It is in the fitting, as in the shirt-waist, that the pattern must be adjusted to square or sloping shoulders.

3. **Skirt Pattern.**—Skirt patterns vary greatly as to the number of pieces included. This variation is due to fashion, which may dictate at one time eleven or fifteen gores and at another only two or four. Not long ago many skirts were made of only one width of material. Such patterns, however, require actual draping for adjusting to the proper size and can hardly be regulated by any measurements. All skirt patterns should be purchased according to the hip measure, which is taken around the large part of the hip about six inches down from the waist line, an easy measure. In locating this hip line the measure should be taken down over the hip and not at the centre front or back.

Before making alterations or accurate tests or giving any attention to details in the pattern, it is a good plan to pin the gores of the skirt together and put it on in order to judge its general appearance. Skirt-fitting is difficult, and if the pattern does not fit and hang fairly well it is much better to discard it entirely and try one of another make. Too many alterations will, usually, spoil the size and shape of the garment.

(1) *Testing and Fitting.*

(a) *Size of Waist.*—The size of the waist should be tested. If it is only a little too large or too small the simplest method is to take a deeper or smaller seam on each gore in basting and leave whatever else may be required until the fitting.

If the waist is much too large or too small it is better

to regulate the pattern itself. Special attention should be paid to maintaining the good shape and proportion of the gores. In regulating a skirt pattern the figure of the wearer should be carefully considered. A pattern may be made to fit yet be unbecoming. Two figures may measure the same but be quite unlike in shape; for instance, there is the rather flat figure with fulness or width at the hips and the round, full figure—it may be full either at the back or in front—with small hips. Accordingly, the pattern must be made to suit the individual figure, adding extra size or removing it to give not only a good-fitting skirt but becoming lines. General directions are difficult for such alterations. They require the discrimination which comes from careful observation and much practice. Good lines in a gored skirt have much to do with making a figure appear well proportioned. However, for the many figures which are not unusual, but may not be exactly regulation size at the waist in proportion to the hip, the changes are simple.

The waist of the pattern should be measured and compared with the individual measures. If it is found too small the amount to be added may usually be evenly distributed on each side of each gore, tapering to nothing at the hip line. Occasionally, as in a six-gored skirt, which has a panel front and back and two side gores, it may be found better not to change the width of the panels but to add the necessary amount to the gores on the seam over the hip. In a skirt of this kind the side seam should fall just back of the hip, straight to the floor, so that it may not be seen from the front. The line of this seam should be carefully observed when any changes are made.

(b) *Fulness at Front, Back, or Hips.*—Much difficulty is often found in changing a skirt pattern to suit the figure which has unusual fulness in front. This fulness usually causes the skirt to stand out at the centre front. To avoid this a tuck may be laid along the hip line, about ¼″ deep, beginning at the seam in front of the hip and tapering to nothing as it nears the front. If, as is often done, the whole skirt is lifted at the back in an attempt to take out

the front fulness, all the seam-lines will be wrong and too much fulness drawn to the back. After the tuck is taken the seam must be straightened and extra material added at the bottom to give the required length. If the figure is very full it may be found necessary to add length and size at the top of the front and side-front gores. If the skirt stands out at the side because of very large hips, the tuck may be taken back of the hip, tapering toward it to make the skirt hang straight.

(c) *Length of Skirt.*—In lengthening or shortening skirts the change should always be made a few inches below the hip line. The same procedure is followed as in waists: tucks are laid parallel to the hip line to take out extra length or the skirt is slashed along the same line and length added.

(d) *Fulness Around the Bottom.*—If fulness is to be taken out around the bottom, in skirts with gores it is generally done on the bias side of the gore.

CHAPTER VII

PATTERN-DESIGNING AND DRAPING

Designing involves not only good technique but a knowledge of textiles and their manufacture; of historic costume, its value and use; and, to as great a degree, a working knowledge of the rules of design and color in their direct application to costume. In addition to this definite technical knowledge and much broad general information in allied fields, there must also exist an indefinite something which Mr. Paul Poiret has called a "sort of feeling." A detailed consideration of all the necessary elements is impossible in this book. An effort has been made, however, to present a few essentials regarding technique, textiles, and historic costume. In this chapter directions are given for the preparation and use of the dress-form and for some draping problems; a few general suggestions are also made for the critical study, discriminating and thoughtful observation, and research necessary to attain the appreciation and right feeling which, with much practice, form the basis for good work in design. Without this *feeling* and true appreciation successful designing is impossible. But while directions may be given for securing much of the required information, for that more intangible but even more necessary factor, feeling, it is impossible to do more than indicate in a general way various subjects which should be taken up and work which should be done to form the requisite background or base of supplies.

One of the most important factors in successful and original designing is the critical faculty. Thoughtful discrimination, which is appreciation, may be developed only through constant, conscious, analytical observation. It is really the power to see with the mind what is constantly presented to the eyes, to see not only that a costume, a

picture, a statue *is* good or bad, but *why* it is so. Only after such searching analysis does the critical faculty come into existence; nor can it function without a background, a base of supplies from which to draw endless examples for comparison and constructive criticism. To establish a background extensive knowledge of what has already been done in art is necessary, and especially in art as applied to costume. "Contact with the best works of art is an essential part of art education, for from them comes power and the stimulus to create." Costumes have been made and worn for many thousands of years. Nothing entirely new is conceived; the old serves as an inspiration and lends itself by skilful adoption or adaptation to meet any modern need. Consequently, these old costumes, of which there are numberless records, must serve as the treasure-house for the designer. These records exist not only in books on historic costume, which are somewhat difficult of access to the majority, but also, with the added charm of the artist's conception, in the costumes of practically all centuries which are presented copiously in sculpture, paintings, and engravings.

At the present time reproductions of many of these works of art and of many costume prints may be obtained without difficulty and at small cost. There are those which the newspapers and fashion magazines frequently present with their current fashions. In general, these are copies of the costumes of the earlier centuries which are most directly influencing modern costume at the moment. Inexpensive post-cards, copies of costumes, of portraits or statues, are sold in shops and in museums. Prints are issued in great numbers and at a minimum cost by such firms as the Perry Picture Co. and the Bureau of University Prints. Catalogues of these prints may be obtained upon request.

A collection of all such illustrative material should be made and, if arranged according to design or period in a scrap-book, proves of the greatest use.

Before the designing collection can be considered complete, representative textile fabrics should also be carefully

chosen and classified according to texture, flexibility, or wearing quality.

While many books on historic costume are too expensive and too difficult for the majority to procure, inexpensive reprints may frequently be obtained. Second-hand copies of originals may be purchased at sales if the market is watched. The regular and special catalogues of firms in large cities in America and Europe are always sent upon request, and by a careful perusal of these a good, if small, library may be selected.

The imagination is greatly stimulated by visits to the theatre and opera, where it is possible to observe not only faithful reproductions of attractive adaptations of period costume, but also skilful and extremely artistic color combinations. Nothing which stimulates the creative power should be overlooked in the training for designing.

The same conscious and analytical observation which is required in developing the critical faculty is as necessary in determining all the practical working details of costumes which are constantly seen by the worker in everyday life—such details as the grain of the material, the keynote to a successful execution of any design; the location of the necessary seams and openings; the finishes of all the edges, and the detailed arrangement of the decoration. Each part is an important factor in the making of the whole, and no detail, however minute, should escape the discriminating eye of the designer. Any observation is of little value which does not include a decision on the worth of the design and an analysis of the parts in which its real value consists.

In choosing a design for a costume there are many factors to be considered if it is to fulfil its purpose satisfactorily. The purpose of a costume is briefly to serve as a suitable covering for the body. "Right dress is, therefore, that which is fit for the station in life, and the work to be done in it, and which is otherwise graceful, becoming, lasting, healthful, and easy; on occasion splendid; always as beautiful as possible." *

* " Arrows of the Chase," J. Ruskin.

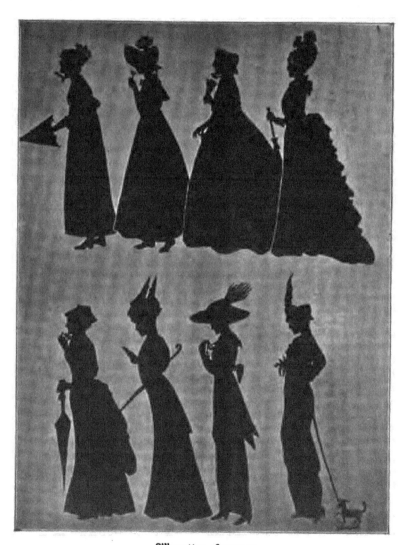

Silhouettes, 1812–1912

The individual—that is, the human factor and not the prevailing fashion—should be the dominant note in any scheme of costume. Costume should be appropriate. No design nor material should be chosen which is not suited to the intended purpose and does not bear a general relation to its surroundings or setting. All garments should allow perfect freedom of action. They should not in any way impede the movement of the entire body nor interfere with its exercise. The most artistic costume is that which indicates and in general follows the leading lines of the figure. No costume can be really graceful or beautiful, though it may be considered fashionable, interesting, or picturesque, which perverts the natural outline of the figure by the addition of various pads, humps, and puffings. In the designs it is usually possible to accentuate or emphasize the good points or lines of the figure and make the less desirable ones inconspicuous. To do this successfully it is necessary to give the silhouette careful consideration. The general scheme of the costume, with all details eliminated, should first be outlined and chosen. This will usually give greater consistency to the whole costume and bring it into closer relation to the figure of the wearer.

A costume should be made not only to give freedom of action to the body, or a graceful interpretation of its outline and movements, but it should also express the individuality and the personality of the wearer. This is a difficult problem, and unless the good taste of the designer is exercised the results may be an eccentric representation, inartistic or even grotesque. The result may be equally grotesque if no allowance is made for individuality. The latest fashion is often worn without any thought as to the fitness of that fashion for a particular personality. It is also a mistake to assume that a costume becoming to one person will necessarily be attractive on another and to choose a costume on that basis.

It is the skilful designer who detects and appreciates the good qualities, and emphasizes them, and yet makes the costume sufficiently fashionable to be inconspicuous. It is

equally unfortunate to be too much out of fashion. Both extremes lead to conspicuousness.

Simplicity in costume, in line, and in decoration cannot be overemphasized. Overelaboration and profuse decoration in general mark the work of the amateur. Mr. Paul Poiret has said that he has formulated only two principles in his art: the search for greater simplicity and the search for original detail. These both imply study and research in design and in historic costume. As a stimulus for original detail there must be constant contact with the best that has already been created both in design and in the costume of past centuries.

To secure good design there must be a general knowledge, simple yet workable, of certain fundamental rules in art governing line and color. From the point of view of design a dress may be considered as a composition. It is made up of lines, some necessary in the actual construction, others added purely for decoration. It has also color, the use of which involves not only the question of harmony but that of the proportionate amount to be used as well as its placing. Both these subjects are too complex and too important to be dealt with in any detail here. A few suggestions for line design are given, but they can prove of no value unless supplemented by the careful perusal of books by well-known masters of line and a study of fine old portraits, Greek statues, etc. Color is too difficult and intricate a subject, and too many factors are involved for more than a passing notice. General suggestions are in too many cases more harmful than helpful when adopted by the beginner. Careful study and observation of fine paintings, Japanese prints, etc., are absolutely necessary.

In all designs there should be unity; that is, there should be such a combination of the various parts as to give one general harmonious effect. All the lines of a costume should so work together that the design presents at once the one main or controlling idea underlying it. It should impress the beholder as the expression of one thought, not in fragments but unified.

Good proportion in a costume, as in a picture, is secured

by the correct arrangement of line. Again unity is the first consideration. There must be some general movement or rhythm of line. A repetition of lines or shapes, if well done, usually makes rhythm.

But repetition of itself does not create beauty; there must be fine spacing and harmony of line in addition. The chief danger in such an arrangement of line is monotony. The most usual illustrations of repetition in line are found in the decoration of shirt-waists, when lengthwise hems and plaits and tucks are used, and in skirts when a hem and tucks are placed at the bottom. In planning a shirt-waist, for instance, if the tucks are of the same width as the hem of the opening, the result is uninteresting. In any arrangement of tucks it is usually better to group the tucks and repeat the groups rather than to repeat the separate tucks.

While plaiting has repetition of line because of its movement when the figure is in motion, there is additional play of line and a constant change in the light and shadow which prevents any monotony.

Splendid examples of rhythmic arrangement of lines are to be observed in architecture. There are many buildings in which the height is divided into spaces by lines of windows or definite decorations and in which columns of good height are so placed as to give the desired effect of lightness, of space, of dignity, or solidity. A careful observation of such effects will be most helpful and suggestive.

For the amateur it is usually safer to try only bisymmetric line arrangement. The even balance of line which this gives produces the effect of completeness. Variation or an unbisymmetric grouping requires great skill and the touch of a master of line.

Too many lines in opposition give an effect of violence which may be counteracted by the introduction of a few curved lines. A design which has lines placed in opposition requires, in general, skill in spacing, a careful choice of texture, and a good silhouette upon which to base the work. A common illustration of such an arrangement is found in the lengthwise straight box plait, or fastening, with a straight belt line or a straight yoke line placed at right

angles or in opposition to it. On a well-rounded figure of graceful outline such a placing of lines serves to enhance and set off to best advantage the curving lines of the silhouette. The use of the same lines for a flat figure, angular in outline, emphasizes the angularities and gives an unfortunate effect.

Designs in which there is a gradual transition from one line to another are more generally becoming. In such designs one line grows out of another and all corners or sharp angles are replaced or softened by curving and slanting lines. In this method the square yoke line is replaced by slanting or curving lines which flow into a straight centre-front line. The waist line, in turn, is curved rather than straight; such arrangements, in which sharp angles and contrasts are avoided, soften the outlines of the angular figure and enhance the curving lines of the more rounded silhouette.

In many designs certain lines are given special emphasis. This is frequently done to bring into prominence some good points of the figure. All the other lines of the design should be arranged to be in harmony with those main lines. They should not detract in any way from the central idea, but should be subordinated to it and should supplement it in such a way as to give added emphasis.

Of equal importance with the line arrangement are the spaces formed by these lines. As in repetition of line, there should be special effort to avoid monotony, which is generally caused by too even a division of space. For example, a skirt which opens exactly at the centre-front line, unless treated in some special way, is not as interesting as one which opens slightly to one side. A double skirt is not good if it has the bottom line of the upper skirt dividing the full length exactly in half.

The various divisions of space should always be well balanced. Too large a space may completely overbalance and obscure the smaller divisions. A skirt is very poorly designed which is divided so that a narrow centre-front panel is entirely overbalanced by two wide spaces on each side.

Greek costume shows many examples of good space relation. In general, the main masses are large and simple, while the smaller are made by the folds of drapery and are entirely subordinate to the large masses and supplement

Greek costume showing good space relation

them in such a way as to make the design complete and satisfactory.

In choosing colors for a costume there are several factors to be considered: a good combination of color in the costume; the proportion and careful placing of the colors selected; and the general becomingness of the color or colors to the wearer.

To determine color combinations and color value successfully it is necessary to be familiar with the rules which govern them and to have had much practice in their use. As has already been said, if it is not possible to secure good instruction in color work much may be done by study and observation. Such a book as Munsell's "Color Notation" will prove exceedingly helpful, if supplemented by careful, discriminating observation of good paintings and Japanese prints.

In testing for colors to suit the wearer no rules can be given; the problem differs with each individual. Satisfactory results can be secured only by a careful study of the individual, her style, and the details which go to make up the general impression conveyed. It is better to overstudy than to understudy and to experiment with various combinations before choosing any one.

Some colors may enhance the hue of the eyes by giving depth or strength to their color. This seems to be more frequently and evidently true of blue eyes than any others. Rather pale blue eyes may be much strengthened by the right shade of blue in the costume. This can be best determined by a trial of many different shades. Other colors may be chosen to give the skin clearness, while still others give brightness and better color to the hair. The designer must determine by a careful study of the individual whether eyes, hair, or skin should be emphasized. This decision should be, in turn, affected by another factor; that is, the purpose of the costume and when it is to be worn. If it is a street costume the wearer is subjected to the brightest light and it may be wise to enhance the skin. On the other hand, if it is for evening wear the desire is to give a good general impression. An evening dress is most frequently seen with many others of the same general character and should emphasize whatever individual characteristic seems most striking, probably most often the hair.

A demure person may easily be made to appear absurdly dressed if strong colors are used in her costume. She will be completely obscured and, if at all sensitive, painfully conscious of her too vivid plumage. On the other hand, the strong, distinctive personality should not attempt expression in pastel tones. A careful consideration of different personalities and their expression or lack of expression in costume proves not only interesting but helpful in a study of color.

There is a quality in material which is so closely allied to color as to be often confused with it; this is its texture. Texture may be defined as the surface quality of a fabric. It depends on the composition; that is, on the manner of making and arranging the threads and their finishing. It is this texture, or surface quality, that determines the way in which any fabric, because of its rough or smooth finish, absorbs or reflects the light and does or does not give variation in light and shadow. For example:

(a) *Cottons.*—There is great variation of texture in cotton materials. The crisp organdie, with its distinct threads

breaking up the reflection of light, serves as an excellent contrast to the batiste and cambric surfaces, which have unbroken lustrous surfaces from the use of mercerized threads or because of finish.

(b) *Wools.*—Some broadcloths, because of their smooth and polished surfaces, have a lustre which gives in drapery marked light and shadow; in contrast, serge, whipcord, or diagonal has, because of its distinct weave, an uneven surface which breaks up the reflections of light and has little variation in light and shadow.

(c) *Silks.*—The smooth surface and very high finish of satin give it a brilliant, almost metallic, high light and a very deep shadow; in contrast, *crêpe de chine* has a somewhat rough, pebbly surface which, by lack of reflection of light, gives a light and shadow without much contrast. In any folds or drapery the light melts gradually into the shadow. Ordinary velvet has scarcely any high light, while mirror and panne velvet have a strong light and correspondingly deep shadow.

(d) *Linen.*—Contrast is secured both by weave and finish. Some fabrics, such as those with a satin weave, have a high lustre, while many others with a plain weave have practically none.

Texture, as can readily be seen, is an extremely subtle quality and for that reason is often overlooked in the consideration of a costume. Its influence on color is very great, and it is in turn affected by color but must be considered and treated as a factor by itself. Because of its subtlety, the unconscious successful use or abuse of it frequently makes or mars an artistic creation. Gowns are often seen which have beautiful harmonious colors and grace of line, yet lack something for complete success. To the casual observer the lack will be indefinable, while the experienced designer will probably observe at once that the combination of texture is wrong. It is just as necessary for successful designing to have the proper combination of texture to secure a pleasing play of light as it is to have harmony of color. The kind of combination depends entirely upon the effect desired. As in color work, violent

contrasts may be made, or, on the contrary, the entire costume may be kept in the same tone. For one costume depth and richness may be required; for another, lightness and airiness. The great perfection of the textile industry ⸜as made available all varieties of materials, and with sufficient knowledge and experience any desired effect can be secured.

Contrasts are seen in such combinations as a dull-finished broadcloth and a lustrous satin; a serge and a satin; or, even more striking, a deep velvet and a brilliant satin. Combinations without contrasts are given by the use of the same dull-finished broadcloth and a chiffon or *crêpe de chine*. The most interesting results are in general achieved by extremes; that is, by great contrasts or by no contrasts whatever.

Very frequently the accessories give the desired play of light and shadow to the costume.

For cotton and linen dresses the right effect is often secured by the use of pearl, bone, or crochet buttons, of buckles, or of belts of leather, velvet, satin, taffeta, moiré, grosgrains, etc.

Many taffetas, which have no high lights or deep shadows, may be made exceedingly effective if fur, a velvet flower, or lace with a metal thread is combined.

When in keeping with the style of costume, artificial flowers of different textures may be used to give interesting combinations, or when accessories are not possible, shoes may be so chosen as to give the necessary note. Patent-leather shoes give a bright, lustrous surface, while calf or suède provide the opposite effect.

In general, it is safe to say that the stout figure should never be clothed in fabrics having a bright texture, as the lustrous surface reflects the light and increases the effect of size.

As in the use of color and choice of lines, for successful combination of texture there must be much experimenting based on careful study and thoughtful analytical observation. Merely following rules or suggestions will not make the successful designer.

Designing should not be attempted until enough work has been done in both drafting and fitting to form a basis for appreciation not only of the proper relations between the lines of the pattern and those of the individual figure, but also of good lines and proportion in patterns.

In the drafting, a flat pattern of the required number of pieces is made by following definite constructive directions. In following these directions there is nothing to indicate to the inexperienced the correct position of the lines or seams of this pattern on the figure for which it is intended. As the location of these lines and their relation to the lines of the figure is most important, this lack must be supplied. It may be satisfactorily done in the careful trying on and fitting of the pattern, which should always follow the drafting. There should be sufficient practice in fitting to familiarize the worker with the correct position and direction on the figure of the foundation lines of all patterns.

The designing problems should be such as require initiative and originality on the part of the worker. The first should be flat-paper work or pattern-designing done on the table in either tissue or drafting paper. Any desired style of pattern or design may be worked out, using as a foundation the flat patterns which have been constructed in the drafting. The second should be the more advanced designing or modelling—the construction of designs in flexible materials on the dress-form to suit the individual. For both the same general rules for direction of line and proportion are observed, but in the latter no patterns are used.

I. FLAT-PAPER WORK OR PATTERN-DESIGNING

I. *Shirt-Waist Designs*

The first designing which is done on the foundation patterns is usually applied to the shirt-waist.

1. **Tucks.**—The simplest designing is that of placing tucks in groups or in regular order for the back and front of a shirt-waist. Lengthwise tucks may be laid from the neck and from the shoulder. They should run with the

grain or thread of the material straight up and down the waist. They are designed before the waist is cut, and, consequently, careful planning is needed to make the shoulder tucks match perfectly when the shoulder seams of the waist are joined. It can be done only by a frequent placing of the pattern on the material as the work progresses. Tissue is better than stiff paper for this work. This problem must be considered from the standpoint of good design quite as much as from that of good technique. Careful joining of shoulder tucks cannot give beauty to the waist if the rules of design in relation to space-filling are ignored.

2. **The Gibson Plait.**—The Gibson plait is often a difficult problem because the plait is not included—that is, stitched flat, as are other plaits—in the shoulder seam. It is so made as to form a continuous plait from the front waist line to the back waist line, running with the straight of the material in the front but slightly on the bias in the back, to give good proportion to the figure.

To design the plait the shoulder seams of the foundation shirt-waist should be joined. Another waist is made on it in tissue in which a plait is laid both back and front, the desired depth, and carefully matched at the shoulder. After the plait is pinned in place the shoulder seam should be distinctly traced and its seam allowance made. The plait and the shoulder seam are then opened and the shoulder seam is basted together exactly on the traced lines. These lines will not be straight because of the plait. When the plait is relaid and pinned, it should lie flat its entire length and fit the shoulder closely.

3. **Yokes.**—Shirt-waists may be designed with applied yokes of various shapes into which the material is usually gathered or plaited. With these any desired amount of fulness may be used in the lower part of the waist, while the shoulders are kept perfectly flat.

(1) A yoke may be used only across the back, extending to the shoulder seams. The technique of this arrangement is very simple, especially if the centre back of the yoke is placed on a lengthwise fold. It is a little more difficult if striped material is used and by making a seam in the

centre back the stripes are so placed as to give a herring-bone effect. In either case the neck and armseye lines and the desired shape of the yoke are traced directly from the shirt-waist pattern and the lower part of the waist planned. Not much extra material is added, as fulness in the back is not generally becoming. The problem in such a yoke is the designing of a good line across the back.

(2) In general, yokes are more attractive and becoming when they extend a little over the shoulder seam and form a straight line in front from neck to armseye into which the fulness of the front may be gathered. The location of the line in front and the direction of that at the back must depend on the taste of the designer and the figure to be suited. Before designing a yoke which is to extend over the shoulder it is necessary to join the shoulder seams of the shirt-waist foundation. The yoke material must be carefully placed at the centre back of the pattern but may fall as it will at the front. The centre back is usually on a lengthwise fold, but a seam may be used for a special design. After the placing of the material the cutting of the yoke is simple. The armseye and neck lines of the yoke are traced; then the fulness for the lower part of the waist may be arranged.

4. **Collars.**—Flat collars of all shapes may be made in the same general way as are the yokes. If they are not cut to have a slightly bias edge over the shoulder they may sometimes require a little extra fulness there to give them sufficient spring. To secure this fulness the shoulder seams of the foundation waist are not brought together when the pattern is made, except at the neck. At the armseye they may be $\frac{1}{4}''$ or $\frac{1}{2}''$ apart. The centre back of the pattern is placed on a lengthwise fold of material, unless a special design is to be made, and the desired neck line and shape of the collar are traced. The neck line and the shape of the collar should depend entirely upon the face and figure of the wearer and should have correct relation to any other lines in the costume. A high, round neck is seldom becoming. A slightly lowered curve or a point at the centre front is better suited to the majority.

5. **Kimono Waists.**—As a more difficult problem in designing, the shirt-waist may be used as a foundation for the making of kimono blouses. The general style and amount of fulness desired determine the various ways in which this may be done. One simple method is suggested here which gives the rather full, free kimono, especially becoming to a tall, slender figure. A few directions are added as a guide for alterations, if less fulness is desired.

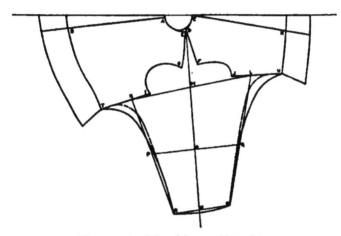

Kimono waist designed from a shirt-waist

(1) *Placing the Foundation Pattern.*—To design the kimono waist the shirt-waist pattern is placed on some firm material, either stout tissue-paper or cambric, about a yard and a quarter in length. (*a*) The shirt-waist front is placed first, with the bottom of the pattern to the cut end of the material; the centre-front line at the neck, point A, should be ½″ in from the lengthwise edge of the material and its waist line, point B, 2″ in from the same edge. (*b*) The back is so placed that its centre-back line at the neck, point C, is on the lengthwise edge and its shoulder, point D, is ½″ away from the front shoulder, point E, and as nearly as possible in line with it. The end of the back shoulder line, point F, should be 2″ or 3″ away from the end of the front shoulder line, point G. This brings the

waist line of the back, point H, about 2½″ to 3″ from the lengthwise edge. These measurements may of necessity vary somewhat if the shirt-waist pattern used has been drafted to measures which are far from normal. A little experience soon teaches the proper adjustments.

(2) *Constructing the Kimono.*—After the shirt-waist is pinned in this position the lines for the kimono may be constructed. The work proceeds as follows:

(a) *Neck.*—It is not wise to follow exactly the neck line formed by this placing of the pattern. A new line should be drawn inside, which makes the neck line smaller and somewhat higher, especially at the back and shoulder. Kimonos have a tendency to draw away or drop at the neck, as they have no fitted armseye to keep them in place.

(b) *Armseye.*—Before beginning the sleeve the armseye must be located as a basis from which to work. The size of the armseye for a kimono is somewhat a question of choice, but it should be at least 2″ larger than an easy armseye measure taken over the dress; otherwise it will be too close for comfort. If the waist is placed as directed above, the distance from underarm seam to underarm seam, points J and I, is usually about 6″ too short; to get additional length it is necessary to measure down 3″ on each underarm seam, to points L and K. A line should be drawn between these points and its centre marked, point M.

(c) *Sleeve.*—From half-way between points E and D on the neck line, through point M, a line should be drawn the intended length of the sleeve. The measure for this is taken from the neck line down over the shoulder and the arm to the desired point. For a full-length sleeve, which it is wise to make in this foundation pattern, the measure will probably not exceed 28″ or 29″. Point N should be marked to indicate the length, and from this point the length of the arm from elbow to wrist, point O, should be measured back on the line. At the elbow, point O, the sleeve should be 2″ more in width than the elbow measure. This gives points P, Q, which are measured an even distance each side of point O. The width of the sleeve at the wrist averages 9″; this amount is to be measured at point

N, using it as the centre; points R, S should be marked. As guide lines, points K and R, L and S, and R and S should be connected.

(*d*) *Underarm and Sleeve Seam.*—If a full waist is desired the lines for the sleeves may extend from the waist line of the foundation pattern, points T and U, to the bottom of the sleeve, points R and S. These lines should form continuous curves passing a little inside the straight sleeve lines above the elbow. If the curves as indicated in the illustration give too much fulness they need not be drawn from the waist line, but from a point several inches above, as shown by the dotted line.

(*e*) *Waist Line.*—The waist lines in this pattern should be traced accurately; they are necessary not only in more elaborate designing, but they also serve as guides in basting together the waist. The basque should also be traced before cutting out.

(*f*) *Centre-Back Line.*—If the centre-back line of the shirt-waist, CH, is used as the centre back of the kimono blouse it does not give sufficient width. On the other hand, if the straight of the material from C is used as the centre-back line it generally gives more fulness than is desirable. A new line may be drawn from C to within about $1''$ or $1\frac{1}{2}''$ of point H. This gives a medium amount of fulness.

(*g*) *Centre-Front Line.*—If the waist opens in the back the centre-front line must of necessity be on a straight fold of the material; otherwise the amount of fulness and its arrangement may be determined by the taste of the designer.

If the kimono is designed for a sloping shoulder the pattern should be so placed that there is less distance between points I and J, as less length is required over the shoulder. This may be accomplished by swinging in the back of the shirt-waist pattern and bringing the points G and F closer together.

This flat kimono pattern may be adapted to an endless variety of designs, for which costume prints and fashion sheets offer many suggestions. Better results will be obtained if tissue rather than stiff paper is used.

II. Sleeve Designs

A few designs may be made in flat paper from the shirt-waist and the tight-fitting sleeve patterns. The majority of sleeve designs are, however, more satisfactorily executed if made on a stiff paper or a padded sleeve. They are, in consequence, considered under *II. Designing and Draping on the Dress Form.*

1. **Shirt-Waist Sleeve.**—Some of the fulness may be removed from the shirt-waist sleeve below the elbow. It is done in various ways:

(1) By placing a seam from the wrist to the elbow. This must be done with care or the sleeve will be ugly at the elbow. The seam should be placed on the under side of the sleeve to extend from the point of the elbow to the wrist in a line with the little finger. This new seam does not affect in any way the regular sleeve seam.

(2) By drawing up the material on the under part of the sleeve and arranging it in tucks near the bend of the elbow. The seam line on the under part of the sleeve from elbow to wrist and also the bottom line of the sleeve should then be reshaped; the seam line of the upper part of the sleeve should remain unchanged.

(3) By placing a series of small tucks extending upward from the wrist. They should taper to a point toward the elbow.

2. **Tight-Fitting Sleeve.**—A one-piece sleeve with fulness at the top or bottom may be made from the tight-fitting pattern.

(1) For fulness at the top the upper and under pieces of the sleeve are placed with the outside seams together from the elbow to the wrist. This placing causes them to spread from the elbow to the top. The curve at the top of the upper should be extended to join the top line of the under, the size desired determining somewhat the direction of this new top line. The straight of the material should lie from the point of the elbow straight up.

(2) For fulness at the bottom of the sleeve the same seams are brought together from the elbow to the top; this

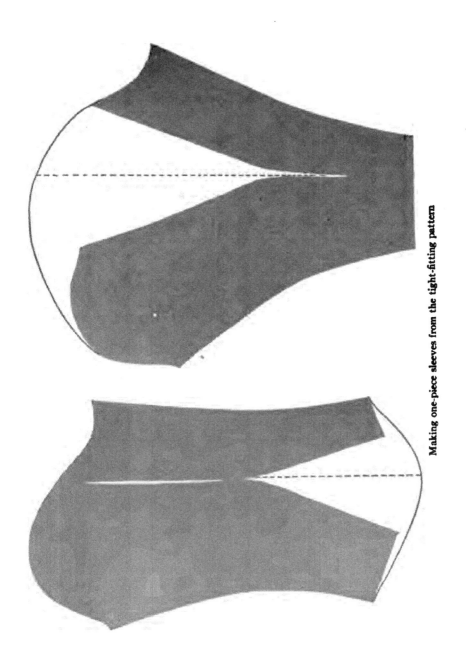

Making one-piece sleeves from the tight-fitting pattern

causes them to spread from the elbow to the wrist. A new line is made for the bottom of the sleeve. Its direction is determined by the size of the puff desired at the wrist. The straight thread falls from the elbow straight down through the centre of the puff.

III. Skirt Designs

Skirt designing is rather more difficult than that for waists and sleeves, because skirts change in shape and size and line so greatly and with such frequency. Waists and sleeves, no matter what the fashion, conform in a general way to the outline of the figure. Skirts cover the figure but do not necessarily take their outline from it, and in consequence there is greater opportunity for change in shape. In all skirt work, in addition to the problem of fitting there is that of hanging as well. Much practice is required for the execution of successful designs.

The plain drafted skirt pattern is used as a foundation for the work. From the draft given in this book a narrow or a full skirt may be made; as a basis for the designs it is wise to choose one of medium size. In adapting a pattern to suit the figure of the wearer, and at the same time making it conform to the general requirements of the fashion of the period, many excellent problems are provided.

The dividing of a skirt into gores of various sizes forms the necessary basis for skirt designing. If directions for making these divisions have not been given in connection with the preceding drafting work they should form the preliminary work in designing.

As has been said, mere technique without reference to good design is of little value. The work of dividing a plain skirt into gores suiting the figure of the wearer is a problem which necessitates a knowledge of the rules of good spacing.

There are two general methods of procedure which may be followed in the making of skirt designs. For both, the foundation draft is made and on it the desired gore divisions are worked out according to the drafting directions, the extra fulness at the waist is determined, the seam lines are

trued, and, when finished, all the necessary lines are plainly indicated on the pattern with a heavy pencil line.

(1) The skirt may be left whole and tissue-paper used over it for the designing, as the indicated seams can easily be seen through.

(2) The skirt may be cut apart into the indicated gore divisions and the designs made by combining the gores. For this either heavy or tissue paper may be used, as the separate gores are placed in any desired position on the paper to serve as guides in the making of patterns.

If the first method is followed and the foundation pattern is not cut apart into gores, it is necessary to remove some, at least, of the surplus fulness which has already been indicated by the darts and gore divisions at the waist. This may be done by pinning in a few shallow darts where the fulness is shown. It may not be possible to make them deep enough to take out all the extra size, but a sufficient amount may be removed to make the pattern a good shape and satisfactory to work with.

As can easily be seen, if the skirt work is to be done in the full size and the patterns used for cutting in materials, more accurate results are attained by the second method—that of the separate gores—as by this method the exact amount of fulness at the waist is removed and the pattern made the correct size. For this work the six-gore division is excellent when made with a centre-front and centre-back gore or panel and two side gores. The same skirt may have a four-gore division by using a dart over the hip rather than a seam. The centre front and back gores will not require changing for this.

When possible, both methods of procedure in making or designing should be tried, as they give variety of practice and one is frequently found to be better suited than the other to certain styles of skirts. In all skirt work great care should be taken to indicate on all patterns and all pieces of a pattern the correct location and direction of the waist and hip lines.

1. **Centre-Front Decoration.**—Many skirts are cut to have a seam at the centre front. This offers opportunity

for a variety of simple designs, as the placket, or skirt-opening, is usually placed in the seam and requires an attractive finish. Either a slot seam or a lengthwise tuck of any width desired may be used. The exact location of the opening should depend somewhat on the decoration. A slot seam should be in the centre, while a tuck should, in general, be placed a little to the left.

2. **Designs Based on the Four or Six Gore Division.**— As has been said, the four or six gore division makes a good foundation pattern for a variety of designs, using either method of procedure. For example, the centre-front and centre-back gores may be treated as panels with tucks or other decorative finishes at their seams. The side gore or gores may be arranged in an even greater variety of ways.

(1) The dart may be used for a plain four-gore or an undecorated seam for the six-gore. A tuck is not used at this seam generally, as it will not lie flat over the curve of the hip. It is seldom wise to emphasize this seam line by using any kind of decoration.

(2) Gathers may be used in place of the dart or seam to draw the fulness in at the waist. These gathers may be covered with a strap or belt placed near the waist line and variously finished.

(3) Fine tucks, rather than gathers, may be made. Care should be taken to taper them to nothing near the hip line; otherwise too much fulness will be taken out below or at the hip, and the skirt will not look well nor will it fit.

3. **Tucks.**—The simplest work in designing is that of using tucks at the seams of a gored skirt. Either of the methods of procedure suggested above may be followed. In both, careful attention should be paid to the placing of the straight of the material. In general, it should fall at the centre front, at the front edge of each gore below the hip line, and, if a panel back is used, at its centre.

(1) Tucks are placed at the back edge of gores, except at the centre back where there is a plain seam or an inverted plait as desired. If there is a centre-back panel, however, the tucks can be used by placing them at each edge and turning them toward the front.

(2) In adding material to the gores for the tucks an equal allowance is made on the back edge of one gore and the front edge of the next. This does not add width to the gores, but leaves them their original size and merely gives enough extra material for the under side of the tuck, so that

Adding material to the gores of a skirt to form a tuck at the seam

the stitching may be as far in from the original gore line as is desired to form the tuck. As can easily be seen, if the width of the tuck is added to the original size of each gore the size of the skirt will necessarily be much increased or the back gores made so small as to be entirely out of proportion to the rest of the skirt divisions.

(3) The work proceeds as follows:

(a) The front gore or panel is planned first. The centre front is placed on the lengthwise straight and its back-

seam line indicated on the paper. Beyond the seam line once the width of the tuck plus the seam allowance is added. The lines forming these should be exactly parallel to the original seam line, as the tuck is of even width its full length. The width of the tuck is a matter of choice. It should not be too wide. The seam allowance should be ¾″ or 1″. Whichever width is decided on should be kept uniform throughout. After these are added to the gore, it should be cut off and its edge turned back exactly along the original seam line; this turns one width of the tuck and the seam allowance to the wrong side.

(b) The same method is followed for other gores which are to have the tucks. The seam allowance and once the width of the tuck are added to each seam line of the gore. The back edge of the gore is turned in along its seam line, but the front edge is allowed to extend, as the back edge of the gore in front of it must be placed on it in joining them together. To join them correctly, the folded edge, which is the original seam line of the front gore, is placed to the original seam line of the next gore and pinned flat.

(c) After the two gores are pinned together, if the wrong side is observed, it will be seen that the lines indicating the width of the tucks on both gores fall exactly together, ready for stitching, and that the two raw edges are also together. By employing this method of making tucks the edge of the tuck on the right side is not a new line, but the original drafted seam line, and the gores are unchanged in size or shape. In consequence, the lines are more easily kept straight and the gores in good proportion.

4. **Inverted Plaits.**—Many skirts have inverted plaits added at the seams for decoration or to give additional width in walking. At the centre back, where such plaits are most often used, or at the centre front they generally extend the full length of the skirt, but in finishing are stitched flat for some distance below the waist. On other seams they are frequently made not more than 8″, 10″, or 12″ in length.

To make these plaits, extra material must be added to the seam lines of the gores. This is not done in the

same way on all seams; their position in the skirt determines the exact method of procedure.

(1) For a plait at the centre back of a skirt an equal amount—twice the width of the plait plus the seam allowance—is added to the adjoining seams of the two back

Adding material to the gores of a skirt to form an inverted plait at the seam

gores. Then, when the plait is laid, the seam line falls at the centre back where the plait meets, exactly as it would without the plait.

(2) For a plait, whether full length or not, placed between any other two gores an equal amount is not added to the adjoining seam lines of the gores. When the plait is laid, the seam should not be in its original position—that is, exactly in the centre, as without the plait—but concealed at one side in a fold of the plait. To place the seam correctly the material is added in this way: to the back edge

of the front gore once the width of the plait plus the seam allowance is added; to the front edge of the next gore, which is usually straight below the hip, three times the width of the plait plus the seam allowance is necessary. This brings the seam in the fold of the plait of the front gore.

(3) The work proceeds as follows:

(*a*) The front gore is placed on the correct grain or thread and its back seam line indicated on the paper. Beyond the seam line once the width of the plait is added. This plait differs from the tuck in that it is not of equal width its full length. The desired width should be measured over at the hip and a proportionate amount at the bottom. A usual proportion is one and a half times the hip at the bottom. The points at the hip and at the bottom should be connected with a straight line. This line should be continued from the hip to the waist in a curve which exactly parallels the curved seam line of the gore. The usual seam allowance should be made the full length of the gore. When both the plait and the seam allowance are added, the gore should be cut off and its edge turned back along the original seam line; this turns one width of the plait and the seam allowance to the wrong side.

(*b*) To the front seam line of the next gore three times the width of the plait at the hip and at the bottom is needed. The front edge of the gore is placed on the correct grain or thread and its seam line indicated on the paper. Beyond this seam line twice the width of the plait is measured over at the hip and bottom lines. These two points should be connected and the line continued *straight* up to the waist. From this new line once the width of the plait should be measured over at the hip and bottom lines. These two points should be connected and the line continued to the waist. Beyond this the seam allowance should be indicated. The back edge of this gore should be treated like the back edge of the front gore and the gore cut off. After this gore is cut out its front edge is turned back along the original seam line. To lay the plait the original seam line is then folded over or brought to the centre line of the

plait. This requires twice the width of the plait. One width of the plait plus the seam allowance is thus left and extends beyond the gore.

(c) In joining the two gores the original seam-line of the front gore should be placed to the original seam-line of the back gore. This brings together the edges of the turned-back width of plait on the back seam of the front gore and the extending width of plait on the front seam of the back gore and also the two seam allowances. As in making tucks, the lines of the gores and their proportions are unchanged. When a gore which has three times the width of an inverted plait added to its front seam is placed on material for cutting, the original front seam should always be placed on the straight lengthwise thread.

Care must be taken to cut these plaits with the proper length and curve at the waist line so that they can be included easily in the belt.

5. **Side Plaits.**—Many narrow skirts have short and rather shallow side plaits set in at the seams to give additional width for walking. These may be easily worked out in tissue, following the directions for making tucks. Sufficient width is generally given if they are placed at each side of the front and back panels. Eight or ten inches is the usual length, while the width or depth of the plait may vary according to the choice of the wearer. These plaits should always turn away from the centre of the panels and, if placed on the side gores, they should be backward turning, as are tucks. If desired the plaits can be arranged to show only when the skirt is in motion, by not allowing them to extend beyond the edge of the gores. Either narrow side or box plaits may be used, however, to give not only fulness but decoration as well, by extending them over the next gore and giving them an ornamental finish.

6. **Plaited Skirts.**—Plaited skirts may be developed from the plain foundation skirt. This is done in various ways, depending on the material used, the prevailing fashion, and the choice of the wearer. Plaids, checks, and stripes, when plaited, usually need special treatment; otherwise the result

is unsatisfactory. There are two general methods of designing plaited skirts, both of which may be varied somewhat.

(1) In the first method the foundation pattern is cut into a number of gores and a plait of required depth is made on the back edge or seam-line of each gore.

First method of making a plaited skirt

(*a*) These plaits are made by the same general method as are the tucks. There are slight differences in detail, however.

(*i*) As has been said, tucks are of even width their full length, while these plaits, like the inverted, are wider at the bottom and require more material.

(*ii*) In finishing, tucks are generally stitched flat their full length, while plaits are left free some inches up from the bottom and give additional fulness.

(*b*) The number of gores used in making a plaited skirt depends entirely upon choice. The more gores the greater will be the number of plaits and the consequent fulness at the bottom. For instance, an eleven-gore skirt will have six plaits on each side of the skirt, the two at the centre back meeting, if desired, to form an inverted plait.

(*c*) The method of procedure is alike for each gore and is as follows: .

(*i*) The front gore or panel is planned first. The centre front is placed on the lengthwise straight and its back seam-line indicated. To this seam-line is added once the width of the plait plus the usual seam allowance. The width of the plait is determined as in making an inverted plait; that is, by measuring the required width at the hip and at the bottom and connecting these two points with a straight line. This line should be continued from the hip to the waist in a curve which exactly parallels the original seam-line curve. After the usual seam allowance is made the full length of the seam the gore should be cut out. This added amount, the width of plait and seam allowance, is turned to the wrong side, the original seam-line serving as a guide.

(*ii*) The same amount is added to the front seam-line of the second gore, but it is allowed to extend as in making the tucks.

(*iii*) The fold of the back edge of the front gore is placed to the original seam-line of the front edge of the second gore and the first plait is made.

(*iv*) An inverted plait at the centre back may be made as already suggested. The gores are unchanged in size or general proportion.

(*d*) In adding material to the gores to form any of these plaits, care must be taken to have it cut sufficiently long above the hip line to continue the curve of the gores and form a good waist line.

(2) The second method of making plaited skirts is one which is much used for short skirts and is especially suitable for checks and stripes. Straight breadths of material are joined and the pattern is so placed that the bottom of

the skirt and the centre of each gore are on the straight threads. The material for these straight plaited skirts is generally used lengthwise, but may be crosswise if desired, if it has sufficient width and no defined up and down. It is usually found, however, that the lengthwise material hangs better and presses better. In this method as many gores are used as desired; the more gores the greater the

Second method of making a plaited skirt

number of plaits. The number does not in any way affect the method of procedure, which is as follows:

(a) In planning the gores the foundation skirt is divided into equal parts. (i) At the bottom, beginning with the front, where, as usual, only half the width of the gore is measured. (ii) At the hip, beginning with the front. In order to give the plaits good direction over the fulness of the hips, the gores which form the side front and side of the skirt should be a little wider on the hip line than those at the back and side back.

(b) After the skirt has been divided into the required number of gores (i) each gore should have its hip lines at 6″ and 10″ carefully marked; (ii) the gores should be numbered and corresponding edges notched, beginning at

the front, and then cut apart for placing on the material; (*iii*) the lengthwise centre of each gore should be distinctly indicated by a tracing. The direction of this tracing is easily secured by folding the gore lengthwise so that its bottom line falls together.

(*c*) (*i*) The material is joined in lengths and folded along its lengthwise centre to give an even amount for each half of the skirt. (*ii*) The centre of the front gore is placed on this fold and pinned. (*iii*) The bottom of each gore must be placed upon exactly the same crosswise thread of the material. This will bring the lengthwise tracing of each gore on a lengthwise thread. (*iv*) The gores should be placed at the bottom of the skirt at equal distances from one another, that distance depending upon the depth of plait required. The first designing by this method is somewhat simpler if the distance between every two gores at the bottom equals the width of the gore. If this makes too shallow a plait the distance may be increased to one and a half times the width of the gore.

(*d*) When the gores are placed in order, according to their numbers, they should be pinned and traced. These tracings must indicate the seam-lines and the hip, waist, and bottom lines of each gore. For the stiff paper, which is the most satisfactory medium for designing the first plaited skirt, the tracing-wheel may be used.

(*e*) After the tracing is finished (*i*) the separate gores may be removed and some of the surplus material may be cut out to make the skirt less clumsy at the waist and hips. The material should not be cut out for more than 6″ below the waist until the skirt has been plaited and tested. (*ii*) A seam allowance of ½″ is required at the waist line beyond the tracing and 1″ where the lengthwise seams are to be cut. In making a skirt of this kind, the amount which may be cut out in the finishing depends entirely on the length to which the plaits are stitched flat. Where the plaits are securely stitched only a 1″ seam allowance is necessary.

(*f*) In laying the plaits the work should begin at the front. (*i*) The back edge of the front gore should be brought

back to the front edge of the second gore, matching seam-lines, waist, and hip lines perfectly. (*ii*) The back edge of gore two must be brought back to the front edge of gore three, and so on. As the paper has no right nor wrong side, this work may be done from either side. In using material the right side of it should be toward the worker in order to bring the plait to the wrong side.

In explaining these two methods, only plaits laid in regular order have been suggested; but with these methods as a foundation the grouping of plaits may easily be worked out.

7. **Gathered Skirts.**—Gathered skirts may be made in various ways, the method chosen depending on the general effect desired.

(1) The simplest method is that in which straight lengths of equal width at the top and bottom are used and the fulness is gathered in at the waist line. If the skirt is very full this gives a large amount of material at the waist. Such a skirt requires little skill in designing, except in the placing of the gathers to give a becoming arrangement of fulness at the waist.

(2) In general, a more satisfactory method is that in which some of the fulness is removed at the waist line of the skirt by goring it out on the seams.

(*a*) In designing a skirt of this kind the plain foundation pattern may be used, drafted to measure about two yards around the bottom. The pattern should be evenly divided into gores, the number of gores depending entirely on the width of the material to be used in making the skirt. For a material of average width, three gores of equal size may be used.

(*b*) The work proceeds as follows:

(*i*) The pattern is divided at the waist line and bottom line into three equal parts, or gores. The points indicating these divisions are connected by straight lines along which the skirt is cut apart. This gives three gores of equal size, the front edges of which should be placed on the straight lengthwise thread in designing the new pattern.

(*ii*) In making the gathered skirt from these the desired

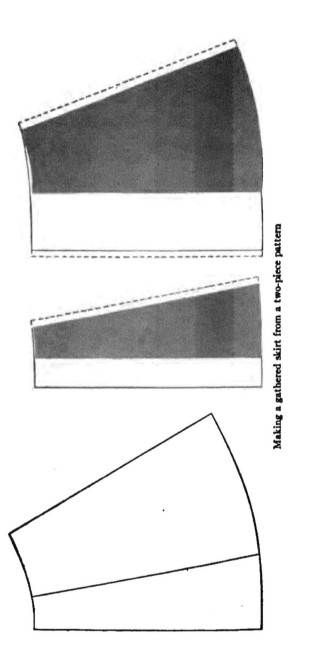

Making a gathered skirt from a two-piece pattern

amount of fulness is secured by setting the straight front edge of each gore a little back from the edge of the material. The amount added in this way depends on the size desired for the finished skirt.

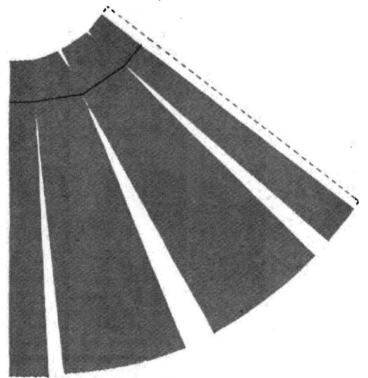

Circular skirt with a centre-back seam

(*iii*) In making this pattern care must be taken to maintain a good waist line. The new front line of each gore should be the same length as its original front line, but the new waist line should not be formed by a straight line connecting the two front lines. In shaping the waist line for the enlarged gore it must rise gradually from the new front line, going above the original front line, until it joins the old waist line at the back edge of the original gore. In this way height or length enough is given to arrange

or push the fulness from the front of the gore along its full
width as required to suit the figure.

8. **Circular Skirts and Tunics.**—Circular skirts and tunics
may be made in two general ways.

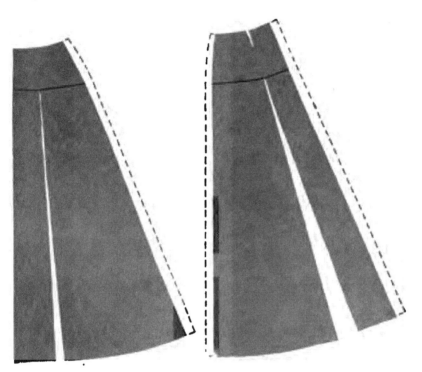

Circular skirt with centre-back and side seams

(1) By using the skirt draft in Chapter V, which may
be adapted to various depths or lengths or widths. This
method needs no further explanation here.

(2) By combining the separate gores of the six-gore skirt,
which may be so arranged as to give any desired depth and
length and width. If a circular skirt or tunic is to be made
from a six-gore pattern the work proceeds as follows:

(a) For a circular skirt with centre-back seam: (i) The
centre of the front panel is on the lengthwise straight fold.

(*ii*) The front seam-line of the second gore is placed to touch the side seam of the front panel at the waist line and for a few inches below; from this point it gradually spreads until the two gores at the bottom are some distance apart. (*iii*) The third gore and the back panel are placed in turn in the same way with these, and a circular skirt is made without any seam but that of the centre back.

(*b*) For a circular skirt with centre-back and side seams: (*i*) The front panel and the second gore are placed as before and cut. (*ii*) The third gore and the back panel are arranged together in the same way, and, in cutting, the front seam-line of the third gore is placed on the straight of the material. With a seam over the hip as well as at the centre back there is less likelihood of the skirt's sagging. Frequently the centre-back line is better if it is made somewhat more bias. The amount depends on the width required for the skirt.

By either of these methods the waist line or curve at the top of the skirt or tunic is the same size as it was originally, but deeply curved, as is necessary for circular skirts and tunics. The depth of a tunic may be regulated as desired.

9. **Circular Flounces.**—A circular flounce can easily be made by using the undivided foundation of a rather narrow skirt. An exact pattern should be cut of that part of the skirt for which the flounce is intended. The depth may be as desired. This pattern is then slashed at regular intervals from the bottom to within $\frac{1}{16}''$ of the top and spread to the required width at the bottom. As in the last method of designing a circular skirt or tunic, this makes the curve at the top edge much more circular but does not change its size, while the lower edge is more circular and has more width.

10. **Triple Skirts.**—Triple skirts may be designed from the plain skirt. Triple skirts are of several kinds and are made in many different ways.

(1) By the use of straight or somewhat fitted flounces, the upper slightly gored and cut from the drafted pattern and the two lower straight, or slightly gored, with their

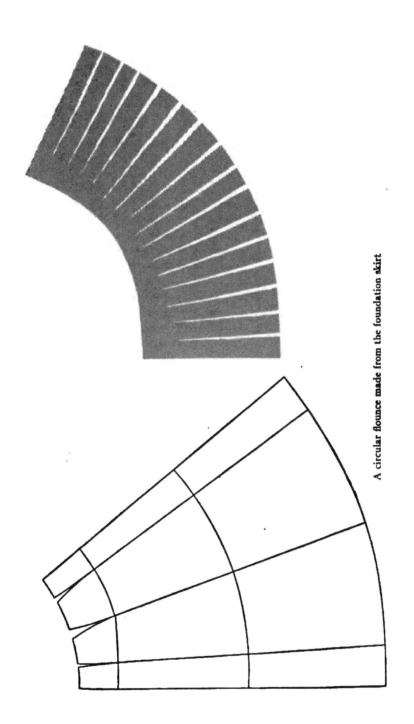

A circular flounce made from the foundation skirt

fulness held in as desired at the side and back. These three flounces may be attached to each other, in which case no foundation is necessary. This is a satisfactory style for soft wash materials. The fitted top flounce may serve as a yoke and the lower rather straight flounces may be joined together and attached to it by cordings or shirrings.

(2) By the use of three straight flounces which are not gored but have their fulness either gathered or plaited. If plaiting is used it may be either side, box, or accordion. Flounces of this style should be attached to a foundation skirt.

(3) By the use of three circular flounces. If these extend around the entire skirt it is generally better to cut them in sections to prevent the material from becoming too bias at the side or back of the skirt. The centre front should be placed on a fold, the front edge of each section on a straight edge. These sections of the flounce correspond to the gores of a skirt and are like them in their general shape. If these flounces are used on a skirt which has a panel front, the fulness of the flounce hangs better and is less likely to fall to the front, if the front edge of the flounce, where it is joined to the panel, is slightly bias rather than straight.

If a series of flounces is used on a skirt and attached to a foundation, as is generally necessary, care should be taken to have each flounce deep enough to overlap the one below satisfactorily. Good division of space should always be considered in determining the width of the various flounces.

As much practice as possible should be given to skirt designing, as many find it a difficult problem. For practice, different-shaped yokes may be added. Yokes may be combined with front, back, or side panels in various ways; shaped pieces, plain or arranged in gathers, or plaits may be inset; the six-gore skirt may be so combined by spreading the gores at the waist as to give a skirt having fulness at the top and little width at the bottom. An example of such a skirt is the peg-top, which has the centre-front and back seams slightly bias and the lengthwise straight of the material over the hip, where there is also extra length of material to form the drapery.

II. Designing and Draping on the Dress-Form

In designing in materials on the dress-form the kind of design to be chosen, the main divisions of the figure, the finer relations of line and combination of color depend entirely upon the individuality of the wearer, the fabric used, and the general fashion followed. All these factors are, therefore, obviously variable and subject to no rules.

Good technique in this work can be acquired only after much practice in drafting and pattern-designing, as all the general principles embodied in these are needed. Drafted patterns are not used except for linings, but a knowledge of the proportions taught by drafting is necessary.

A dress-form is required for the work, as it is not convenient or even possible in the majority of cases to work directly on the figure. The form should be so arranged as to have, in as far as possible, the general outline and shape of the person for whom the design is to be made. In consequence, the selection of the design to be made cannot be arbitrary. The design may be based on an illustration in the latest fashion book or on an eighteenth-century costume, but whatever its source it must be adapted to suit the wearer.

I. Preparation of the Dress-Form for Draping

While the dress-form is considered here purely as a necessary tool in designing, its use is really one of the most important things to learn in dressmaking. Not only is it necessary in the designing of a costume but in the making as well. When its use is understood and skill is acquired by practice, not only the designing but much of the fitting, adjusting, and sewing may be done on it. Only the most experienced designers attempt to do much work directly on the person, and then usually because of some peculiarity in the individual which makes the finding and adjusting of a suitable style extremely difficult.

1. **Purchase of a Form.**—Dress-forms of various kinds may be purchased at varying prices. The expensive ones,

such as those which may be adjusted by various mechan-ical devices to the required sizes, are not necessary and are not considered here. The most satisfactory for general use are the non-adjustable, which may be purchased at small cost and are of good shape in recent makes. In the selection of a form, care should be taken to get one small enough. It is not safe to depend entirely on the bust measure of the form which may be the required size, while the rest of the measures will be much too large. The neck, bust, and hip measures should all be tested. A form which is too small may be made larger but one which is too large is quite useless.

2. **Preparation of the Dress-Form Cover.**—The prepara-tion of the form requires a little time and care; all forms are made in what are considered to be regulation sizes but may be made the desired size by covering and pad-ding. It is very easy to make a form the correct size and shape by covering it with a tight-fitting waist and a plain skirt drafted to the required individual measures. These covers may be made to fit smoothly and closely by using soft tissue-paper or cotton wadding as a padding.

The material used should be strong and not easily stretched. Unbleached muslin, of a quality costing about fifteen cents per yard, is preferable. It is usually kept on the form for some time and has much work done on it, and its firmness prevents any stretching.

(1) *Tight-Fitting Waist and Collar. Making and Padding.*
(a) *Making.*
(i) *Waist.*—The cover for the waist or bust is made first. For this the tight-fitting waist, drafted to the required in-dividual measures, is used. (See *Drafting.*) If the waist pattern is cut to extend 10″ below the waist it is more satisfactory for the padding. It should be very carefully and rather closely fitted; otherwise the garments made over it, when it is on the form, will be too large. In this fitting care should be taken that the direction of the seam-lines is good; for, while these seams are not usually indi-cated in any way in the designs themselves, yet they serve as a basis for them and affect their quality. To pre-

pare this tight lining for the form after the fitting, the seams are stitched and notched, a collar is made and basted on, and the centre-back lines, height of bust, waist line, and armseye line are marked with blue cotton.

(*ii*) *Collar.*—The collar may be constructed from the draft (see *Drafting*) or by fitting a straight piece of material (see *Waists*). After it is fitted it is turned to the exact size and height and its darts carefully stitched. It is better to baste rather than stitch it to the waist, as collars cannot be used on all forms.

(*b*) *Padding.*

(*i*) *Waist.*—After the collar is attached the waist is slipped on the form to see where the padding is needed. After the way in which the pattern fits is carefully observed, it is taken off and the padding arranged as required. It is not satisfactory to put the waist on first and push the padding in, as is sometimes tried.

Soft but strong tissue-paper is a very satisfactory padding; other materials, such as cotton wadding, are frequently used. In arranging the padding on the form every effort should be made to have it smooth and so placed that the waist will not only fit well but indicate very definitely the particular outline and shape of its wearer; otherwise the designs made on it will not be becoming. There are no detailed rules which can be given for the placing of the paper; in general, it gives a better surface if put on in folds without any bunching. If the form is too small below the bust, at the waist, or over the hips, the paper may be wrapped around it in smooth layers. Often, in order to have the neck the correct size, a form must be purchased which is otherwise too small. To remedy this, the paper may be wrapped around as already suggested and still more added by arranging it surplice fashion—that is, strips are brought over each shoulder from waist line to waist line and crossed at centre front and back. If the shoulders are too sloping, extra strips may be used there and also around the armseye. If the lining, which is cut 10″ below the waist line, is carefully padded, a skirt need not necessarily be added.

After all the padding which seems necessary has been added, the lining is put on the form once more and carefully smoothed into place. The form must be firm and the correct shape. If not, the lining must be taken off once more and the padding rearranged or more added as is necessary.

(*ii*) *Collar.*—It is frequently difficult to pad the collar successfully or to keep the padding in place once it is arranged. A piece of stiff paper may be used in addition to the padding. If it is cut wider than the collar, and the correct length, and is placed between collar and padding, it will usually keep the collar stretched into shape and free from wrinkles.

Both the waist and the collar, when satisfactorily arranged on the form, should be sewed together along the centre-back line with rather long stitches. Pins are sometimes used, but they catch in the designing fabrics and are not convenient.

(2) *Tight-Fitting Sleeve. Making and Padding.*

(*a*) *Making.*—One sleeve, the right, is prepared. A pattern of the tight-fitting sleeve is drafted to the required measures. A lining is then cut from this pattern and carefully basted, fitted, and stitched. (See *Drafting.*) This lining should not be permanently attached to the waist. It is often in the way when work is going on, or it may be required for separate sleeve-designing. If the armseye line is plainly marked in the sleeve and the waist, and the positions for the correct placing of the sleeve indicated in the sleeve and the waist, it can be either basted or pinned in when needed.

(*b*) *Padding.*—The sleeve must be very firmly padded with tissue-paper or with curled hair. To keep the padding in place it is necessary to cover the sleeve at the armseye line or top and also at the wrist with an extra piece of material.

(3) *Skirt.*—As has been said, if the tight-fitting waist is cut to extend 10″ below the waist and is well padded, a skirt is not really necessary.

Without a skirt the form is frequently more satisfactory

for draping close-fitting skirts and is also more convenient for general handling and moving. If one is used, however, there is no definite rule in choosing it, as to the number of gores required. The plain foundation pattern may be used. It is drafted to the required measures, carefully fitted, and hung. (See *Drafting*.) After it is stitched and a belt attached it is put on the form, and if more padding about the hips is required than has been used for the waist, it is added, using the same methods as for the waist.

The placket should be fastened, as was the centre back of the waist, with a few rather long stitches.

A few seam-lines should be indicated in pencil on the skirt to serve as a guide in the designing and draping. The seam-line most generally useful, aside from those of the centre front and back, is a line well placed at the side over the hip. A four, five, or six gore skirt may be used satisfactorily.

Whatever division is made, great care should be taken to proportion the gores so that their seams give good lines to the figure for which the skirt is intended. This is a design problem in itself, and as these lines serve as a basis for many other designs it is of special importance that they should be technically and artistically correct. A successful division of gores requires much practice based upon appreciation for good spacing. While in drafting it is necessary to give certain definite directions for these gore divisions, which are in general based upon the hip measure, in designing, these arbitrary divisions should be considered, if at all, as suggestive, as providing merely a starting-point for the work. Two figures may have practically the same hip measure but be quite unlike in contour; one may be wide and flat, the other full and round. They naturally require different designs, and in consequence attention must be given to these differences in the padding of the forms and in the making of the gore divisions of the skirts to be used on the forms. While the width of the gores in a skirt may be largely determined by the prevailing fashion, they can and should be so modified as to be well proportioned and consequently becoming to the wearer.

II. *Technique of the Dress-Form*

Draping and designing on the form can be done with much less difficulty if the worker first familiarizes herself with its mechanical construction and manner of operation. Any form may be raised or lowered on its standard to a convenient height, which should be such as to enable the worker to use it without unnecessary fatigue. It is impossible to bend over or reach up for any length of time; and, as all good designing requires time and an attention not diverted by inconvenience, it is necessary for the worker to be comfortable before attempting even the simplest problem. The part of the form in use should be as much as possible within easy reach and also on a level with the eyes, so that eyes and hands may work together. If the form is not arranged so that it is practically stationary on its standard, it proves very annoying, as it moves and turns with each movement of the worker. This difficulty can be easily remedied by the use of a wooden collar—there should be such a collar on every standard. It fits into the opening in the wooden base of the form and is held there by a metal band which can be kept firmly in the required position by turning its screw. With the careful tightening of the screw or head at the top this should make the form practically motionless on its standard. There should be sufficient space about the dress-form for the worker to step away and get a good perspective of her work.

These may seem minor details, but they play an important part in the ease with which satisfactory results are secured, especially with beginners.

III. *Handling Materials*

As materials are to be used in this designing, certain general information is required regarding the various types or classes of standard fabrics which are in most common use. Such information can be satisfactorily acquired only through experience in the actual handling of fabrics, based on the knowledge which may be acquired in a study of textiles. Some fabrics, such as soft satins, are exceedingly

pliable and lend themselves to elaborate design in drapery. Others, like the heavy bengalines in silks and the serges and cheviots in wools, are in general much less flexible and in consequence require simpler treatment. Many materials, like broadcloth, have a decided up and down; because of their napped surface this is easy to determine. On the other hand, there are materials, like henrietta and cashmere, with as decided an up and down, which affects their color in draping but which have no nap to serve as a guide in the work. There are many materials which have a pile surface, such as velvets, corduroys, and plushes. These require special attention in making, as they have a decided up and down. Mirror and chiffon velvets must be used with the pile running down; otherwise the polished or mirrored surface is destroyed. Many velvets and plushes are made, however, with the pile standing, as this gives a much richer surface to the fabric. It also gives a rougher surface which easily catches dust.

In working with materials the fingers should be highly sensitive and as active as the eyes. Flexibility is of as great importance in the hands of the designer as in the hands of the musician, and it is acquired in much the same way— through continuous use. Fingers may be made capable in judging and skilful in arranging materials only through constant and thoughtful use. They should be, through practice, so well trained in recognizing the general quality, the up and down, and right and wrong of fabrics as to render a decision as quickly and as satisfactorily as the eyes. Without well-trained eyes and hands successful dressmaking is impossible. In manipulating material the whole hand should be brought into use rather than, as too often happens, just a few fingers. All the fingers should be dexterous; they should hold the fabric firmly but lightly. Material should never be clutched or grasped, and in arranging it in the desired way there should be no dragging of the fabric, either up or down, into place. If it cannot be made to fall naturally into the required folds, another arrangement to which the material will lend itself should be tried.

IV. Important Factors in Designing

(1) Emphasis has already been laid on the necessity for accuracy in dressmaking; it cannot be overstressed here. Even trifling variation in the details of the designing work affects the result seriously. In testing for accuracy in the size and shape of pieces and to secure true direction of line, there is no more useful tool than the tape-measure. In establishing the long seams of a skirt which is made in flexible material, it is frequently difficult to keep straight lines. If the tape-measure is attached to the waist and drawn tautly to the floor in the desired direction, it acts as a guide in truing the lines.

(2) The greatest care is required in maintaining in all draping the correct grain of the material. The slightest variation may completely ruin a costume.

It may safely be said, in fact, that the successful execution of all designs is dependent on the placing or locating of the straight grain or thread of the material. In copying any designs this is the most important detail to observe and the one most frequently ignored by the beginning designer. Its placing in waist, sleeve, and skirt is not subject to rules but depends entirely upon the design.

If a centre front or centre back of a costume requires the lengthwise straight of the material, as it frequently does, the most careful attention should be paid to the establishment of the straight grain the entire length and width of the piece. The same is true of a bias; if a true bias is required it must be maintained.

A variation in grain, even though it is a slight one, on the two sides of a costume makes it absolutely impossible to arrange the fulness in the same way or to have the folds take the same lines. The two sides will vary decidedly. No general rules can be given for the placing of the straight grain or thread of material, as the character of the design determines its position.

(3) In arranging folds in both waists and skirts the grain of the material must be carefully observed. Folds running on the lengthwise threads give a straight effect and can

·be pressed flat. This is frequently very important in skirt work when plaits are used and a sharp edge is desired. Folds on the crosswise threads are much rounder; they give ·the tubular effect which is sometimes desirable. They can be pressed to give a fairly sharp edge but are not as satisfactory in this way as folds on the lengthwise. They are, in general, less graceful than the lengthwise folds.

Folds on the bias of the material are exceedingly artistic and graceful in the way in which they hang and the general effect they give. They are most desirable in all elaborate designing, especially when silk material is used. If a sharp edge is required they are not good. They will not press flat, as the fold crosses two threads of the material. But, on the other hand, they give very excellent service, as they do not crease or mat in wearing.

(4) When the divisions or lines of a garment are to be determined, the varying outlines of the human figure must be considered as the space to be filled. Because of the great variation in the general outline no exact rules can be given. Each figure presents an individual problem. In beginning designing it is frequently helpful to use tape to indicate on the form the lines desired in the costume. If the tape is of contrasting color the lines show clearly and give a well-defined design, which may then be judged as to correctness of proportion, becomingness, and general suitability.

V. Suggestive Designing Problems

Designs which may be easily executed should be chosen for the first work in draping on the dress-form. However simple the problem may be, it must necessarily involve some new factors. No attempt should be made at first at originality or adaptation of elaborate patterns, and it is much wiser to have the materials of such kind as to be easily handled. Cheese-cloth, net, unbleached muslin, and outing flannel are all good for beginning draping; they drape easily and hang well, and do not require any attention to nap or pattern. Draping which demands consideration of combination of color and texture may follow after

the worker has had some experience in using the dress-form and in the handling of simple materials.

1. **Linings.**—For the preliminary drill various linings and foundation patterns may be made, until facility is ac-· quired in working directly on the form and in cutting the material into the required shapes without the guide-lines of a pattern.

Directions are given here for draping a shirt-waist or semifitting lining and an evening-waist lining. One or both of these may be attempted to gain experience—each offers a slightly different problem.

In any draping too many pins should not be used. Very frequently many attempts must be made before the desired effect is secured, and when the draping is done directly in the material it becomes defaced by pin-holes. In attaching the material to the form a few pins may be placed horizontally to hold it in place. In fastening the seams together the pins, with their points down, should parallel the seam-lines. The regulation seam allowances should be made even though the models are not to be used later.

(1) *Shirt-Waist Lining, Opening at Centre Front.*—This lining is simpler in construction than any other. It has three pieces, the back and the two fronts. The back and one front are all that need be made if trial material is used. The amount of material is approximately twice the length from the highest point of the shoulder down the front to the bottom of the waist, with an additional 2″ for seams.

(a) The back of the waist is draped first. The material may be more easily managed if the required length is cut off. The centre-back line is marked with colored cotton and the material folded along the line so that the two sides may be draped together. The draping is done on the right side of the form. In pinning this lengthwise centre fold to the centre-back line of the form it should be placed ⅟₁₆″ to the right to allow for the material included in the fold. Extra material should extend above the neck line to form the shoulder and its seam. The straight threads of the material must be carefully watched throughout the work. They should extend straight across the back from armseye

to armseye. Pins placed near the armseye will hold the material in place while the neck is shaped. The material must be carefully fitted about the curve of the neck to the shoulder seam. A seam allowance of nearly ½" should be left at the neck line which may require slashing to fit smoothly. The general position of the shoulder seam may be regulated as in the draft, but its exact direction and location should be guided by the requirements of the padded form. It is generally most becoming when it lies just back of the highest part of the shoulder. The material is pinned in place to indicate the seam, but it should not be cut until the underarm seam and the waist line are pinned, as some adjusting may be necessary. The underarm seam falls in a straight line from the centre of the underarm to the waist. The amount of fulness at the waist line is a question of taste. Too much makes the waist clumsy, while none usually makes too great a bias at the seam. In determining the amount of fulness the material should be smoothed down over the back from the armseye along the underarm seam to the waist and pinned at the waist line. The general appearance of the back should then be observed as to fit and direction of grain of material and the shoulder and underarm seam cut with a ¾" allowance. An allowance of ½" must be made at the armseye, which must be cut sufficiently high under the arm to give a good line. The location of the neck, shoulder, underarm, and armseye lines must be indicated with colored bastings on the two thicknesses of material while it is still pinned in place on the form. It should then be opened and pinned to the form in correct position. If the left side of the padded form is not exactly like the right, any required alterations may be made in the pattern and the bastings changed to indicate the correct lines.

(*b*) The making of the front is simple, as the seam-lines are already indicated. In pinning the material at the centre front more must be allowed than at the back above the neck line to reach the shoulder seam. The straight threads must extend across the front from armseye to armseye.

The material should be pinned in place near the arms-eye while the neck is shaped. The front shoulder seam must be shorter than the back seam, and consequently it must be stretched until the two edges can be smoothly pinned together. This seam is not cut until the front is finished. In order to give fulness over the bust the material should be eased in or swung in a little from the point or end of the shoulder. In doing this care should be taken not to make the armseye too full. The fulness at the front is adjusted at the waist line before the underarm seam is pinned. The front should be inspected for fit and grain of material and all its seams marked to form good lines and cut with correct allowances. The seams of the front and back may be pinned together matching bastings, and when an even line is made around the bottom the waist is finished. If the entire waist is to be made the two fronts should be draped together.

Following this, various other linings to be used later may be made—net, China silk, *crêpe de chine*, and muslin are all satisfactory. The linings may be made in various ways, the style and material chosen depending on the figure of the wearer and the kind of dress in which they are to be used. A good armseye and neck line should be established; the shoulder seam should be correctly placed; the fulness at the waist line should be carefully arranged; and the required straight grain or thread of material should be preserved.

(2) *Evening-Waist Lining.*—Evening-waist linings and wide girdles give variety of practice, as they have more seams than the shirt-waist. Their seams are not always placed as are those of the form cover, as many linings are made without an underarm piece.

An evening-waist lining opening at the centre back may be made from a straight piece of 20″ material about 18″ in length. The draping may be done directly in the lining material.

(a) The lengthwise centre of half the length of the material is marked and pinned to the centre-front line of the form. It is then drawn easily over the bust to the underarm, where there should be a seam. The width of the

material brings the selvage about in position for the seam which falls from the centre underarm straight down to the waist. The fulness in the front below the bust is removed by darts—one at each side of the centre. For a 36″ bust measure these darts are about 3″ apart at the waist line and 5″ at the top. They extend from the waist to within about 1½″ of the upper edge of the lining.

(*b*) To form the back the second length of material is cut lengthwise along its centre. The back is usually made with two pieces, a centre and a side back, both wider than the corresponding pieces of the form cover because there is to be no underarm piece. The centre and side back pieces should be well proportioned to fill the space to the underarm seam. Attention should be given to the direction of the seam-lines, to the required seam allowances, and to the grain of the material before the lining is considered finished.

A *tight lining* may also be draped, but, as the correct lines are definitely indicated by the form cover, there is no great advantage to be gained unless the worker uses another dress-form of a size and shape requiring some variation. For instance, for a stout figure two underarm pieces are frequently used and the side front may be cut to have a bias grain of material across the chest rather than a straight.

Following the making of linings, the designs suggested for the flat paper work will serve as well for practice in draping. Their becomingness to a special figure can now be tested and necessary alterations made.

2. **Shirt-Waist Designs.**—As the shirt-waist designs are the simplest, they are the first to be made. Various forms of decoration, such as tucks and gathers, which introduce fulness, may be attempted, as well as different styles of yokes and turnover collars. When these are made in material it can be seen how important it is to give careful attention to the proper direction of the threads, as on this depends much of the fit and hang of the garment.

3. **Kimono-Waist Designs.**—The plain kimono-waist gives a very good draping problem. The waist is often

found to fit better when draped on the form than when drafted to measure or designed from the shirt-waist pattern. This is largely because the height of shoulders varies, and, as the plain kimono has no shoulder seam, it is practically impossible to alter by refitting, once the waist is cut.

(1) While draping the kimono the padded sleeve should be attached to the form—practically at right angles to it—otherwise there is no opportunity for testing to get sufficient length of material from armseye to waist to allow freedom of motion. No definite instructions can be given for the direction of the crosswise threads which run from the shoulder down through the sleeve to the wrist, as this depends so largely on the height of the shoulder and the general shape of the figure. They should be so arranged as to remove any unnecessary fulness at the back near the armseye. This requires practice and for this reason is an excellent problem. The lengthwise threads which go around the sleeve should be made to meet at the seam by holding or easing in any extra fulness or length near the armseye and above the elbow. This makes it possible to match the stripes or cords in materials like Bedford cord and piqué. In draping any kimono very careful consideration must be given to the threads of the material.

(2) A kimono-waist may be close-fitting or full. (a) In making a rather full kimono the centre back and centre front may both be on the straight of the material. Some of the fulness may be removed in the underarm and sleeve seam. (b) If a kimono pattern is required which has little fulness the extra material may be removed in three different ways; that is: (i) The material may be drawn to the front and the centre front finished with a slight bias, or with the extra material turned back to form decorative revers. (ii) The centre back may have a seam the edges of which are slightly bias. This removes the extra fulness and allows the front to be straight. (iii) A seam may be made, extending from the neck line down the shoulder and arm to the wrist.

All these methods should be tried for the experience they

give. The patterns acquired may be used for a foundation for various designs which are made by the introduction of lines forming different divisions. As illustration, the raglan sleeve may be suggested by using a line which forms a 2″ yoke at the centre back and gradually drops in a curve under the arm and is then brought up again in a straighter line at the front to form a shallow yoke. There are many possible variations of these lines to suit different figures.

4. **Sleeve Designs.**—Designs may be made from the foundation or plain shirt-waist sleeve and the plain fitted sleeve. Both lend themselves to a great variety of treatment. The designing may be done in several ways: on a sleeve form which may be purchased and prepared; on a sleeve which has been drafted to individual measures made in material and padded; on a stiff-paper sleeve which is made from the drafted pattern.

Of these the first method is the least satisfactory. The form is expensive; it is heavy and stiff, difficult to manage in consequence, and it requires as much preparation as the other methods. Like the dress-forms, it must be padded to fit a covering which has been drafted to individual measures and fitted.

As sleeves are an exceedingly important part of any costume and are often difficult to make satisfactorily, all possible practice should be given in their designing. For this practice it is a good plan to have a stiff-paper sleeve and a padded sleeve; for, as the stiff-paper sleeve is flat and the padded sleeve is round, each is specially suited to certain kinds of sleeve work. For instance, in the making of a rather elaborate fitted sleeve of chiffon with a net or mousseline-de-soie lining the material can, in general, be more easily manipulated and sewed on the flat-paper sleeve; on the other hand, in the making of semifitted sleeves and shirt-waist sleeves the padded sleeve is much more satisfactory.

In preparing both the stiff-paper sleeve and the padded sleeve it is necessary to draft a fitted pattern to individual measures, cut it in material, and baste and fit it. The stiff-paper sleeve should be made first, as the muslin pattern

from which it is cut may afterward be made by padding into a padded sleeve.

(1) *Making the Sleeves.*

(a) *The Stiff-Paper Sleeve.*—(i) A muslin sleeve is first made to measure, using the tight-fitting-sleeve draft. If this sleeve is correctly drafted and basted and its seams notched, it will lie flat on the table without twisting or drawing and the straight of the material will lie along its back fold from armseye to elbow. It is easier to cut the paper pattern from the sleeve if its seams are turned to the wrong side, as no seam allowances are made in the paper— the pattern is cut the exact size of the sleeve. (ii) The paper should be heavy but not so stiff as to break or crack in the handling. As the pattern must be double, like the sleeve, a large sheet about 30″ by 20″ should be used and folded in the centre on the lengthwise straight. (iii) The work proceeds as follows: The straight fold of the basted sleeve from armseye to elbow is placed to the lengthwise fold of the paper and the sleeve held in place by pins, perfectly smooth and flat, while its entire outline is traced with a wheel.

A tracing should also be made to indicate the line of the top of the under part of the sleeve. After the muslin sleeve is removed from the paper all the traced lines of the pattern should be trued, as it is usually difficult to get good lines in tracing around soft materials. The pattern is then cut out along the seam tracings and the top shaped by the traced line. The sleeve will be in one piece, as it must not be cut open along the fold. If the pattern is well made the muslin sleeve should slip over it and fit perfectly.

(b) *The Padded Sleeve.*—(i) The muslin sleeve which served as a pattern in cutting the stiff paper is used for the padded sleeve. (ii) In preparing it for cutting in the paper it was necessary only to baste the seams carefully and notch them. Before it can be padded, however, the seams must be stitched in order to stand the pressure of the padding. (iii) After stitching, the seams are turned to the inside and the sleeve firmly and evenly padded with tissue-paper or with curled hair, which is much better but more expensive.

(2) *Materials.*—Flexible materials, such as cheese-cloth, unbleached muslin, cambric, tissue-paper, and inexpensive net are most satisfactory for practice in sleeve designing.

(3) *Shirt-Waist-Sleeve Designs.*—The padded sleeve is usually found to be more satisfactory for shirt-waist-sleeve designing than the stiff paper.

To aid in the designing, a plain shirt-waist sleeve which has been drafted to measure, fitted, and made should first be placed on the padded sleeve and pinned in proper position for general inspection as to the direction of its seam and the location of the straight of the material. The seam should be in line with the inside seam of the padded sleeve, just inside the arm, but not too much under it. The thread of the material should fall from the highest or central point of the sleeve in a straight line to the elbow. The grain or straight thread of the material is as important in sleeve designing as in all other designing.

(a) There is a regulation model for the sleeve of the strictly tailored shirt. Its only variation is in size; that is, in the amount of fulness used and in the width of its cuff—details which are regulated by fashion. Such changes are easily made and do not provide a designing problem.

(b) Sleeves which are used in semi-tailored waists and in lingerie or silk waists, however, may be changed in many ways; while their general style as to the size, location of fulness, or decoration is usually determined by the demands of fashion, the details of execution—that is, the methods used for adding or removing fulness and for making decoration—are determined by the design. In general, there is much less opportunity for decoration above the elbow of a full or semifitted sleeve than below.

Occasionally fashion demands a sleeve which is full below the elbow and close above. One method of making such a sleeve is by removing the fulness at the top by a series of tucks or plaits of the desired length. These must always be laid absolutely along the straight threads of the material. Tucks are also used around a sleeve its full length; these are purely decorative. They must be made on the straight crosswise threads, and may be in groups or

at regular intervals and with or without the added decoration of insertion. The use of tucks always provides a problem in good spacing.

There are many variations in methods of finishing below the elbow or at the wrist. The straight cuff and placket are usually omitted. The sleeve may be made to fit closely below the elbow by removing its fulness in a seam, as suggested in the flat-paper work. This seam runs from the point of the elbow to the hand in a straight line, which if extended would touch the little finger. It may be finished as a plain seam or to form a decoration. If the fulness is allowed to remain it may be tucked or gathered in at the wrist and the sleeve finished with a plain band cut the lengthwise straight of the material and finished in different ways: a plain band with a plaiting or ruffling falling over the hand; a circular or flaring cuff falling over the hand; or various-shaped turn-back cuffs.

(4) *Tight-Fitting-Sleeve Designs.*

(a) *Fitted Linings.*—As beginning-work with the tight-fitting sleeve, pattern linings should be made. They give excellent preliminary drill in the use of the stiff-paper sleeve and may be used later as foundations for the more elaborate designs in fitted or semifitted sleeves. If possible, net should be used in making the linings, although tissue-paper is satisfactory. The net is strong enough to be used as a foundation for the making of several designs, and because of this strength and its flexibility it is easier for the inexperienced to handle.

Three different linings may be made. They serve as linings or foundations for practically all types of sleeves. These three differ chiefly in length. They are: the full length, or long sleeve, covering the wrist; the three-quarter, or short sleeve, extending a few inches below the elbow; and the very short sleeve, or cap, only a few inches in length and generally used in fitted and semifitted waist linings and for evening dresses.

(i) *Long Sleeve Lining.*—The long sleeve lining does not require much material—once its length and a little more than twice its width, about three-quarters of a yard of 18″

material. The work proceeds as follows: The material is
folded in the centre on the lengthwise straight thread and
the paper sleeve slipped into it, with the fold of the pattern
along the fold of the material. Before beginning the work
the material should be pinned in place, as its straight thread
must be kept along this fold from armseye to elbow. The

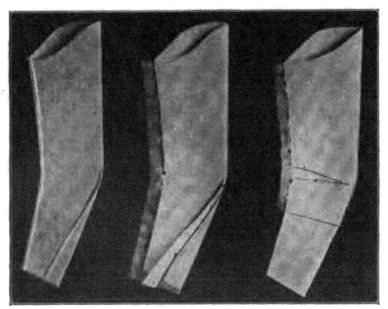

Net linings made on the stiff-paper sleeve

material is next pinned along the inside of the sleeve its
full length, close to the pattern; this forms a seam which
takes the place of the inside seam of the original muslin
sleeve. When this is done the upper part of the sleeve—
that is, above the elbow—is fitted and finished except for
cutting the proper seam allowance. Below the elbow at
the back, however, there is surplus material which must
be taken out to give shape to the lower part of the sleeve.
This surplus is removed by making a seam, not on the out-
side of the sleeve along the edge of the paper, but on the
under side, from the point of the elbow to the centre of the

wrist. If this seam were to extend along the outer edge of the pattern, as seems its natural position, it would bring both the seam and the sleeve opening (which, if one is needed, should be in this seam) too far back on the arm, to look well. It may seem difficult at first to draw the surplus material smoothly around to the proper place and make a good seam-line, but it can be accomplished with a little practice. The direction of the seam should be straight for about 2″ up from the bottom of the sleeve because of the opening, which must be straight. This makes the seam for 2″ at right angles to the lower edge of the sleeve. From the 2″ point it should slant directly toward the elbow. This direction may be indicated first in pencil on the paper pattern. After the material is drawn into place and the seam pinned, the surplus material may be cut away, leaving only a seam allowance which will be narrow as it nears the elbow.

(*ii*) *Short Sleeve Lining.*—A short sleeve lining extending a few inches below the elbow may be made in much the same way. The material is placed with its straight threads along the fold of the pattern as before and its inside seam securely pinned. There is a different method, however, for removing surplus fulness below the elbow. In place of the downward-slanting seam from the elbow the material is drawn up to fit the pattern by making a crosswise seam. This seam is laid just in the bend of the elbow so that in wearing it seldom shows. It extends straight across and is quite deep at the inside of the elbow but tapers to nothing at the point.

(*iii*) *The Cap, or Very Short Lining.*—This very short sleeve differs from the longer ones in that it has but one seam which is placed exactly in the centre of the under side of the pattern. This requires less work in making and also prevents the seam showing if, as is frequent. transparent fabrics are used in the making of the sleeve itself. The lining is very simple to design; there is no surplus fulness to remove and the material may be drawn smoothly around the pattern with its straight threads extending along the fold. The seam when finished should

form a straight line along the lengthwise centre of the under sleeve.

(b) *Fitted Sleeves.*

(i) *Unlined.*—When practice in the modelling of linings has given sufficient skill a sleeve without a lining should be made, with the usual inside seam but with the surplus fulness below the elbow taken out in such a way as to give the sleeve its distinctive style. The fulness need not necessarily be removed on the under side of the sleeve, as in the linings, but may be drawn to the upper side and so arranged and cut out as to form the decoration. Cambric and unbleached muslin are very satisfactory mediums for this designing.

(ii) *Lined.*—In making many of the elaborate sleeves over linings frequently one seam is all that is required in the sleeve itself. This one should fall from the centre of the underarm; that is, the centre of the under side of the pattern straight down the sleeve and join the lining seam at the point 2″ above the wrist, where that seam straightens for the opening. As an example of a sleeve which may be made in this way, directions are given for the mousquetaire.

The mousquetaire sleeve may be worked out successfully with tissue. Unless it is to be very full—and it should not be—one and a half times the·length of the sleeve is material enough for the fulness. This fulness may be arranged in various ways: by the use of lengthwise shirred tucks, cording, gathers, or by crosswise shallow tucks or plaits. The amount of material required in width depends somewhat upon the method chosen. In making the mousquetaire sleeve, no matter what the style of decoration may be, the straight of the material must be kept in the centre of the upper side of the sleeve from shoulder to wrist; that is, half-way between the two edges of the paper pattern. Any lengthwise decoration for the centre of the upper side of the sleeve, such as shirred tucks, gathers, or cording, is made on the straight of the material and drawn up to the required length before being pinned in place on the sleeve. After the material is prepared the work proceeds

as follows: the straight of the material is first pinned along the centre line of the upper side of the sleeve, which may be indicated in pencil on the paper. It is wise to pin the material in place as well along both edges of the pattern. If this is done the fulness can be better arranged. By keeping the straight of the material in the centre of the upper side when the material is drawn around to the under part of the sleeve for adjustment, there is necessarily additional fulness at the inside or bend of the elbow, to give sufficient fulness at the point of the elbow. This fulness can without difficulty be gathered or laid in small plaits and, if lightly attached to the lining, will lie flat and stay in place. When all the fulness is satisfactorily arranged the edges of the material are brought together along the centre line of the under side of the sleeve and cut off evenly, allowing ¼″ on one edge and enough on the other for a small ¼″ turning to finish the seam neatly. Both edges are gathered, one along the raw edge, the other after the ¼″ turning is made. The gathered raw edge is pinned to the net lining and then covered by the folded edge.

By this same general method of procedure, using the padded or stiff-paper sleeve, fulness may be arranged in various attractive ways, caps and cuffs may be added, slashings may be introduced, all according to the prevailing fashion and suitably adapted by the taste of the designer. All fashion sheets and historic costume prints and books give an endless variety of designs for simple and elaborate, full, semifitted, and fitted sleeves.

5. **Skirt Designs.**—Skirt work in draping, as in pattern-designing, should begin with the making of gore divisions which form the basis for all other designs. In making these the principles of construction used in drafting should be kept carefully in mind. Special figures must now be considered; there should be much testing of various divisions, such as have already been tried in the flat-paper work, with regard to the becomingness of the lines and the proportions of the gores. It will soon be seen that any definite rules already given for gore directions can be only generally sug-

gestive for this work. In many cases they do not give well-proportioned divisions or the most becoming lines to the figure for which they are intended. While the general style of a skirt and its divisions are somewhat determined by fashion, they may always be modified to be in good proportion and give grace of line to the figure. All gore lines should be at right angles to the waist line. If the tape-measure is pinned at the waist and drawn down to the floor it shows the effect of the gore divisions distinctly and also gives good direction of line. Many of the gored skirts made may serve as foundations for more elaborate draping for which very few directions can be given.

In the draping of all skirts there are certain factors to be observed.

(1) In general, (*a*) if a straight-hanging skirt is desired —that is, straight as a plumb-line falls—the straight lengthwise thread should be used. This gives a waist line with little curve. (*b*) If a skirt which flares or stands away from the figure is required the bias should fall from the waist to the floor; this gives a waist line which is rather deeply curved. It will be remembered that, in drafting, the narrow, straight skirt had a fairly straight waist line when compared to the deeply curving one of the circular skirt. The same principle holds true in draping.

(2) In manipulating material in the skirt work it will be seen: (*a*) that in the straight skirt with the straight lengthwise threads there is always the straight crosswise thread of the material around the hip; (*b*) that as the material is drawn up off the straight crosswise grain from the front toward the back, the skirt becomes narrower at the bottom line and fuller at the hip; (*c*) that, on the contrary, as the grain is allowed to sag or drop, making the circular waist line, the skirt begins to flare. The amount of flare is always determined by the depth of the waist circle, the greatest flare coming where the circle is deepest.

As facility is secured in executing waist and skirt designs in rather simple materials, those ·requiring more skill in manipulation and a more subtle combination of textures and colors should be attempted, their choice depending

always on the individuality of the wearer. Because of the great number and variety of the factors involved and the amount of practice necessary before any skill can be acquired, too rapid progress in designing should not be attempted or expected.

CHAPTER VIII

WAISTS

There are two general types of waists: the shirt-waist or semifitting waist; the tight-fitting or draped waist.

There is opportunity for great variety in each type of waist.

The shirt-waist or semifitting waist may be cut from a pattern or draped on the form; it may be made flat on the table without the use of the dress-form; it may be lined or unlined. A lining is not necessary, as generally the main sections or pieces of the waist are sewed together into one garment. A lining is frequently used as a protection to the material of the waist or it serves as a foundation to which various accessories, such as collars and vests, may be attached.

The tight-fitting or draped waist is draped on the form directly in the material or in trial material which serves as a pattern or is cut from a pattern and the form is used in arranging the various sections of the waist. It should be made on the form. It cannot be successfully made if the work is done flat on the table, as generally the various sections are not attached to each other but to the foundation to secure the desired free effect; it is lined and the lining serves as a foundation to which the various main sections and such pieces as sleeves, vests, collars, etc., are attached.

In this chapter the making of (I) shirt-waists, (II) guimpes, and (III) linings is discussed. Fairly definite directions are possible for making the various styles of shirt-waists or semifitted waists. In general construction they are much alike, and general directions for making can be followed with slight modifications to meet any variations in detail.

Draped or tight-fitting waists, on the contrary, vary so greatly in construction as to shape, size, and number of

313

pieces required to complete the design, that general directions for making are practically useless. The same may be said regarding the making of sleeves other than those suitable for shirt-waists. They also vary greatly, as they must bear close relation to the design of the dress. Each waist and its sleeve presents a special problem, in the working out of which it is possible to give here only a few directions, such as those for the making of linings and various finishings. These directions combined with those already given for designing and draping should make much less difficult the satisfactory construction of any draped waist.

I. Shirt-Waists

The discussion in this chapter presupposes a good-fitting foundation shirt-waist pattern, the detailed directions for securing which by various methods have already been given in Chapters V, VI, VII. Those directions are, of necessity, frequently referred to here, but repetition is avoided when possible.

There are many styles of waists which may be made from the foundation shirt-waist pattern. All unlined waists, in fact, except the kimono, are cut on practically the same general lines and differ chiefly in finish and in the amount and kind of decoration. For better organization of the directions for making these waists the various styles may be grouped under two heads or as two general types: tailored shirt-waists, non-tailored or fancy waists.

1. **Tailored Shirt-Waists.**—There are many ways in which tailored shirt-waists may be made, but in general they may be said to open at the centre front, to have a stitched centre-front plait, little fulness, a narrow collarband, and plain sleeves finished with stiff cuffs. Variety is given in different ways: in the use of yokes, in the arrangement of the fulness by gathers, tucks, or plaits, and in the manner of putting in the sleeve. All tailored shirts are machine-made. They are plainer from point of decoration than any other, but they are not as a result simpler to make. They are dependent for their finish and good

style on cut and workmanship, and consequently emphasis must be placed on the technique. Cottons, as madras, piqué, percale; wash silks, as silk duck, China silk, pongee, and habutai; wools, as flannels, batiste, or nun's veiling; and fairly heavy linens and crashes are the materials most frequently used.

2. **Non-Tailored or Fancy Waists.**—For waists which are not tailored there is unlimited variety in cut and finish. They may be made by hand or machine; they may be cut to open at front or back, to be full or plain, to have short or long sleeves, a standing or flat collar; and they may be finished in a way best suited to the material used. Cottons, as batistes, dimities, crêpes, and voiles; silks, as *crêpe de chine*, *crêpe meteor*, poplin, and taffeta; and handkerchief linens and linen lawns are all suitable materials.

I. *General Directions for Making*

In making waists of both types, with few exceptions, the same general procedure must be followed; that is, there must be:

(1) Securing the pattern.

(2) Preliminary preparation of the material for cutting.

(3) Arranging seam allowances; placing the pattern and cutting.

(4) Marking for basting.

(5) Basting and preparation for fitting.

(6) Fitting.

(7) Making and finishing.

In the detail of these steps there is great opportunity for variation, owing to the many kinds of material it is possible to use and to the constant change in fashions it is possible to have. For this reason general directions are given which are necessary in the making of practically all waists; and, in addition, a few suggestions are included which it is hoped will aid in adapting the general rules to meet the requirements of specific problems.

1. **Securing the Pattern.**—Four general methods of procedure may be followed; the pattern may be:

(1) Drafted to measure. (See *Drafting*.)

(2) Adapted from a commercial pattern. (See *Use of Commercial Patterns*.)

(3) Designed in paper or material on a flat foundation pattern. (See *Designing*.)

(4) Draped on the dress-form. (See *Designing*.)

No definite directions can be given for the selection of a suitable method for securing a pattern. There are too many varying factors, such as the experience of the worker, the type of waist, its material and style.

2. **Preliminary Preparation of the Material for Cutting.** —In addition to the shrinking or sponging of the material which is generally preliminary to the making of any garment (see *General Suggestions*), there is other preparation necessary before a waist can be cut out. All waist openings, whether at the centre front, centre back, or side front, should be planned if not made. Much of the decoration which may be used, such as tucks, shirrings, cordings, and smocking, should also be planned if not entirely finished.

Lace insets forming a design which extends over the shoulder from front to back cannot be included in this list. It is necessary to cut the waist and join it at the shoulder seam before the lace can be applied. Straight rows of lace, however, which are inset in both the front and the back and so planned as to meet at the shoulder seam and be included in it, should be applied before any cutting is done.

(1) *Openings.*—The majority of waists, whether the opening is at the front or the back, have the right side fastening over the left, as it is in general easier for the wearer to manage. This is not, however, an arbitrary rule.

In making any style of hem or plait whatever, the selvage of the material should first be removed. It does not give, as the body of the material does, and frequently puckers or draws.

After either a centre back or front opening is made, the lengthwise centre line of the opening finish of each side of the front or back must be carefully indicated by a line of colored basting. This line serves many important purposes—in planning the decoration and in the cutting, fitting, and finishing.

(*a*) *Centre-Back Openings.*—If the necessary openings in a waist are placed at the centre back there is less chance for variety in planning. They are usually finished with plain hems of equal or nearly equal width. These hems are seldom wider than ¾″ or 1″, and are made in the regulation way by first turning in the raw edge about ¼″ and then making a second turning the width desired.

(*b*) *Centre or Side Front Openings.*

(*i*) *Plain Hems.*—If plain hems are used at the centre or side front, the hem on the right side is often somewhat wider than that of the left but not necessarily so. It should always be in good proportion to any other decoration on the waist. Extremes in width should be avoided whatever the general decoration. These hems are made in the usual way.

(*ii*) *Box Plait and Hem.*—A centre-front opening which is frequently used is that which has a box plait and hem. This is especially true of all styles of tailored waists, which are seldom finished in any other manner. The width of the box plait may vary to suit the taste of the wearer or to correspond to any other decoration used on the waist. It is generally not less than 1″ in width and not more than 2″.

(*a*) *Making the Box Plait.*—In commercial patterns there is frequently a separate piece for the box plait. The work is much more quickly done, however, if the plait is cut in one piece with the waist. It can then be planned and entirely finished before the waist is cut out. There are many ways of making plaits. The following is an exceedingly simple method:

The raw edge is turned to the wrong side the width of the plait and basted carefully about ⅛″ in from its folded edge. The material is then turned to the wrong side again; this time the turning is made along the line of the raw edge and encloses it. This makes the second turning the same width as the first; that is, the width of the plait. This folded edge should be basted, as was the first, ⅛″ in; this distance is sufficient to enclose the raw edge if the folding has been done close to it, as it should be.

The plait is ready for stitching. The first row may be

made along the fold just turned. The distance in from
the edge depends upon the width of the plait; it must be
sufficient to enclose and hold the raw edge. It should not
be less than $\frac{1}{8}''$ and generally not more than $\frac{1}{4}''$. After
the first stitching is done the plait is turned back to the
right side and creased into place. It will be seen that this
stitching forms a tuck which is one edge—the inside edge
—of the plait. The opposite folded edge, which is the first
one turned and basted, should be stitched to correspond
and the plait is completed.

(b) *Making the Hem.*—The width of the hem used to
finish the other side of the waist opening depends on the
width of the plait. It should be a little narrower to avoid
showing its stitched line beyond the plait. For a $1''$ plait
a hem $\frac{5}{8}''$ or $\frac{3}{4}''$ wide is satisfactory. It is made in the
regulation way.

After the hem and plait are finished the line of colored
basting must be placed along the lengthwise centre of each
to indicate the centre-front line of both sides of the waist.

(2) *Decoration.*—From the point of view of decoration
waists should be divided into two classes: those that re-
quire constant laundering and those that do not.

Under the first head may come all kinds of tailored and
the so-called lingerie waists which are made up in linens,
cottons, wash silks, and flannels.

Such decoration should be chosen for these as can be
designed to follow the threads of the material; that is,
tucks, plaits, shirrings, and smockings. The Gibson plait
is an exception to this. For part of its length, at least, it
must be on the bias, but if made in firm material and care-
fully planned it does not twist when laundered.

Under the second head may be included the fancy waists,
for which silks and satins are generally used. For these
the same decorations may be used as well as many others,
but they may all be arranged in designs which require
curved and bias lines as well as straight.

(a) *Waist Decoration.*—In making any decoration for
the front and back of a waist, preliminary to cutting it out,
the work is much simplified if the design is first planned on

the pattern. The pattern should then be frequently laid on the material in order to determine exactly where the line of decoration is to fall. The centre front and centre back of the waist must first be definitely indicated and a lengthwise centre line marked to serve as a guide in placing the pattern; this line and the armseye line regulate the placing of practically all decoration.

Difficulty is frequently experienced in planning tucks, in making the two sides of the waist perfectly even, and in matching the tucks at the shoulder seams when they are used both in the front and back.

There are a few suggestions which may be of assistance in securing evenness:

(*i*) *To Tuck the Front of a Waist Which Has a Centre-Front Opening.*—(The following is a convenient method but not always an economical one.) In general, two lengths of material are needed to make the fronts of such a waist. If these two lengths are torn or cut off in one whole piece and the tucks for both sides are made at the same time in the length of the material, the two fronts are sure to match when the waist is cut out. The tucks cannot be made, however, until the centre-front opening has been planned, as their location and spacing are largely determined by the width of the plait or hem.

(a) *In Making the Centre-Front Openings.*—If hems of equal width are to be used for the two sides they can be made, as are the tucks, the full length of the material. No directions are required here.

If, on the other hand, a box plait and hem or two hems of different width are used, as is probable, a little planning is necessary. After the full length of material for the fronts is cut off, the selvage along one edge should be removed. The material is then folded in half, end to end, and a slash made straight in from the raw edge at right angles to it along this fold, about $2\frac{1}{2}''$ or $3''$ in depth. This slash makes it possible to finish the centre front of each half in a different way without difficulty.

When the box plait and hem are used the method of making is as already described. The plait is folded first.

It must be planned to come on the half which, when cut, will form the right side of the waist. After the plait is made the desired width, its lengthwise centre is marked by a colored basting. This line of basting should be extended the full length of the other half, or front, to serve as a guide for indicating the centre line of the hem which

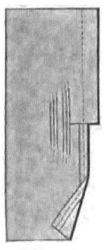

is to be made. The hem is made, as usual, somewhat narrower than the plait, and in the making care must be taken to have it an equal width each side of the centre colored marking already made; that is, the true centre line of the hem must be the continuation of the centre line of the plait.

When hems of different widths are used to finish the centre-front openings the same general method is followed.

After the hems or the plait and hem are basted, the tucks may be planned and made, using the line of colored bastings as the basis for all measurements.

(b) *In Making the Tucks.*—If the tucks are to extend the full length of the front the procedure is very simple. The pattern is placed on the material with its centre-front edge to the centre front of the plait to locate the first tuck. It

Making the two fronts of a waist (with the box plait and hem) in one length of material

should also be used to determine the number of tucks necessary to give the right width to the shoulder of the waist.

If the tucks are to be made only long enough to form a yoke, more definite indications are required. The shape of the yoke and its depth should be traced on the pattern. The material is then folded, end to end, as for cutting the slash, the pattern is laid on, and a mark is made through the two thicknesses of material to indicate the length of the first tucks. The material may then be opened and the tucks turned and made between the two points. The length of the tucks should be frequently tested by the pat-

tern in order that they may form, when finished, a good line for the bottom of the yoke.

(*ii*) *To Tuck the Front of a Waist Which Has a Centre-Back Opening.*—If one length of material is not sufficiently wide to form the front a second length is added. Generally half of this is sewed to each side of the full width and an attempt is made to have the joining inconspicuous by placing it so that it is concealed by some lengthwise decoration. Before any decoration is planned, however, the lengthwise centre line must be indicated by a colored basting. The material is then folded along this basting and the two sides marked at once for the lines of decoration, beginning at the centre front and working toward the armseye.

(*iii*) *To Make the Back of a Waist Which Has a Centre-Front or Centre-Back Opening.*—One length of material is usually all that is necessary to form the back of any waist.

(a) If the opening is in the back the selvage may be removed from both edges of the material and the two hems for the opening turned along these edges. After these hems have their centre lines indicated they should be pinned together along these lines and the two sides should be marked at once by the pattern for the lines of decoration. If the decoration of the front extends entirely across the front to the armseye so that it is included in the shoulder seams, the decoration of the back must be so planned as to match any there may be on the front shoulder. This is easily done by placing the shoulder seam of the pattern of the back to the shoulder seam of the material for the front—which should have its decorations already made—and marking with tracings their exact location. If the decoration of the front does not extend to the shoulder, that of the back should be planned with reference to the centre-back hem.

(b) If the opening is in the front, before planning any decoration the lengthwise centre-back line must be established as a guide. The material is folded along this line and both sides are marked at once. The decoration of the back should be planned with reference to that of the front.

(b) *Sleeve Decoration.*—In making any decoration for a fancy sleeve preliminary to the cutting out, the design is planned on the pattern which is then frequently laid on the material in order to determine the correct location of the lines. Both sleeves should be marked at once. Care is needed in placing lengthwise decoration on a shirt-waist sleeve—its centre line should fall from the central point of the shoulder straight down.

The sleeves of strictly tailored waists should have no decoration.

(c) *Collar and Cuff Decoration.*—Many of the lingerie and fancy waists have decoration on the collar and cuffs. This should be planned if not made before any cutting out is done. The decoration of the two cuffs and of the two sides of the collar should be made to correspond by preliminary tracing and careful use of the pattern. For the straight cuffs and the collar-band of the tailored waists no decoration is used and no patterns are required, as they are made to the desired measures with their length on the lengthwise straight of the material.

3. **Arranging Seam Allowances; Placing the Pattern and Cutting.**

(1) *Seam Allowances.*—When placing any pattern for cutting it is absolutely necessary to notice whether the seam allowances have already been added to it and if not to plan for them. The majority of commercial patterns have a regulation allowance which is explained in the description of the pattern and indicated generally by perforations; drafted and designed patterns may or may not have, according to the choice of the worker. Occasionally it may seem safer for a beginner to use a pattern with the allowance added. Seam allowances are, in general, as follows:

(a) For the waist: $1''$ on the lengthwise and shoulder seams and $\frac{1}{4}''$ at the neck and armseye.

(b) For the sleeve: $1''$ on the lengthwise seams and $\frac{1}{4}''$ at the top and bottom.

(c) For the yoke, collar, collar-band, and cuffs: $\frac{1}{4}''$ is sufficient for finishing on all edges.

(*d*) For the placket pieces: ⅛" is sufficient.

(*e*) As the centre-front or centre-back openings are planned before placing the pattern, no extra allowance is needed.

(*f*) If the waist pattern is cut to extend 4" below the waist line it is sufficiently long for finishing.

(2) *Placing and Cutting.*—When possible the entire waist pattern should be placed and cut at once; that is, all the parts of the waist itself—front, back, sleeves, and such minor parts as the yoke, collar, collar-band, cuffs, and any pieces for finishing the sleeve or the sleeve placket. In general, the material should be folded and all corresponding pieces cut together, as it saves time and confusion and helps to prevent having two pieces for one side if the material has a right and a wrong side. (For exceptions, see *General Suggestions.*)

In placing a pattern, economy of material should be considered. No definite rule for doing this can be given because of the variety of designs and the fact that the materials used differ as greatly in width as do the patterns in size.

The direction of the lengthwise and crosswise threads of the material is exceedingly important in placing and cutting a pattern. For a regulation shirt-waist the two fronts, the back, the length of the sleeve, the length of the straight collar or collar-band, the length of the belt, the length of the pieces for the sleeve placket, and the length of any straight cuff are, in general, placed on the lengthwise straight grain or thread of the material. The various pieces of elaborate waists usually require different treatment in placing. This should always be indicated in the pattern whether it be purchased or made by the worker.

All commercial shirt-waist patterns include such pieces as those for yokes, cuffs, collar-band, collars, and sleeve plackets, as the pattern is for one definite design and consequently requires a special shape for these. The way in which they are to be placed on the material is usually indicated. The drafted shirt-waist pattern given under *Drafting* does not include any special directions for such

pieces, as it is merely a foundation pattern on which may be made a variety of designs, each of which affects somewhat differently the size and style of the various pieces.

(*a*) *Placing the Waist.*—In cutting out a waist which opens at the centre front and has a box plait and hem or two hems, the lines of colored bastings which indicate the exact centre line of the fronts of the waist should be carefully pinned together and the centre-front edge of the pattern should be placed to them.

The half of both the plait and hem which extends beyond this centre-front line should be turned back on the waist and pinned firmly while the neck is cut out. Each half of the plait and hem must have the same curve at the neck in order to go into the band correctly. If allowed to extend while the cutting is done, the extensions are frequently cut off straight across and are thus made too short. They are then very difficult to manage in the making. The same procedure should be followed for a waist which has its opening at the centre back. Care should be taken to match and pin in place any decoration already made in the material so that the two sides of the waist when cut may correspond and all shoulder decorations meet.

(*b*) *Placing the Yoke.*—When a yoke is used it is generally cut with its centre-back line on a lengthwise fold. If there is a special design and the material has stripes or figures, a seam is usually necessary. The material at this seam may be either bias or straight. Two yokes are occasionally required, one of which serves as a lining. The grain of the material in these two yokes should correspond.

(*c*) *Placing the Collar and Collar-Band.*—There are two general styles of collars which may be used on all but the strictly tailored waists—these are the standing collar and the flat or turnover collar.

(*i*) If a standing collar is to be attached to a waist, unless a special pattern is used its length is cut on the lengthwise thread and its centre front or back, as required, on the straight crosswise fold. It should equal in length the neck measure plus one-half the width of any plaits or hems used

at the waist opening, plus a hem allowance which matches in width the hems or plaits of the waist opening. The finishing of the opening of the collar should appear as a continuation of the opening of the waist.

(*ii*) When a flat or turnover collar, opening in front, is used, if it is not cut in some special design its centre back should be placed on a fold which may be the lengthwise straight grain or a true bias.

(*iii*) If a collar-band is used, unless there is a great difference in the size of the neck of the wearer at the top and the base a straight band may be made. It can be cut in one piece and folded lengthwise, and in consequence time and difficulty are saved. This band, whether straight or curved, should not be too wide when finished—not more than 1″—as it serves merely as a band to which the collar is attached. In length, when finished, it should equal the neck size plus one-half the width of the plait and hem or hems used at the centre front.

(*d*) *Placing the Sleeve.*—The cutting of any sleeve pattern is very important. If the lengthwise threads do not fall as they should, according to the pattern used, the sleeve will twist and the most careful fitting cannot make it hang well. The directions for the lengthwise threads should always be indicated in some way in all patterns. In general, they should fall in a straight line from the point of the shoulder to the elbow.

(*e*) *Placing the Cuffs.*—There are many kinds of cuffs which may be used, depending on the style of the waist.

(*i*) Tailored cuffs are always straight pieces. They depend in length on the wearer's hand and wrist, in width on the prevailing style. An average finished size is 9″ in length and $2\frac{1}{2}$″ in width. (a) If a plain material is used the cuff pieces are often cut the required length and three times the width. This gives a cuff with a folded edge at the hand and allows one width to be turned in to give a little additional stiffness to the cuff. When cutting a cuff in this way $\frac{1}{4}$″ seam allowance is made on each lengthwise end; that is, $\frac{1}{2}$″ in all, but only $\frac{1}{4}$″ is necessary on the width. (b) If figured or striped material is used the cuff

is cut the required length and only twice the width, with the regular seam allowances. To give the necessary stiffness, plain and heavy material must be cut to take the place of the extra width of the other cuff.

(*ii*) Straight soft cuffs and shaped cuffs are frequently used on all but the tailored waists. No directions can be given for their size or their cutting, as both depend entirely upon the design, which is, in turn, determined by the wearer and the prevailing fashion.

(*f*) *Placing the Pieces for the Sleeve Placket of a Tailored Waist.*—The pieces for finishing the sleeve plackets should be cut with their length on the lengthwise straight grain. If the material of the waist is figured or striped the pieces must be cut to match the sleeve. This finishing may be cut in one piece or two for each sleeve, governed by the method of making.

The width of the pieces is a matter of choice but the length of the placket is not. When finished, a placket should be sufficiently long to allow a cuff to open enough to lie flat when ironed. It must be half the length of the cuff to do this; consequently, its length is dependent upon the size of the cuff.

4. **Marking for Basting.**—There are three ways of marking the lines which are necessary in the basting and making of a garment. (See *General Suggestions*.) The majority of the materials ordinarily used for unlined waists—that is, cottons, linens, and wash silks—can be satisfactorily marked with the tracing-wheel. If wool is used tailor's chalk and tailor bastings may be required.

If the tracing-wheel is used all the necessary marking may be done after the waist pattern is pinned in place and before cutting out. If the material is such that the tracings do not show or will not last, the waist may be marked temporarily and cut. In making the tailor bastings, after cutting out, especial care should be taken to have the two pieces of material so firmly pinned together that they cannot slip and their corresponding seam-lines be uneven.

Tracings should be made around the pattern of the front and back, which gives the seam-lines, the neck, armseye,

and bottom lines; through the waist line; around the yoke and through its centre-back line; around the collar or collarband and through its centre back or front line; around the belt and through its centre back or front line; around the cuffs and placket finishings; around the sleeve to give the seam-lines; and through the tracings in the sleeve to indicate the line of gathering and the location and length of the placket opening. In marking the seams of a pattern it must be remembered that it is the seam-line itself and not the seam-allowance line which should be marked. These tracings are to indicate the lines on which the basting and the sewing are to be done, and they must be correctly placed and true.

The neck, armseye, and waist lines, and the cross-marks at the shoulder, the marks for sleeve-gathering and the centre front or back lines of yokes, collars, etc., serve various important purposes in the making of a waist and must be carefully maintained until the waist is practically finished. They act as a guide (*a*) in the joining of the various pieces of the waist; (*b*) in the adjusting of the collarband, sleeve, and belt; (*c*) in the placing of corresponding pieces together for needed alterations after one side of the waist is fitted. As the mark of the tracing-wheel is easily lost in handling the material in the sewing and fitting, these lines and markings should be retraced by bastings of colored cotton after the waist is cut out. Colored cotton is used because it can be plainly seen in the fittings and shows the correctness of the placing of the lines, and it can also be easily distinguished from the other basting lines.

5. **Basting and Preparation for Fitting.**—There are a few general rules for the basting of all waists. These have already been suggested in the making of the shirt-waist pattern under *Drafting* but are treated here in more detail.

Seams are basted on either the right or the wrong side of the waist, depending on the style of finish. For French seams, for fells, or for *entre-deux* with French-seam finishes, all of which are used for wash waists, the basting should be done on the right side, as the seams are required there for the finishing. The basting should be done on the wrong

side for all plain seams, for a welt seam, and for *entre-deux* with bound-seam finishes.

In basting for fitting: (*a*) The thread should be well fastened in the beginning and the finishing and short stitches should be used where there is any strain. If the waist does not need fitting and the basting merely serves to keep the seam-lines in place for stitching, longer stitches may be used. Unless a worker is very experienced, stitching should not be attempted without basting. Even careful pinning is not satisfactory. (*b*) The line of the basting should always follow the exact line of the tracing. (*c*) Before basting any seams together all corresponding tracings should be matched and pinned. For example, in basting the underarm seam the waist lines should be pinned together, the material should be smoothed toward the armseye and pinned again there, matching armseye tracings. This keeps the seam-lines together and makes their basting simpler. It also prevents the slight fulling of the side nearest the worker, which frequently occurs, especially in the work of the inexperienced or careless.

(1) *Basting the Waist.*—(*a*) For the lengthwise waist seams the basting is done from the armseye line to the waist line and 1″ below. If the two underarm seams do not correspond exactly in length, due to careless measuring and cutting, the difference should come at the armseye and not at the waist line. (*b*) In the shoulder seams the two armseye tracings, the two neck tracings, and the centre tracings, or cross-marks, are placed together and pinned. In doing this in the majority of waist patterns it is necessary to stretch the front shoulder, since it should always be cut about ¼″ shorter than the back. By pinning the seam at the centre as well as at both ends the fulness is regulated and it is easier to baste. In the basting, the back shoulder seam should be toward the worker, as the fulness is easier to manage, especially if the work is held over the fingers of the left hand. (*c*) As nearly all waists are planned to have fulness at the waist line in the back, the row of gathering should be put in exactly on the waist line from underarm seam to underarm seam. The fronts

may also be gathered, but, in general, waists opening in front, especially those which are to be washed, are more satisfactory if the fulness is left free and is held in, when worn, by fastening a belt over it. (*d*) A belt is necessary for the fitting. Non-elastic tape may be used or one may be made of the material of the waist. If made of the material it may be cut in one piece, about 1½″ or 2″ in width, with sufficient length allowed beyond the actual waist size to fasten satisfactorily. The belt should be, when finished, not more than ½″ or ¾″ wide. After all the edges have been turned in ¼″ the belt may be folded along its lengthwise centre and basted on this fold and on the remaining three sides. An open edge is not needed, as the belt is attached to the outside of the waist with its upper edge on the waist line. Its centre should be marked with colored bastings. The belt is not basted to the waist when it is being prepared for the fitting but is pinned on during the fitting.

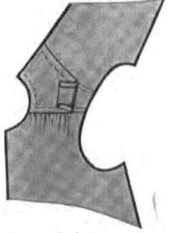

Basting a lined yoke to a waist

(2) *Basting Yokes.*—If a yoke is to be used it must be attached to the waist before any of the waist seams are basted. Yokes are of many shapes and are used in all styles of waists. Depending upon the definite style of the waist, they may be lined or unlined.

(*a*) *Unlined.*—When unlined they are most frequently used in thin wash waists and are joined to the waist by *entre-deux*, or beading. The fulness in the waist must be arranged and the yoke *entre-deux* and waist joined by basting according to the kind of seam finish chosen. Care must be taken not to stretch the yoke out of shape while the work is being done.

(*b*) *Lined.*—The procedure for lined yokes may differ in detail, depending on various factors. If there is fulness

in the waist at the front or back it is arranged in the desired tucks, plaits, or gathers. The two yoke pieces are carefully basted wrong sides together before joining to the waist in order to have the yoke perfectly flat when finished. This basting is done down the centre-back line and around the entire yoke 1″ in, as it must not be close enough to the front and back edges of the yoke to interfere with the work of joining. After the yoke and waist are prepared they may be joined in two ways, giving the same results.

(*i*) The piece serving for the lining of the yoke is basted to the waist along the tracings with the seams to the right side. These seams are creased to the lining and basted flat. The yoke itself with its turned-in seam allowances is then basted to the waist with its edges following and covering the seams by which the lining is joined.

(*ii*) The seam allowance on the two pieces is turned in to correspond and the waist slipped in between the edges, as the neck of the waist is slipped into the collar-band, and basted. This is a good method if the yoke has a very curved or pointed line across the back or front and it is difficult to make a good seam otherwise.

A yoke is sometimes applied to the back of a waist by much the same method, if the back is cut the regulation size, and serves as a lining. This can be done only when the back has no fulness from armseye to armseye. The yoke should be carefully basted to the back to keep it flat, while its lower edge is turned in and basted.

For many fancy waists, where a lining is desired for protection or to keep the yoke in shape, both yoke and lining are joined to the waist in a seam on the wrong side and may be finished as desired.

(3) *Basting the Sleeve.*—The sleeve should be placed flat on the table and the seam tracings should be brought together and pinned, beginning at the wrist. If the sleeve does not lie flat after the tracings are matched, a readjustment is necessary before any basting is done. It is better to have the sleeve smooth without twisting than to have the tracings match.

If there is any fulness whatever the sleeve should have

two rows of gatherings at the top before it is basted into the waist for the first fitting. The amount to be gathered is indicated by marks or tracings. The first gathering should be ¼" in on the traced seam-line, which is also the basting line; the second should be ⅛" in from that, to hold the gathers in place. The bottom of the sleeve should be gathered in the same way as the top, beginning at the opening and going entirely around it.

When a sleeve is basted into a waist it is placed in the armseye and corresponding marks are pinned together. The number and location of these marks may differ widely, according to the pattern used. But in every case they should be carefully observed.

If the drafted pattern is used or a pattern which has no marks indicated, the rule for placing and basting a sleeve to a waist, already given under *Drafting*, may be safely followed and need not be repeated here. The same general procedure is followed, but the work is simplified somewhat if the sleeve is nearly the same size as the armseye of the waist and there is no necessity for gathers and their adjustment.

(4) *Basting the Collar and Collar-Band.*

(a) *Collars.*

(i) If the standing collar is a straight, unshaped piece, as is usual in a wash waist, it requires no preparation except the basting of the necessary turnings on each edge and the hems at each end. As has been said, these hems must be cut and basted to match the finishes of the waist openings. If this collar is to be attached before the fitting, it is basted to the right side of the waist, with its centre marking at the centre mark of the neck and its folded edge along the indicated neck line of the waist.

(ii) The flat or turn-over collar should have its edge basted for the desired finish and should be attached to the waist. It should be placed flat, with its wrong side to the right side of the waist, its centre mark on the centre mark of the neck, and its neck line matching the neck line of the waist.

(b) *Collar-Bands.*

(*i*) There are two ways of making collar-bands: by using a straight strip of material or one which is slightly shaped; the former is generally satisfactory.

(a) If a straight lengthwise strip is used for a collar-band it is cut in one piece the required length and width, with ¼" allowed on all edges for seams. In preparing it for basting to the waist the ¼" turning is made around it and basted. It is then folded through its lengthwise centre and basted along the fold and at each end to prevent any twisting. The lengthwise edges are left open to insert the waist.

(b) If a shaped band is used it is cut in two pieces, with the length on the lengthwise thread of the material. Each piece must have the usual ¼" allowance on all edges for seams. The two pieces are placed together, right side to right side, and stitched ¼" in on all but the lower edge. The band is then turned right side out, the stitched edge creased and basted flat, and when the allowance is turned on its lower edges it is ready for basting to the waist.

(*ii*) In basting any kind of collar-band to a waist the edge of the band should fall exactly on the indicated neck line. The band may be basted on in two ways.

(a) The neck of the waist is slipped into the band with its centre mark to the centre mark of the neck-band. It should be pinned there and at each end. Care must be taken to have the two sides of the waist correspond exactly and not to stretch the neck of the waist in the pinning or basting. It should be eased in, as it is curved, while the band is straight or nearly so.

(b) The waist may be basted to the outside piece of the band first and then the inside piece basted flat to the two.

6. **Fitting.**—In many cases much time is wasted by too frequent fittings, which are usually necessitated by the lack of proper preparation for fitting. Except for very elaborate waists, two fittings are all that is necessary, if the pattern used has been properly made, tested, and fitted. For a first fitting the whole waist should be together; that is, the seams of the waist and the sleeve should be basted and the sleeve basted in. A belt should be prepared to be

pinned in place after the waist is put on, and also a collar or collar-band as the style of the waist requires; thus the fit of the waist and collar and the length, fit, and hang of the sleeve may all be determined. If the fitting is carefully done and the work which follows is equally careful, the second fitting may be a finished fitting with the waist and sleeve seams stitched, the belt and collar attached, the

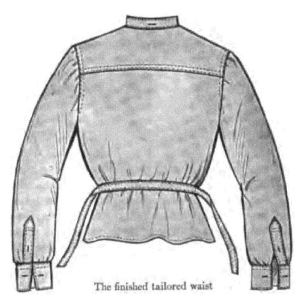

The finished tailored waist

bottom of the waist finished, and the sleeves finished and sewed in. The fitting of the waist itself and of the sleeves and the alterations which any changes may necessitate are exactly the same as for the shirt-waist and shirt-waist-sleeve patterns, which are given under *Drafting*, and in consequence are not repeated here.

7. **Making and Finishing.**—The kind and variety of finishes necessary in the making of a waist depend upon so many factors, and these are so variable, that only general directions are possible. The directions given here are purely suggestive and deal with only a few of the many ways in which a desired result may be successfully secured.

The finishing of a waist requires:

(1) Making seams.
(2) Finishing the bottoms of waists.
(3) Making and attaching belts.
(4) Making and attaching collars and collar-bands.
(5) Making and attaching yokes.
(6) Making and attaching sleeves.
(7) Making buttonholes.

(1) *Making Seams.*—There are several seams which may be used in shirt-waists.

(a) Plain seam.
(b) Fell seam.
(c) Welt seam.
(d) French seam.
(e) Seam finished with *entre-deux*.
(f) Hemstitched seam.

The choice of seams must be governed by the style of the waist and the kind of material of which it is made. Generally in all wash waists, whether tailored or lingerie, such seams are used as in the making and finishing enclose the raw edges or so attach them that they cannot fray. Whatever kind of finish is chosen as suitable for the seams of a waist should generally be maintained throughout. It need not be made by the same method in all parts of the waist, but its appearance should be the same when completed; that is, in a tailored waist, if either the fell or welt seam is used, the shoulder, underarm, and sleeve seams are made in that way; and the armseye seam, the cuffs, and the yoke, if there is one, are finished to give the same effect. In a lingerie waist, if *entre-deux* is used it should be placed in the shoulder, underarm, sleeve, and armseye seams, and it should also join to the waist any yoke, collar, or cuffs which may be used.

(a) *Plain Seam.*—This seam is not satisfactory in wash waists, but is much used for fancy waists of silk, satin, and wool. There are various ways in which its raw edges may be finished. (i) Pinking or notching is the simplest finish. It should be used only for materials which do not fray. (ii) Overcasting is frequently used. The two edges

of a seam may be overcast separately or together. (*iii*) Binding with taffeta ribbon makes a satisfactory finish for many seams. The two edges may be bound together or separately. A bound seam does not launder well, and it sometimes makes too thick an edge for waists which require frequent pressing. (*iv*) Turning in the edges is used to make an open or closed seam. The open seam is not very satisfactory for heavy materials nor for those requiring frequent laundering. The closed seam may be satisfactorily used in wash waists and in any style not requiring a tailored finish.

(*b*) *Fell Seam.*—This seam is used for the majority of tailored waists. It is easily made and presses and launders well.

(*c*) *Welt Seam.*—This seam launders well, is frequently used in machine-made waists, and is especially good in heavy materials.

(*d*) *French Seam.*—This seam may be used for many wash waists and also for silk and fancy waists. It should not be used for those which are strictly tailored.

(*e*) *Seams Finished with Entre-Deux.*—Such seams are suitable only for lingerie waists. There are several methods of finishing: by the use of French seams, by the use of bound seams, or by rolling and whipping the raw edges. A seam finished by any one of these methods launders well. When the French seam is used its second line of stitching must be exactly on the seam-line of the waist and close to the edge or cord of the *entre-deux* embroidery, otherwise the seam will be unattractive and the size of the waist changed. The bound seam is generally found more satisfactory than the French seam. It, like the French seam, is standing rather than flat, and no stitching shows on the right side of the garment. Rolling and whipping are very satisfactory for fine materials.

(*f*) *Hemstitched Seam.*—This finish requires a special machine and consequently cannot be generally considered as a means of joining and finishing. It may be used for practically all waists except the strictly tailored ones.

For details in making and finishing seams, see *Finishings*.

(2) *Finishing the Bottoms of Waists.*—The raw edges of the bottom of a waist may be finished by overcasting, by binding, or by hemming. Whatever method is chosen, the effort should be to have the edge flat, otherwise it will form a ridge which will show through the skirt.

(*a*) Overcasting, if closely done, may be used for all kinds of materials. It is done in the usual way.

(*b*) Binding is more satisfactory for waists which are not to be laundered. It is done as for seams.

(*c*) Hemming by hand or machine may be used for all kinds of material. A narrow hem should be made.

If the material is heavy it is frequently a good plan to finish the hem by a row of running stitches or to make only one turning and to stitch that twice—once along the fold and again close to the raw edge to keep it from fraying.

If, as is usual, the underarm seams are stitched together only 1″ below the waist line to give sufficient spring over the hips, their free edges should be finished to correspond with the bottom of the waist.

(3) *Making and Attaching Belts.*—In attaching a belt to a waist there should be a row of stitching, by hand or machine, at the top and bottom edges of the belt; this will keep the gathers of the waist in place and the belt flat.

When the waist fastens in front and the belt is to be attached only from underarm seam to underarm seam the stitching should be carried across the belt at these seams and along both edges between the seams. If it has been made of material its free ends should also be finished by a row of stitching close to the edge. The method of fastening such a belt may be a matter of choice; it may be the correct length and finished with a hook and eye; it may be cut a few inches too long and be fastened by pinning or tying. When the waist fastens in the back the belt is generally cut the correct waist measure and is attached to the waist its full length. It may be fastened as desired.

(4) *Making and Attaching Collars and Collar-Bands.*— Collars should be as nearly finished as possible before being permanently attached to the waist, as this prevents handling the entire waist while the work is going on.

(*a*) *Standing Collars.*—These may be finished in a great variety of ways, both by hand and by machine, depending upon the finish of the waist.

For lingerie waists the collar hems are usually turned on a straight thread and match in width those of the waist opening. A collar fastening either at the centre back or front may have its hems turned slightly off the thread if the neck is much smaller at the top than at the base. In many cases this is not required, as the necessary boning holds the collar up and makes it fit the neck sufficiently well. Standing collars may also be made to fit by the use of one or two darts at the side. These are usually finished to be inconspicuous. *Entre-deux*, lace beading, and insertion are all used to attach as well as decorate collars. For these the sewing may be done by hand or by machine.

There are several methods of attaching a standing collar when no decoration is used in the seam.

(*i*) *Stitching by Machine.*—The first row of stitching may be made on the right side close to the folded edge of the collar. By this method the seam is already turned up on the collar and is ready to be stitched again. The raw edges, if likely to fray, may be overcast closely or, before the second stitching, they may be turned in. With this finish binding may also be used. It is included in the first stitching; the raw edges of the material are cut close and the folded edge of the binding stitched flat to the collar. Care must be taken in this finishing not to have the seam clumsy. These methods are suitable for practically all materials on which machine stitching may be used.

(*ii*) *Stitching by Hand or Machine and Hemming by Hand.*—The sewing line of the collar may be placed to the neck line and stitched by hand or machine with the seam to the wrong side. The seam may then be turned up on the collar, its edges properly cut and turned in and hemmed by hand. This finish is used in waists on which no machine stitching shows.

(*iii*) *Stitching by Hand or Machine and Whipping.*—In many materials, especially the thinner ones, an inconspicuous and sufficiently strong seam is made if the collar and

waist are stitched together along the tracings, with the seam to the wrong side, and the edges are then cut a small ⅛" away from the stitching and whipped together. Such a seam launders well.

(b) *Flat or Turn-Over Collars.*—For attaching a flat collar to a waist the wrong side of the collar is placed to the right side of the waist, with neck tracings together. To provide a finish a bias strip is placed to the collar and included in the stitching. The seam edges and the bias strip are creased down to the wrong side of the waist and basted flat along the turning. If the prepared bias binding with a folded edge is not used, the edge of the bias must be turned in and basted flat to the waist. It may be stitched by machine or hemmed by hand. The stitching or hand sewing on the right side is concealed by the collar.

(c) *Collar-Bands.*—If a collar-band is carefully basted to a waist its finishing is very simple. It is stitched to the neck of the waist and the stitching continued completely around it, close to its edge, to keep it perfectly flat. It may be stitched once or twice.

(d) *Shaped Neck Line without a Collar.*—If no collar is used and the neck line is shaped, it may be finished with a facing or by machine hemstitching, cording, piping, etc. (For details, see *Finishings.*)

(5) *Making and Attaching Yokes.*—The making of yokes is very simple if they are carefully basted according to the directions given. They require only the finishing of the joining seam. This may be done by hand or machine to correspond with the other finishings of the waist. For any stitched yoke the first row of stitching must be close to the edge of the yoke to hold it flat and in place for laundering. The basting holding the yoke and lining together should not be removed until the collar-band and sleeve are attached and the waist practically finished.

(6) *Making and Attaching Sleeves.*

(a) *Tailored Sleeve.*

(i) *Planning the Sleeve.*—In making a tailored sleeve a shirt-waist-sleeve pattern should be used.

The sleeve may or may not have fulness at the top, ac-

cording to the fashion; the amount of fulness does not affect the general method of procedure.

The sleeve is usually finished with either a fell or a welt seam, as they give the desired tailored appearance.

This sleeve should have a tailored placket and a stiff cuff.

(*ii*) *Making the Placket.*—The placket should be completely finishéd before anything else is done, as it cannot be made after the sleeve seam is stitched. There are many ways in which a placket may be made, any one of which may be chosen if it is found to give the desired result—strength and neatness. The placket opening must be cut on a lengthwise thread of the material. It should be of sufficient length to allow the cuff to lie perfectly flat upon the table for ironing. Its position in the sleeve varies somewhat according to the taste of the wearer and as the amount of fulness to be gathered into the cuff varies. It is never cut exactly in the centre of the sleeve, but should be in the

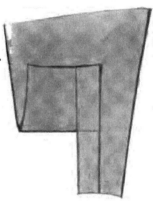

The placket finished on the under part of the sleeve

under half of it and near enough to the seam to give little fulness to that section of the sleeve which comes under the arm.

The usual position is 1″ from the centre. A placket in the finished sleeve should lie along the outside of the arm in a line with the elbow and little finger.

The following is an exceedingly simple method of making. Two pieces of lengthwise material are needed for the finishing, one twice the length of the opening, the other about 1½″ longer than the length of the opening. The width of these is somewhat a matter of taste, but when finished, a placket should not be more than 1″, 1¼″, or 1⅜″ wide. The long piece of material is used first; it is basted and stitched around the entire opening, with its right side placed to the wrong side of the sleeve. The seam

which joins this strip to the sleeve should be on the right side of the sleeve and not too wide; it should be ⅛″ in width at the ends of the opening, tapering near its upper point until just at the point it takes in as small an amount as possible. The narrow seam is to prevent having a pucker or fold in the sleeve at this point. The inexperienced worker may require a little practice before a satisfactory seam can be made. When the stitching is finished the other edge of this strip should be turned to the wrong side ⅛″ and creased. Half the length of this strip, the half which is stitched to the under part of the sleeve, should be folded over on to the sleeve, creased along the seam-line just made, and then basted flat to the sleeve. When this is stitched that half of the opening is finished. The placket is stronger and irons better if the stitching is done completely around the piece except at the open end, which is to go into the cuff. The other, or upper, half of the opening with its extension should next be finished. The short strip of material is for that purpose; it is to cover the raw edges. Its two edges should be turned in until it is of the same width as the under strip, or extension, and when basted flat to it will cover it and the stitching which joins it to the sleeve. The 1½″ of extra length on the short strip extends beyond the point of the opening and should be turned in and basted flat to form a point or a square. The point makes a better finish. When the basting is done the stitching of this strip requires a little planning. The simplest method is to turn back the under half of the sleeve out of the way and to stitch up one side, straight across, just at the fold of the long strip and down the other side. This leaves the point to be stitched. To do this the under half must be turned down into its proper place again; then the stitching may easily be done and the placket completed.

(*iii*) *Making the Seam*.—After the placket is finished, before putting on the cuff, the sleeve seam must be stitched to match the seams of the waist.

(*iv*) *Making the Cuffs*.—Stiff cuffs require three thicknesses of material; that is, the cuff itself and one interlining.

Butcher's linen is frequently used for interlining, as it takes starch well. The directions given here are for the making of the cuff which is cut in one piece, as it is exceedingly simple. The cuffs are cut to the required length plus a seam allowance on each end and three times the desired width plus one seam allowance. The ¼″ allowance on the width is turned to the wrong side and basted. The material is then divided widthwise into three equal parts and folded in this way: the centre third is folded over on to the third which has the turned seam allowance, right

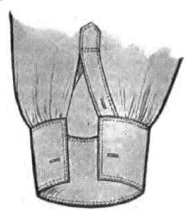

The tailored placket and cuff to fasten with links

sides together, the remaining third is folded back over the centre third, wrong sides together, with its raw edge coming just to the folded edge. These three thicknesess should then be basted flat and stitched together across each end in the seam tracings. In turning these seams to the wrong side the two pieces basted right sides together come out and form the cuff. It should be carefully creased and basted along the two stitched ends and across the folded edge and its centre marked. It is then ready to be joined to the sleeve.

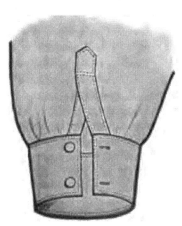

The tailored placket and cuff to button

(v) *Attaching the Cuffs to the Sleeve.*—If the cuffs are to fasten with links the placket extension on the under part of the sleeve is turned to the wrong side and pinned to

keep it in place. If the cuff is to button it is allowed to extend. Two rows of gathering are needed around the bottom of the sleeve from one edge of the placket to the other. The gathering is drawn up to make the sleeve the required size. It is slipped into the cuff, the centre of which is about ½" away from the sleeve seam on the upper part of the sleeve. It is pinned there and at each end. The gathers should be arranged so that most of the fulness comes near the placket on the back of the upper part of

Basting the sleeve to the waist

the arm. The cuff must be carefully pinned and basted, as good stitching is otherwise difficult. The first row of stitching should be on the very edge of the cuff, entirely around it. The second row may be placed to correspond to the seam finishes of the waist or it may extend only across the top of the cuff ½" in from the first to keep the lining in place.

(*vi*) *Putting in the Sleeve.*—Directions for the careful basting of a sleeve are emphasized elsewhere and need not be repeated here. The finishing may be done in several ways. In any finish but the fell the seam must be turned up on the waist and never toward or into the sleeve.

(a) The welt seam is frequently used; the second row of stitching holds the seam to the waist. The raw edges of the seam may be cut close to the stitching or be left wide enough to be overcast.

(b) The plain seam may be used and bound with bias seam binding. There are two methods:

In the first method the binding, waist, and sleeve are stitched at once, with the right side of the binding to the wrong side of the waist. Careful basting must be done. For the beginner it is wise to baste the sleeve in first and

then add the binding, as it must be held loosely enough not to draw. After the stitching, the edges are cut and the binding is turned to enclose them and is hemmed to the stitching line. This makes a standing seam which should be caught to the waist at the shoulder seam; otherwise it turns into the sleeve and causes the gathers in the sleeve to stand up in an ugly manner.

In the second method the binding is put next the sleeve, basted and stitched. The seam is then turned up on the waist and the raw edges are covered by the binding, which is stitched flat to the waist. On the right side this has the appearance of a welt seam.

(c) The fell is frequently used if there is no fulness in the sleeve and the material is not too heavy. When used the seam edges of the waist turn over to enclose the sleeve seam.

(b) *Non-Tailored or Fancy Sleeve.*

(i) *Planning the Sleeve.*—In making a sleeve for non-tailored and fancy waists much greater freedom can be exercised, as there are practically no limitations to the combinations which may be made. Because of this only very general directions are possible. Such sleeves are usually cut from the shirt-waist pattern. The details in the making are governed by fashion—the sleeve may be long or short, large or small, and finished without a cuff or with any style of cuff which matches the waist. If an opening or placket is needed to give sufficient size for the hand and opportunity for pressing it can be quickly made. It must be finished before the seam is stitched.

(ii) *Making the Placket.*—It is cut and placed much as is the tailored placket, but is much simpler. To finish it only one strip of material is necessary, cut twice the length of the opening and about $1\frac{1}{4}''$ wide, which allows for the seam. It is stitched around the opening of the sleeve with its right side to the wrong side of the sleeve. The seam is then creased flat to the strip, the other edge of which is turned in $\frac{1}{8}''$ and basted to the line of stitching. This encloses the raw edges and finishes the opening. If this placket is to be sewed by hand it should be sewed first to

the right side of the sleeve and turned to the wrong side for the hemming.

(*iii*) *Making the Cuffs.*—The finishes for a sleeve are much the same whether it is cut to come to the elbow, to the wrist, or nearly to the wrist.

(a) A long sleeve may have a cuff made in practically the same manner as was the strictly tailored one. It is

not always necessary to have an extra thickness for stiffening. Waists of nearly all materials may have this style of cuff if they are to be finished with stitching. The method of procedure is as already given.

(b) A sleeve may have a soft cuff which fits the arm at the elbow or wrist rather closely and is usually made single. Such cuffs are generally cut on the straight length of the material, with the necessary allowances for seams and hems. The decoration and the hems should be made before attaching the cuff to the sleeve. If

A finish for a sleeve which has no opening at the wrist

the cuff is at the elbow no opening is necessary; if at the wrist an opening is a matter of choice. It is usually placed in line with the sleeve seam and may be made by cutting the cuffs long enough to have their hems overlap and fasten.

The cuffs are joined to the sleeve with a seam finish which matches that used in the waist.

(c) A sleeve may have a deep cuff from the elbow to the wrist which is shaped to fit the arm by a seam at the back. These cuffs are single and are attached to the sleeve with a finish which corresponds with the seams of the waist. They are usually close-fitting and require an opening which may be placed in the seam.

(d) A sleeve may have a turn-back cuff. If the sleeve is long it is usually large enough to allow the hand to pass through to avoid an opening. The cuff may be made single or double and decorated and finished as desired. If a double cuff is used the joining seam should be concealed between the two thicknesses of the cuff. If a single cuff

is used it may be joined in two ways, according to the material. The seam may come between the sleeve and the cuff on the right side of the sleeve and be finished by overcasting. It is concealed by the turn-back cuff. The cuff, sleeve, and a facing may be stitched together, turned to the wrong side, and finished as in the attaching of the flat collar.

(e) A sleeve may have a hem or decorated edge. Frequently sleeves of lingerie or silk waists are made the desired length and are finished with a hem and decorated edge. These are usually more attractive if large enough to go over the hand without an opening. They may be made to fit closely, when worn, by having a row of corresponding loops and buttons a short distance apart. These, when fastened, make a small fold or tuck in the sleeve which does not detract from its appearance. The fastenings should be placed as is a sleeve-opening. If a hem is used to finish a sleeve it is usually sewed by hand and carefully pressed to show as little as possible.

(7) *Making Buttonholes.*—The size of any buttonhole depends on the diameter of the button used plus a small allowance for the thickness of button.

(a) *For Tailored Waists.*

(i) In the front the buttonholes are placed lengthwise in the plait. The number used depends on the size—an average number is five. The first one is usually placed 1½" or 2" below the neck line and the last one should be at or just above the waist line. These buttonholes should be barred at each end. After they are made the hem and plait should be pinned with their lengthwise centre lines together and the position of the button carefully marked at the centre of the buttonhole.

(ii) In a collar-band three crosswise buttonholes are required—one at the centre back, about ¼" up from the stitched edge, and one in each end. The latter should be so placed that the end of each buttonhole and not the centre comes just to the centre-front line; otherwise when worn the band will not be the correct size.

(iii) In the cuff placket only one buttonhole is needed.

It is placed lengthwise in the upper or outer half, about 1″ up from the edge of the cuff and in the centre of the placket.

(*iv*) In the cuff two crosswise buttonholes, one at each end, are required for links. They are placed about ¼″ in from the edge, at right angles to it, and about in the centre of the width of the cuff and possibly a little nearer the top. If the cuff is to button, two crosswise buttonholes should be placed in one end.

Buttonholes in the centre-front plait and neck-band of a tailored waist

(*b*) *For Fancy Waists.*—Definite rules cannot be given because of the variety of fastenings possible.

Buttonholes are usually placed lengthwise in the centre-front plaits but widthwise in any hems. At the centre back they are found more satisfactory if made widthwise, as there is more strain.

Crosswise buttonholes are placed in straight cuffs, the number depending on the size of the cuff.

When a waist is finished it should be carefully pressed, even though much pressing has been done in the making. (For details, see *General Suggestions*.)

II. Guimpes

A guimpe is a kind of chemisette or underwaist usually made of wash silk or net, to be worn with waists or one-piece dresses in place of an attached lining. Guimpes protect the waist and they also frequently serve as a foundation to which collars and vests or fancy fronts of all kinds may be attached. As they are not fastened to the waist itself, they may be worn with several different waists, and they

may also be laundered or cleansed without including the entire garment.

Guimpes are made from the plain shirt-waist pattern and are finished at the neck, armseye, etc., according to their use. As it is possible to cut and make a plain guimpe by following the directions given elsewhere for plain shirt-waists, the discussion here deals with a more elaborate style of guimpe—one which is draped on the form and has a stretched yoke and plain standing collar. The guimpe is, in general, more satisfactory if made of a fairly firm net, while the yoke and collar may be made of a finer net or lace.

1. **To Drape the Foundation.**—The net foundation is made on the form, following the general directions for draping a shirt-waist. There are a few changes necessary, as the guimpe is to open at the centre back and the front is to be draped first. To keep the grain of the material straight its lengthwise centre is marked with a line of colored basting.

The net is folded along this line and the two sides are draped together. The draping is done on the right side of the form. The fold is pinned $\frac{1}{16}''$ to the right of the centre-front line of the form to allow for the extra material required in the fold. At least $4''$ of material should extend above the neck line. After the net is pinned in place it is slashed to within $\frac{1}{2}''$ of the neck line to make possible the smoothing of the material around the neck. The draping of the front proceeds as for the shirt-waist. Care must be taken not to draw the material too closely about the form or to cut it to be too narrow across the chest, as net usually shrinks in laundering. Both thicknesses of net should be marked separately with colored cotton to indicate the neck, shoulder, underarm, and armseye seams. The net is then opened, the entire front is pinned in place, and any necessary alterations are made.

In draping the back the centre line of the net is marked and it is folded like the front. This fold should be placed $1''$ beyond the centre line of the form to give an extension for the finishing of the opening. The back of the guimpe is draped, marked, opened, and pinned in place as in the

shirt-waist. Any necessary alterations are made in the left side.

The seams of the front and back are pinned together, matching bastings, the waist is taken off and its seams are finished. In draping this foundation waist the material should be cut to the waist line plus 1″ for finishing. The 1″ is turned to form a hem around the waist, and elastic of the required length is run in to hold the guimpe in place.

2. **To Stretch the Yoke.**—The yoke may be made in two ways, with shoulder seams or without. If the seams are used two thicknesses of material are draped together, marked, and opened, as in draping the guimpe itself. No further directions are needed than those already given. If no seams are used the two sides are draped separately in order to stretch the material over the shoulder and secure a good-fitting yoke. Directions are given here for the draping of such a yoke.

The material may be of fine net or of all-over lace. If all-over lace is used, a design which has no up and down is necessary for a yoke without shoulder seams, as the pattern when correctly placed at the front will be upside down at the back. About one-half yard in length is needed for the yoke. Usually the material is wide enough to allow the cutting off of a strip along one side to make the collar. The length of the collar should be on the lengthwise of the material and in width the strip should be 1″ wider than the finished collar.

The lengthwise centre of the yoke material should be indicated with a colored basting. The depth of the yoke in front is a question of choice. If it is to be 9″, which is an average depth, the material is cut open along the centre line of basting, leaving uncut only the 9″ which is to make the front. The material for the front is pinned on the form with its lengthwise basting to the centre front basting of the foundation. The end of the cut is placed exactly at the neck line of the form and the material is drawn tightly down from there. As the grain of the material is very important, it is necessary to pin it firmly in place across the chest to keep the crosswise threads perfectly straight

while the net is drawn around the neck and over the shoulder. To draw it around the neck it must be slashed. This requires care, as the slashes should not be too deep. In stretching the net the work should be done with or along the threads of the material. As the material is drawn back over the shoulder the lengthwise threads run in closer to the neck and at the centre back they form almost a true bias. (In the yoke having shoulder seams the centre back is on the straight.) The material must really be stretched over the shoulder; otherwise when the net lining is cut out the yoke will not fit closely into the curve of the shoulder.

The finishing of the two yokes is much the same. In either, a ½″ seam allowance is made at the neck and 1″ at the centre back for finishing. The lower edge of the yoke may be shaped across the back and front as is desired.

Before the guimpe is removed from the form the yoke must be very carefully pinned and basted to it and its neck line clearly marked with colored basting. The hems at the centre back of the yoke are more easily turned in to form the correct opening, while the guimpe is still on the form. In turning these to the wrong side they should not include the foundation hems; otherwise there is difficulty when the guimpe is cut away under the yoke in the finishing.

3. **To Make the Collar.**—The collar of the guimpe may be made in a new way; that is, the pattern may be draped or fitted rather than drafted. In this draping the work must be done directly on the person rather than on the form. It is a good plan to fit a collar while a tight-fitting lining or a shirt-waist is being fitted, as it must be pinned to a correct neck line. It frequently requires less time to drape than to draft a collar. A lengthwise strip of material is necessary; it should be in length the size of the neck at the base plus 1″, in width the required height at the highest part of the neck plus ½″. Its centre front is marked with a line of colored basting and one lengthwise edge is turned in ¼″. This folded edge is pinned along the neck line of the waist, beginning at the front and placing the centre-front marking to the centre front of the

waist. The material should be drawn rather tightly toward the back and pinned together at the centre back along its straight grain. Some fulness is thus left at the top of the collar which may be removed by making one or two darts. The first dart is placed back of the ear in line with the shoulder seam of the waist. The second is half-way between that and the centre back. If the neck is straight one dart may be sufficient. The darts must be deep enough at the top to make the collar fit the neck closely and they should taper to nothing near the neck line. The top line of the collar should be correctly shaped by slashing the material and turning over the edges. When finished the centre back and the neck line of the collar should be on the straight grain of the material. For fitting a neck which is very different in size at top and bottom, however, it may be found impossible to maintain a straight line at the centre back, in which case the line may slant in slightly at the top.

A stiff-paper pattern is cut from this draped collar. The collar should first be tested; that is, it should be folded along the centre basting line and the two sides should be made exactly even. It may then be pinned to paper such as is used for the stiff-paper sleeve and a tracing made around it and to indicate the centre-front line. The paper is cut out, following the traced lines, and taking care to make the pattern true and the edges straight.

The net or lace collar is made on this paper pattern. The centre of the material is marked by a colored basting and a $\frac{1}{4}''$ hem is turned along one lengthwise edge. This folded edge must be stretched as much as possible in order to have the centre-back opening on the straight of the material. In pinning the net to the paper the centre-front lines of paper and material are matched and the hem is toward the worker. The net must be stretched evenly in both directions from this centre line and when pinned at each end it should be tight enough to curl the paper a little. The top of the collar is made by turning the net to match the line of the pattern. The width of the hems at each end should match those of the yoke of the guimpe. To do

this the hem at the left must be made to extend slightly beyond the centre-back line of the collar as there must be an extension on the guimpe for the fastenings. A collar of this kind requires boning; usually five bones are necessary, one at the centre back on the left or under side, one just back of the ear in line with the shoulder seam, and one in front slanting from 1″ away from the centre front, at the bottom of the collar, to a point at the top half-way between the centre-front line and the side bone.

While the net is still on the paper, the bones, except possibly those at the side which may require changing, may be sewed in. In sewing them the hems at the top and bottom of the collar should not be caught down as they must be free for the finishing of the collar. Small, flexible bones, as invisible as possible, should be used; in attaching them no more stitches should be put in than are necessary, but they must be firmly sewed at the top and bottom. The bone at the left-centre back may be placed to cover the raw edge of the hem. On the right side a second turning must be made to finish the hem.

4. **To Finish the Guimpe.**—After the guimpe is taken from the form the collar should be pinned and basted to the yoke, its lower edge falling exactly on the indicated neck line. The basting should be on the folded edge of the collar and only through the yoke, as the foundation is to be cut away. The raw edges of the bottom of the yoke are turned in and sewed to the foundation with fine running stitches and an occasional back stitch. The foundation is then cut out about ⅜″ away from the stitches just made and its edges are turned in and sewed to the yoke.

The guimpe is given a final fitting for the yoke and collar, and if no changes are required the finishing may be done.

The underarm seams may be French-seamed or felled and the hem at the bottom stitched. The simplest way of attaching the collar is by using fine running stitches on the right side close to the edge of the collar. The raw edges on the wrong side are then cut to a little less than ⅛″ and whipped together, drawing them in enough to give the ap-

pearance of a rolled hem but not enough to tighten the edge of the collar and make it draw.

There are various attractive methods for finishing the top of collars. A very simple one is by turning the raw edge to the right side and covering it with a narrow lace insertion or picot.

As has already been said, in finishing the centre-back openings the hems of collar and yoke should match and appear continuous. The hem may be held in place by the running stitch or by hemming. Small hooks—No. 0 or 1 —or snaps are used on the collar and yoke and placed about $\frac{1}{2}''$ apart and $\frac{1}{8}''$ in from the edge. On the left side thread or twist loops, peets, or snaps are used. They are placed on the bone in the collar and along the hem of the yoke, exactly on the centre-back line. Below the yoke not many fasteners are required and they may be a larger size. One fastener should be placed at the belt and sewed through net and elastic.

The armseye may be finished by using a narrow lace edge, by rolling and whipping, or by adding a short sleeve. If a sleeve is required the stiff-paper pattern should be used for the draping. (See under *Draping*.) The sleeve is usually short and very little work is required in its making. The seam may be a French seam or a fell; the bottom may have a narrow hem or, if the waist with which it is to be used is very transparent, a rolled hem or an added lace edge. The sleeve may be joined to the waist by a fell, French seam, or by stitching and whipping the edges.

III. Linings

Linings may be placed in practically all kinds of waists. There are two general styles or types in each of which much variety of cut and finish is permitted. These two styles may be designated as (a) semifitting linings (based on the foundation shirt-waist pattern); (b) tight-fitting linings (based on the foundation tight-fitting-waist pattern).

The kind of lining chosen for a waist should depend largely upon two factors: the figure of the wearer and the cut or style of the waist in which the lining is to be used.

A waist which is to be made for a stout figure requires a close-fitting lining with several seams many of which are boned. If a waist is to be made for a slight figure, and it is not desirable to follow too closely the lines of the figure, a semifitting lining, one with few seams and a little fulness, is generally more satisfactory.

Semifitting Linings.—Semifitting linings may be used in any waist which, because of its style or the figure of its wearer, does not demand a close-fitting boned foundation. They require less time in the cutting and making and form a sufficiently firm foundation for many designs. Such linings may open at the centre front or back; they may be cut with a round, high neck line or with a somewhat shaped one or in suitable line for an evening waist, and they may be with or without sleeves. Very little fulness if any is used at the centre back and generally but little in the front. All fulness in the front may be removed by the use of darts at each side of the centre front.

Semifitting linings may be made in silks, such as Corsica and China silks, *crêpe de chine*, and chiffon; in net and in lawn. The last, while least expensive, is generally found to be least satisfactory for continued wear.

Tight-Fitting Linings.—The tight-fitting-waist pattern may be cut to give a greater variety of linings than the semifitting. There may be (*a*) Regulation tight-fitting linings. These vary somewhat in their cut in such details as the exact number of pieces, the shape of the neck line, and the use of sleeves. (*b*) Evening-waist linings. These may be made exactly as the tight lining and differ from it only in the cut-out shape of the neck or yoke line. They frequently, however, are not cut to extend over the shoulders, but have the lining material there replaced by chiffon or *mousseline de soie* or bands of lace or ribbon to give a desired transparent effect. (*c*) Girdles. These are cut to extend only a few inches above and below the waist. They are generally used in waists and dresses which do not require linings but need more foundation than is given by the use of wide belting. They are given firmness and are held in place by the use of bones in the seams. They are often

used in evening dresses, when they may have a chiffon
or net semifitting lining attached to them. (*d*) Princess
linings. These are really a combination of a tight-fitting-
waist lining and a skirt. They are most frequently used
as unattached slips or foundations in lingerie dresses or in
such transparent dresses as require a one-piece foundation.

All of these fitted linings may be cut to open at the centre
front or back. The number of seams used is not an ar-
bitrary matter but may depend on the necessity for boning
and the general style of the waist. They require more
time in the making than the semifitting because of the
greater number of seams to be finished.

Fitted linings may be made of silk, such as Corsica, mes-
saline, China silks, *crêpe de chine*, or of lawn. The material
chosen should be a firm quality to stand the strain which
is frequently demanded of close-fitting waists.

I. *General Directions for Making Semifitting and Tight-Fitting Linings*

In cutting and making all types of linings practically
the same general procedure must be followed; that is,
there must be:

(1) Securing the pattern.

(2) Arranging seam allowances; placing the pattern and
cutting.

(3) Marking for basting.

(4) Basting and preparation for fitting.

(5) Fitting.

(6) Making and finishing.

In the details of these various steps there is an op-
portunity for variation because of the possible difference
in materials and in design. For this reason all directions
given are made as general and as inclusive as possible.

1. Securing the Pattern.—To secure a pattern for these
two general types of linings three methods of procedure may
be followed; the pattern may be:

(1) Drafted to measure. (See *Drafting.*)

(2) Adapted from a commercial pattern. (See *Use of
Commercial Patterns.*)

(3) Draped on the dress-form. (See *Designing.*)

The discussion in this chapter presupposes not only well-fitting patterns but practice in their making by these methods, the directions for securing which have been already given elsewhere. As far as possible the directions for the work are not repeated here, but of necessity are frequently referred to.

There are various factors to consider in choosing a suitable method for the making of different lining patterns. These factors include, in general, the experience and skill of the worker, the material to be used, and the style of lining to be made.

(1) *Shirt-Waist or Semifitting Linings.*—For these all three methods may be satisfactorily used. If patterns made by drafting or by adapting a commercial pattern are used the lining must be cut in material from them. In draping, the pattern may be secured by using trial material or the lining itself may be draped directly in the material. If the lining itself is made it should be trued and tested when removed from the form; if the pattern is draped it should be trued and then cut in material.

(2) *Tight-Fitting Lining.*—The most direct and satisfactory method of securing a tight-fitting lining is by drafting to measures. A commercial pattern may be used, but if there are irregularities in the figure the pattern must be altered. In doing this, time is consumed and the lines of the pattern may be spoiled. Good lines are as important in the lining of a waist as in the waist itself, as they are frequently used as guides in draping and making. In general, the draping of a lining is not a suitable method, as it requires too much time and skill to make the several pieces well proportioned with correct seam-lines and true grain of material.

(3) *Evening Waists and Girdles.*—Many evening waists —especially those which are not cut to extend over the shoulders—and all girdles are easily draped. They do not require as many seams as the regulation tight lining and may be done directly in the material. If a pattern is used, the regulation tight-waist lining may be cut the required

height by measuring along the seams above the waist and making adjoining seam-lines equal in length. The height of a girdle may be determined by taste. The evening linings which do not extend over the shoulders should come well up under the arms.

(4) *Princess Lining.*—Unless the worker is experienced or desires to gain experience in draping, the quicker and more generally satisfactory method of securing a princess pattern is by drafting to measure or by adapting a commercial pattern.

2. Arranging Seam Allowances; Placing the Pattern and Cutting.

(1) If a pattern is used for any of the linings it must be placed on the material for cutting with regard to the grain of the material and required seam allowances. Directions for this need not be repeated here, as they are given under *Shirt-Waists* and *Drafting*.

(2) If a draped lining is used it is already placed and cut with regard to the grain of material and the seam allowances.

(3) *Reinforcements for Fitted Linings.*—To withstand the strain along the line of fastening, all tight-fitting linings require reinforcing of the centre front or back pieces, depending on the opening. This reinforcement extends about 5″ above the waist line and 2″ below and is of the same material as the lining and cut on the same grain with the same seam allowances. It should be traced to match the corresponding waist pieces. Girdles, when made of thin material, are frequently cut double.

3. Marking for Basting.

(1) *The Pattern.*—While the pattern is pinned in place, and before cutting, it should be marked for basting. Directions for this need not be repeated here, as they are given in detail under *Shirt-Waists* and *Drafting*.

(2) *The Draped Lining.*—The two thicknesses of the lining are draped at the same time and the seam-lines marked. After it is taken from the form the seams are basted and it is again put on the form for any necessary alterations on the left side.

4. **Basting and Preparation for Fitting.**—The finish of a seam determines the method of basting; the finish in turn is determined by the material of the lining and its cut.

(1) Semifitting linings are usually finished with a French seam or with a fell and are basted as the finish requires. Directions for this are given under *Shirt-Waists* and need not be repeated here.

(2) The seams of all fitted linings are basted to the wrong side, as they are to be stitched and pressed open for finishing.

Before any tight lining is basted together the reinforcements should be basted to the centre front or back pieces along the seam-lines and at the waist line and the two sides of the opening should be completely finished. (See *Making and Finishing*.) The basting of the waist then proceeds according to the directions given under *Drafting*. These directions may be applied, with a few minor alterations, to all styles of tight-fitting linings.

(3) When the girdle or the fitted evening-waist lining which does not extend over the shoulder is cut from patterns the waist lines are matched and the basting is done up and down from that.

(4) *In Basting the Princess.*—For the waist the tight-lining directions are followed; for the skirt the general directions for matching hip lines and for holding all bias seam edges toward the worker to prevent stretching.

5. **Fitting.**—Directions for fitting are given under *Drafting* and need not be repeated here. Only one fitting should be necessary for a lining cut from a pattern or for a lining draped on the dress-form, if the work has been properly done; that is, the pattern tested or the dress-form carefully prepared.

6. **Making and Finishing.**—The two general kinds of linings differ in their finishing.

(1) *Semifitting Linings.*—The making of a semifitting lining is very simple. It includes the finishing of (a) seams; (b) centre front or back opening; (c) waist line; (d) armseye; (e) neck line.

(a) *Seams.*—A semifitting lining has two seams, the shoulder and underarm. For these a French seam or a

fell seam is generally used. The fell is preferred for the shoulder.

A plain seam may be used for a silk or lawn lining, but it requires finishing by binding, overcasting, or turning in the edges.

Directions for the making of seams are given under *Shirt-Waists* and need not be repeated here.

(*b*) *Centre Front or Back Openings.*—Whether the openings of the linings are at the centre front or back they are very simple to finish. A ½″ hem is made at each edge of the opening and fasteners, either hooks and eyes or snaps, are sewed on. The location of all fastenings should be marked before any are sewed on. One should be placed at the extreme top of the opening and one about 1″ or 1½″ above the waist line. There may be two or three between, according to the length of the opening.

(*c*) *The Waist-Line Finish.*— (*i*) All semifitting linings should extend only to the waist line and should be attached there to stiff belting to keep them in place. (*ii*) Belting about 2″ or 2½″ wide is generally used. It is cut the correct waist size plus ½″ for finishing. It should be darted to fit it to the figure and each end should be turned in ¼″ and hooks and eyes sewed on. Usually three are necessary, one each at the top and bottom and one at the centre. After they are attached, a piece of taffeta or Prussian binding-ribbon is hemmed on to cover both the raw edge of the belt and the sewing of the hooks and eyes. (*iii*) The centre back or front of the belt must be marked by a line of colored basting and attached to the corresponding mark in the lining. (*iv*) The underarm seams should be placed to fall straight down to the waist line. Any fulness at the waist may be arranged as desired. It is usually more satis-

A finished semifitting lining

factory if it is spread rather than confined in a small space
at the centre front or back. (*v*) The lining should be sewed
to the outside of the belt. It is generally attached along
the centre of the belt rather than at the top or bottom
edge of it. The waist itself may then be attached to the
lower edge of the belt without making too much thickness
at the waist line. After the lining is pinned to the belt
and sewed, it should be cut off just below the line of stitches
and its raw edge covered by taffeta or Prussian binding
stitched flat on each edge by hand or machine. Care should
be taken not to strike the fasteners at the end of the belt
if the stitching is done by machine. If Prussian or taffeta
binding-ribbon is not available the lining may be stitched
on and its raw edge held in place by catch-stitching. The
joining when finished should be flat.

(*d*) *The Armseye Finish.*—There are various finishes for
the armseye of a lining:

(*i*) *Without a Sleeve.*—(a) The edge of a net lining may
be rolled and whipped. This method gives a sufficiently
firm edge and one which is inconspicuous and not clumsy.
(b) The raw edge may be turned in and a narrow lace
edge sewed by hand over it. This is suitable for all ma-
terials. (c) Silk linings may have the armseye bound with
taffeta binding-ribbon. This finish is not satisfactory for
wash material, as the ribbon yellows.

(*ii*) *With a Sleeve.*—Sleeves are frequently used in the
semifitting linings, especially in those which have collars
or fancy fronts attached. They make a lining fit better by
keeping it in place on the shoulders. Such sleeves are
usually short and without fulness. The top of the sleeve
should be cut ¾″ larger than the armseye of the lining.
No matter what the material of the lining may be, the
sleeve is most satisfactory when made of net, as it fits the
arm better and is less conspicuous. It may be joined by
four different methods: (a) Fells may be used for linings
of silk. net, or lawn, as they give the desired flat finish.
(b) A French seam may be used in any kind of material,
but is not generally as satisfactory as the fell because of
the method of making. (c) Taffeta binding-ribbon is fre-

quently used to finish the armseye of a silk lining and a net sleeve. (d) A net lining and net sleeve may be stitched together by hand or machine and the edges cut to a ⅛″ width and whipped together.

(e) *The Neck-Line Finish.*

(i) *With a Collar.*—Directions for attaching standing, flat, or turnover collars to a high or shaped neck line are given under *Shirt-Waists* and need not be repeated here. The method chosen should depend largely upon the lining and the collar material.

(ii) *Without a Collar.*—There are two usual methods of finishing the neck line if it has no collar. It is seldom finished at the normal neck line but is somewhat shaped to suit the cut of the waist. It may be finished with a very narrow hem sewed by hand. This is not as satisfactory nor as attractive as the edge which is given by using a narrow finishing lace. The raw edge of the material is turned to the wrong side and basted in place. The lace is sewed on to cover the raw edge and to allow its edge to extend beyond the lining. These lace edges come in many patterns and give an attractive and quickly made finish. They may be bought with sufficiently open edges to allow the running in of narrow ribbon, which may be drawn up to regulate the size and height of the neck line.

(2) *Tight-Fitting Linings.*—The finishing of a tight-fitting lining is in general rather tedious. The usual method of procedure in making is as follows: finishing centre front or back openings; basting and fitting waist; general finishing. To assemble all finishing directions, however, those for the centre front or back openings are given here rather than in their proper place before basting. The finishing includes the making of (a) Seams: (i) stitching; (ii) finishing the edges; (iii) boning. (b) Centre front or back opening. (c) Belt and its attaching. (d) Bottom finish. (e) Armseye finish. (f) Neck line or top finish.

(a) *Seams.*

(i) *Stitching.*—All the seams of the lining are stitched on the wrong side just outside the line of basting. As stitch-

ing is much firmer than basting the size of the waist is not changed.

(*ii*) *Finishing the Edges.*—All the bastings are removed, the seam allowances are cut to an even width, ½″, and notched. The notches are made at the waist line and 2″ above to give sufficient spring to the seams to fit the curves of the figure without drawing. They are cut to within ¼″ of the stitching which leaves width enough for the sewing in of the bones. The sharp corners of the notches should be rounded off as they bind more easily. (The princess lining should be notched again 1″ or 1½″ below the waist line.) The seams are then pressed. It is easier to press open a curved seam if the seam-line is placed on the curving edge of the ironing table or board rather than on its flat surface.

There are four ways in which the seam edges may be finished. They may be pinked or notched, overcast, bound with taffeta binding-ribbon, or their edges turned to the wrong side and run. (For details, see *Finishings.*)

(*iii*) *Boning.*—Bones may be placed in every seam of a lining. Frequently, however, only the centre front and back and the underarm seams are boned. The length of the bones depends upon the length of the waist of the wearer. They should never be high enough to poke out and show. The centre front and back bones are shorter than the others. An average length is 4″ above the waist line at the centre front, with each bone toward the back increasing a little in height. Whalebone or featherbone may be used. Whalebone requires more time, as a casing must be made and attached to the lining by hand. Featherbone has its own casing and may be stitched by machine to the lining. Whalebone is also more expensive, but it gives a lighter and more flexible waist, which is to be considered if many bones are necessary. Either kind of boning gives satisfaction.

(*a*) *Whalebone.*—A casing must be made for each bone. Prussian binding is used and is prepared as follows: Before sewing to the waist, 1″ of the binding is turned over to the wrong side and the edges are overhanded to make a closed pocket to hold the upper end of the bone. In attaching the

binding to the seam this pocket is left free. Beginning at
the bottom of the pocket, the binding is sewed with a run-
ning stitch along each edge flat to the seam with its centre
line exactly over the seam-line. It should be fulled slightly,
especially near the waist line, to allow the bone to be sprung
in. To prevent catching any stitches through into the
waist itself the seam allowance may be held parallel with
the worker, with the fingers behind the half of the seam on
which the sewing is being done. The binding is carried

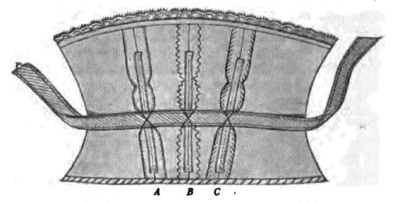

Seam boning and finishing—featherbone used and seam edges (*A*) turned in
and run, (*B*) notched or pinked, and (*C*) overcast

about 1″ below the waist line. A bone with rounded end
is slipped into the casing to within ¼″ of the top of the
pocket. To keep it in this position a few stitches are taken
through it and the casing just at the bottom of the pocket.
Heavy sewing silk or twist should be used and a fairly large
needle. Featherbone offers no resistance to the needle and
the whalebone can be pierced if softened a little by the heat
of the fingers. By leaving the pocket unattached to the
seam, the end of the bone, while covered and firmly fastened
to the casing, is still sufficiently free to prevent its wearing
through the lining. Before attaching the bone at the waist
line it should be sprung a little. This gives it a slight curve
which makes it fit into the figure better. The bone is at-
tached again at the waist line and the Prussian binding is

cut off ½″ below the end of the bone and turned up and sewed to form another pocket for it.

(b) *Featherbone.*—A pocket made of its own casing is formed at each end of the featherbone. The stitching which holds the bone and the casing together is ripped and about ½″ of the bone is cut off and its end rounded. The casing is turned to the wrong side and, without being drawn too tightly over the end of the bone, is overhanded into place. The bone is stitched to the seam, beginning about ½″ from the end of the bone and extending to within ½″ of the lower end. The line of stitching which joins bone and casing serves as a guide and is placed just to the right of the seam-line. The waist is turned back so that the stitching does not go through it, and the bone is stitched to the right seam allowance close to the seam-line. If Warren featherbone is used directions for its use and a guide fitting any sewing-machine may be secured. The stitching of the bone in place is simplified by the use of the machine attachment.

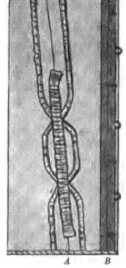

(*A*) Side-back seam boned with whalebone and bound with taffeta ribbon. (*B*) Centre-back seam finished with Prussian binding

(b) *Centre Front or Back Openings.* —As the finish is the same for the front or back, to simplify the discussion the opening may be considered as at the centre back. Both sides of the opening are finished in exactly the same manner.

(*i*) In cutting the lining and the reinforcements a 1″ seam allowance was made. This is turned to the wrong side along the tracings. As the two thicknesses of silk are not firm enough for the fasteners, a narrow strip should be included in this turning, extending from the top of the reinforcement to the neck of the waist. The waist is then stitched its entire length ⅛″ in from this folded edge.

A casing for the bone must next be made. If featherbone is used a bone without any covering is required. In a girdle the bone extends the entire length; in all other linings its length depends on the length of the other bones. To make the bone casing, a second stitching is made parallel to the first and just far enough in to permit a bone to slip in. The distance is about ¼″ or ⅜″. The bone should fit closely. This stitching should be made not the length of the bone but the full length of the lining, to give strength and a firm line on which to sew the hooks and eyes. The end of the bone should be rounded to prevent its pushing through the lining with wear. The bone is held in place by a few stitches at the waist line and at about ½″ in from each end.

(*ii*) For fastenings a plain hook without any hump, like the Swan-bill, should be used. No. 4 is the usual size; the color, black or white, depends on the color of the lining. The hooks and eyes should alternate and their position should be indicated before any are sewed on. Beginning at the waist line, they are placed about 1¼″ apart. (For details, see *Finishings*.) While both the hooks and eyes should be sewed on very firmly, it is not necessary to use the blanket stitch in the rings. Several stitches in each ring and at the outer end of each hook and eye are all that is necessary. Twist is better than sewing-silk.

When the fasteners are attached the extending edge of the centre-back seam allowance should be cut off and both its raw edge and the sewing of the hooks and eyes should be covered by a strip of wide taffeta ribbon or Prussian binding, which is slipped under the hooks and hemmed on each edge flat to the waist.

(*c*) *Belt and Its Attaching.*—A belt should be used in any kind of fitted lining; it assists in holding it in place. Belting 1½″ in width is all that is necessary. It is prepared as is the wider belting, but requires only one fastening placed at the centre. It should be ½″ to 1″ shorter than the waist measure of the lining. The belt is sewed to the inside of the lining with its centre to the centre-front seam of the lining and its lower edge exactly along the

waist line. It is attached to the centre and side front seams by catch-stitching, which should not show on the right side of the waist but should be taken through the bones to give firmness.

(*d*) *Bottom Finish.*—There are various methods for finishing the bottom of tight linings. (*i*) The raw edge may be overcast. This gives very little thickness and is often advisable. (*ii*) The raw edge may be turned ⅛″ to the wrong side and the folded edge overcast. (*iii*) The raw edge may be bound, as are the seams, with binding-ribbon. (*iv*) The raw edge may be turned ⅛″ to the wrong side and finished with a lace edge like the neck line of the semifitting lining.

The finishing of the bottom of the princess is a problem in skirt-making and is not considered here.

(*e*) *Armseye Finish.*—For this the same methods may be used as for the semifitting waists and need not be repeated here.

(*f*) *Neck Line or Top Finish.*—There are many different ways in which each lining may be finished at the top. Several suggestive methods, each capable of variation, are given here.

(*i*) *Regulation Tight-Fitting Lining.*—This may be finished with (a) a normal neck line and attached collar or (b) a shaped neck line with or without a collar.

(a) *A Normal Neck Line with a Standing Collar of Lace or Net Attached.*—There are three general ways in which this may be made.

The lining material may extend to the neck line and have the collar sewed to it. This is possible only when the waist itself is cut to extend to the collar line and conceals the lining entirely.

The lining material may be replaced by a shallow yoke formed by a lace edge or insertion which is fitted to the required shape. Such a yoke is frequently used when the waist does not extend quite to the collar line and something is required to replace the lining above the line of the waist. The work is done on the form. The centre front of the lace is marked with colored basting and attached to the centre front of the waist. The lower edge is pinned in place

first—it should be eased enough to lie perfectly flat. The fulness at the neck line may be removed in two ways—by the use of darts or by appliqué work; the design of the lace generally determines the method. Beginning at each side of the centre front, darts may be made at regular intervals. A more even circle for the neck line is secured if many shallow darts, rather than a few deep ones, are taken. The darts may be finished in two ways. They may be carefully marked, turned to the wrong side, sewed, cut, and pressed open; they may be hemmed flat, with invisible stitches, on the right side. For the latter method they should be turned on each side toward the back. In many designs the darts show very little. Frequently the design of the lace is such that the piecing done in shaping the collar may be entirely concealed. This is done by appliqué; that is, the figures in the lace are cut around and skilfully lapped.

The neck line of the waist may be rather uneven, due to the edge of the lace, and if the collar is made of the same lace it may also be uneven. This necessitates planning in the making and attaching of the collar. The kind of sewing stitch used should be determined by the condition of the two edges.

A net or chiffon lining may be used for these shallow yokes; it should be fitted or stretched to the lining and cut in the desired shape. It serves as a guide in shaping the lace, but it frequently makes too thick a yoke. Its use affects but little the method of making the yoke. The stitches are taken through the net and the sewing is done either from the right or wrong side.

The lining material may be replaced by a deep yoke of net, lace, or chiffon, which is stretched and cut in the desired shape. The work is done on the form. The yoke may be made in two ways—without any seam except in the centre back, where the yoke must open, as suggested for the yokes of the guimpe, or with a seam on each shoulder. This latter method has advantages. It requires less skill in fitting and brings the straight of the material at the centre back, which makes finishing much easier. It may be used if it

is necessary to have the opening of a waist at the centre front, as the fastening of the yoke may then come on the shoulder.

If the yoke is to be covered on the shoulder by the waist the shoulder seam does not show and the only requirement is a flat finish. If the yoke is not covered the seam is often not attractive unless finished by some decoration such as machine hemstitching. The seam may be stitched and its edges whipped to make it less conspicuous.

In making a yoke with a shoulder seam, if the front shoulder is stretched to the back a much better yoke is secured than by having the back and front shoulder seam edges even. This really follows the drafting rule of having the front shoulder ¼″ shorter than the back. Directions for the making of yokes are given under *Guimpes* and need not be repeated here.

In making a standing collar the pattern may be secured by drafting (see *Drafting*) or by fitting a straight length of material. (See *Guimpes*.)

The collar should be as nearly finished as possible before attaching it to the waist. Directions for making a net or lace collar are given under *Guimpes* and need not be repeated here.

In attaching the collar it should be pinned to the lining after it is taken from the form. Its lower edge should lie along the indicated neck line with the centre-front mark at the centre front of the waist. The curved neck line of the waist should be eased to the straight edge of the collar.

In finishing the lining the same directions should be followed as are given in the making of the guimpe yoke for marking the centre front and the neck line, for turning in the allowances at the centre-back opening without including the lining, and for attaching the yoke to the lining along the lower edge.

When these are done and the lining is removed from the form, the yoke and collar should be carefully basted in place and the yoke lining cut out. The lining is then ready for the fitting. Skill is required in stretching yokes and attaching collars to fit well, and the work should be carefully tested to secure good results.

The linings require finishing at the neck line, at the opening of yoke and collar, and around the bottom of the yoke.

The neck-line finish for collar and yoke or for collar and lining should be as inconspicuous as possible. A generally satisfactory method is that already described under *Guimpes;* that is, the attaching of the collar along its edge, from the right or wrong side, as can be most easily done, and the finishing of the edge on the wrong side by whipping.

If two finished lace edges come together, as is possible in the shallow yoke, they may be hemmed, run, or whipped as required.

If the opening of yoke and collar is at the centre back the hems of yoke and collar should match in width. Their finish may be as directed for the opening of the guimpe.

If the collar is sewed to the lining it may be finished before attaching, with the exception of the fastening at the very bottom, which should be put on just at the neck line, after the collar is joined to the lining.

If the opening of the yoke is on the shoulder the fastening should be from front to back. The seam allowance of the front is turned back and the hooks are sewed to it ⅛″ in. The allowance, with its raw edge turned in, is then slipped under the hooks and hemmed flat for a finish. The extending allowance on the back should be turned and hemmed to come sufficiently beyond the seam-line to serve as a foundation for hooks or peets.

The finish at the bottom of the yoke may be as directed for the yoke of the guimpe. If decoration is desired a narrow lace edge or insertion may be run on along the line of the yoke. The turned-back edge of the lining may be covered with taffeta binding. It sometimes gives a smoother finish than hemming the turned-in edges of the silk.

(b) *A Shaped Neck Line.*—Without a collar the neck line may be finished as in the semifitting lining, directions for which are given in this chapter. With a flat or turnover collar attached the finishing may be done as in the shirtwaists, directions for which are given in this chapter.

(*ii*) *Tight-Fitting Evening-Waist Linings.*—Each evening-waist lining may be said to require somewhat different treatment, as it must be made to meet the requirements of the dress to which it is to be attached. To simplify the discussion, however, these linings may be considered as of two general kinds.

(a) *Linings Cut to Extend Over the Shoulder.*—These are like the regulation tight-fitting lining but they require entirely different treatment in the shaping and finishing of the neck line. This line is indicated while the waist is on the form or during a fitting. The shape of the neck depends upon the face and figure of the wearer.

The lining is cut out along the indicated line and the raw edge is turned back ¼″ to the wrong side and

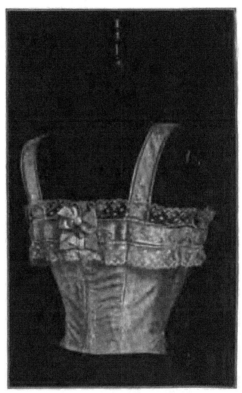

Elaborate finish for tight-fitting evening-waist lining

covered with lace beading sewed flat to the waist. This makes the opening somewhat larger than indicated. If a V-shaped neck is used the point of the V must be slashed and the beading carefully turned to keep the finish flat. Even more care must be taken if the neck is square. The material at each corner must be slashed and the beading mitred. Ribbon is run through the beading to keep the

neck of the lining in place. If the ribbon is not considered sufficient a tiny round elastic is used in addition. When the raw edge of the material is turned to the wrong side a row of running stitches is made just far enough in from the folded edge to hold the elastic. For a V-shaped neck the elastic is attached at the front point of the V and carried over the shoulder, where the ends are fastened, or are left to pull up and tie. For the square neck the elastic is frequently carried only over the shoulders, but it may also be carried across the front and back.

Some transparent material, such as silk net, tulle, chiffon, Georgette crêpe, or *mousseline de soie*, is used to give a soft finishing line to the opening. It is put on in many different ways.

Folds of net or tulle are frequently made and invisibly attached from the wrong side. For the V-shaped neck two strips are needed. They are attached to the centre front and drawn up over the shoulder, where a tiny dart is usually needed at the seam to make them fit closely. Their ends are turned in and securely sewed at each side of the centre-back opening. For the square neck, strips are drawn across the front and the back first and securely fastened, allowing the required opening. Other strips are then fastened at the front corners and carried over the shoulders, where they are darted if necessary.

Chiffon, crêpe, and *mousseline de soie* may be put on in a somewhat different way. Strips of material are folded in the centre, to be two or three inches wide. The fold forms

Front of finished girdle

the edge of the opening. For a square neck one strip is, stretched as tightly as possible across the front; the back is likewise arranged, allowing for the opening. The two strips for the shoulders frequently have the tiny round elastic run in the fold for which a row of running stitches is made close to the folded edge. The strips and the elastic are attached at the front corners of the square opening and drawn tightly over the shoulders to the other corners. The elastic is drawn up, and it and the material are securely fastened. If necessary a dart is made at the shoulder seam. For the V-shaped neck these strips are carried —as are the folds of tulle—from point to point.

In attaching any of these finishings the stitches must not be taken through the beading already fastened to the neck line, otherwise the ribbon cannot be drawn through.

(b) *Linings Cut to Extend Only to the Bust Line.*—These are, in general, like the regulation tight-fitting lining, but in place of the lining material they have bands of lace and ribbon over the shoulders. The line of the top is tested for direction and for height on the figure before finishing.

The raw edge of the material is then turned to the wrong side $\frac{1}{4}''$ and a row of running stitches is made less than $\frac{1}{8}''$ in. This forms a casing for the elastic, which is needed to hold the lining in place and to make it fit the figure closely. The raw edge is covered with lace beading through which a ribbon is run.

A simple or an elaborate decoration may be added to this as a finish.

Shoulder straps may be made of lace insertion overhanded together to carry ribbon. The decoration of the edge of the lining may correspond; that is, a strip of insertion with lace overhanded to each edge may be attached to the right side of the lining with one lace edge extending above the edge of the lining. Ribbon like that of the shoulder straps is then drawn through the insertion and finished at one end by small bows.

For a simpler finish, chiffon, Georgette crêpe, or *mousseline de soie* may be used over the shoulders. Strips are folded in the centre to give strength and thickness as well

as a folded edge for the neck line. These strips may be wide enough to meet under the arms and form an armseye. Each strip should have the elastic placed in the fold and its raw edges should be rolled and whipped or turned in and run to form the armseye.

In attaching either the bands or the chiffon top the lining must be tried on to insure their correct placing.

(*iii*) *Girdles.*—The two edges—that is, the top and bottom—of a girdle are finished in the same way, and if a semi-fitted net or chiffon lining is to be attached it does not change its finish, as the lining should be sewed to the waist line of the girdle rather than to the top. The edges may be finished, as are the seam edges, by enclosing them in the folded taffeta binding-ribbon. A somewhat flatter edge may be secured by using two pieces of binding-

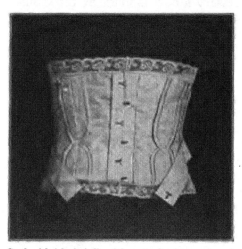

Back of finished girdle with centre-back seam boned

ribbon, one on each side of the lining. These are held together by running stitches at each edge.

For decoration, the raw edges of the girdle may be turned to the wrong side and covered with a lace edge, as already suggested for neck finishes. More decoration is secured by whipping together a narrow lace insertion and edge and sewing them on to cover the raw edge which is then turned to the right side. A ribbon may be drawn through under the insertion.

(*iv*) *Princess Lining.*—The princess may be finished by any method already described for tight-fitting linings and evening-waist linings. No other directions need be given.

CHAPTER IX

SKIRTS

The discussion in this chapter presupposes a well-fitting foundation-skirt pattern and experience in the division of a plain skirt into gores. Detailed directions for securing such a pattern and for skirt work based on the pattern are given in Chapters V, VI, VII. Those directions are, of necessity, referred to here, but repetition is avoided when possible.

There are many different kinds of skirts which may be made from the foundation-skirt pattern. Any definite division into distinct types is very difficult, because the variety in each type is so great and because many of the characteristics of each seem interchangeable. For better organization of the directions for making skirts, however, they may be grouped under four general heads or as four general types: Foundation Skirts or Linings; Tailored and Semi-Tailored Skirts; Lingerie Skirts; Draped Skirts.

1. **Foundation Skirts or Linings.**—Foundation skirts may be made in various ways by the use of drafted, designed, or commercial patterns. They may be sewed by hand or machine. They may be cut and made flat on the table or modelled on the form. They are usually cut in gores to remove all fulness at the waist. There may be any number of gores, but generally few are used to avoid having many seams to finish. The skirt may be with or without decoration at the bottom, depending on the style of the costume with which it is to be worn.

Silks—such as messaline, *peau de cygne*, soft satin, China silk, habutai, and *crêpe de chine*—make the most satisfactory foundation skirts, as they generally do not wrinkle, are light in weight, and do not catch or stick to the material of the dress. Cottons—such as lawn, sateen, and percaline —are frequently used.

2. Tailored and Semi-Tailored Skirts.—Tailored and semi-tailored skirts may be made in many ways by the use of drafted, designed, or commercial patterns. They are sewed by machine; they do not require a foundation skirt and may be cut and made flat on the table or modelled on the form; they may be cut in plain or decorated gores or in gores or straight lengths to be plaited, gathered, or somewhat draped; they may be close-fitting or free at the hips, narrow or wide at the bottom, and with plain or decorated seams. Such skirts are generally plainer from point of decoration than any other, but they are not, as a result, simpler to make. They are dependent for their finish, style, and good design on the cut, fit, and workmanship, and consequently emphasis must be placed on the technique. Cottons, as duck, indian-head, poplin, and piqué; silks, as silk serge, wash silks, pongee, and shantung; wools, as serge, broadcloth, covert cloth, diagonal, gaberdine, prunella, etc.; and linens, as dress linen, crash, and Jacquard designs, are the materials most frequently used.

3. **Lingerie Skirts.**—Lingerie skirts may be made in many ways by the use of drafted, designed, or commercial patterns. They are sewed by hand or by machine. They may or may not require a foundation, and may be cut and made flat on the table or modelled on the form. They may be cut in plain or decorated gores or in gores or straight lengths to be plaited, gathered, or somewhat draped. They are usually not made to fit as closely as other skirts. They may be narrow or wide at the bottom, with or without flounces, and with plain or decorated seams. Such decoration as will launder well or clean easily should be chosen.

Cottons, as dimity, organdie, crêpe, voile, batiste, and lawn; linens, as handkerchief linen and linen lawn, are all suitable materials.

4. **Draped Skirts.**—Draped skirts may be made in a greater variety of ways than any of the others. They may be made by the use of designed or commercial patterns or they may be draped directly on the form. They are sewed by hand or by machine. Generally they require a founda-

tion skirt to which various pieces may be attached to secure the desired effect. They cannot be satisfactorily arranged and draped without a dress-form. Draped skirts are less mechanical and require greater skill in the manipulation of material than any of the others. They should not be attempted until much experience has been gained in the making of the simpler kinds of skirts.

Silks and wools are more frequently used for draped skirts; silks, as charmeuse, *crêpe de chine, crêpe meteor*, satins and failles, chiffon and chiffon cloth; wools, as voile and fine broadcloth.

General Directions for Making

Skirt-making cannot be well done unless it is thoroughly understood before beginning that its success depends almost entirely upon the careful observance, in the cutting and making, of the correct grain or thread of the material. The grain required for the desired hang and effect in the different parts of the skirt must be determined and maintained absolutely.

If two sides of a skirt, whether it is gored or draped, are to give the same effect the thread of the material must exactly correspond in each; the same shape in the pieces, without the same grain, cannot produce similarity of appearance and hang. A skirt may sometimes be made to fit at waist and hip, but it cannot be made to hang well unless a true grain is kept. Different effects in folds and in light and shadow, etc., may also be secured by the correct placing of the lengthwise, crosswise, or bias thread of the material. (See *Designing*.) Skill in securing a desired effect comes from much experience in the handling of materials and from a knowledge of the results which may be obtained by the use of a certain direction of grain.

In making nearly all skirts much the same general procedure must be followed; that is, there must be:

(1) Securing the pattern.

(2) Arranging seam allowances; placing the pattern and cutting.

(3) Marking for basting.
(4) Basting and preparation for fitting.
(5) Fitting.
(6) Making and finishing.

In the detail of these steps there is great opportunity for variation, owing to the many kinds of material it is possible to use and to the constant change in fashions it is possible to have.

The same method of procedure cannot always be followed for draped skirts as for the others, especially if the design is made on the form, working directly in the materials. Because of this, and because of the many different styles and methods of making, the general directions may require much modifying and adapting to meet the specific problems which arise in the making of draped skirts.

I. Securing the Pattern

Four general methods of procedure may be followed; the pattern may be:

(1) Drafted to measure. (See *Drafting.*)
(2) Adapted from a commercial pattern. (See *Use of Commercial Patterns.*)
(3) Designed in paper or material on a flat foundation pattern. (See *Designing.*)
(4) Draped on the dress-form. (See *Designing.*)

No definite directions can be given for the selection of a suitable method for securing a pattern. There are too many varying factors to be considered, such as the experience of the worker, the type of skirt, its material and style.

II. Arranging Seam Allowances; Placing the Pattern and Cutting

1. **Seam Allowances.**—Before using any pattern it is absolutely necessary to notice whether any seam allowances have been made. The majority of commercial patterns have a regulation allowance which is explained in the description of the pattern and indicated generally by perforations.

Drafted and modelled patterns may or may not have these allowances, according to the choice of the worker. It is simpler to use patterns without allowances, but it is sometimes thought safer for a beginner to have them added. The following allowances are usually made in the placing of a skirt pattern: 1″ on all the lengthwise seams; ¼″ at the waist line.

The hem allowance is variable, depending on the style and finish of the skirt; the finishing allowance on any yoke, flounce, or applied piece also depends on the finish.

2. **Placing and Cutting.**—When possible the entire skirt pattern should be placed and cut at once; that is, all gores or lengths and any decorative pieces such as yokes and flounces. In general, the material should be folded to have all corresponding pieces cut together, as it saves time and confusion and prevents having two pieces for one side if the material has a right and a wrong side. Care should be taken to observe, when necessary, the up and down of material. Even if there is no nap to be considered, the color is frequently affected by a reversal of the up and down. (See *General Suggestions*.) In placing a pattern, economy of material should be considered. No definite rules for doing this can be given because of the variety of design and the fact that the materials used differ as greatly in width as do the patterns in size and length. As has been said, the direction of the threads of the material is exceedingly important.

A few general suggestions or rules may be given for placing and cutting. To nearly all of these, however, there may be exceptions.

(1) *Different Ways in Which Skirts May Be Cut.*—Skirts may be made to fall straight or to flare; they may be plain, plaited, or gathered. To secure the desired effect they may be cut in straight lengths or divided into a few large gores or many small ones. Usually for straight, close-fitting skirts few gores are used, while for wide skirts many gores are frequently considered better, as they give greater opportunity for adding fulness without too great bias. In general—

(*a*) *The straight, narrow skirts* usually have two, four, five, or six gores. The gores should be nearly equal in size at the top and the bottom, with the fulness held in at the waist to give the best results. A narrow skirt which is gored and fitted in at the waist and the hip usually fits the figure too closely and gives it an ugly line at the back.

(*b*) *The flaring or full skirts* may be made in two ways.

(*i*) By the use of many gores cut wide at the bottom in proportion to the size at the hip; that is, gores which may be fitted at the waist and the hip and have a flare added below at one or both edges. The greater the number of gores the greater the width at the bottom. Such a skirt is seldom cut in less than six gores.

(*ii*) By the use of the circular skirt, which may be a complete circle or a part of a circle and cut in gores.

A narrow circular skirt cut in gores may be made to fit at the hip as well as at the waist, but as the circle increases in size it fits closely only at the waist line and hangs free from the figure below. Two or four gores are the usual divisions. The complete circle may be in one or two pieces.

(*c*) *The plaited skirts* may be made in two ways.

(*i*) By the use of gores to which plaits are added. The greater the number of gores the greater the number of plaits. Such skirts may fit at the waist and the hip.

(*ii*) By the use of straight lengths in which plaits are so laid as to fit at the hip and the waist.

(*d*) *The gathered skirts* may be made in two ways.

(*i*) By the use of gores which are cut sufficiently large to allow gathers at the waist line.

(*ii*) By the use of straight lengths which are gathered at the waist line. Both these skirts are made to fit at the waist but fall free from the figure below.

(For details in planning tucks, plaits, and gathers for skirts, see *Designing*.)

(2) *Arrangement of Gore Divisions.*—When the general style of the skirt and the number of gores are decided, there is still the question of the arrangement of the gores in the skirt. Several possible arrangements are suggested.

(*a*) *Skirts with Two Gores.*

(*i*) *Straight Skirts.*—A straight skirt may be cut with a seam at the centre front and centre back. If the centre-front seam is straight and the centre-back is slightly bias there is less fulness at the waist than if two straight seams are used.

A straight skirt may also be cut with a fold at the centre front and centre back and with a seam at each hip. If these two seams are slightly bias there is less fulness at the waist than if they are straight.

For all of these straight skirts there is fulness at the waist which may be arranged in folds, plaits, or gathers. The waist lines are wide and only slightly curved.

(*ii*) *Circular Skirts.*—A circular skirt may be cut with a seam at the centre front and centre back. If the centre-front seam is slightly bias and the centre-back is bias there is less fulness at the waist than if a straight centre-front seam and a bias centre-back seam are used.

A circular skirt may also be cut with a fold at the centre front and centre back and with a seam at each hip. These seams are both bias.

For all of these circular skirts there need be no fulness at the waist. The waist lines are the required size and more deeply curved than for the straight skirts.

(*iii*) *Peg-Top Skirts.*—The peg-top skirt, which has two gores, is an exception to any of the above. It has a centre-front and centre-back seam, both of which are bias and are cut to give more width at the waist than at the bottom. The waist line is irregular and curves up over the hip to give material for the drapery. The straight of the material extends down over the hip.

(*b*) *Skirts with Four Gores.*

(*i*) *Straight Skirts.*—A straight skirt may be cut with a seam at the centre front, centre back, and at each hip. The centre-front seam is straight, the centre-back is slightly bias, while the hip seam has a bias and a straight edge.

A straight skirt may also be cut with a panel front which has slightly bias edges, a panel back with slightly bias edges, and a wide side gore which requires a dart or some

other device for removing the fulness at the waist line. The side gore may have its front edge straight below the hip or slightly bias. Its back edge is bias.

(*ii*) *Circular Skirts.*—A circular skirt may be cut with a seam at the centre front, centre back, and at each hip. The centre-front seam may be straight, the centre-back bias, while the hip seam has a bias and a straight edge.

A circular skirt may also be cut with the front seam slightly bias rather than straight and with the usual bias back seam and the hip seam with a bias and a straight edge.

While the circular skirt is cut much as is the straight one, it secures its fulness or flare by the curving waist line, which brings its seams, especially that of the centre back, much more bias than any of those of the straight skirt.

(*c*) *Skirts with Five Gores.*—A skirt with five gores has a panel with slightly bias edges placed either at the centre front or back. Its two side gores may be cut to hang straight or to have a circular flare. If the panel is placed at the centre back there is a straight seam at centre front and a hip seam with a bias and a straight edge. If the panel is placed at the centre front there is a bias seam at centre back and a hip seam with a bias and a straight edge.

(*d*) *Skirts with Six Gores.*—The most frequently used design for the skirt having six gores has a panel front with slightly bias edges, a panel back with slightly bias edges, and a seam at each hip which may have two slightly bias edges or a bias and a straight edge.

(*e*) *Skirts with Seven Gores.*—The most frequently used design for the skirt having seven gores has a panel front and three gores on each side. The panel front has slightly bias edges and the centre-back seam is bias. The two seams at each side may have two slightly bias edges or a bias and a straight edge. (For the proportion of various gores, see *Drafting.*)

(3) *Different Ways in Which the Gores or Lengths of Skirts May Be Placed on the Material.*

(*a*) The lengthwise centre of a centre front or back panel is placed on a lengthwise straight fold. This makes its two seam edges slightly bias.

(*b*) The fronts of all the gores of a skirt are placed, below the hip line, on a lengthwise straight thread. This makes the front seam edge straight and the back slightly bias. In joining such gores a slightly bias and a straight edge fall together. '

Exception.—The exception made to this is so frequent that it may also be considered a rule. The lengthwise centre of a gore may be placed on a lengthwise straight thread.

This makes the front and back seam edges bias. In joining such gores two bias edges fall together. By cutting the gores in this way a different flare is given the skirt. If the side and back gores of a skirt are cut with the straight lengthwise centre they will stand out in the large, tubelike folds which are sometimes demanded by fashion.

(*c*) In placing gores which have tucks or any style of plaits added at their seams, the original gore line rather than the line which forms the edge of the tuck or plait must always be the one to determine the direction of the lengthwise thread. The front of the gore should be placed on the straight lengthwise grain.

(*d*) In placing a skirt which is a complete circle the centre front and centre back are both on the lengthwise straight thread. The centre front may be on a fold, if desired. In piecing material to secure sufficient size for such a skirt the joining is done along the selvage and the seam slants upward and toward the back.

(*e*) In placing a skirt which is circular but not a complete circle, many different ways are possible.

(*i*) It may be cut with a lengthwise straight fold at centre front and back and with a seam at each hip. This brings two quite bias edges together at the hip. The finish of this seam should be such as to hold the edges in place and keep them from stretching. The slot seam is frequently used. Such a skirt will flare at the side and be rather straight at the back.

(*ii*) It may be cut with four seams—one at the centre front and back and at each hip. The seam at the centre front may be on a straight lengthwise thread. This throws the ripple of the skirt to the side. It may be slightly bias,

placing the pattern 6″ or 8″ in at the waist line. This grain gives a better effect and a better fit, as the thread of the material lends itself to the line of the figure. The ripple or flare comes nearer the front. If striped material is used the stripes are frequently made to form a design by cutting the centre-front seam slightly bias. The centre-back and the hip seams are bias.

(*f*) Plaited and gathered skirts may be cut in two ways—in straight lengths or in gores. If they are cut in gores the rules already suggested may be followed. If they are cut in straight lengths the lengthwise of the material is generally used for the length of the skirt but need not necessarily be so used. If material is of sufficient width it may be made up crosswise into plaited or gathered skirts. The edges of the plaits do not press as sharply and the gathers do not hang as well.

No directions need be attempted for placing commercial skirt patterns. They always have a definite design and include all the necessary pieces for the gores, yokes, and various decorative pieces. Their proper placing is indicated in the pattern.

The skirt draft given in *Drafting* is for a foundation skirt on which any variety of design may be made. Each design affects somewhat differently the size and style of the various pieces. When any gores or decorative pieces are designed on this pattern, marks for their placing must be clearly indicated.

Skirts which are draped directly in the material require rather different treatment from those cut from patterns. In their draping regard is given to the grain of material and the arranging of proper seam allowance. The suggestions given above may be followed in their draping, or more elaborate designs may be used for which no rules can be given.

III. Marking for Basting

There are three ways of marking the lines which are necessary in the basting and making of a garment. (See *General Suggestions*.) Some of the materials used for skirts

can be satisfactorily marked with the tracing-wheel. Others require tailor's chalk and tailor bastings. If the tracing-wheel is used, all the necessary tracing may be done after the pattern is pinned in place and before cutting out. If the material is such that the tracings do not show or will not last, the skirt should be marked temporarily with chalk and cut. In making the tailor bastings, after cutting out, especial care should be taken to have the two pieces of material so firmly pinned together that they cannot slip and their corresponding seam-lines be uneven.

A tracing should be made around the entire pattern, which gives the waist, bottom, and all seam-lines of the skirt; through the hip lines just at the seam-lines, to aid in joining the seams; to indicate any darts which are used; through all guide lines for the turning of tucks or plaits or the making of gathers; through the joining lines of the placket. In marking the seams of a pattern it must be remembered that it is the seam-line itself and not the seam-allowance line which should be marked. These tracings are to indicate the sewing lines and must be correctly placed and true.

If there are gores it is an excellent plan to cross-mark corresponding seam-lines. These serve as a guide in basting the seams together and also in matching adjoining gores. Without some indicating marks the wrong edges of gores are frequently joined by the inexperienced or careless.

The waist and hip lines are very important in the basting, fitting, and making of a skirt, and must be carefully maintained until the skirt is practically finished. As the mark of the tracing-wheel is easily lost in the necessary handling of the material and in the sewing and fitting, these lines should be retraced by bastings of colored cotton after the skirt is cut out. Colored cotton is used because it can be plainly seen in the fittings and shows the correctness of the placing of the lines, and it can also be distinguished from the other basting lines.

If the design of a draped skirt is such that there are corresponding pieces, they should be placed together and their seam-lines trued, straightened, and traced.

IV. *Basting and Preparation for Fitting*

There are a few general rules for the basting of all skirts. Those required in the making of a skirt pattern have already been given under *Drafting*. More detailed directions are necessary for the making of the skirt itself because of the variety of design possible.

Seams are basted on either the right or the wrong side of a skirt, depending on the style of the finish. In basting for fitting the thread should be well fastened in the beginning and the finishing and short stitches should be used where there is any strain. If the skirt has been fitted and the basting serves merely to keep the seam-lines in place for stitching, longer stitches may be used. Unless a worker is very experienced, stitching should not be attempted without basting. Even careful pinning is not satisfactory. The line of basting should always follow exactly the line of tracing. Before basting any seams together the corresponding tracings should be matched and pinned and all long seams pinned together at short intervals. This keeps the seam-lines together and makes their basting simpler. It also prevents the slight fulling of the side nearest the worker, which frequently occurs, especially in the work of the inexperienced or careless. All skirt basting should be done with the work flat on the table, as the seams are too long to be handled well in the lap. For a fitting all the pieces of a skirt should be joined and a belt prepared but not attached. The style determines the number of pieces in the skirt and the kind of belt required. The width of the belt depends on the height of the skirt at the waist.

1. **To Join Plain Gores.**—An edge which is straight below the hip and an edge which is bias frequently fall together. In pinning and basting such seams the bias edge must be toward the worker; that is, the gore with the straight edge is placed flat on the table and the gore with the bias edge is placed on it. If the edge is very bias it may be more easily managed if some of the basting is done over the hand. If two bias edges fall together, with one more

bias than the other, the more bias edge should be toward the worker. Two equally bias edges may come together as in many centre-back seams. When this occurs great care should be taken to join them evenly and not to stretch the edges. The basting must be done with the work flat on the table.

2. **To Join Gores Which Have Tucks or Plaits at Their Seams.**—If tucks or plaits of any kind are used on the seams of gores they must be basted in place before the gores are joined. It must be remembered that all tucks and plaits are so cut and made aś not to change the original size of the gore. (For details in planning tucks, plaits, etc., see *Designing*.)

(1) Tucks are placed at the back edge of gores, but an equal allowance is made for them on the adjoining edges of each gore.

To prepare the gores for joining, the back edge of the front gore is turned to the wrong side, exactly along the original seam-line, and basted flat. This turns the width of the tuck and the seam allowance to the wrong side. The tuck and seam allowance on the front edge of the next gore are not turned back but are allowed to extend.

The folded edge of the front gore is placed to the seam-line of the second gore and pinned and basted along its folded edge. If the pins are put in at right angles to the edge they are more easily managed and hold the material better. A second basting should be put in parallel to the first to indicate the width of the tuck where the stitching or the required finish is to come.

(2) Side plaits are basted and joined in the same manner.

(3) Inverted plaits require a little more planning.

(a) If inverted plaits are placed at the centre back of a skirt, an equal allowance is made on the adjoining edges of the gores and the edges are basted in the same way; that is, the edge of the gore is turned to the wrong side along its seam-line and basted flat. This folded edge is then placed to the edge of the plait, which is also the sewing line for the centre-back seam and is already indicated by a tracing, and is pinned and basted in place. When this

is done on the two gores the back seam which joins these gores is basted, with the seam edges to the wrong side.

(*b*) If an inverted plait is placed at the back of a gore the basting is done in much the same way. The back edge of the front gore is turned to the wrong side and basted flat. This turns the width of the plait and the seam allowance to the wrong side. The front edge of the next gore is turned to the wrong side and basted flat along the fold. This folded edge is then brought forward to the indicated centre of the plait and is pinned and basted in place. As three times the width of the plait plus the seam allowance was added here, one width of plait and the seam allowance still extends. The turned-in edge of the front gore is placed on this extension close to the turned-in edge of the back gore and is pinned and basted in place. The skirt may then be turned to the wrong side and the two raw edges basted together along their indicated seam-line. This seam is in the fold of the front plait and turns to the front of the skirt.

3. **To Join Panels.**—Panels are usually finished with a tuck at each seam. These tucks are arranged and the panel is joined to the next gore in the same way as are the gores which have tucks at their seams. No directions are necessary. In all this work much attention should be paid to careful matching of hip-line tracings.

4. **To Turn Hems.**—The bottom of the skirt should be turned on the indicated hem line and basted along the fold. The second basting at the top of the hem need not be a careful one, as it merely holds the hem in place during fitting. If there are tucks or plaits they are already basted flat the full length of the skirt and should not be opened for this basting.

5. **To Arrange Fulness at the Waist Line.**—Fulness at the waist line is arranged by the use of darts, gathers, plaits, or tucks.

(1) If darts are used they are indicated by tracings and are basted before any gores are joined. They require careful work. The basting should be done from the point of the dart to the waist line. The two seam-lines should al-

ways be pinned first, as it is very easy to match the tracings incorrectly or to full one side too much. Darts, when basted, should always have an outward curve to follow the lines of the figure.

(2) If gathers, plaits, or tucks are used they generally cannot be made until the different parts of the skirt are joined. The plaits or tucks should be arranged or the gathering stitches made before the skirt is put on for a fitting.

6. **To Attach Yokes and Decorative Pieces.**—Definite directions cannot be given for these as they vary too much in design. When possible, all such pieces should be attached to that section of the skirt to which they belong before the whole skirt is put together. This saves the handling of the entire skirt as well as the wrinkling and the wear of the material.

Yokes are usually joined to skirts in the same manner as panels; that is, their joining edge is turned in along its seam-line and basted flat to the skirt, matching tracings. Decorative pieces which are applied to the skirt may be finished in the same way. When pieces are inset the edges of the skirt to which they are attached are generally turned in and stitched flat to them.

7. **To Finish the Waist Line.**—The material and the cut of a skirt determine its waist-line finish.

(1) For a foundation skirt or lining two or three waist finishes are possible. Those most frequently used are the narrow standing belt, which encloses the raw edge of the skirt, and the narrow bias facing, which also encloses the raw edge and is sewed to the wrong side of the skirt. With either of these methods a flat, thin finish is possible.

(a) *Belt.*—If a standing belt is used it is generally of the material of the skirt. It is cut twice the required finished width plus ½″ for seam allowances and the required length plus finishing and seam allowances. For the fitting its lengthwise centre line and its crosswise centre line should be marked. From the crosswise centre mark the exact waist size should be measured and indicated in order to

have the two sides of the skirt even when the belt and skirt are joined in the fitting.

(b) *Bias Facing.*—If a bias facing is used it need not be prepared for the fitting. The skirt is fitted to the required size and the facing is attached in the finishing. This facing may be arranged to give less thickness around the waist than the standing belt, as, if desired, the top line of the skirt when finished may come just to the waist line.

(2) For the majority of skirts a standing belt made of belting is required. For wash skirts a belting which does not lose its stiffening in laundering should be chosen. It should be shrunk before making. For cloth skirts this need not be considered. For all kinds of belting the following preparation is necessary:

It is cut the required length plus ½" for finishing. The centre line is indicated, the ¼" at each end is turned in, and the hooks and eyes are attached. The number of fastenings varies with the width of the belt; one is sewed at the top edge and another at the lower edge, with the required number between, about ½" or ¾" apart. Even a wide belt seldom requires more than three. The position of all should be indicated before any are sewed on. The hooks are sewed on the right side and the eyes on the left. They should be placed so that the two edges of the belt exactly meet. In sewing, strength and not finish is required, as they are to be covered by binding-ribbon or Prussian binding, hemmed at each edge to the belting. (For details in sewing on fastenings, see *Finishings.*)

V. *Fitting*

In many cases much time is wasted by too frequent fittings, which are usually necessitated by the lack of proper preparation for fitting. Except for very elaborate skirts, two or three fittings are all that is necessary, if the pattern used has been properly made, tested, and fitted. For a first fitting the whole skirt should be together and a belt should be prepared, to which the skirt may be pinned during the fitting. Before the skirt is put on, the belt is

placed around the waist with its lower edge just at the normal waist line. The general appearance of the skirt, its fit, hang, and length, and the direction of the waist and the bottom lines may all be observed and the skirt and belt may be attached. If the fitting is carefully done and the work which follows is equally careful, at the second fitting the skirt may be nearly completed and a finished fitting may follow.

The fitting of the skirt and the alterations which any changes necessitate are practically the same as for the foundation skirt, which are given in detail under *Drafting* and need not be repeated here.

VI. Making and Finishing

After a skirt is properly fitted and basted it is ready for the finishing. Many different kinds of finishes are required not only because of the four general types of skirts but also because of the great variety of style and material possible in each type. For instance, a tailored skirt may be plain or plaited, may have few seams or many, may be made of wool, silk, linen, or cotton. For such a skirt at least three or four different finishes are possible for the seams and an equal number for the placket and belt. The choosing of suitable finishes for any skirt must necessarily be a question of good judgment rather than an attempt at strict adherence to any one rule. For this reason only a few directions for finishings are given here, with suggestions for their application to the different kinds of skirts. These directions include only a few of the many methods by which practically the same results may be achieved. Each skirt presents its own special problem of design and material, and the finishings chosen should be such as to meet that problem.

The finishing of a skirt usually requires:

(1) Stitching and finishing seams.
(2) Planning and making the placket.
(3) Attaching the belt and finishing at the waist.
(4) Finishes for the bottom of skirts, the edges of tunics, overskirts, flounces, etc.

1. **Stitching and Finishing Seams.**—There are many seams which may be used in skirts. Certain seams are suitable for only one type of garment while others may be adapted for all types. The seams most frequently used are:

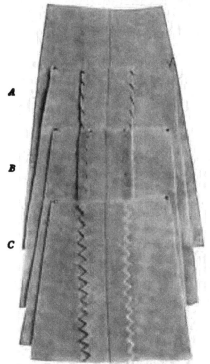

(1) Plain seam with different finishes.

(2) French seam.

(3) Seam finished with *entre-deux*.

(4) Fell seam.

(5) Welt seam.

(6) Lapped seam.

(7) Slot seam.

(8) Strapped seam.

(9) Machine-hem-stitched seam.

In making any seam finish, whether plain or fancy, care should be taken to keep the skirt absolutely its original shape and size. All the correct seam-lines must be indicated by some means which is sufficiently plain to be easily seen and sufficiently permanent to last as long as needed.

Plain seam finished by (*A*) overcasting, (*B*) binding, and (*C*) notching

Whatever kind of finish is chosen as suitable for the seams of a skirt should be maintained throughout. It need not be made by the same method in all parts of the skirt, but its appearance should be the same when completed.

(1) *Plain Seam.*—The method of making this seam is very simple. It may be finished in different ways, both on the right and on the wrong side.

(*a*) Finishes for the wrong side. (*i*) Notching or pinking is the simplest finish. (*ii*) Overcasting may be satis-

factorily used in all styles of skirts made in all kinds of materials. (*iii*) Binding with taffeta ribbon gives a neat finish to seam edges. It may be used for silk seams, which do not require pressing or laundering, and is frequently seen in wool skirts of various kinds. It is used for the

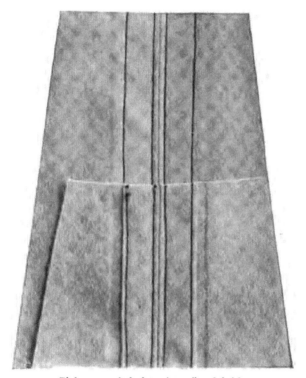

Plain seam stitched to give tailored finish

seams of linings. (*iv*) Turning in the edges is used to make an open or a closed seam. It is an especially good method for finishing the seams of the foundation skirts or linings; it is quickly done and does not necessitate the purchase of any extra finishing materials. The open seam is not satisfactory in very heavy materials, but for light-weight fabrics it does not give too much thickness. It is frequently used in silks, linens, and cotton, where too

frequent laundering is not required. The closed seam is exceedingly satisfactory for wash materials which are not tailored, as the raw edges are enclosed.

(*b*) Finishes for the right side: In making a plain seam

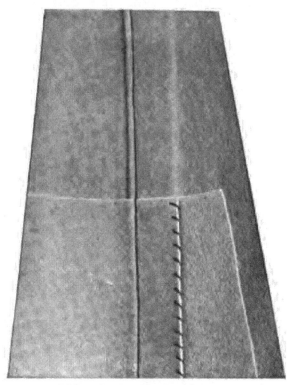

Right and wrong side of a welt seam

no stitching is required on the right side. One or more rows may be added to give a tailored finish.

(2) *French Seam.*—The use of the French seam in dress-making—in skirt-making especially—should in general be discouraged. It may be used occasionally in straight seams in lingerie skirts but it is not satisfactory in fitted linings.

(3) *Seam Finished with Entre-Deux.*—Such seams are suitable only for lingerie skirts. There are several meth-

ods of finishing—by the use of French seams, which is the least satisfactory; by the use of bound seams, which is the simplest method; and by rolling and whipping the raw edges, which gives the most inconspicuous seam but is suitable only for the thin materials.

(4) *Fell Seam.*—The fell is a flat seam frequently used for tailored skirts and satisfactory for all but very heavy materials. It wears and launders well.

(5) *Welt Seam.*—This seam has somewhat the same effect as the fell and is frequently found to be more satis-

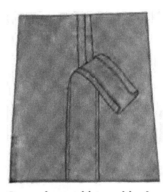

Lapped seam with raw edges Strapped seam with turned-in edges

factory for the heavy materials. It launders and wears well. It is very frequently used for tailored skirts and also for many of the softer materials which are machine stitched but not strictly tailored.

(6) *Lapped Seam.*—This seam is used in tailored skirts and is made in two ways—with raw edges or with turned-in edges. The general effect is the same for either method.

(7) *Slot Seam.*—The slot seam is frequently used to form a decorative finish to a centre-front seam. It is also very good for a circular skirt which has a seam over the hip in which two bias edges come together. It prevents the sagging of the seam. It is generally used in tailored and semi-tailored skirts.

(8) *Strapped Seam.*—This seam is made in two ways—with a strap having turned-in edges or with a strap hav-

ing raw edges. It may be used as a finish in silks, wools, cottons, and linens in tailored and semi-tailored skirts.

(9) *Hemstitched Seam.*—Machine hemstitching requires a special machine and consequently cannot be generally used as a seam finish. It is used for thin materials, such

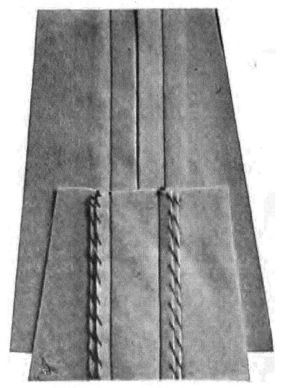

Right and wrong side of a slot seam

as chiffon, net, and crêpe, and for lingerie skirts. It is both strong and decorative.

(For details in making and finishing seams, see *Finishings*.)

2. **Planning and Making the Placket.**—There are many different methods possible for the finishing of plackets, and, as they are in general not easy to make successfully, care

should be exercised in choosing the most suitable methods. The directions given here are merely suggestive and must be applied and modified by the worker to meet the problems presented in each different skirt.

Several factors must be considered in deciding upon the suitable finish—the general type or kind of skirt, whether foundation, tailored, lingerie, etc.; the definite style within that type, whether made by hand or machine; the material used, whether firm or easily drawn out of shape; the exact location of the placket, whether at the centre front or centre back, at the side, or over the hip, and whether the placket is to form a part of the decoration of the skirt or is to be concealed.

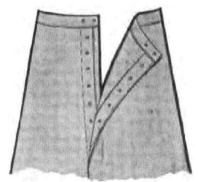

Foundation skirt with finished placket and standing belt

The placing of a placket is somewhat a matter of choice. It is usually in a seam of the skirt. It should be arranged for the convenience of the wearer, and its fastenings and the details of finishing should be made as invisible as possible. Too much finishing is frequently attempted, especially by the beginner, and the placket made both clumsy and conspicuous. The finish used should, as far as possible, accord with that chosen for the rest of the skirt.

(1) *Plackets for Foundation Skirts or Linings.*—These plackets are as simply made as possible. If the lining is to be attached to a skirt the placing of the placket depends upon the opening of the skirt; if the lining is to be free, and to be worn with one or many skirts, its placing may be governed entirely by the convenience of the wearer. When possible the placket is made in a seam. It is about 12″ or 14″ in length and opens from right to left. One simple method of making is as follows:

(a) To form the upper or outer side of the placket the 1″ seam allowance is turned along the seam-line to the wrong

side, its raw edge is turned in, and it is stitched flat to the
skirt. The stitching may also be done along the outer edge
of the placket but should not extend across the lower end.
If the seam is bias a straight facing may be included in
the turning to prevent any stretching.

(*b*) For the other side of the opening the 1″ seam allow-
ance acts as an extension. A reinforcement of some kind
must be added to which the fastenings may be sewed.
(*i*) If the edge is not very bias a piece of Prussian binding
placed to the wrong side along the line of fastening may be
all that is necessary. The edge of the extension is then
overcast, bound, or hemmed. (*ii*) If the edge is very bias,
however, it may be wise to face the entire seam allowance
with a straight lengthwise piece of material the same width
and length as the allowance. This is stitched to the raw
edge of the extension, with right sides together; it is then
turned to the wrong side, its raw edges are turned in, and it
is stitched flat at both lengthwise edges.

(*c*) The placket should be closed accurately, with its
opening line forming a continuation of the seam-line of the
skirt, and a row of stitching should be made across its lower
end. This prevents the tearing down of the placket. With
the placket still closed the position of the fastenings should
be indicated. They must be placed to keep the placket
neatly closed and the fit of the skirt unchanged. Hooks
and peets or snaps may be used.

(2) *Plackets for Tailored Skirts.*—Tailored plackets are
most frequently placed, according to the number and posi-
tion of the seams of a skirt, at the centre front, centre
back, left side front, and left side back. Some styles of
skirts, however, may require a somewhat different man-
agement. For instance, if there is only one seam, and
that over the hip, the placket must be placed in it. This
is a less desirable position than the others, as it is con-
spicuous. The seam is usually curved and its edges are
bias and the placket is in consequence difficult to make suc-
cessfully. Such a placket must always be stayed or faced
to prevent its edges stretching.

Generally the right side of a placket laps over the left;

this cannot be considered a definite rule, however, as the construction of the dress frequently requires the opposite treatment. Plackets vary in length, depending on the size of the waist in relation to the size of the hips and the width of the shoulders of the wearer. The placket must be sufficiently long to allow the skirt to be put on easily. An average length varies from 12″ to 14″.

Nearly all plackets, whatever the method of making, require facings or reinforcements to prevent the stretching of their edges and to strengthen the sewing lines of the fastenings. The exact placing and the size of the facing depend in general upon the kind of material used for the skirt, the position of the placket, and the strain on the fastenings. The amount of material used should be only such as gives the required strength and neatness to the placket. All unnecessary thickness should be carefully avoided.

If the design of the skirt is such that the outer or upper edge of the placket may be finished by stitching, its making is much simplified and it is less likely to get out of shape in wearing. The majority of tailored plackets are stitched.

(*a*) A placket is placed in many skirts in a seam which is finished with a stitched tuck. Such a placket is easy to make and is very firm because the stitching of the tuck not only keeps the material in place but gives, as well, a sewing line for the fastenings.

As it is not possible to include all the methods which may be followed for the making of plackets, directions are given here for one placed in a seam which is finished with a tuck, as it is a finish in general use. With slight differences in detail, the directions may be used for making many different plackets. To simplify these directions they are applied to a definite style of placket—a placket 14″ in length, fastening from right to left with hooks and peets, and placed in a seam which is finished with a tuck ¾″ wide and has a seam allowance of 1″. With the directions are included a few suggestions for possible changes in detail.

(*i*) *Basting the Tucks and the Seam.*—Preliminary to making the placket the tuck is turned, basted, and pressed its full length. The two gores of the skirt should then be basted together along the indicated seam-line, matching all tracings, to within 15″ of the top. The extra 1″ in the opening is for convenience in the finishing of the placket. The work then proceeds as follows:

(*ii*) *Making the Right Side of the Placket.*—The basting is removed from the tuck the length of the placket to allow its being opened for a facing or reinforcement. The facing may be of silk, satin, sateen, or cambric, depending on the material of the skirt. It should not be too stiff or too heavy. It should be a lengthwise straight strip 15″ long and 4½″ wide. It is cut this width in order to line the tuck, and not only to enclose the raw edge of the seam allowance but also to extend to cover the sewing which keeps the hooks in place. The 4½″ strip is slipped into the tuck with its raw edge to the fold of the tuck and its right side to the wrong side of the skirt. It must be basted so that it is perfectly smooth otherwise the tuck will not lie flat. The tuck is then stitched along its seam-line from the top of the skirt just the finished length of the placket, 14″. While this is done the left side of the placket must be turned back out of the way in order not to be included in the stitching.

The extending raw edge of the facing is turned in ¼″ and basted. It is then folded over, enclosing the raw edge of the seam allowance of the skirt, is basted flat to the tuck ½″ in from its edge, and carefully pressed. The basting is removed later when the fastenings are sewed on. This side is now ready for the fastenings, but before they are attached the left side should be faced.

(*a*) *Possible Changes in Making the Right Side.*—The width of the facing or reinforcement may vary according to the choice of the worker, depending somewhat upon certain details—such as the width of the tuck and the seam allowance (as these are greater or less the facing is wider or narrower); the kind of fasteners used (if snaps are used their sewing cannot be concealed and the facing need then

be only of sufficient width to line the tuck and enclose the raw edge of the seam allowance); the material of the skirt (if this is very firm and will not ravel, the facing need not enclose the raw edge, it need only line the tuck and be included in the stitching which holds the tuck).

(*iii*) *Making the Left Side of the Placket.*—A lengthwise straight strip 15″ long and 1¾″ wide is required. The raw edges of this are turned in ¼″, except across one end, and are basted and pressed. The wrong side of this facing is then placed to the wrong side of the gore with the end having the raw edge at the top of the placket and with one turned-in edge close to the notched or overcasted raw edge of the seam allowance. It should be basted in place and pressed and stitched close to its turned-in edges.

(a) *Possible Changes in Making the Left Side.*—There are various other methods of facing this side of the placket.

If the material of the skirt ravels or frays easily the facing is sewed on to enclose its raw edge. This is easily done. The raw edges of the facing are not turned in; the facing is placed to the edge of the placket-seam allowance, with its right side to the right side of the material, and stitched. It is then turned to the wrong side and basted along the turning, its raw edges are turned in except across the top, and it is basted flat to the skirt.

If the material is firm a piece of Prussian binding is frequently all that is necessary for a reinforcement. It is placed under the sewing line of the fasteners to give the necessary firmness. It may be stitched along both edges or it may be temporarily basted in place and later held by the sewing on of the fasteners. This is a matter of choice. It should not be stitched unless the stitching is entirely covered by the tuck on the upper edge of the placket.

(*iv*) *Finishing the Placket.*—If the seam allowance on the gore edges is exactly 1″, as directed, and the tuck is ¾″, one row of stitching on the left or under side of the placket—the row nearest the joining seam-line of the gores —should fall, when the placket is closed, exactly in line with the edge of the facing basted ½″ in from the edge of the tuck on the right or upper side of the placket. If it

does not, the work has not been accurately done and must be corrected. These two lines serve as guides for the fastenings, and unless they fall together the placket will not fasten well. If they are correct the gores of the skirt should be permanently joined by completing the stitching of the tuck along its seam-line. This stitching should be a continuation of the 14″ of stitching already done the length of the placket.

The placket should be correctly closed and pinned to hold it in place while the stitching is done. If the stitching begins 1″ or 2″ above the end of the 14″ of stitching it makes a neat joining; it also includes both facings and gives a firm finish to the end of the placket. After stitching, both the seam and the placket must be well pressed, as the pressing cannot be done as thoroughly after the fastenings are sewed on. If sufficiently long ends of silk are left when the stitching is started they may be drawn through to the wrong side and used for a row of catchstitching across the end of the placket through the two facings to hold them together. These stitches must not be taken through to the right side of the skirt.

Hooks and peets or snaps are used to fasten the placket. If a skirt fits very closely, hooks and peets are frequently found more satisfactory as they are less likely to unfasten. Each side of the placket should be marked for the fastenings before any are sewed on. The hooks or the snaps are placed about 1¼″ or 1½″ apart. The first one should be at the very top of the placket; its location may be marked, but it should not be attached until the belt of the skirt is adjusted.

If hooks are used they should be spread slightly to prevent their pulling out of place. As the placket fastens from right to left, the hooks are sewed to the right side of the placket. The basting which holds the facing to the tuck is removed and the hooks are sewed with twist to the stitching-line of the tuck. Stitches should also be taken across the shank of the hook near the end. All these stitches are covered by the facing which, after the fasteners are attached, is slipped back into place under the

ends of the hooks. It is held by hemming, which should begin about ¾″ down from the top. This end of the facing must be left free to finish the top of the skirt after the belt is put on. The facing comes just to the end of the hooks and makes a very neat finish. If snaps are used, some of the stitches which attach them should be taken into the line of the stitching to keep them in place.

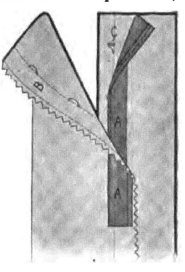

The peet, or the other half of the snap, is sewed to the line of stitching which holds the facing on the left side of the placket. If Prussian binding has been used and there is no stitching, the exact position of the fasteners must be tested by closing the placket. If the fasteners are not correctly placed an otherwise well-made placket is spoiled and the fit of the skirt is changed.

Tailored placket, showing (*A*) facings on right and left sides, (*B*) peets attached to line of stitching, (*C*) hooks spread and attached to line of stitching

(*b*) Plackets which are placed in seams not finished by tucks are frequently stitched for a finish on the outer or upper side. The stitching should parallel the opening line of the placket and be placed at such a distance from the edge that the fastenings may be sewed to it. It may be carried for a finish in a straight or slanting line across the end of the placket. The use of stitching simplifies the finishing of any placket and is generally permissible, although the seams of the skirt are not similarly decorated.

(3) *Plackets for Semi-Tailored and Fancy Skirts Made by Hand or by Machine.*—For all such skirts practically one general method of finishing may be followed; but there is as much variation possible in the details of the finishing as there is variety possible in the styles of the skirts.

In many skirts the style is such and the placket so placed that no facing or reinforcement is necessary; while in others as firm a facing is required as in many tailored skirts, especially if the gores are bias and the material is not firm.

(a) *For Straight or Nearly Straight Edges.*—Very little finishing is necessary for a placket in a skirt which has gathers at the waist. There is no strain on the placket and it is generally concealed in the fulness. The edges of the gores of such skirts are usually nearly straight, and unless the material is easily stretched out of shape no facing is needed. There should be the usual 1″ seam allowance to give material enough for the finishing of the placket. The length of the placket is regulated as in the tailored skirt. Its placing may be determined by the convenience of the wearer or by the position of the waist opening.

The placket is made as follows: Both the seam allowances are turned in the same direction; that is, one edge extends, the other folds back. The folded edge is generally the right one and becomes the upper or outer edge of the placket.

No stitching is necessary along this folded edge as there is no strain on it because of the fulness in the skirt. The fold may be carefully pressed and held in place by the sewing on of the belt.

The finishing is simple; the raw edges are bound with taffeta ribbon or are overcast, according to the material. Binding is usually preferred. Each side should be marked for fasteners; either snaps or hooks and peets are used. The first fastening should be near the top of the skirt as in the tailored placket. Its position may be marked, but it should not be put on until the belt is adjusted.

The fastenings on the upper or outer edge of the placket are sewed to the turned-back seam allowance. In the sewing, stitches should not be taken through to the right side of the skirt. The other row of fasteners is sewed to the extending side of the placket. Unless the material is very firm it is usually more satisfactory to baste a piece of Prussian binding to the wrong side of this and sew the

fasteners through to that. This is especially the case if snaps are used, as the skirt material is easily torn in unfastening the placket.

To strengthen the end of the placket and prevent its tearing down, the two seam allowances should be firmly sewed together across the end of the placket. No attempt need be made to catch them to the skirt. The sewing may be stitching or catch-stitching.

(b) *For Slightly Bias or Very Bias Edges.*—This same finish may be used in many different skirts with slight changes.

(i) For slightly bias edges or for material which stretches. If the outer or upper edge of a placket needs reinforcing to prevent stretching, a piece of wide taffeta binding-ribbon, a lengthwise piece of silk or of thin cambric is slipped into the fold. This is held in place either by sewing the fastenings through to it or, if the seam can be decorated by a line of hand or machine stitching on the right side, by stitching through the facing to hold it firmly in place. The row of stitching may be used for just the length of the placket if it can be repeated on the corresponding skirt seam. It then appears as a decoration, even though the other seams are not finished in the same way.

(ii) For very bias edges. If the two edges of a placket are quite bias they must be carefully stayed to prevent stretching. Such seam edges are frequently found in skirts which are very circular and are cut to have only two gores, a wide front and a wide back gore. A straight piece of silk cut about 1¾" wide and the length of the placket may be used to reinforce the upper or outer edge of the placket. Its straight raw edge is placed to the bias raw edge of the placket and folded over with it. When folded the three edges must not fall together, as they make too heavy a line and show when pressed. If the seam allowance is the usual 1" and the facing is cut as directed, 1¾" wide, there will be no difficulty.

If possible this folded edge should be finished with a line of sewing either by hand or machine through the four thicknesses to give it the required firmness. Running

stitches or stitching placed about $\frac{1}{4}''$ in may be used to simulate a tuck. This should be repeated on the corresponding skirt seam. It then appears as a decoration.

The fasteners—hooks or the upper section of the snaps —may be more firmly attached to the placket if they are first sewed to a piece of Prussian binding which is then hemmed to the placket. Its front edge should be placed along and attached to the line of sewing just made.

The left or under side of either placket may be finished, as already suggested, by placing the Prussian binding to the wrong side along the sewing line of the fasteners.

The edges of the plackets are finished by overcasting or binding. The ends must be carefully stayed by stitching the two seam allowances together.

3. **Attaching the Belt and Finishing at the Waist.**—To simplify the directions for the finishing of skirts at the waist line two general divisions may be made.

(1) Foundation skirts or linings.

(2) Skirts attached to waists and separate skirts, tailored, semi-tailored, lingerie, or draped.

For the finishing of all these certain preliminary steps are necessary—the skirt must be carefully fitted and hung, the seams must be finished, and the placket made. A good waist line must be determined. The required kind of belt must be prepared.

Directions for the fitting and hanging of the skirt and for the finishing of the seams and the placket have already been given and need not be repeated here.

The direction and exact location of the waist line depends upon the figure of the wearer and the general design of the skirt. For foundation skirts and linings the sewing line of the skirt to which the belt or facing is attached is generally at the normal waist line. For skirts which are to be attached to waists the sewing line varies greatly. It may be at the normal waist line or several inches above. The method of attaching is practically the same for all. The majority of separate skirts are finished to extend somewhat above the normal waist line. This is a matter of taste and fashion. In general, a waist line

which is slightly higher at the back than at the front is more becoming than one which has the same height its entire length. The height and direction of the line at the top of the skirt should be chosen for its becomingness rather than to meet the demands of fashion.

When the sewing line of any skirt is determined it is carefully marked by a basting. A seam allowance of $\frac{1}{4}''$ or more is measured above this and the top of the skirt is cut in a good straight line. The exact width of the allowance depends on the kind of skirt and on the style of its finish. The centre front, centre back, and sides of the top of the skirt are marked. Care must be taken to have the two sides of the skirt exactly equal in size and even in height, unless a difference is demanded by some peculiarity in the figure of the wearer.

Belts are of two general kinds—those made of the material of the skirt and seldom used except for foundation skirts; those made of stiff belting and used for practically all separate skirts and for those which are to be attached to waists. Both kinds of belts need some preparation before they are attached to the skirt.

(1) *Finishing the Waist Line of Foundation Skirts or Linings.*—Linings may be finished at the waist in two ways—by using a standing belt or a bias facing.

(a) *Standing Belt.*—Belts made of the material of the skirt are in general use only for foundation skirts or linings. Such skirts are usually made of silk, satin, percaline, and lawn.

(i) *Making the Belt.*—The belt is cut with its length on the length of the material. In width it should be twice the finished width plus $\frac{1}{2}''$ for seam allowances and in length the waist size plus about $3''$. This gives sufficient length for the placket extension, which usually measures from $\frac{3}{4}''$ to $1''$, and a $\frac{1}{2}''$ turning at each end to provide firmness for the fasteners. Such a belt should not be over $\frac{3}{4}''$ in width when finished and may be as narrow as $\frac{1}{2}''$. It is prepared and attached to the skirt in two different ways. For both it should be folded along its lengthwise centre and basted close to the fold to prevent its

twisting. The crosswise centre should be marked, and measuring from that, each way, the correct waist measure should be indicated.

(*ii*) *Attaching the Belt to the Skirt.*—The belt is placed with its right side to the right side of the skirt with the centre marks together and with its ¼″ seam-line to the sewing line of the skirt. This sewing line is usually ¼″ in from the edge of the skirt. The belt is basted in place and stitched along the sewing line. The bastings are removed and the belt is turned up, creased, and basted along the fold. The exact length of the belt may now be determined. It is cut off to have only the ½″ seam allowance at each end. These are turned in, and also the ¼″ allowance along the unattached side; the belt is already turned along its lengthwise centre line and is ready to be basted flat to the wrong side of the skirt along the line of stitching just made. In doing this the centre markings and the two ends of the belt must be matched correctly. The edge of the belt may be hemmed to the skirt and the ends finished by overhanding.

Practically the same effect is secured by the use of another method. More preparation is needed before sewing the belt to the skirt. The folding, basting, and marking are done as for the other and the raw edge along each side of the belt is turned in ¼″ and basted. The skirt is then slipped into the belt so that the lower edge of the belt lies along the indicated sewing line of the skirt and all corresponding markings match. The belt is pinned in place and cut to the required length for the ½″ allowance at each end. These allowances are turned in and the belt is basted to the skirt and across each end and is stitched. The stitching should hold both edges of the belt in place; it may be carried entirely around the belt to make a neat finish.

(*iii*) *Fastenings.*—For such belts two hooks and eyes or two snaps are usually required, one to hold the skirt together at the top of the placket, another to hold the extension of the placket in place. The correct position for all the fasteners must be carefully indicated before any are

sewed on. They should be placed to give the correct size to the skirt and, as well, a neat closing to the belt and placket. Twist is satisfactory for sewing on the fasteners.

(b) *Facing.*

(i) *Preparing the Facing.*—A facing for the top of a skirt must be cut on the true bias. Its width should be once the finished width plus ½" for seam allowances, and in length, like the belt, the waist size plus about 3". The facing should not be more than ¾" wide when finished and may be slightly narrower. Its crosswise centre should be marked, and measuring from that, each way, the correct waist measure should be indicated.

(ii) *Attaching the Facing.*—To attach it to the skirt it is placed with its right side to the right side of the skirt, with the centre marks together, and its ¼" seam-line to the seam-line of the skirt. It is basted and stitched in place. The exact length is determined, the belt is cut off, and the seam allowance turned in. The facing is then turned over to the wrong side along the line of stitching and is creased and basted close to the fold. Its raw edge is turned in ¼" and basted flat to the skirt. Stitching or hemming may be done to hold the edge in place and the ends may be overhanded. In general, it is better to stitch entirely around the facing; it gives a flatter finish.

(iii) *Fastenings.*—The fastenings for a skirt finished with a facing are the same as for one with a standing belt. One fastening is needed at the top of the placket and another to hold the extension of the placket in place.

(2) *Finishing the Waist Line of Separate Skirts and of Skirts Attached to Waists (Tailored, Semi-Tailored, Lingerie, and Draped).*

For practically all such skirts stiff ribbon belting is used, as it keeps the skirt in place and does not lose its firmness when worn. Some lingerie skirts are an exception to this. The belting may vary in width from ¾" to 3½". It should be prepared before being attached to the skirt.

The finishings for the separate and attached skirts are of two kinds: (a) Those which are not decorative and are usually concealed by additional belts and girdles of the

same or contrasting material. (*b*) Those which are decorative and are not concealed by additional belts or girdles.

(*a*) *Non-Decorative Waist Finishes (Tailored, Semi-Tailored, Lingerie, and Draped Skirts).*

(*i*) *Skirts Which Are Attached to Waists.*—The belt which is used to join a waist and skirt may be of any width; it is frequently sufficiently wide to form a kind of girdle. It is usually shaped by the use of darts, and it may also be stiffened by the stitching on of several strips of featherbone which should extend from edge to edge. The lower edge of the belt falls at the waist line and the skirt is attached to its right side in the desired position, which should be determined in the fitting. Its position should not be the same as for the waist, as that gives too many thicknesses of material in one line. The skirt is attached by hand or by machine. The sewing must be sufficiently strong to stand not only the weight of the skirt but any unusual strain to which it may be subjected.

The skirt may be basted to the belt, matching all corresponding markings, and its edge covered by a piece of taffeta binding-ribbon, which, if stitched at each edge, makes a neat finish as well as a firm one. If taffeta binding-ribbon is not used the skirt may be sewed by hand or by machine and its raw edge held in place by a row of catch-stitching. The finish must be flat, and all extra thickness from unnecessary material must be avoided, as a fancy girdle or belt is to be added later.

Belts for lingerie dresses frequently differ from those just described. The waist and skirt may be joined by a belt made of the material. This should be double and the two strips should be cut separately, as the raw edge of waist and skirt are to be enclosed. The two strips should be cut on the lengthwise of the material the required length plus $\frac{1}{2}''$ for seam allowances and the desired width plus the same seam allowances. They may be attached in various ways.

They may be basted together through their lengthwise centre, a $\frac{1}{4}''$ turning may be made around each, and the skirt and waist may be slipped in and stitched; the stitching should extend around the entire belt.

The skirt may be placed between the two lengthwise bands, with raw edges together, and basted and stitched. The waist may then be stitched to the other edge of the band which forms the right or outside of the belt. When this seam is turned to the belt and basted, the raw edge of the inside belt is turned in and basted flat along the stitched line. This may be hemmed in place and the ends of the belt overhanded. By this second method no stitching shows.

(*ii*) *Separate Skirts.*—The separate skirt is sewed to a belt in practically the same manner as just described for the skirt which is attached to a waist. Its exact position is determined in the fitting, and all the necessary finishing is done as neatly as possible, although, when worn, it is to be covered.

(*b*) *Decorative Waist Finishes* (*Tailored, Semi-Tailored, and Lingerie Skirts*).

(*i*) *Separate Skirts.*—These are generally more difficult to finish than the attached skirt and are consequently given first.

The majority of tailored and semi-tailored skirts have a slightly raised waist line. The finishing of a skirt of this kind should be very carefully done, as belts and girdles are seldom worn and it in consequence forms a part of the decoration. The finishing of all tailored skirts with the raised waist line is much the same. There is usually a row of stitching near the top of the skirt to which is attached a standing belt placed inside the skirt to hold it in place. The row of stitching gives firmness but is not necessary and does not affect the general method of procedure.

The width of the belt is determined by the height of the skirt above the waist line, as one edge of it is placed about ⅛″ down from the top of the skirt and the other falls just at the normal waist line. While the belt need not be tight, it should fit the waist sufficiently close to hold the skirt in to the figure at the top and keep it in its proper position. The belt is cut and made according to directions given above.

The line for the top of the separate skirt is of greater

importance than for any of the others; the skirt should
be put on, the placket should be fastened, and the skirt
settled into its proper position. The turning or sewing line
should be distinctly indicated, the skirt should be removed,
and the line marked by a row of basting. Although a line
may have been indicated when the skirt was cut and
marked, its direction is easily changed during the necessary
fitting and making, and it should not be used until tested.
The seam allowance necessary beyond this turning line de-
pends on the finish. It should not be less than ⅜″. After
the seam allowance is carefully measured the extra ma-
terial should be cut off to give an even edge.

To finish the top of the skirt it is to be turned to the
wrong side exactly on the indicated turning line and
stitched. The details in this finishing may vary some-
what. A facing or reinforcement may or may not be
placed in this turning. Its use is determined by several
factors. If the material is firm or heavy and the worker
experienced, the turning can probably be made and stitched
without stretching the edge. If the worker is inexperi-
enced or the material has a tendency to stretch out of
shape easily, the facing or reinforcement is of assistance
in maintaining the correct shape and size of the top of the
skirt.

The facing is cut a true bias, about 1″ in width and of
the required length. Thin material, such as silicia or cam-
bric, is used to avoid a clumsy fold. It is necessary to
shrink the facing, otherwise it will pucker when wet or
dampened in the subsequent laundering or pressing which
the majority of tailored skirts require. The facing is at-
tached before the top of the skirt is turned. It is placed
to the wrong side, with its raw edge to the raw edge of the
skirt, and is basted, without stretching or fulling, along the
line of basting which indicates the turning line of the skirt.
If the facing is not held securely in place along this line it
may not turn evenly with the skirt. If the seam allow-
ance of the skirt is ⅜″ and the facing is cut, as directed,
1″ in width, the two edges of the facing will not fall to-
gether when the turning is made. The facing should al-

ways be of such a width that the turning will not lie exactly at its centre. If its two edges fall together they may be of sufficient thickness to make a line or mark on the skirt when it is pressed. The facing should extend from one placket facing to the other. If it extends over these facings it makes the top of the skirt clumsy. When the facing is once attached its use does not change in any way the subsequent steps required in the finishing of the skirt.

The top of the skirt is turned over along the indicated line, is basted flat close to the folded edge, and pressed. The placket extension on the left side of the skirt should be included in this turning, but the facing of the right or upper side should not be. In making the right side of the placket one edge was not hemmed but was left free ¾" at the top. To make a neat finish the other edge must also be

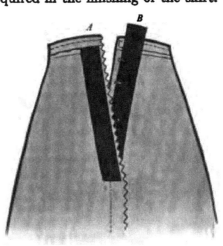

Tailored placket, showing (*A*) edge of skirt turned and stitched; (*B*) end of placket free for finishing at the top

freed. It may be slit down about ¾" along its edge just under the fold so the slash will not show. The end of the facing is then perfectly free and can be brought up over the raw edge of the skirt turning, to cover it.

Before the folded edge of the skirt is stitched or finished in any way it should be carefully inspected to see that it is absolutely straight. The skirt is then ready for stitching and for the sewing in of the belt. There are two methods of doing this.

(a) The skirt may be stitched by machine and the belt may then be hemmed by hand to the line of stitching.

The stitching is done by machine around the skirt the

required distance from the edge. If a facing is not used great care must be taken not to stretch the edge of the skirt. The stitching, like the basting, includes the facing on the extension or under side of the placket but leaves free that on the upper or outer side.

The belt is already prepared. It should be placed in the dress so that the hooks and eyes are next the wearer. If the hooks and eyes have been sewed on correctly the two ends of the belt meet when fastened; and if the measuring and making have been carefully done the belt and the skirt, when the placket is properly closed, are of the same length. The top of the belt and the skirt are not the same size. The skirt is necessarily the width of the placket extension longer than the belt, as the two ends of the belt meet when fastened, while one side of the placket laps over the other.

Inside of finished skirt, showing belt and placket closed

The belt should be pinned in place—matching all cross-marks—with its upper edge just at the line of stitching. The end of the belt to which the eyes are sewed should be placed to the left or extension edge of the placket, with the edge of the extension and the end of the belt together. The pinning should begin at this point, and the belt should be just long enough to extend around the skirt and to meet and fasten at the edge of the placket extension when the placket is closed. (In the tailor placket described above

the belt comes just to the edge of the facing of the upper or right side of the placket.) If the placket and the belt do not come together exactly they must be altered until they do. When they are correct the belt is basted in place and sewed permanently. In basting, the work should be held over the hand, with the skirt toward the worker, to ease it to the belt. It should then be firmly finished by hemming along its top edge to the line of stitching. The stitches should not be taken through to the right side of the skirt. The lower edge of the belt is left free. When the hemming is done the top of the skirt is finished, except for the right side of the placket, which extends beyond the belt and is not covered by it. If the placket facing is brought up it will cover nearly all of this. The raw edge of the facing is turned in the required amount to bring it in line with the upper edge of the belt. It is then hemmed to the skirt as was the belt.

In sewing on the fasteners for the placket the position of the top ones is always indicated but they are not attached until the belt finish is made. If there is a tuck of any width on the upper side of the placket it is usually better if the top hook is sewed on, not in line with the other hooks, but nearer the edge of the tuck.

If any of the folded-over raw edge of the skirt is not covered by the right placket facing, as it will not be if the tuck is wide, the hook may be sewed on to cover this raw edge. It serves as a finish for the edge and is also in good position to keep the tuck flat and in place at the waist line. It may fasten to a loop of twist or to a peet placed in the required position on the other side of the placket. As this hook is not covered, if it is sewed on with the buttonhole stitch a neater and stronger finish is given.

(b) The belt may be stitched to the skirt by machine. This method requires only one sewing to finish the top of the skirt and to attach the belt to it.

The belt is pinned and basted to the skirt as already directed. Its top edge should be placed a small $\frac{1}{16}''$ above the line indicated for stitching. This allows the worker to stitch just inside the corded edge, which nearly all stiff

belting has, and makes it less difficult to keep a straight line in stitching. Only this corded edge of the belt must be allowed to project above the stitching line, as the top of the skirt when worn may turn back slightly and the belting may show. The skirt should be eased to the belt when the basting is done and should fit as described above. All the finishing after the belt is stitched on is the same.

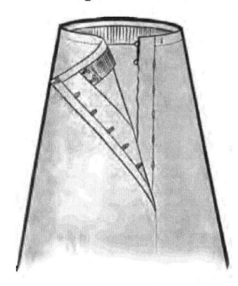

Right side of skirt, showing placket and belt entirely finished

The first method is by far the safer and better, especially for the inexperienced. The combined thickness of the skirt and belt make good stitching difficult; and if the stitching is not straight and the stitches of good size the top of the skirt will not look well. (The majority of tailors stitch belts in by machine, as the process is quicker.)

The distance from the edge at which the stitching is placed may vary somewhat; the usual widths are from ⅛″ to ¼″. If the stitching is too far in, the folded edge may roll over and stand away from the figure. The stitching must go entirely around the top of the skirt an even distance from the edge.

(*ii*) *Skirts Which Are Attached to Waists.*—The tailored and semi-tailored skirts are finished at the waist line much as are the separate skirts. There are a few necessary differences; there may or may not be a belt. If one is used it is prepared as directed above and the waist is attached to it. The use of the belt does not affect the preparation of the skirt. The line at the top is determined and plainly

marked; the facing, or reinforcement, is placed from placket finish to placket finish and is basted to be included in the turning; the turning is made, basted, and pressed.

There are two methods of attaching the skirt after it is carefully prepared; that is, it may be stitched first entirely around the top and attached by hand to the belt and waist or to the waist; it may be basted to the waist and the stitching may be made through both the waist and the skirt. The method chosen should depend largely upon the thickness of the material, as to the ease with which it may be handled, and on the skill of the worker.

Lingerie skirts are frequently joined to waists with decorative finishes which are not suited to any other style of skirt. These finishes usually include the joining by hand of bands of lace, embroidery, or *entre-deux* to form a belt to attach the skirt and waist. If these belts or girdles are shaped—they are frequently made on flat-paper patterns designed for the purpose—their making is a sewing problem and need not be discussed here.

4. **Finishes for the Bottom of Skirts, the Edges of Tunics, Overskirts, Flounces, etc.**—The finishes for foundation skirts or linings are discussed separately, as they require somewhat different treatment. (1) Finishes may be made in different ways, according to the design of the skirt, by the use of (a) hems, (b) facings, (c) bindings, (d) cordings and pipings, (e) machine hemstitching, (f) rolling and whipping, and (g) thin linings for the entire skirt.

Before any finishing is done the skirt must be carefully hung and its turning line at the bottom must be plainly indicated. Any surplus material beyond the hem and finishing allowance should be cut off and a straight edge should be made. Generally, skirts are cut to be an even distance from the floor. Fashion occasionally suggests, however, the use of points, scallops, or curving lines.

Hems and facings are more generally used than any of the other suggested methods, as they are suitable finishes for practically all styles of garments and for all kinds of materials.

A hem can be satisfactorily made only on a straight

edge; a facing, however, may be used with equal success on a straight or a shaped edge.

(a) *Hems.*—Hems may be made by many different methods and may be finished on the right or the wrong side

of the skirt. For convenience they may be divided into plain and fancy hems.

(i) *Plain Hems.*—These may be made with one or two turnings, according to the material of the skirt. The turning of the material to the wrong side to form the hem is done in the same way for all. The skirt is turned along the indicated line and its folded edge is basted and pressed. The edge line, except for some silks, should be straight and sharp.

Plain hem with turned-in edge, machine-stitched

(a) *A Hem with Two Turnings.*—The allowance for such a hem is the finished width plus ¼" for the turning in of the raw edge. The ¼" is turned in and basted flat to the skirt. It may be hemmed invisibly by hand or stitched by machine. A final pressing should be given and all bastings should be removed. This kind of hem is suitable in hand and machine made garments in practically all materials.

(b) *A Hem with One Turning.*—The allowance for a hem with one turning is the required width of the hem with little, if any, additional material for finishing the raw edge.

Plain hem with raw edge, catch-stitched

The raw edge may be finished by catch-stitching or binding. Catch-stitching attaches the hem to the skirt, encloses its raw edge, and prevents any

ravelling. It is frequently used for soft wool material like broadcloth. (Catch-stitching is a sewing stitch and requires no explanation here.)

Binding is done with taffeta ribbon, Prussian or bias binding. Taffeta ribbon should not be used in skirts which are to have hard wear. Prussian binding is generally easier to handle than bias binding and makes a finish which looks and wears well. Bias strips of cambric may be used if Prussian binding cannot be procured. Any binding should be shrunk before using. They may all be attached in the same way.

Plain hem with raw edge covered with Prussian binding

The hem is turned the required amount, is basted and pressed. One edge of the binding is then stitched to its raw edge about ⅛" in and the other edge is attached to the skirt by hand hemming or machine stitching. The hem is pressed and all bastings are removed. Such hems are in general use in materials which are heavy and which require frequent pressing. If a folded edge is used the line of the top of the hem shows plainly on the right side when pressed.

Nearly all hems at the bottom of skirts have surplus fulness at the upper edge which must be taken care of in some way. Extra thickness makes a hem clumsy and when the hem is pressed it usually causes creases or shiny spots on the right side. In all tailored or semi-tailored skirts this fulness is removed by shrinking.

The skirt is turned along the indicated line and its folded edge is basted and pressed. A line of running stitches is placed at the edge or top of the hem to hold the fulness in evenly and make the edge the correct size. The hem is then turned back from the skirt, covered with a damp cloth, and pressed with a hot iron until the fulness

is removed by the shrinking, which is caused by the dampness and the heat. The iron must not be pushed back and forth or up and down, but must be lifted from place to place to prevent any stretching of the material. Such hems usually have one turning. Their raw edges are finished with catch-stitching or binding.

In thin material and in those which cannot be shrunk the fulness may be arranged by gathers or plaits to give a flat hem. For the gathers the line of running stitches is made and the fulness arranged to make an even hem. When the fulness is removed by plaits there should be several small plaits properly placed rather than a few large ones. With several small ones it is easier to keep good lines at the edge of the skirt and at the top of the hem. Plaits should not be placed too near or on the skirt seams, as they then give too much thickness in one place. They should be at right angles to the hem.

(*ii*) *Fancy Hems.*

(a) A straight edge may have a hem turned to the right side and finished to give added decoration to the skirt. The raw edge may be turned in and stitched or it may be turned in and finished with cording or piping. The cord may be included in the second turning of the hem or it may be made separately and joined. Such a finish is generally used for soft materials, like *crêpe de chine*, which have no definite right or wrong side.

(b) A hem may be turned once to the wrong side and its raw edge finished by a row of machine hemstitching. This is a satisfactory finish for many thin materials; it wears and launders well.

(c) A hem may be turned to the wrong side and hand hemstitched. This can be done only on the hems of thin cottons, linens, and chiffons which are turned on a straight thread, as threads must be drawn for the work.

(*b*) *Facings.*—Facings are applied to the wrong side of the skirt. They are, in general, used on edges which are too shaped to permit the turning of a hem. Facings are more frequently seen in semi-tailored, in fancy, and in draped skirts than in those which are strictly tailored.

(c) *Bindings.*—Bias bindings are used to give a decorative finish to edges. They are more frequently seen on the edges of skirts which have flounces, overskirts, or tunics than on the bottom edge of plain skirts.

(d) *Cordings and Pipings.*—These finishes are not suitable for tailored skirts and are generally not used in those which are made of the heavier materials. For soft silks and chiffons the cordings frequently serve to give weight as well as decoration to the edges. In general, cordings and pipings are not satisfactory in garments requiring constant laundering.

(e) *Machine Hemstitching.*—Machine hemstitching is used for thin materials. It gives an edge which is attractive and strong without the use of extra material, much skill or time. It requires a special machine.

(f) *Rolling and Whipping.*—This finish, like the machine hemstitching, is used for thin materials. It gives a firm and attractive edge. After skill is acquired in its making it may be quickly done.

(g) *Linings.*—Linings are sometimes used in elaborately draped afternoon and evening dresses. They are of thin materials, usually chiffon or net. They give additional weight to the dress material and make the finishing of edges easier.

(For details in making fancy hems, facings, etc., see *Finishings.*)

(2) Foundation skirts or linings are usually finished at the bottom in a somewhat different way from those given above. Their finish depends upon the general design. Linings may be made as follows:

(a) They may be cut the full length and may be finished with a hem sewed by hand or machine.

(b) They may be cut the full length and may be finished with a hem and with a ruffle or side plaiting which is set up on the skirt rather than attached to its edge. These may be finished and attached to the skirt with (i) a bias fold stitched flat at each edge or with (ii) a tuck for which an allowance of twice its width must be made in the cutting of the skirt. The tuck must be carefully placed; its

lower edge when stitched flat should cover the sewing line of the ruffle.

(c) They may be cut several inches shorter than the finished length and have the edge finished with a ruffle or plaiting. These may be attached, as when set on, by a bias fold or a tuck. In making the tuck twice the width of the tuck plus the seam allowance is required. The tuck is made; the ruffle is attached to the skirt with the seam to the right side; the seam is then turned up under the tuck, the lower edge of which is stitched flat to cover the row of stitching just made.

(d) They may be cut about three-quarter length and have a circular flounce added to give the required length and fulness. This flounce may be cut (i) from a commercial pattern, (ii) from a circular skirt draft, or (iii) by using the bottom of the pattern from which the skirt top was cut and slashing it to give the fulness as directed under *Designing*.

The circular flounce may be attached to the skirt by a bias fold or by a tuck. It may be finished at the bottom by a plain hem.

CHAPTER X

FINISHINGS AND EMBROIDERY

I. Finishings

It is not possible to give many definite rules for dress finishings because there is from time to time such a great difference in their use and in the methods of their making. These differences are due to the constantly changing demands of fashion, which require at one time decorative finishings and fastenings and at another those which are practically invisible. An effort is made here to give suggestions for the finishings which are discarded so seldom as to be in almost constant use.

Finishings must be chosen according to the general design of the costume; that is, according to the cut of the garment and the material of which it is made. For instance, in chiffons such finishings are generally used as are decorative, since it is practically impossible, because of the thinness of the fabric, to make them invisible. In such non-transparent material as broadcloth and serge, invisible finishings of edges and seams are possible. In many cases, however, tailored finishings, which generally include decorative stitchings, are used.

To simplify the suggestions given here, finishings are divided as follows:

(1) Seam Finishes.
(2) Edge Finishes.
(3) Fastenings.
(4) Decorative Ways of Securing Fulness.
(5) Decorative Methods of Finishing Plaits, Stitching, Buttons, etc.

1. **Seam Finishes.**—In making any seams there are a few general directions to be remembered.

Pinning.—Before basting a seam the tracings and corresponding markings should be matched and the seam should be pinned its entire length.

Basting should always be on the traced seam-lines. The bastings should be removed after the seam is stitched and before any other finishing is done. In removing them the stitches should be cut at close intervals and the short threads pulled out. There is less chance of injury to the material if these directions are followed.

Stitching, by hand or machine, should be placed not on the basted line but as close to it as possible and just outside. This makes the removing of the bastings a simple matter, and, as stitching is much firmer than basting, it does not change the size of the garment.

Pressing.—After a seam is stitched and the bastings are removed it is pressed. The exact manner of pressing depends on the kind of seam; some finishings require a flat, open seam, others a closed one. In pressing open a plain seam preparatory to certain kinds of finishings, if the seam is curved, it is often easier to manage if the seam-line is pressed over the curving edge of the ironing-board rather than, as is usual, on its flat surface. The pressing of curved seams is also much simplified if their edges are given more spring by notching.

The seams in general use in waists and skirts are:

(1) *Plain Seam*, which is made by hand or machine and is suitable for all materials.

This seam is more quickly made than any other, but additional time is required in the finishing of its raw edges. The method of making is very simple. The pinning, basting, and stitching are done on the wrong side. The bastings are removed and the seam edges are cut ½″ or ¾″ in width. They are pressed either open or closed, as required by the finish.

If it is necessary to notch a seam because of its curve, the notches should be placed where the curve is greatest. They should not be too deep; if they are cut to within ⅛″ of the stitching they usually give sufficient spring to the edges of the seam. The corners of the notches should be

rounded off to give a better appearance and to make the finishing of the seam easier.

(*a*) *Finishes for the Wrong Side.*—The raw edges of a plain seam may be finished in various ways.

(*i*) *Pinking or Notching.*—This is the simplest method of finishing, but it can be used only for very firm materials which do not fray in wearing.

(*ii*) *Overcasting.*—This is frequently used, as it wears and launders well. Unless carefully done it does not make as neat a finish as binding. The stitches should be closely and carefully made to keep the edges from fraying. Overcasting gives less thickness to the edges than does binding, a fact which is of importance in garments requiring frequent pressing. The two edges of a seam may be overcast separately or together.

(*iii*) *Binding.*—Taffeta binding-ribbon makes a satisfactory finish for seam edges. The ribbon should be folded lengthwise and should either be creased with the fingers or pressed with an iron. The fold thus made should not be in the exact centre of the ribbon, and when the seam edge is slipped into it the extra width should be at the back of the seam or away from the worker. If held in this way it is easier to include both edges of the binding in the sewing. The ribbon should be eased on, so that the seam edges are not drawn, and should be sewed with the running stitch. The two edges of a seam may be bound together or separately. A bound seam does not launder well, as the silk binding-ribbon soon yellows. It sometimes makes too thick an edge for garments which require frequent pressing.

(*iv*) *Turning in the Edges.*—This finish may be used to make an open or closed seam. For either it is attractive and may be quickly done. The seam edges should be about ½" in width.

(a) *For an Open Seam.*—The seam is pressed open, the raw edges are turned in to the wrong side toward the gar- ment, ⅛" to ¼", and are held in place by running stitches which must not be caught into the waist itself. This finish, like overcasting, gives less thickness to the edges than binding and is more quickly done. It is not very satisfactory

for heavy materials nor for those requiring frequent laundering.

(b) *For a Closed Seam.*—The two edges of the seam are pressed together, their raw edges are turned in evenly, to the inside, and held together by running stitches. This encloses the raw edges as does the French seam. In general it is much more satisfactory for dressmaking than the French seam. In making it the stitching is done along the seam-line and the original shape and size of the garment is easily maintained. In the French seam the first stitching is not on the seam-line, and if its distance from that line is not successfully gauged the second stitching may not be properly placed. This seam may be satisfactorily used in wash waists and in any style of waist not requiring a tailored finish.

(b) *Finishes for the Right Side.*—Added decoration may be given the plain seam by rows of stitching on the right side. The stitching must parallel the seam-line. The number of rows used—that is, one or two—and their exact location may be determined by the taste of the worker. There must be the same number on each side of the seam. The seam is pressed open after it is stitched. If one row of decorative stitching is used the seam allowance should be such that but little of the raw edge projects beyond the stitching. The raw edges may be finished by overcasting.

If another row is added the seam allowance must be sufficiently wide to allow this row to be the required distance from the first. The raw edges may be finished as with one row of stitching. To make an attractive seam the rows of stitching must be absolutely parallel and well spaced. Such a finish is used only in tailored garments.

(2) *Fell seam*, which is suitable for linings and for machine-made garments. This is a flat seam stitched to the right side of a garment. It is simple to make and when well made is extremely neat in appearance and satisfactory for pressing and laundering. The seam is basted and stitched along the seam-line with the raw edges to the right side. It is cut to be a little less than ½″ in width, is turned and pressed toward the front of the garment, and is then

basted flat, close to the line of stitching. This basting keeps it in place and prevents any twisting. The under or inside edge of the seam is again cut, this time to make it less than $\frac{1}{4}''$ wide, and the outer edge is folded over to enclose the narrow inner one. When the folded edge is perfectly straight the seam is basted once more, flat to the garment along this folded edge, and is stitched. This gives a seam about $\frac{1}{4}''$ wide stitched at each edge. It can easily be seen that if the two lines of stitching are not parallel or the edge is not neatly folded the seam will not be attractive. This seam is not satisfactory in a hand-made garment; its purpose is to give a tailored effect which, to be successful, requires machine stitching.

(3) *Well seam*, which is suitable for machine-made garments. This seam, like the fell, is flat, is simple to make, and launders well. It is frequently used and is especially good in heavy materials. Unlike the fell, it is made on the wrong side of the. garment.

. A plain seam is made on the wrong side of the material and is cut to the required width, about $\frac{3}{8}''$. It is turned toward the front of the garment and basted flat, close to the line of stitching, to keep it in place and prevent any twisting. It is then stitched about $\frac{1}{4}''$ away from the first stitching and parallel to it. This is the only row of stitching which shows on the right side. The edges of the seam, although raw, may be kept from fraying by the stitching, or they may be overcast.

(4) *French seam*, which is not a generally satisfactory dressmaking finish. It may be used for lingerie waists and skirts. It should not be used for any garments which are strictly tailored. It does not give a tailored appearance; it is not flat and there is no stitching on the right side. In many cases the French seam is found to be unsatisfactory. If the material used is heavy the seam will be clumsy; if the seam is very much curved it will draw; if the second stitching is not correctly placed the size of the garment will be changed.

The basting is done along the seam-line with the seam to the right side. The first stitching is nearly $\frac{1}{4}''$ away,

toward the raw edge, from this basting. The edges are cut close to the stitching and the bastings are removed. The seam is turned to the wrong side, is creased to form a fold along the line of stitching, and basted. The second stitching should be exactly on the original seam-line tracing so that the size of the garment will be unchanged. The French seam is more used for underwear than for the finishing of dresses.

(5) *Lapped seam*, which is suitable only for tailored garments. It is finished, according to the material, with raw edges or with turned-in edges.

(*a*) The lapped seam with raw edges is very satisfactory for heavy materials which do not ravel. It is most frequently used for wools. The sewing line must be plainly indicated and the two seams must be cut the required width with clean, straight edges. These edges are lapped with one raw edge to the right side and one to the wrong. Their seam-lines must lie exactly together, otherwise the size of the garment will be changed. After the seam is pinned it should be basted along the seam and also along the raw edges. If the edges are not carefully basted the material may push out of place, or the edges may be stretched, in the stitching.

The first row of stitching is done close to the raw edge on the right side; the other is frequently placed exactly on the seam-line, but its position may be a matter of taste. The raw edge on the wrong side may be cut rather close to the stitching or allowed to extend and be finished by overcasting or binding.

(*b*) The lapped seam with turned-in edges is made in much the same way. It may be used for a variety of materials but is not satisfactory for the very heavy ones. The edges of the material are carefully cut and lapped with the seam-lines placed together. After pinning and basting along the seam to hold the material in place, the raw edges on both the right and the wrong side are turned in an even amount and basted flat. They are then pressed and stitched close to the turned-in edge. The edges must be turned and stitched to make straight, parallel lines, otherwise the seam is very ugly.

(6) *Slot seam*, which is suitable for machine-made garments, especially skirts. It is frequently used to give a decorative finish to the centre-front seam of a skirt. It is also very good for a circular skirt which has a seam over the hip in which two bias edges come together. It prevents the sagging of the seam. It is generally used in tailored and semi-tailored skirts.

The two seam-lines are placed together as in the making of a plain seam. They are basted with short stitches, but not stitched, and the seam is pressed open. A piece of material cut on the lengthwise straight, the length of the seam, and nearly wide enough to extend from edge to edge of the seam allowance, is required. Its lengthwise centre is indicated by a basting, and it is pinned and basted flat to the back of the seam just made. It should be basted at the centre and along each edge, with its lengthwise centre basting directly along the seam-line. It is then pressed, to make it lie perfectly flat, and is carefully stitched. There should be one or two rows of stitching each side of the seam-line. The first should not be too far away from the seam, otherwise, when the bastings which hold the seam together are removed, the tuck formed by the folded edges will be too wide and stand away from the skirt too much. After all the bastings are cut and removed the seam should again be pressed. '

In finishing this seam on the wrong side the edges of the applied piece and of the seam allowance may be allowed to fall together, or, as suggested, the piece may be cut slightly narrower. If the edges do not fall together they require separate finishing, but when pressed they are less likely to make a line on the face of the material.

(7) *Strapped seam*, which is suitable for machine-made garments. This seam is made in two ways—with a strap having turned-in edges or with a strap having raw edges. It may be used as a finish in many materials and in tailored and semi-tailored garments.

(a) For a strapped seam with turned-in edges the two seam-lines are placed together and stitched with their raw edges to the right side. The strap to be applied is in general cut on the lengthwise straight thread but may, for

special reasons, be cut on the crosswise or the true bias. It is cut the length of the seam and wide enough to give the desired finish plus an allowance for turning in. Very little seam allowance should be left on the skirt, and the turnings of the strip should be of such width that there is no overlapping of their edges with those of the skirt, otherwise the seam will be very clumsy. The edges of the strap should be turned in, basted, and pressed before it is basted to the skirt. In attaching it to the skirt its length-

wise centre should be plainly indicated and placed and pinned along the seam-line of the skirt. It should be basted flat at the centre and also at each

Entre-deux finished with a bound seam

edge to keep it in place for the stitching. It should be stitched rather close to the edge and pressed.

(*b*) For a strapped seam with raw edges the same general method of procedure is followed. The strap to be applied is cut the exact width without seam allowance. Its centre line is marked and it is placed flat to the skirt; it should then be pinned, basted, pressed, and stitched in place. The stitching must be close to the raw edge to prevent any ravelling. This finish is not satisfactory for materials which fray easily.

(8) *Seam finished with entre-deux*, which is suitable for lingerie waists and skirts. There are several methods of finishing by hand or by machine—by the use of French seams, by the use of bound seams, or by rolling and whipping the raw edges. A seam finished by any one of these methods launders well.

(*a*) The French seam has already been described. When used its second line of stitching must be exactly on the seam-line of the waist and close to the edge or cord of the *entre-deux* embroidery, otherwise the seam will be unattractive and the size of the waist will be changed.

(*b*) The bound seam is generally found more satisfactory than the French seam. The seams are basted to the wrong side with the edge of the *entre-deux* to the traced line of the garment; the stitching should be done along this line. The material of the waist is cut away to leave only a narrow edge beyond the stitching and the material of the *entre-deux* is cut about ⅜″ wide. Its raw edge is turned in and it is turned and basted to the line of stitching, thus enclosing the standing edge of the material. It is finished by hemming into the stitching. This seam, like the French seam, which it closely resembles, is standing rather than flat, and no stitching shows on the right side of the garment.

Entre-deux finished by rolling and whipping the seam

(*c*) Rolling and whipping are used for fine materials. The material of the waist should be held firmly in the right hand and rolled against the first finger of the left hand with the thumb. The raw edge of the *entre-deux* should be trimmed to within ⅛″ of its cord and overcast closely to the roll of the material working from right to left.

(9) *Seam finished by machine hemstitching*, which is suitable only for thin materials, such as chiffon, net, or crêpe. It requires a special machine and consequently cannot be generally used. It is both strong and decorative. It requires no preparation except the basting together of the two pieces to be joined and no finishing except the cutting off of the raw edges close to the line of stitching.

(10) There are two additional methods which are particularly suitable for thin materials, such as fine net, chiffon, or Georgette crêpe, when (*a*) a finish is required which is, as far as possible, invisible or when (*b*) the finish is made to appear a part of the decoration of the costume.

(*a*) A seam shows very little if it is joined by machine stitching or by running stitches and its edges are cut close and whipped together to form a small roll. If the seam is

machine-stitched, fairly thick paper is used in the stitching to prevent any drawing along the stitched lines. For all thin materials a machine should be regulated to have a medium stitch and a loose tension.

(*b*) For decoration, two edges of a seam may be turned in and joined by fagoting. This requires time, as it is done entirely by hand. There are three different kinds of fagoting which may be used, the plain herring-bone stitch, the Indian herring-bone stitch, and the straight fagoting stitch. Directions for making these stitches are given under *Embroidery*.

2. **Edge Finishes.** The edge finishes in general use are: (1) *Hems.*—(*a*) The usual methods of making hems are: (*i*) With two turnings to the wrong side and the hemming done by hand. This hem is suitable for all materials and for hand and machine made garments. (*ii*) With two turnings to the wrong side and the hemming done by machine. This hem is suitable for all materials and for machine-made garments. (*iii*) With two turnings to the right side and the edge finished with a row of stitching or with piping or cording (see *Cordings and Pipings*). (*iv*) With one turning to the wrong side and the raw edge finished by catch-stitching, binding, or machine hemstitching. Catch-stitching and binding are suitable for heavy materials and machine hemstitching for thin, transparent ones. Directions for making these hems are given under *Waists* and *Skirts* and need not be repeated here.

(*b*) In addition to these usual methods for making hems, there are other finishes which are more decorative and are especially suitable for thin materials.

(*i*) If the hem is turned on a straight grain so that threads may be drawn, it may be finished by hand hemstitching either single or double. (Hemstitching is a sewing stitch and requires no explanation here.) (*ii*) Bermuda, French, and Cuban fagoting somewhat resemble hand hemstitching, but, as they do not require any drawing of threads, and consequently may be done both in straight and curved lines, they are frequently found more convenient than the hemstitching. (*iii*) Various other

embroidery stitches which form single or double rows of decoration at the top of the hem may be made. Those most used are the Portuguese laid work, the outline stitch, the chain stitch, the beading stitch, the feather stitch, and the coral stitch. (*iv*) The fagoting stitches, the plain herring-bone, the Indian herring-bone, and the straight fagoting, which were suggested for the finishing of seams, may all be used to finish edges. They join to the garment, for a hem, a prepared band of the same or other material. Directions for all these decorative stitches are given under *Embroidery* and need not be repeated here.

(2) *Facings.*—Facings are used to finish the edges of waists, sleeves, and skirts. They are cut in two ways, on the true bias or to match the shape and grain of the material to which they are applied.

True bias strips are generally used in waists to face the sleeves, the neck and centre-front openings, any armseye to which the sleeve is not attached, and sections or pieces which have free edges requiring finishing. Shaped pieces are more frequently used in skirts to finish the bottom of the skirt and any free edges of drapery.

Both facings are put on in various ways, by machine or by hand, according to the material used and the shape, placing, etc., of the pieces.

(*a*) The turning edge of the garment is carefully indicated. The facing is cut with a $\frac{1}{4}''$ seam allowance. The seam-line of the facing is placed to the turning line of the garment with the two right sides together and is basted with the facing toward the worker. It should be eased on. The stitching by hand or by machine is done, not on this seam-line, but close to it on the side toward the raw edge. The bastings are removed and the seam is turned to the wrong side. If this turn is made on the indicated turning line rather than exactly on the stitched seam the facing will not show along the edge. It is basted in place along the turning and is pressed. The raw edge of the facing is then turned in and basted flat to the garment. It may be stitched on this edge, if a row of stitching is desired on the right side, or it may be hemmed by hand.

This latter, if carefully done, makes the edge finish invisible.

If a scalloped edge is to be faced the facing is cut to match the edge of the garment in shape and in grain. The facing is placed, basted, and sewed as just described. Before turning it to the wrong side, however, the seam allowance should be slashed all around the curve, and especially at the point between the scallops, to allow the edges to slip by, otherwise the seam allowance cannot lie flat.

(*b*) In facing the edges of irregular-shaped pieces, such as the drapery or the bottom edge of a shaped skirt, a different method is used. The turning line of the piece to be faced is distinctly marked and a generous seam allowance, about 1″, is made. The facing must be cut exactly the same grain and shape and the required width plus seam allowances. The seam allowances of the garment and of each edge of the facing are turned in and basted. The folded edge of the facing is then placed about ⅛″ in from the folded edge of the garment. In basting the facing on, the work should be held over the fingers, with the facing toward the worker, to ease it on. It is necessary to have the facing looser than the outside. It may be blind hemmed at each edge. The materials used affect the details of this method somewhat.

For either method, if the material used for facing were wool or heavy linen, its upper edge should not be turned in but should be finished according to directions already given for hems.

(3) *Linings.*—Very frequently the pieces which form the drapery on skirts and waists are lined throughout. These linings must be cut the correct grain, shape, and size, with seam allowances. The edges of the drapery and of the lining are turned in and the lining is basted in place and its folded edges are blind hemmed or run. Care should be taken to ease the lining to the outside to prevent its drawing. If the draped pieces are large and hang free, the lining may be caught to them by a few stitches in one or two places. Such materials as chiffons, nets, and crêpes are most used for these linings.

(4) *Bias Bindings.*—Bias and straight edges may be bound with bias folds of the same or different material. All bias folds are cut and applied in the same way, with one exception. This one exception is a simulated rather than a true bias fold, which is frequently convenient.

(a) *Bias Folds.*—The material for the folds must be cut absolutely on the true bias, of the required width plus a seam allowance of about ½". The width may be determined in this way. When finished, one-half of the fold shows on the right side, consequently, in cutting, it should be twice this finished width plus a seam allowance for each edge; that is, a ¼" fold requires a strip 1" wide. (The method of cutting a band on the true bias need not be given here, as it is included in all sewing directions.) In sewing bias strips together care must

Bias fold (wrong side)

be taken to have the grain of each strip run in the same direction. It is very easy to piece the strips to give the required lengths and yet have the grain wrong.

The raw edge of the bias fold is placed to that of the material, with right sides together, and is basted. As the bias fold must be eased on, it is held toward the worker. It may be sewed by hand or by machine. Hand sewing is preferable on curved and bias edges; it must be done carefully in either case. If it is drawn or puckered the effect is spoiled.

The unattached edge of the bias fold is turned in and that folded edge is then turned up over the extending raw edges and is basted and hemmed along the line of sewing just made. Great care should be taken in the turning and basting not to draw the material so that the fold twists. The bias fold may be any width desired; if it is to be nar-

row, however—that is, ⅛″ or ¼″ in width—the extending seam allowances must be cut narrow enough to lie flat in the fold. If they are too wide, they will be turned up with the bias and will make a thick edge.

Curved edges or scallops are frequently bound with bias folds. In making these the bias fold should be basted and stitched as when applied to any edge. Before turning the bias to the wrong side over the raw edges, however, the edges should be shaped somewhat; that is, the seam allowance should be made much narrower as it nears the point between every two curves than it is at the greatest depth of the curves. This makes the finishing of the fold at the point much simpler and less clumsy.

Simulated bias fold (wrong side)

(b) *Simulated Bias Folds.*—These are frequently used on the edges of an overskirt or tunic. They are made of the edge of the garment itself without applying an extra piece, and consequently have the same grain. Extra length must be allowed on the material, the exact amount depending, as in the true bias, on the width of the fold. A ¼″ fold requires a 1″ allowance. The fold, to be entirely successful, should be made by hand. If a ¼″ fold is to be made, 1″ of material is turned up to the right side and is pinned or basted along the folded edge. A line of running stitches is then made ⅛″ or ³⁄₁₆″ in from the edge; this sewing forms a tuck on the wrong side. The raw edge of this turned-up piece is turned in to the wrong side ¼″ and is basted. This folded edge is then turned over to the wrong side, enclosing the tuck, and is hemmed to the tuck close to the row of running stitches. This tuck, like the extending seam allowance in the true bias, must not be too wide to be easily in-

cluded in the fold which is formed by turning the material up on to the wrong side.

As in the true bias, care must be taken to prevent the fold from twisting. If the work is held over the finger while the hemming is done, any extra fulness in the edge can be held in and smoothly hemmed to the tuck. The edge of the fold may be left round or pressed flat.

(5) *Cordings and Pipings.*—These two kinds of decoration are made in much the same way and may be used to finish any edge whether bias, straight, or shaped. Both are made of folded strips of material cut on a true bias. The piping, because it has no enclosure, is flat and when pressed has a sharp edge. The cording, because of the fine or heavy cord or

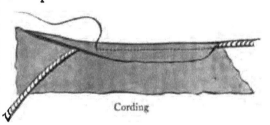

Cording

roll enclosed, is round and firm and adds to an edge not only decoration but firmness. For both, bias strips of material are cut the required width and are joined as in making bias folds.

(*a*) *Cordings.*—The size of the cord used depends upon its place in the garment and the taste of the worker. Small cords are generally better for finishing the edges of the various pieces of waists and skirts, but large ones may be used for the bottom of the skirts. A smooth cord should always be chosen. If one having pronounced twists is used, the twists show even when covered with heavy material, and the covering wears off much more quickly. In making the cording the bias strip may be folded nearly in the centre; that is, with the raw edges about ⅛″ apart to prevent their making a ridge, or it may be folded unevenly with one edge much wider than the other. This latter method is followed when the edge of the wider side is to be finished with a hem and is to serve as a facing for the garment. The cord is sewed into the bias strip in the same manner for both methods. It is placed in the fold and held

there by a row of fine running stitches made as close as possible to it. If the bias is not drawn smoothly and tightly over the cord it does not look well. When the bias strip is to serve as a facing the wider side is finished by having its raw edge turned to the wrong side and run. Before applying cording by any method the turning line of the piece to which it is to be attached must be plainly indicated by bastings, otherwise the finished edge may not be true or the size of the piece may be changed.

Cording is applied in different ways.

(*i*) The line on which the edge of the garment is to be turned is indicated; the sewing line of the cording is placed to this on the right side of the garment with the raw edges together. According to the shape of the garment, all these edges may be bias or one may be straight. The sewing should be carefully done by hand along the line of stitches in the cording. After the cording is attached the raw edges are all turned to the wrong side, along the indicated line of the garment, and are basted and pressed. This leaves just the cord extending. If the cording serves as a facing the narrow side is placed next the garment and the extending side has sufficient width, after its raw edge is turned in and run, to cover all the raw edges of the garment and the cording.

Frequently the garment is lined; if so, the edge of the lining is turned in and blind stitched to the sewing line of the cord. It covers all lines of sewing and all raw edges.

(*ii*) The edge of the garment may be turned to the wrong side before the cord is applied.

(a) The edge of the garment is turned in along the indicated line, is basted and pressed; the cording is so placed as to allow just the cord to extend beyond this folded edge. It is attached by machine stitching or by running stitches. Care is necessary not to take any of the running stitches through to the right side.

(b) After the edge of the garment is turned in, basted, and pressed, it may be stitched about $\frac{1}{16}''$ or $\frac{1}{8}''$ in, according to the general design. This stitched edge is firm and simplifies the attaching of the cording, as the sewing may be

done through the row of stitching. This is the method generally used if a stitched edge is desired. Stitching and pressing the folded edge before applying the cording prevents any puckering and gives a much better finish than is secured if the stitching is done after the cord is basted on.

The cording may be cut and made to serve as a facing or its sewing line and raw edges may be concealed by a lining.

(*iii*) The bias covering of cords is sometimes gathered and put on full. This adds somewhat to the decoration. It is satisfactory for silks, but is not a suitable method for heavy materials nor should it be used in tailored garments. Large, rather soft cords covered in this way are frequently used to finish the bottom of skirts.

The bias strip, because of its fulness, cannot be used as a facing. A facing may be added by hemming

Cording which serves as a facing, applied to a stitched edge

one edge to the cord and blind hemming the other to the skirt. Another method is occasionally used. The turned-up edge of the skirt may be wide enough to be brought up and folded over to enclose the raw edges of the cording to which it may be hemmed. Its upper folded edge should be blind hemmed to the skirt; otherwise it will stand away from the skirt and the cording will not hang correctly. This facing is not, of course, a true bias; its grain is that of the bottom of the skirt.

(*iv*) Cording is frequently used to join cuffs to sleeves. In general, the sleeves have fulness and the cuffs are lined. The cording may be attached to sleeve, cuff, and lining with one sewing, by placing it between their two right sides with all the raw edges extending in the same direction, but not falling exactly together. The sewing should be done

through the seam-lines of the cuff and the sleeve and the sewing line of the cord. To finish the lower edge of the cuff, the cording and the cuff are sewed and the lining is then turned in and hemmed to the cording. All the raw edges are enclosed in the cuff.

(*v*) A cord is frequently used as a finish at the top of a hem which is turned to the right side. Such hems are generally in straight breadths of material. The cord is placed in the fold of the first turning and is run. The hem is sewed to the garment by running stitches along this same line.

(*b*) *Pipings.*—No special directions need to be given for the making and applying of pipings, as the general method of procedure is practically the same as for the cordings.

(6) *Machine Hemstitching.*—This finish is used for such materials as chiffons, gauzes, crêpes, thin silks, and sheer linens and cottons, but, as it necessitates the use of a hemstitching machine, it is not always possible. The hemstitching is done on the raw edge of the material along the indicated finishing line. The material may be cut just at the edge of the stitching. This gives somewhat the effect of applied *entre-deux*. The cutting may be done through the centre of the stitching. This gives a slightly irregular edge which has the appearance of a picot added to a whipped edge.

(7) *Rolling and Whipping.*—This finish is practicable for much the same class of material as the machine hemstitching. The edge of the material is cut close, is rolled, and whipped. Occasionally the whipping is done a second time; it should be started at the finishing end of the first row. These stitches will slant in the opposite direction, and by placing the needle in the same holes as in making the first row, they will form a cross over the edge. The silk used need not be of the same color as the garment.

3. **Fastenings.**—There are several ways in which garments may be fastened. These include the use of fasteners, such as (1) hooks and eyes, peets, or loops; (2) snaps; also the use of (3) buttons and buttonholes; (4) bound and tailor buttonholes; (5) eyelets for lacing.

Care should be taken in making the fastenings of any garment, as much of its appearance and its general satisfaction depend upon such details. Before any fastenings are made or attached, the exact location of all should be carefully marked, otherwise the pieces to be joined may not match when finished. If fastenings are to be sewed along the two edges of a garment opening, the two edges and a tape-measure are placed together side by side and pins are put straight through both edges to mark the location of the fastenings. A basting is then made, taking a stitch at right angles to the edge, each stitch indicating the position of a fastening. The basting may be done down one edge and up the other with the pins still holding them together.

(1) *Hooks and Eyes, Hooks and Peets, or Hooks and Loops.*—Hooks and eyes are sewed to the wrong side of a garment. The rings of each hook should be spread, as this distributes any strain which may come on it and prevents its pulling forward. The end of the hook is placed ⅛″ in from the edge; it is sewed through both rings and across the end. The stitches should be taken entirely around the rings and not grouped in one place. In a tight-fitting lining the hooks and eyes usually alternate on each side to prevent unfastening. The eye is placed to extend just enough beyond the edge to allow the hook to slip in easily. It is sewed around the rings, as is the hook, and across each side near the edge of the garment. If the stitches in the hooks and eyes are not to be concealed by a facing, they have a neater appearance if the blanket stitch is used in the rings. This is not a necessity, however.

Peets and loops are placed on the right side of the garment. They are usually ⅛″ in from the edge and are so arranged that the hooks slip into them easily. The stitches should be made around the rings of the peets. Loops are used where it is desirable to have as flat and invisible an opening as possible. The method of making is a sewing problem and need not be described here.

(2) *Snaps or Ball-and-Socket Fasteners.*—These have replaced hooks and eyes in many cases. They make a flat

and secure opening. Their attaching is too simple to need explanation.

(3) *Buttons and Buttonholes.*—The sewing on of buttons and the making of plain buttonholes are problems in sewing and need not be discussed here.

(4) *Bound Buttonholes and Tailor Buttonholes.*—There are buttonholes which are decorative as well as useful and the making of which requires explanation.

(a) *Bound Buttonholes.*—There are two general methods of making bound buttonholes each of which may be varied in its detail and may be adapted to suit the material of the garment and the location of the buttonhole.

(i) *Reinforcing Material.*—The material in which the buttonholes are to be made should be reinforced. The kind of reinforcing material used depends entirely upon the material of the garment. For chiffon, the same material should be used. For broadcloth and other wool fabrics, silk or a fairly fine cambric may be used. For silk, the same material, or a thin silk or soft muslin is good. For cotton and linen, thinner cotton fabrics may be used, their quality depending upon the quality of the garment material. If cottons and linens are used it is a good plan to shrink them first, especially if they are to be placed in a garment which is to be laundered, cleaned, or pressed. The reinforcement is always cut on the bias; it should be about 1″ wider than the buttonhole is to be long and long enough to include all the buttonholes in the group. The reinforcing material should be basted to the wrong side of the garment, to extend ½″ beyond each end of the buttonhole.

(ii) *Size of Buttonholes.*—The length of a buttonhole depends on the size of the button. It should equal the diameter of the button plus its thickness. The spacing of the buttonholes is determined by their position in the garment, by their size, and the taste of the worker.

(iii) *Marking.*—The location and the size of each buttonhole must be very carefully marked before any cutting is done. Two parallel bastings the full length of the garment may be made to indicate their length. Another basting at right angles to these should show the exact line of

cutting for each buttonhole. This insures absolute regularity. These bastings should show both on the wrong side and on the right side.

(*iv*) *Binding Material.*—The binding may or may not be of the same material and color as the garment. Chiffon may be bound with silk, silk may be bound with cloth, or cloth with satin. It is entirely a question of the design of the costume. The cutting of the binding materials is determined by the way in which the buttonhole is to be made. The binding may be continuous or it may be in two sections. For both, the material must be cut absolutely on the true bias.

(*v*) *Methods of Making.*

(a) *Buttonhole with a Continuous Binding.*—In width the binding should be the same as the reinforcement; in length it is not necessary to have it all in one piece, if there are short lengths to be used, as it is later cut apart between every two buttonholes. Having it in one piece usually saves time in basting it on.

Buttonholes with a continuous binding, showing (*A*) reinforcement, (*B*) basting to indicate length and position of buttonhole, (*C*) stitching to give the required shape

The right side of the binding material is basted to the right side of the garment in the same position as the reinforcement. As the location of the buttonholes is indicated on the wrong side, the work is done on that side. The stitching may be done by hand or by machine. Machine stitching is better because it is firmer. Stitching to indicate the shape of the buttonhole must be done through the three thicknesses of material. The success of the buttonhole depends entirely upon the stitching. The stitching begins at the inside lengthwise basting, close to the crosswise basting indicating the buttonhole. It should curve out gradually to the centre of the buttonhole and

should then curve in to a point at the other end. The second side should match the first. All the buttonholes are stitched in the same way. If the stitching is not the same on all they will not match in shape and size when finished. The ends of the sewing silk must be fastened securely to prevent any ravelling. The buttonholes are cut exactly along the line of basting from point to point,

Right side, showing (*A*) finished buttonholes, (*B*) buttonhole ready for cutting

taking care to cut close to but not through the stitching. Sharp scissors are necessary. The binding material is next cut half-way between the buttonholes and is brought through each buttonhole to the wrong side. It requires a little pulling into place to make the edges even before it can be turned back to enclose the extending raw edge and basted close to the edge of the buttonholes. Because of the direction in which it is stitched, more of the binding material shows at the sides of the buttonhole than at the ends. The buttonholes must be carefully pressed on the wrong side. They are then finished, except for the raw edges of the binding, on the wrong side. Because of the continuous binding, this buttonhole is suitable for garments which are to be laundered frequently.

(b) *Buttonhole with the Binding in Two Sections.*—This method of binding gives a more decorative buttonhole. The two pieces of bias binding material are cut about 1″ wide and ½″ longer than the buttonhole. These are placed with edges touching, one on each side of the crosswise basting, with their right sides to the right side of the material and are firmly basted. These strips extend ¼″ beyond each end of the buttonhole. They are stitched on with straight, not curved, lines. The two rows of stitching parallel the crosswise basting and their distance each

side of that basting determines the width of the binding in the finished buttonhole. A regulation width is about ⅛". The stitching must extend from one lengthwise basting to the other. The ends of the sewing silk must be firmly fastened before the buttonhole is cut.

The extra length of binding which extends beyond each end of the buttonhole is turned back to its wrong side and

Buttonhole with binding in two sections—wrong side, ready for cutting

Right side, showing (*A*) finished buttonholes, (*B*) buttonhole ready for cutting

creased or basted. These turnings make the bindings just the length of the buttonholes. They must be even at each end of each strip, otherwise the buttonhole will be unevenly finished. The buttonholes are cut exactly on the crosswise basting, the binding is drawn through to the wrong side, is turned back to enclose the extending raw edges, and is basted and pressed. If the stitching is ⅛" in, the binding on each side of the buttonhole is that width. If well made the binding is of even width, its folded edges are straight and meet the length of the buttonhole, each end of which is square.

(*b*) *Tailor Buttonhole.*—The preparation for reinforcing and marking the length and the exact location of a tailor buttonhole is the same as for a bound buttonhole. In addi-

tion, it is necessary to mark on the right side the width of the finished buttonhole. If it is to be ⅛″ finished, two rows of bastings ⅜″ apart must be made; that is, each must be placed ⅟₁₆″ away from the basting which marks the cutting line.

Two pieces of bias binding material are cut 1″ wide and ½″ longer than the buttonhole. These are folded in the

Right side of tailored button-
hole, showing (*A*) finished
buttonhole, (*B*) one length
of folded binding basted in
place

Wrong side of tailored button-
hole, showing (*A*) lines for cut-
ting buttonhole, (*B*) folded
binding stitched and turned
to form the buttonhole

centre, right side out, and are placed to the right side of the material on each side of the buttonhole with the folded edge to the line of basting, ⅟₁₆″ in from the cutting line, and the raw edges toward the cutting line. It is simpler to manage if one fold at a time is placed, basted, and stitched. The fold is stitched to the garment ⅟₁₆″ in from its folded edge and the length of the button-hole. The second strip is placed, basted, and stitched in the same way. The ends of the machine silk must be securely fastened. This buttonhole is cut open a little differently from the others. It is not cut the full length

of the basting, but to within ⅛″ of each end, and from each end of this cut diagonal cuts or slashes are made to the stitched lines. This leaves a tiny projection at each end of the buttonhole, which is turned to the wrong side with the bias binding and prevents a raw edge at the end of the buttonhole. In drawing this binding to the wrong side the raw edges of the seam allowance are not allowed to extend to be enclosed by the binding, as usual, but are turned back along the line of stitching. The folded edges of the binding project, however, and fill the space. If the ends of the buttonhole require a little finish to make them strong, a few stitches on the wrong side may be taken to hold in place the small, turned-in piece of material.

(*c*) *Finishing Bound and Tailor Buttonholes.*—All these buttonholes may be finished on the wrong side in two ways, according to the material used. (*i*) The raw edges of the binding material may be turned in and run or hemmed to the reinforcement or (*ii*) a facing may be applied the entire length of the garment. If the facing is used a slit is made in it at each buttonhole and its raw edges are turned in and hemmed.

(5) *Eyelets.*—The making of eyelets is a problem in sewing and need not be discussed here. Eyelets are not in constant use in dressmaking.

4. Decorative Ways of Securing Fulness.—The usual way of securing fulness is by the use of a row of gathering stitches. For decoration there are various other means. These include the use of:

(1) *Plain Shirring.*—Several rows of running stitches are made in which the stitches may be even or uneven. In general the rows are parallel, but need not be, as their spacing is merely a matter of taste.

(2) *Tucked or Corded Shirring.*—A small tuck may be made at each row of gathering or a cord may be enclosed as in making cording. The cord is used to draw up the material and to regulate the fulness. As many rows of the tucks or of the cordings may be made as desired.

(3) *Lengthwise Tucks or Plaits.*—These need no explanation.

(4) *Smocking.*—The preparation of the material for smocking and the making of various stitches are given in detail under *Embroidery* and need not be repeated here.

5. **Decorative Methods of Finishing Plaits, Stitching, Buttons, etc.**—The decorative finishes which are most often used are the bar tacks, arrowhead tacks, and crow tacks, or crow's-foot tacks. These are generally made of firmly twisted, rather coarse silk or twist, according to the fabric on which they are used. Occasionally, however, some of the finishes are for purely decorative purposes, such as the ornamentation of buttons made of materials, and a greater variety of threads may then be used.

(1) *Bar Tacks.*—The length and the direction of the bar are marked and several long stitches are made close together from end to end of the indicated line. The thread is carried through to the wrong side each time to make the bar sufficiently strong. These stitches are then closely covered by others which cross them from side to side at right angles. The cross stitches are taken in two ways: (a) to include only the lengthwise stitches or (b) to include the material as well as the stitches. The first gives a free bar; the second, one firmly attached to the material.

(2) *Arrowhead Tacks.*—There are several varieties, or they may be called modifications or combinations of the arrowhead tacks. Many of them are made by a series of two stitches taken alternately, first on one side, then on the other, of the design, which is in general shape like a right-angle triangle.

Before any stitches are taken the desired shape of the design must be clearly marked. (Chalk is a good medium for this.) To place the stitches accurately the needle must be carried up and down through the material, as when a hoop is used in embroidery. This is more easily done if the material is stretched firmly in the left hand with the thumb and first finger on top, with the middle finger underneath pressed to the first finger, and with both the third and little fingers pressed to the thumb.

(a) The simplest form of arrowhead tack is described first. A triangle with a stem is drawn. If its three points

are marked—the upper *a*, the left *b*, the right *c*—the explanation is much simplified. From the upper point, *a*, of the triangle down through the centre of the stem a straight line is needed as a guide for the placing of the stitches. With these indications, and with the material properly held, the work proceeds as follows: (*i*) Two stitches are made on the left side. The needle is brought up at the upper point of the triangle, *a*, and carried down through the left point, *b*; it is brought up again close to this point, to the right, on the line *bc* and carried down on the centre line near the upper point, *a*. This gives the required two stitches side by side extending from the upper to the left point. (*ii*) Two stitches are made on the right side by following the same procedure: the needle is brought up in the hole used for the first stitch at the upper point, *a*, and carried down through the right point, *c*, is brought up close to this point, to the left, on the line *cb* and carried down in the hole of the second stitch on the centre line. This gives the required two stitches side by side extending from the upper to the right point. (*iii*) The needle is next brought up on the centre line near the upper

Simplest form of arrowhead

point, and the work continues as described, making two stitches to the left and two to the right until the triangle and its stem are filled. The thread should be securely fastened on the wrong side.

(*b*) A more complicated and firmer arrowhead may be made by using the same outline and interlacing the stitches somewhat. The centre line is not required, but the triangle should be marked, as for the other, *abc*. The work may proceed in two different ways as follows:

Two stitches at a time are made on each side.

(*i*) Two stitches are made on the left side. The needle

is brought up at the upper point, *a*, and carried down at the left point, *b*. It is brought up again close to this point, to the right, on the line *bc* and carried down, not on a central line, as in the other arrowhead, but on the line *ac* joining the upper and right points. This gives the required two stitches side by side on the left.

(*ii*) Two stitches are made on the right side. The needle is brought up close to the upper point, *a*, on the

Arrowhead formed by using two stitches at a time on each side

line *ab*. This brings the thread outside the first stitch taken from *a* to *b*. In carrying the thread down to the right point, *c*, it must go under the second thread between *a* and *b*. The needle is slipped under this second stitch and the thread carried down to the right point, *c*. It is brought up again close to the point, to the left, on the line *cb* and carried down near *a* on the line *ab* outside the two stitches from *a* to *b*. This gives the required two stitches side by side on the right.

(*iii*) Two stitches are made on the left side. The needle is brought up near point *a* on the line *ac* outside the two stitches from *a* to *c* and carried down near point *b* on the

line *bc*. It is brought up again on this line, to the right, close to the last stitch, and carried down on the line *ac* outside the stitches from *a* to *c*. This gives the required two stitches side by side on the left.

(*iv*) Two stitches are made on the right side. The needle is brought up on the other side of the triangle on the line *ab*, outside the stitches from *a* to *b*. In carrying this thread down to the right point, *c*, it must go under the last (the fourth) thread between *a* and *b*. The needle is slipped under this stitch and the thread carried down to the line *cb* near *c*. It is brought up again on this line, to the left, close to this last stitch, and carried down on the line *ab* outside the stitches from *a* to *b*. This gives the required two stitches side by side on the right.

(*v*) The needle is brought up on the line *ac* and the work continues as already described. This method is not

Arrowhead formed by using one stitch at a time on each side

difficult if the directions are followed accurately. It gives a series of parallel lines on the wrong side across the triangle between lines *ab* and *ac*.

One stitch at a time is made on each side.

(*i*) The needle is brought up at the left point, *b*, and carried down at the upper point, *a*. It is brought up again at point *c* and carried down near point *a*, outside the stitch from *a* to *b*.

(*ii*) The needle is brought up at point *b*, to the left, on the line *bc* and carried down near point *a* on the line *ac*. It is brought out again near point *c* on the line *cb* and carried down near point *a* on the line *bc* outside the stitch from *b* to *a*.

This method is somewhat simpler than the other described, but the wrong side does not have as neat an appearance.

(*c*) Several variations may be made: The triangle may be drawn without the stem. It is filled in in the same manner. A diamond-shaped stay may be made by placing

two triangles with their bases together. Each triangle is filled in separately. Three and five pointed stars may also be worked out, using the same general method of procedure. Squares filled in with stitches forming a basket pattern are easily made. The square is marked and the threads are laid in one direction, forming a warp. The number should be divisible by three, five, or seven, according to the size of the square. The crosswise threads are interwoven. They pass over three, five, or seven, under three, five, or seven, and over three, five, or seven. There must be the three

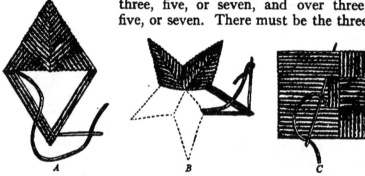

(*A*) Diamond-shaped stay; (*B*) five-pointed star; (*C*) square with a basket pattern

divisions to balance the design. This is a good design for ornamenting buttons.

(3) *Crow Tacks.*—The second method given for making arrowhead tacks may be slightly changed for the making of crow tacks.

A triangle is used, but each side should be slightly indented at its centre. Its points must be marked *a b c*. The stitches are made one at a time around the triangle.

(*i*) The needle is brought up at point *a*, carried down at point *b*. It is brought up again at *b*, a little to the left on *ba*, and carried down at *c*. It is brought up at *c* on the line *cb* and carried down at *a* outside the first stitch on the line *ab*.

(*ii*) The needle is brought up at *a* on the line *ac*, outside the stitch already taken, and carried down near *b* on the line *bc*, outside the stitch already taken. It is

brought up near *b* on the line *ba*, outside the two stitches, and carried down near *c* on the line *ca* and outside the stitches from *a* to *c*. It is brought up near *c* on the line *cb*, outside the stitches, and carried down near *a* on the line *ab* outside the stitches.

(*iii*) The needle is brought up near *a* on the line *ac*, and the work continues as already described. Each succeeding round of stitches is placed outside those already made. If the needle is carried back and forth through the indented lines of the triangle the stitches are drawn in and the desired effect is secured. When the tack is finished there is

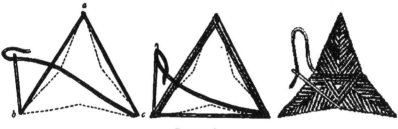

Crow tacks

a small triangle at the centre, formed by the stitches, with its points touching the indentation of the side lines of the big triangle.

II. EMBROIDERY

For several years embroidery as a means of decoration and finish has held an important place in dressmaking. While from time to time it appears to change in general style, the fundamental stitches are practically the same, and the chief difference is really in the manner of their application.

The stitches may be used in various ways; they may be combined to form an all-over decoration for a waist or dress, they may be made to serve as a finish to edges, or on otherwise plain costumes they may be used to ornament the collars, cuffs, girdles, panels, etc.

1. **Design.**—The design and the color chosen for any embroidery are very important. The choice usually depends

on the dictates of fashion, in many cases influenced somewhat by individual taste. Neither the pattern nor the color should be chosen without careful consideration, for upon these, more than upon the variety of stitches and the workmanship, depend the beauty and the suitability of the finished work. Patterns in which all the rules of design governing the placing and the spacing of lines, the combination of colors, and the proportion of dark and light are ignored cannot give satisfactory results, though the embroidery itself is most skilfully done.

Much of the technical as well as all of the artistic success of embroidery depends on the choice of the pattern. The design should be suited to the material and to the stitches which are most satisfactorily made on the material. For instance, on a transparent material a fairly continuous design should be used and should be embroidered in a stitch which requires little breaking of threads. An excellent illustration is the use on chiffon of a design simulating braiding, which is made by a combination of continuous running stitches.

Patterns prepared in various ways may be secured for use. Many publications issue designs. Some are made with perforated patterns which are transferred to the material by using a specially prepared powder; others are not perforated and are transferred merely by pressing with a hot iron. If the design is made rather than purchased the perforating may be done at a shop. When embroidery is done on such transparent materials as chiffons and nets the design is frequently made on tissue-paper and basted to the under side of the work. It can easily be seen, and the paper gives body to the material while the work is being done. Often in doing solid French embroidery on a thin material, or on a material like net, the design, stamped on lawn, is basted to the right side of the net and the work is done over it. When the work is finished any lawn which shows is cut away. This method simplifies the work and gives firmness to the design.

2. **Tools.**—A few tools which are not required for dressmaking are needed for dress embroidery. The most im-

portant of these are an embroidery-frame, crewel needles, and a case for holding embroidery silks.

(1) *Frame.*—Embroidery-frames may be made or purchased. They are needed for nearly all dress embroidery. To make a frame, four pieces of soft wood are required, each about two and a half feet long, 1″ wide, and ¼″ or ½″ thick. A piece of heavy muslin 1″ wide is tacked along the side of each strip of wood. The strips are arranged to form a square and are held in place at the four corners by metal clamps which may be purchased at any hardware store. As these clamps are easily operated, there is no difficulty in regulating the size of the square to that of the material to be embroidered.

The material is held in the frame by sewing it to the pieces of muslin. If the material to be embroidered is very uneven in shape it may be attached to extra pieces of muslin, which are in turn fastened to the attached strips. The material must be held taut while the work is going on. The frame is placed between tables or chairs so that it need not be held in the hands of the worker. Both hands are thus left free to pass the needle back and forth, as is necessary in much of the dress embroidery. When finished, all embroidery should be pressed before being removed from the frame. The right side of the material is placed against a soft pad, the wrong side is dampened slightly and very carefully pressed with a warm iron.

(2) *Needles.*—Many different sizes of crewel needles should be purchased, as the numbers required vary greatly, depending on the material and the silks. A needle too small for the silk often ruins the effect of a stitch and may also tear or pull the material.

(3) *Cases for Silks.*—Of the many kinds of embroidery cases any is satisfactory which is so arranged that the silk will not become tangled and roughened while in use.

3. **Materials.**—Embroidery materials, like the designs, change with the changing fashions. Each fashion brings in a new variety and usually revives an old. Besides the usual embroidery flosses, of which there is an endless vari-

ety in twist and in finish, there are many sizes and kinds
of gilt and silver threads, chenille and art worsteds, also
rat-tail braid, soutache braid, soft ribbons, beads, bugles,
spangles, and brilliants.

The choice of embroidery materials depends on the gar-
ment to be decorated; that is, it depends on the purpose
for which the garment is intended, the fabric of which it is
made, and the kind of stitches which are chosen as suit-
able for the fabric and the design.

In the following explanation of the various stitches an
effort has been made to suggest possible uses and suitable
embroidery materials for each; but, as has already been
said, too much depends upon the changing demands of
fashion to permit much detail.

In making any kind of embroidery stitches a knot
should not be used in starting. The thread may be fast-
ened at the beginning and at the end of the work by a few
stitches easily concealed by the embroidery.

4. **Stitches.**

(1) *Running Stitch.*

(*a*) *Use.*—This is an adaptation of the running stitch
used in sewing. The method of procedure in sewing and
in embroidery is the same; but in the latter there may be
variation in the proportionate length of stitch and space,
according to its use.

The running stitch has various uses—to outline a de-
sign with a single row of even stitches (the proportionate
length of stitch and space should be well chosen); to form
a design such as that of a leaf or a flower petal by grouping
a number of uneven stitches; to simulate braiding, which
is generally used to form a border, by a few parallel rows
of even stitches; to make a background by covering the
entire surface with parallel rows of stitches.

(*b*) *Materials.*—In general such threads should be used
as pull through easily and are suited to the material and
the design. These include a great variety of gold and
silver threads, embroidery silks, and worsteds. The very
decorative chenilles and soft ribbons may also be used,
with care, on many fabrics. The softly twisted threads

usually prove most satisfactory in making the background for a design.

(c) *Method.*—The work is done from right to left. In sewing it is made with an even stitch and space; in embroidery the stitch is made to give a long thread and a

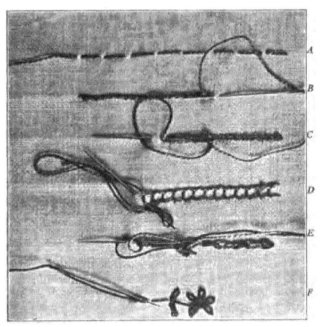

(A) Running stitch; (B) outline stitch; (C) chain-stitch; (D) wide chain-stitch; (E) magic chain-stitch; (F) lazy-daisy stitch

short space. Its purpose is not to give strength but to cover the surface of the fabric as much as possible with embroidery.

In using the stitch to outline, its length may depend on the kind and size of the design; but the length chosen must be kept uniform throughout.

In forming a design by grouping a number of stitches the desired effect is more easily secured by the use of uneven stitches, as the space to be filled is usually irregular in size.

When a braiding or an entire background is made all the stitches should be of even length. They may be two or three times the length of the space. The rows must be straight and parallel, and in making each row a stitch should be placed opposite a space. If the stitches are opposite each other the effect is that of a stripe, which is not generally desirable.

(2) *Portuguese Laid Work.*

(*a*) *Use.*—The running stitch forms the framework or foundation for Portuguese laid work, which is used chiefly as a border decoration.

(*b*) *Material.*—A great variety of threads may be used. The stitch gives opportunity for variety of both material and color, as two different kinds of thread may be combined. The foundation may be of fine threads, while the blocks are formed of heavy silks, chenille, or ribbon of the same or contrasting color.

(*c*) *Method.*—The work progresses in two directions, the running stitch from right to left, as usual, the blocks from left to right. Three parallel rows of even running stitches are made some distance apart, about $\frac{1}{4}''$. The stitches are longer than the spaces and are opposite each other in the three rows. These rows are joined in alternate groups—that is, first, one and two; second, two and three—by a series of blocks, each one of which is formed by three over and over stitches placed close together. The blocks and the spaces between should be equal in size.

(3) *Outline Stitch.*

(*a*) *Use.*—The outline stitch is chiefly used to outline designs. It may be made, however, to form a border or a background by placing several parallel rows rather close together. It is then usually called Bulgarian stitch.

(*b*) *Materials.*—It is better to make this stitch with materials which will pull through the fabric without much difficulty and without becoming rough. Soft and hard twisted silks, cottons, and wools are most frequently used.

(*c*) *Method.*—Unlike the majority of stitches, the work progresses from left to right. Each stitch is made, however, by putting the needle in from right to left. The

length of the stitch varies according to the size of the embroidery material used; but the length chosen must be kept uniform throughout. From ⅛″ to ³⁄₁₆″ or ¼″ is usually found satisfactory.

The thread is always kept to the left of the needle away from the worker. For the first stitch the needle is put in the required length of stitch in advance, to the right of the starting-point, and brought back and out again exactly beside the starting-point; for the second stitch the needle is put in the same distance in advance, to the right of this first stitch, and brought back exactly beside its end. By bringing the needle out beside the end of the last stitch each time, rather than in the same hole with it, the outline is given a little breadth and each stitch is given a slight curve.

(4) *Chain-Stitch.*

(*a*) *Use.*—The chain-stitch is most frequently used to outline designs. It may also serve to fill in a design or to form a solid background by using several parallel rows placed close together.

(*b*) *Materials.*—In general, the materials most used are the twisted silks, cottons, and wools. Chenilles and ribbons, however, if carefully used, give attractive results.

(*c*) *Method.*—The work is done toward the worker. The stitch is made up of a series of loops resembling the links in a chain. The length of each loop depends on the choice of the worker, the kind of material used, and the purpose of the stitch. For instance, in outlining, too long a stitch should not be used for a curving line. For a background, however, a long loop is as effective as a short one and the space is more quickly filled. The size, once decided, must be uniform throughout. The material should be held over the finger; the needle is brought out at the starting-point, the thread is held down toward the worker by the left thumb, and the needle is inserted in the same hole as before and is then brought out a short distance, ⅛″ or ¼″, in advance. While bringing the needle out, the thread which the thumb has been holding is freed and is drawn up into a loop under the needle and

the thread just drawn out. The length of this loop is determined by the amount of material taken up as the needle is brought forward and out. For the second stitch the needle is put back in the hole at the end of the last loop, through which it was just drawn, and is brought forward and out as before, with the thread held down by the thumb. For each stitch the thread is pulled out from the end of the last loop and the needle is put back in it.

(5) *Magic Chain-Stitch.*

(a) *Use and Materials.*—This is a variation of the plain chain-stitch. It is used for the same purposes and is made of the same general kinds of material. It differs in that two threads of different colors are used in its construction instead of one.

(b) *Method.*—The stitch is made toward the worker. It is composed of a series of loops which alternate in color. The two colored threads are carried by the same needle and the alternation of color is caused by holding down under the thumb only one of these threads at a time. Both threads are brought to the right side each time, but, as the needle, in forming the loops, is put back in the same hole through which it has just been drawn, the free thread not held down by the thumb is carried back with it to the wrong side and does not show at all on the face of the fabric until it is drawn through again and is held in place to form the next loop.

(6) *Wide Chain-Stitch.*

(a) *Use.*—This is another variation of the plain chain-stitch. Because of its width it is used for border designs. For additional ornamentation French knots, made of the same or another material, may be placed in the centre of each loop.

(b) *Material.*—The same materials as for the plain chain-stitch are most satisfactory for general use.

(c) *Method.*—The method of making is much the same as for the plain chain. Instead, however, of putting the needle back in the same hole through which it has just been drawn, it is put in on the same line with that hole, but to the right of it, and is drawn out directly in line with

the first point at which it was brought out. When the needle is put down through, at the right, each time, it must be inside the loop just made. If the needle is carried to the right a quarter of an inch and is then brought forward the same distance, a perfect square is formed.

(7) *Lazy Daisy.*

(a) *Use.*—A variation of the chain-stitch is used to form flowers and leaves. In place of a series of loops, one following the other in outline, each loop is separate and is so arranged as to form the petal of a flower or a leaf. It is combined with feather-stitching and French knots to form designs. These are very often used with tucks on lingerie dresses but are also suitable as a decoration for silks.

(b) *Materials.*—It is most frequently done in cottons, such as D.M.C., in twisted silks, and in wools.

(c) *Method.*—The needle is at the centre of the flower when the work begins. Each petal is formed of one loop, which may be any size desired. The loops are made exactly as in the regular chain-stitch, except that after the needle is brought out at the end of the petal or loop it is put back into the cloth just outside the end of the loop rather than inside, as when forming a second loop. By this method the end of the loop is held in place at the end of the petal by the small overstitch. The needle is then carried back to the centre of the flower and the other petals are made. The stem may be in the outline or the running stitch. The leaves on the stem are formed by one loop. French knots usually finish the centre of the flower.

(8) *Feather-Chain.*

(a) *Use.*—In this the chain-stitch is combined with a long slanting stitch to form a vine-like design. It may be used as a border or to form the design itself.

(b) *Materials.*—As great a variety of materials is suitable for this as for the plain chain-stitch.

(c) *Method.*—Each chain-stitch forms a leaf. These are placed in a slanting position on alternate sides of a stem. As the long stitches for the stem should slant a little from right to left and from left to right, to give the desired effect, they do not form a straight centre line. This

makes it more difficult to keep an equal amount of embroidery at each side of the centre of the design. The stitch is made toward the worker. In beginning, a chain-stitch is made at the right, slanting in to the centre. After the thread is drawn out at the lower end of this stitch or loop the needle is put in about a quarter of an inch below, to form the slanting stem, and is brought out a little above that point and to the left, to begin the second chain.

(9) *Beading-Stitch.*

(a) *Use.*—This is another variation of the chain-stitch and is used to form borders and to outline designs.

(b) *Materials.*—It may be made with the same materials as the chain-stitch.

(c) *Method.*—The stitch is made toward the worker and the method is much the same as for the plain chain-stitch. The needle is brought up through on the centre line, at the starting-point; the thread is held in a straight line by the thumb, as in the plain chain-stitch. Instead, however, of putting the needle back through the same hole as in the chain-stitch, it is put in $\frac{1}{8}''$ below that point, and a little to the left, over the held-down thread. The needle should be slanted downward and brought out on the centre line, at the right of the held-down thread and through the loop which it forms. As the thread is freed by the thumb and drawn through, a slanting loop is made, which looks like a knot, across the end of the straight thread. The effect of this stitch is of a straight line crossed at intervals by a slanting knot.

(10) *Feather-Stitch.*

(a) *Use.*—This stitch has a variety of uses, both by itself and in combination with other stitches, such as French knots and the lazy daisy. It is used to outline and to form designs. It may be made in straight lines, in curves, or to form squares, circles, the Greek key, etc. The design chosen should not be intricate but should be made up of fairly simple lines. Tucks and hems may be held in place and finished by various uses of the feather-stitch.

(b) *Materials.*—It is most frequently made in materials, like D.M.C., which will launder. Silks, linens, and wools

may, however, be used successfully, especially if they are rather firmly twisted.

(c) *Method.*—Feather-stitching is always done toward the worker. A good centre line must be kept with an

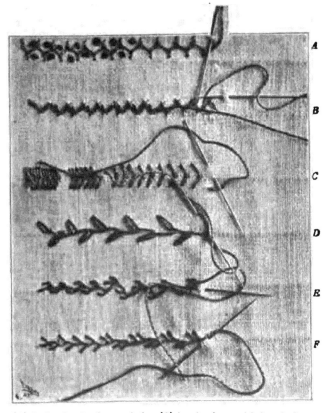

(A) Indian herring-bone stitch; (B) herring-bone with interlacing; (C) oriental stitch; (D) feather-chain stitch; (E) coral stitch; (F) feather-stitch

equal amount of embroidery on each side. This is accomplished if, in making the slanting stitches on alternate sides, the needle is brought back to the centre line each time. The method of procedure somewhat resembles that of the chain-stitch. In starting, the needle is at the centre line.

A slanting stitch is made at the right by putting the needle in about ⅛" to the right and just below the starting-point and by bringing it out ⅛" down from this point on the centre line. By holding the thread under the thumb when the needle is put in, as in chain-stitch, it forms a loop through which the needle is drawn out. For the second stitch the needle should be put in to the left, ⅛" over, and just below the end of the last stitch, and should be brought out again ⅛" down on the centre line. With the thread held down as before, another loop is formed. One side of these open loops forms an almost straight line down the centre; the other gives the slanting stitches on alternate sides. Groups of two or three stitches on alternate sides may be made. This is a rather more difficult but more elaborate stitch. The stitches must be fairly close together and absolutely even, otherwise the result is unattractive.

(11) *Coral Stitch.*

(a) *Use and Materials.*—This stitch is used for practically the same purposes as the feather-stitch. It may be employed by itself or in combination with others. It is made with the same materials.

(b) *Method.*—The method is much the same as for feather-stitching, and there must be an equal amount of embroidery on each side of the centre. There is, however, no straight centre line formed of embroidery stitches to serve as a guide as in the feather-stitch. The stitches are perpendicular rather than slanting and in consequence do not come to the centre. This causes the centre line to slant first to the right and then to the left. In starting, the needle is brought out at the centre line and a perpendicular stitch is taken, putting the needle in ⅛" to the right and bringing it out, straight down, ⅛" below. By holding the thread under the thumb while taking the stitch the loop is formed as the needle is drawn out. For the second stitch the needle should be put in to the left, ⅛" from the centre, opposite the end of the stitch just taken, and should be brought out straight down. One side of these open loops forms, as has been said, a centre line which slants from side to side. Groups of two or three

perpendicular stitches on alternate sides may also be made. The stitches must be evenly spaced and the design evenly balanced.

(12) *Oriental Stitch.*

(a) *Use.*—This stitch is considered a variation of the feather-stitch, but, although it is made in somewhat the same manner, there is really very little resemblance when it is finished. It has various uses, but is most frequently employed to form borders or to fill in leaf-shaped designs and such surfaces as are too wide for a successful use of the satin stitch.

(b) *Materials.*—Nearly all kinds of materials may be used—silks, wools, linens, cottons, also chenilles and soft ribbons.

(c) *Method.*—This stitch is done toward the worker, as is the feather-stitch, but the stitches are placed close together, are nearly horizontal, and are held at the centre by a small overstitch. The small stitches form the centre line, on each side of which there must be an equal length of stitch.

The needle is brought out about ⅛″ to the left of the centre and is put in again ⅛″ to the right of the centre and exactly in line with the point of bringing out at the left. After this stitch is made the needle is brought up at the centre of it, but just above, and is put in again below and close to it. This forms the small vertical overstitch which encloses and holds in place the long crosswise stitch.

(13) *Satin Stitch.*

(a) *Use.*—The satin stitch is used in a design which has small surfaces or spaces to be entirely covered with embroidery.

(b) *Materials.*—Practically all kinds of embroidery materials may be used. The rather softly twisted threads fill the spaces more quickly and are generally most effective.

(c) *Method.*—The satin stitch for dress embroidery is practically the same as that used for household linens. The same general method of procedure is always followed, but in the dress embroidery there may be more variation as to the amount, if any, of padding used and the closeness with which the stitches are placed.

If heavy materials like chenilles and soft, bulky silks are used, especially on thin materials like chiffons, the padding is often omitted and the stitches are so placed as not to give too solid a surface or too heavy an effect.

(*i*) *Padding.*—Padding must be carefully done. The outline, the running, and the chain stitches are all used, the choice depending generally on the size of the space to be filled. The chain and the outline stitches cover the space more quickly than the running stitch. The running stitch should always be made with a long stitch and a short space, to give all the thread possible on the surface. Whichever stitch is used, the stitches must be kept well within the lines of the design, otherwise the space is much enlarged when the satin stitch is added, and the padding stitches must be made the lengthwise of the space; that is, in the opposite direction from that of the satin stitch itself. If they are made in the same direction the satin stitches sink into the spaces between the padding stitches and give an uneven surface.

(*ii*) *Satin Stitch.*—The work is done from left to right. As each stitch is made the needle is brought through the material toward the worker. The stitches are taken across the space to be filled and should cover smoothly the back as well as the face of the design. When padding is used the satin stitches should be placed so close together as to conceal it completely. The satin stitches should, in general, parallel each other. When, however, a curve is embroidered, it is necessary to crowd the stitches on the inside in order to cover the outside edge completely.

(14) *Herring-Bone.*

(*a*) *Use and Materials.*—This is an adaptation of a stitch used in sewing and in dressmaking to finish seams. In embroidery it is made by the same method. It is used to fill in borders and designs and may be made in a great variety of materials. For additional ornamentation, threads of a different material and color may be interwoven or made into French knots.

(*b*) *Method.*—The work is done from left to right, but each stitch is made by putting the needle in from right to

left. The thread is always kept to the right of the needle. There are two parallel rows of small stitches connected by slanting threads. These stitches are made alternately in the two rows and are so placed that a stitch is over a space.

The needle is brought through on what is to 'form the upper line of the design; a stitch is taken a little to the right on the lower line, followed by another at the right on the upper line, and so on. In making these stitches, the needle is put in, in the opposite direction from which the work is progressing. By doing this the slanting threads which join the stitches form little crosses. The stitches must be not only even in length and evenly spaced but on perfectly straight lines. This regulates the direction and length of the slanting threads.

(15) *Indian Herring-Bone.*

(a) *Use and Materials.*—This stitch may be used for the same purposes and made of the same materials as the plain herring-bone.

(b) *Method.*—The method is much the same as for plain herring-bone. The work is done from left to right, but each stitch is toward rather than parallel to the worker. The thread is always at the right of the needle. In making the stitches in the row nearer the worker the position of the material must be changed a little to get the stitch absolutely straight. The stitches are the same size as in the plain herring-bone, but they are vertical rather than horizontal, and in making them the needle points toward the centre instead of to the left.

This gives a somewhat open stitch, and for that reason the French knot forms a satisfactory decoration when placed in the centre of each space.

(16) *French Knots.*

(a) *Use.*—French knots are used alone and in combination with other stitches in a great variety of ways— to outline designs, to form designs, to simulate flowers by careful grouping, and to make a solid background.

(b) *Materials.*—Almost all kinds of materials are satisfactory, the choice depending largely on the special use

of the knots. For instance, when a well-covered back-ground is to be made, fine materials, such as fine silks and worsteds, are best.

(c) *Method.*—The needle is brought out at the point where the work is to begin. The thread is held firmly under the left thumb. The needle is put under the thread and so manipulated by turning that the thread is wound or twisted around it two or three times, according to the desired size of the knot. With the thread wound tightly around the needle and still held by the thumb, the needle

French knots

is turned and put back into the material very close to the point at which it came out. As the thread is slowly freed by the thumb and drawn down through the material it encloses and holds in place the little circles of thread which were formed by the twisting around the needle. The needle is then brought up in position for the next knot.

(17) *Bullion Stitch.*

(a) *Use and Materials.*—This stitch is used to form flowers and leaves, which are, in turn, arranged in combination with other stitches to form both designs and borders. As the making of this stitch necessitates winding the threads many times about the needle, too heavy embroidery materials should not be used.

(b) *Method.*—In forming a flower, the base of the petal which is being made is held toward the worker. The thread is brought out at the base of the petal; the needle is

then stuck in the material at the top of the petal and its point brought out again at its base. Around this projecting point the thread is wound six or eight times, depending on the length of the petal and the size of the embroidery thread. In doing this care must be taken not to use the thread near the eye of the needle but rather at the end where it comes up to the surface and is near the point of the needle. After the thread is wound on the needle it is held in place by the thumb while the needle is drawn out through the coils. These coils should be tightened gently as the thread is drawn through them. The needle is carried away from the worker and put through to the wrong side again at the point or tip of the petal. One stitch is made for each petal; for a leaf, two of these stitches should generally be used.

(18) *Couching.*

(*a*) *Use.*—Couching is used to form borders, to cover seams and whole surfaces, and to form and outline patterns. The designs used should be simple, as couching does not lend itself satisfactorily to many or intricate lines. It may be made in several ways.

Bullion stitch

(*b*) *Materials.*—Practically all kinds of materials are used. The choice depends upon the use of the stitch and the fabric to which it is applied. Two threads are necessary, consequently, two materials are generally combined—a heavy, softly twisted one which is attached to the fabric by a much finer one. It is sometimes desirable to use different colors. In addition to twisted and untwisted silks, wools, linens, and cottons, the chenilles, fancy ribbons, and gold and silver threads give satisfactory results.

(*c*) *Method.*—The variety of design is usually produced by the method of attaching the embroidery materials to the fabric. For all methods the material to be attached

when a well-covered b.
is drawn through from the wrong als, such as fine silks a
desired direction on the surface of the n.

(*i*) For the simplest method a series of out at the poin
taken at regular intervals at right angles to is held firmly
and enclosing it.
er the thread
is wound
to the
ghtly
eedle

(*A*) Plain couching; (*B*) puffy couching; (*C*) twisted couching;
(*D*) brick couching; (*E*) Portuguese laid work

(*ii*) In puffy couching the material to be attached is held
loosely and is thus allowed to form little puffs between the
small stitches, which are made as in the plain couching.

(*iii*) Brick couching is used chiefly for covering sur-
faces. The method of procedure is the same as for the
plain couching, but there are several parallel rows of the
material to be attached, and each is held in place by small
stitches which are placed to alternate with each succeed-

row and thus form brick-shaped blocks. One row is
made at a time. The rows must be so close to each other
that the fabric does not show between them.

(*iv*) If a heavy material with a pronounced twist is at-
tached it may be held in place by using slanting rather
than straight stitches. The work is more effective and
the attaching stitch is invisible if it follows the twist of
the material.

Another method of invisible attaching is by the use of
fine silk or thread; the stitches must be taken through
rather than over the embroidery material. The work may
be done from the right or the wrong side. For thin ma-
terials like chiffon it is easier, and the fabric is less likely
to pucker if it is done from the wrong side.

(*v*) In twisted couching the effect is produced by having
both materials of equal weight but generally of contrast-
ing color. The attaching thread is twisted around the
other material and is caught into the fabric in such a way
as to form a slightly slanting thread on the right side and
a nearly straight line in the back.

(19) *Interlacing Stitch.*

(*a*) *Use.*—This stitch is used to outline patterns, to
form narrow borders, and to simulate braiding.

(*b*) *Materials.*—It is usually made of two materials which
may be of the same or contrasting colors; for instance, the
foundation stitch may be of heavy, softly twisted silk and
the interlacing threads of gold or silver cord.

(*c*) *Method.*—All the work is done from right to left.
The stitching stitch forms the foundation; the length of
the stitch may vary, but too short a stitch is not effective
unless the materials used are very fine. There are two
rows of interlacing threads put in, one at a time. After
the stitching stitch is made the interlacing thread is
brought to the surface at the beginning of the stitching
stitch and is carried down through or under one stitch
and up through or under the next, forming a stitch first
on one side, then on the other, with a space between every
two stitches. This space is filled when the second row of
interlacing is done. It begins at the same point as the

other and goes up under the stitch through which the first row was carried down, and so on.

(20) *Seed Stitch.*

(*a*) *Use.*—This stitch is sometimes used to outline designs but its general use is to fill in spaces. It may be

(*A*) Interlacing stitch; (*B*) seed stitch; (*C*) German knot stitch
(*D*) beading-stitch

used to fill a conventional design or the leaves and petals of flowers, or it may form an entire background.

(*b*) *Materials.*—Twisted and untwisted silks, wools, gilt and silver threads, and chenille may all be used. Gilt thread on a velvet background is effective, as is the soft chenille.

(*c*) *Method.*—The stitch is worked from right to left and is exceedingly simple. It is a short back-stitch with the space between somewhat longer than the stitch. The length of the stitch and of the space may both vary, but the length chosen should be kept uniform throughout.

When made in rows, to form a background, a stitch should be opposite a space to prevent an effect of stripes.

(21) *German Knot Stitch.*

(a) *Use.*—This stitch is used to outline designs and to form borders.

(b) *Materials.*—Practically all kinds of materials are suitable for this stitch.

(c) *Method.*—This stitch is made toward the worker. The needle is brought out at the starting-point and a slanting thread is formed by putting the needle into the material horizontally, from right to left, about ⅛" below this point, and taking a stitch a little less than ⅛" in length. While doing this the thread must be kept to the right or above the needle. The thread is then carried up over this slanting stitch and the needle is brought down under it, eye foremost. The eye is used rather than the point, as the needle is to pass under the stitch but not through the fabric. With the thread held to the left with the left thumb, the needle is brought down through again in the same way and is drawn out and over the held-down loop of thread, which, when pulled up, forms a blanket stitch over the first slanting line of thread.

(22) *Fagoting.*

(a) *Use.*—Fagoting is used to join two edges. Necessary seams may be made more decorative and materials of the same or different kinds may be joined to form a trimming. Collars and cuffs are often made by joining bands of material and lace.

(b) *Materials.*—Fagoting is usually done with fairly firmly twisted materials in silks, wools, and cottons.

(c) *Method.*—The edges to be joined by fagoting cannot be raw but must be finished in some way before the fagoting is done.

(i) In making bands which are to be joined for trimming, the material is generally so folded as to have its raw edges turned in to form a seam along one edge. The material must be cut double the width of the finished bands plus a seam allowance at each edge. The seam edges are held together by the fagoting.

(*ii*) The edges of seams are finished according to the material and the strength required of the seam. A French hem makes an excellent finish.

(*iii*) In preparing any material for fagoting the finished edges are basted face to each other on stiff paper or glazed muslin with a space of the required width between.

(*iv*) There are various methods by which fagoting may be done; the two simplest are those in which the *plain herring-bone* or the *Indian herring-bone* stitches are used. When these stitches are used to join edges they are made in the same way as when they serve purely as a decoration.

The two rows of alternating stitches are taken from left to right along the two edges of the material. In the Indian herring-bone, however, where the stitch is vertical, the needle is put into the material as usual, but instead of coming out in the material and making the usual stitch it is brought forward and comes out in the space.

In *straight fagoting* the work is done from left to right, but the lines go, as the term indicates, straight across the space from side to side. The needle is brought up through from the wrong side in the edge toward the worker, is carried straight across to the other side, and put down through the material from the right side. Before inserting the needle again in the edge toward the worker, to make a second stitch, it should be carried around, that is, back of the stitch just taken, and should then be brought up through the material ⅛″ to the right. Each bar across is thus made up of two threads twisted about each other, which gives added strength and beauty.

(23) *Bermuda Fagoting.*

(*a*) *Use.*—This stitch is used to outline designs, to finish hems in chiffon and in other thin fabrics, and to insert lace.

(*b*) *Materials.*—To be effective it must be done with a coarse needle, size 1, and with fine, firmly twisted materials, such as fine thread or silk.

(*c*) *Method.*—Parallel rows of holes are made by using a large needle in a fairly firm fabric. These holes are so

placed and so connected by stitches that the finished work has the appearance of a row of squares.

The stitches are usually about ⅛″ in length, making the holes that distance apart. The stitch is made toward the worker.

The process in general is this: Two adjoining holes at the right are connected or bound together by two stitches. The two holes at the left, directly opposite these, are also bound with two stitches in the same way. Then these two parallel sets are connected by binding together the two holes nearest the worker by two stitches, which are at right angles to those just made. If the rows of holes at the right are considered to be marked 1, 3, 5, 7, and those at the left 2, 4, 6, 8, the explanation of the method is much simplified.

The work in detail proceeds as follows: To make the right side of the square a stitch is taken ⅛″ long from the starting-point, 1 to 3; the thread is tied and the knot is drawn through to the wrong side. The needle is put in at 1 again, to make the second stitch between 1 and 3, and with a slanting stitch at the back is brought out, at the left, at 4, exactly opposite 3. To make the left side of the square the needle is put in at 2, brought out at 4, put in at 2 again, to make the second stitch between 2 and 4, and with a slanting stitch at the back is brought out, at the right, at 3. To make the lower side of the square the needle is put in at 4, brought out at 3, put in at 4 again, to make the second stitch between 3 and 4, and with a slanting stitch at the back is brought out, at the right, at 5. From this point the work proceeds as explained, connecting 5 and 3 at the right with two stitches, 6 and 4 at the left with two stitches, and completing the square by joining 5 and 6, after which, to continue the work, the needle is carried forward and across to 7. As has been said, when finished the right side of the work shows a series of squares at the back of each of which a cross has been formed by the slanting stitches.

(24) *French Fagoting.*

(*a*) *Use.*—This stitch is used as is the Bermuda fagoting.

(*b*) *Materials.*—The same materials are employed.

(c) *Method.*—While the same general method is employed
as for Bermuda fagoting, it differs from the Bermuda in
that the holes, while arranged in two parallel rows, are not
opposite each other, but are so placed and so connected as
to give, in place of the straight stitches which form squares,

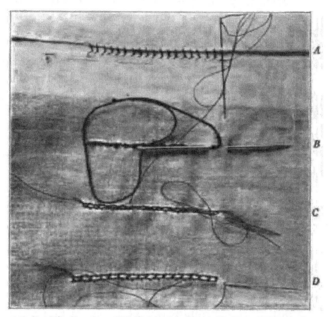

(*A*) Straight fagoting; (*B*) Cuban fagoting; (*C*) French fagoting;
(*D*) Bermuda fagoting

a series of straight and slanting stitches which form tri-
angles. The stitch is made toward the worker.

The process in general is this: Two upward slanting
stitches are made from left to right; two vertical stitches
are made at the right; two upward slanting stitches are
made from right to left; two vertical stitches are made at
the left, and so on. The holes may be numbered, as before,
1, 3, 5, 7 at the right, 2, 4, 6, 8 at the left.

The work in detail proceeds as follows: To make the
slanting stitch from left to right a stitch is taken ⅛" long
from the starting-point, 1 to 2. The thread is tied and

the knot is drawn through to the wrong side. The needle is put in at 1 again to make the second stitch between 1 and 2, and with a straight stitch at the back is brought out at 3. To make the vertical stitches the needle is put in at 1, brought out at 3, put in at 1 again, to make the second stitch between 1 and 3, and is brought out at 3.

To make the slanting stitch from right to left the needle is put in at 2, brought out at 3, put in at 2 again, to make the second stitch between 2 and 3, and with a straight stitch at the back is brought out at 4. To make the vertical stitch the needle is put in .at 2, brought out at 4, put in at 2 again, to make the second stitch between 2 and 4, and is brought out at 4.

To make the slanting stitch from left to right, which parallels the first slanting stitch made, the needle is put in at 3, brought out at 4, put in at 3 again, to make the second stitch between 3 and 4, and with a straight stitch at the back is brought out at 5, and so on, as explained. When finished, the work at the back shows a series of triangles.

(25) *Cuban Fagoting.*

(a) *Use.*—This stitch is used as are the Bermuda and the French fagoting.

(b) *Materials.*—The same kind of needle is necessary, No. 1, but, in place of the fine thread or silk, coarse materials are used. In chiffon or chiffon cloth it is most effective when done in heavy twisted worsteds or silks. A rather tightly twisted material simplifies the work and gives better results.

(c) *Method.*—The finished work has the appearance of a row of stitching stitches, except that between every two stitches there is a distinct hole through which nothing shows at the back. This hole is made by using a big needle. The thread does not show because it is kept first to the right, or below the needle, while two stitches are taken, and then to the left, or above the needle, while the next two stitches are taken, and so on. . The stitch is made from right to left.

The process in general is that of stitching. In stitching

the thread is brought forward, underneath, the length of two stitches and carried back on the surface the length of one, brought forward two and carried back one. In Cuban fagoting the thread is brought forward two stitches, but in place of one back-stitch two are made, one over the other, before the thread is again carried forward the length of two stitches.

A stitch is taken ⅛" long from the starting-point, 1 to 2, the thread is tied, and the knot is drawn through to the wrong side. The needle is put in with the thread below the needle at 1 and brought out at 3. The distance from 2 to 3 equals that from 1 to 2. The first back-stitch is made by putting the needle in at 2 and out at 3. While doing this the thread should still be below the needle or toward the worker. When the second back-stitch and the long forward stitch are taken, by putting the needle back in at 2 and bringing it forward to 4, the thread should be above the needle. To make the first back-stitch, the needle is put in at 3 and brought out at 4, with the thread still above the needle. When the second back-stitch and long forward stitch are taken by putting the needle in again at 3 and bringing it forward to 5, the thread must be below the needle. To make the first back-stitch, the needle is put in at 4 and brought out at 5, with the thread still below the needle. When the second back-stitch and the long forward stitch are taken by putting the needle in again at 4 and bringing it out at 6, the thread must be above the needle.

The success of the stitch depends almost entirely on keeping the thread in the proper position and in having the stitches at the back entirely distinct. If the needle is caught in these stitches while the work is being done, the thread shows through the holes and the effect is spoiled.

(26) *Rococo or Ribbon Embroidery.*

(a) *Use.*—Narrow silk embroidery ribbons are frequently combined with various kinds of threads in the making of many of the stitches already described. Their chief use, however, is for the so-called ribbon or rococo embroidery.

This embroidery is too decorative and perishable to be suitable for all fabrics or for all types of garments. It does not lend itself to conventional designs but rather to the more elaborate floral ones; in consequence, it is more satisfactory on taffeta, chiffon, mousselines de soie, net, and lace, when these are made into such garments as evening coats, waists, and dresses which are not required to give much service.

(*b*) *Materials.*—Embroidery ribbons are made in a variety of colors, either plain or shaded, and in several widths and qualities. The colors most frequently used are the more delicate ones; that is, the soft pinks, blues, lavenders, and greens. There are two widths, $\frac{1}{4}''$ and $\frac{1}{2}''$, of a soft grosgrain with a picot edge, which are much used in forming flowers. There are also the softer ribbons as narrow as $\frac{1}{8}''$, which are made into flowers and into leaves and stems as well. Both kinds of ribbon may be combined in one design, or either may be used as flowers, with the twisted embroidery silks serving as stems and leaves.

(*c*) *Method.*—There are three general ways in which the ribbon may be applied to the fabric: First, by shirring it on one edge and forming it into the desired shape before attaching it. In sewing it to the fabric the raw edges of the ends of the ribbon must be concealed as well as all the necessary stitches. The wider ribbons lend themselves to this treatment better than the narrower.

Second, the ribbon may be made into loops to form the separate petals of a flower. The ends of the loops are caught to the fabric by invisible stitches, for which sewing-silk of the same color is used. The design is more attractive if the ribbon is twisted somewhat and if the arrangement is not too much alike for each petal. The ends of the ribbon are usually drawn through to the wrong side and attached.

Third, both narrow and wide ribbon may be threaded into a needle and drawn back and forth through the fabric, much as is embroidery silk, to form both leaves and flowers. This may be done in two ways: (*i*) by drawing the ribbon through so that it lies perfectly flat on the surface

of the fabric or (*ii*) by drawing it through to leave short standing loops. In general the design chosen determines the width of ribbon to be used and the method of application. In all the designs the ribbons, if shaded, are so applied that the darker tones form the shadows, such as the centre of the flowers or the base of the flower petals.

(27) *Smocking*.

(*a*) *Use*.—Smocking is a decorative method of arranging fulness in garments. It is used to form yokes in waists and skirts, to form cuffs, and to decorate sleeves, waists, and skirts.

(*b*) *Materials*.—The materials used are twisted embroidery silks or wools for silk and wool fabrics and embroidery cottons, such as D.M.C., for wash fabrics.

(*c*) *Preparation of the Material*.—Much of the beauty of the finished work depends upon the care with which the material is prepared for the smocking. This preparation includes (*i*) *marking* and (*ii*) *gathering*, both of which are done on the wrong side of the material. The purpose of the gathering is to draw together in even tucks or plaits as much material as is required for fulness. These tucks are then held in place by the smocking stitches which are so taken in their folded edges as to form designs.

(*i*) *Marking*.—To have the tucks absolutely even it is necessary to indicate not only the lines of gathering but the location of each stitch. A series of parallel lines at right angles to each other are made over the entire surface to be smocked. The crosswise lines indicate the direction of the gathering and the lengthwise the length of the space between the gathering stitches. This length of space is determined entirely by the amount of fulness required or desired in the garment. The space may be as small as ⅛″ but usually not less. Too much fulness makes the tucks too deep and the garment clumsy and unbecoming.

(*ii*) *Gathering*.—The rows of gathering are put in on the crosswise lines with a small stitch at each lengthwise line. A separate thread should be used for each row, which is started with a knot. The gathers should be drawn up so that the tucks or plaits which are formed will

lie closely side by side. With the tucks held firmly in place, the threads are fastened about pins placed at the end of each row of gathering.

As smocking is done by joining the tucks in various ways, if the tucks are drawn into shape—that is, if the edge of each tuck is made to lie straight its full length—the work is much simplified. When the smocking is finished all the gathering-threads are removed and the tucks spread out in the shape allowed by the design used.

If the work is done on an evenly striped material, like a dimity, the marking of the lengthwise lines may be omitted and the stripes used as guides. The same care should be taken to keep the crosswise lines straight and evenly spaced.

There is a great variety of stitches which may be used in joining the tucks. The design depends not only upon the kinds chosen but upon the way in which they are combined.

If a yoke is to be made, straight lines of stitches which do not allow the tucks to spread or open much are usually chosen to form the neck line; while for the bottom of the yoke the opposite is done, and the decoration is more often in the form of points or curves.

(*d*) *Stitches*.

(*i*) *Rope-Stitch*.—The simplest form of smocking stitch is called the rope-stitch. It is an outline stitch which may be made like the outline stitch or may be slightly varied. It is worked from left to right. In making the regular outline stitch a small back-stitch is taken up in each tuck, with the thread held above the needle or away from the worker. In the variation, the stitch is the same, but the thread is at the side of the needle next the worker. There is little difference in the appearance of the stitches made by these two methods. The first gives more the appearance of a solid line of color than the latter.

In making either, the line of tucks is at right angles to the worker, and the stitches are easily taken in the edge of the tuck, putting the needle in from right to left. This is an excellent stitch, when made in a straight line, to use in

beginning any smocking. It holds the fulness in place, at
a neck line to form a yoke and at the bottom of a sleeve
to form a cuff. It may be made in curving lines. Two
or more rows may be arranged to form spaces in which
dots or flowers are placed to
give added decoration.

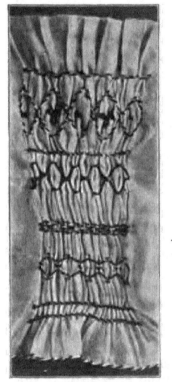

Smocking

A variation of the rope-stitch
gives two parallel rows of sepa-
rate stitches, each stitch includ-
ing two folds or plaits. The
work is more easily done away
from the worker, with the
thread first to the left, then to
the right of the needle. The
thread is drawn to the surface
and is carried forward over two
plaits. A back-stitch is made
in the second plait, with the
thread to the left of the needle.
Instead of putting the needle in
straight toward the worker and
bringing it out on the same line,
as in regular rope-stitch, it is
slanted to the right, to come
out in the same fold but a short
distance, about 1/16'' or 1/8'', be-
low. The thread is carried for-
ward on this new line, over two
plaits; a back-stitch is taken
in the second; this time the
thread is to the right of the
needle and the needle slants to the left, which brings it
back to the original line again. With this method alter-
nate folds are joined by the two rows of stitches.

The outline stitch may be so used as to form points by
having the work progress in a slanting direction, first up
and then down. Two rows parallel to each other may be
used to make a heavier line of points, or two rows may be
so placed, facing each other, as to form diamonds. In

making the stitches on the upward slant the thread is held below the needle, next the worker. In making the stitches on the downward slant, the thread is held above the needle, away from the worker.

In detail, the work is this: The thread is drawn to the surface in the first tuck and a back-stitch is taken directly opposite in the second tuck. Then, with the thread below the needle, back-stitches are taken, upward in progression, in three different tucks. After taking the third stitch the thread is thrown above the needle and another stitch is taken opposite this third stitch in the next tuck. This makes the centre point. With the thread still above the needle, three stitches are taken, in downward progression, in three different tucks. After the third stitch is taken, another is made opposite it in the next tuck, with the thread below the needle. This indicates the centre of the point and should be exactly in line with the first stitch taken. The three upward stitches follow with the thread down. The centre of the point is made with the thread up, and so on.

If a parallel row is made the stitches must be taken and the thread held in the same way in the second row as in the first, and the two must be absolutely parallel. If the rows are placed face to face to form a diamond, in making the first stitch of the three downward stitches the thread must be above the needle for the stitch at the centre point, and for the three upward stitches it must be below, and so on.

If desired, more than three stitches may be used and the points made deeper.

(*ii*) *Cable-Stitch.*—This stitch has somewhat the same effect as the separated rope-stitches. In this, however, the work is done from left to right along one straight line. Each stitch encloses two tucks. In making these stitches the needle is not slanted, as in the other, but is carried straight through the tucks from right to left. The effect of separate stitches is secured by holding the thread first above and then below the needle. After the thread is drawn to the surface in the first tuck the first stitch is

taken in the next tuck with the thread above the needle. For the second stitch taken in the third tuck, it is below the needle; for the third stitch, above; and so on. This may be made more elaborate by adding a second row close to the first. But whereas the first stitch in the first row was made with the thread above the needle, in the second row it is made with the thread below the needle. This brings the first stitches in the two rows apart and the second together, the third apart, etc. If a fairly heavy, solid line of color is desired, three or four rows of this can be used. In this case the first and third rows are alike and the second and fourth.

(*iii*) *Diamond-Stitch.*—This stitch also forms points which, placed face to each other, form diamonds. Rows of these points are so arranged in diamonds as to form deep points which are very decorative. They are especially satisfactory for the bottom of yokes, as they allow the tucks to spread and the fulness to fall as desired. The stitches slant first down, then up, and, as in forming the other diamonds, in the downward stitches the thread is above the needle and in the upward it is below.

In working, the thread is drawn to the surface in the first tuck. A stitch is taken directly opposite in the second tuck, with the thread above the needle. The next stitch is taken ⅛" below in the third tuck, with the thread still above the needle. With the thread below the needle, the next stitch is taken directly opposite this, in the fourth tuck. With the thread still below, a stitch is taken ⅛" above, on the original line. With the thread thrown above the needle, a stitch directly opposite is taken, and another ⅛" below, and so on.

In making the second row of points, which completes the first row of diamonds, the same procedure is followed. The thread is so arranged in making the straight stitches at the meeting of the points that they parallel each other.

The first and second rows of stitches begin in the first tuck; the third row may begin at the third tuck, and so on, to form the point which may be regulated in width and in length according to taste.

(*iv*) *Van Dyke Stitch.*—Unlike the majority of stitches, this begins at the right and progresses to the left. The stitches in this slant, first down, then up, and form points, and these points, placed face to face, form diamonds.

The thread is drawn to the surface in the second plait and a stitch is taken to include it and the first plait, bringing the needle out as at first. One-eighth inch below, the needle is passed through the second and third plaits and a stitch is taken back over them, with the needle brought out in the same place. The next stitch is on the original line, through the third and fourth plaits, with a stitch over them. Working in this way brings more of the embroidery thread on the top of the tucks. The same effect with more elasticity may be obtained by combining one and two on the first line, three and four on the second, five and six on the first, and so on.

(*v*) *Plain Smocking.*—A simple form of smocking is often used. It gives fulness, but shows very little of the embroidery materials and is not so decorative as the methods just described.

Dots instead of lines may be made to indicate the positions. If the lines are used the lengthwise are put in, as for the other work, but the crosswise must be nearer together. The distance between them usually nearly equals that of the lengthwise. Gatherings need not be put in; the tucks and folds are caught together by stitches placed at the intersection of the two sets of lines.

The work is done from left to right, beginning in the upper left-hand corner. Two rows of alternating stitches, each stitch joining two tucks, are made at a time; that is, the first and second rows, the third and fourth, etc. The slanting threads which are necessarily made in passing from one row to another show only on the back. The thread is brought up in the first or upper row through the first tuck, which is joined to the second tuck by two back-stitches taken one over the other. In making the second back-stitch the needle is put back through the second tuck at the same point and is carried straight down to the second row, and brought out in this same fold, the second, which

is then joined at this point to the third tuck by two back-stitches. The needle is put back through the material at this point, carried straight up to the first row, and brought out in this same fold, the third, which is then joined at this point to the fourth tuck, and so on until the first and second rows are finished. In smocking in this way, the second or last tuck of the group enclosed by one stitch should form the first tuck of the group to be enclosed by the succeeding stitch. The third and fourth rows are done in the same way, and the fifth and sixth, to the desired number.

This may be arranged, as were the diamonds, to form a deep point or a succession of points.

(*vi*) *Feather-Stitching and Chain-Stitching.*—These may both be used to keep the tucks in place. For both, the material must first be gathered. The work proceeds as usual, the stitches joining as many tucks as desired.

(*vii*) *French Knots and Flowers.*—Various decorations may be added in the way of French knots and flowers. These are usually placed in the centre of diamonds or between curved rows of rope-stitch. Both French knots and the lazy daisy are used. They are made as already directed in this chapter. In addition to these there is a small flower which is made of stitches resembling those used in the smocking itself.

It is made as follows: The needle is brought up to the surface in a tuck (4) and a stitch is taken joining this tuck to the next (5). A second stitch is taken, below and parallel to this first, close to it, and joining the same two tucks. The thread is then carried back underneath, to a tuck (3), and a stitch is taken joining two tucks (3) and (4). This stitch should be just below the last and practically touching it at tuck 4. A second stitch is taken here also, below and parallel to the first, close to it, and joining the same two tucks. From this stitch the needle is brought out in tuck 4 and a stitch is taken joining two tucks (4) and (5), followed by a parallel stitch. These two stitches should touch the last two at tuck 4 and should be directly under the first two, as they join the same two tucks. The

needle is then carried up to join two tucks (5) and (6) with two parallel stitches, which should be directly opposite those joining the tucks 3 and 4. This completes the making of one flower.

BIBLIOGRAPHY

HISTORY OF COSTUME

Racinet: "Histoire du Costume."
Erman: "Life in Ancient Egypt."
Wilkinson: "The Ancient Egyptian."
Evans: "Greek Dress."
Hope: "Costume of the Ancients."
Abrahams: "Greek Dress."
Preston and Dodge: "Private Life of the Romans."
Smith: "Dictionary of Classical Antiquities."
Harper: "Dictionary of Classical Antiquities."
Planché: "History and Cyclopedia of Costume."
Quicherat: "Histoire du Costume en France."
Viollet-le-Duc: "Dictionnaire du Mobilier Français."
Renan: "Le Costume en France."
Robida: "Ten Centuries of Toilette."
Hottenroth: "Le Costume chez les Peuples Anciens et Modernes."
Pauquet Frères: "Modes et Costumes Historiques."
Challamel: "The History of Costume in France from Gallo-Roman to Present Time."
Le Comte de Riset: "Modes et usages au temps de Marie Antoinette."
La Croix: "Manners, Customs and Dress During the Middle Ages and Renaissance."
Uzanne: "Fashion in Paris. 1797–1897."
Hughes: "Dress Design, An Account of Costume for Artists and Dressmakers."
Fairholt: "Costume in England."
Calthorp: "English Costume."
Hill: "History of English Dress."
Ashdown: "British Costume."
Clinch: "English Costume."
McClellan: "Historic Dress in America."

TEXTILES

Woolman and McGowan: "Textiles."
Walton: "The Story of Textiles."

American School of Correspondence: "Cyclopedia of Textile Work."

Posselt: "Textile Library."

Barker: "Textiles."

Watson: "Textiles and Clothing."

Dooley: "Textiles." ·

Gibbs: "Household Textiles."

Matthews: "Textile Fibres."

Mitchell and Prideau: "Fibres Used in Textile Industries."

Kinne and Cooley: "Shelter and Clothing."

Earle: "Home Life in Colonial Days."

Marsden: "Cotton Spinning."

Marsden: "Cotton Weaving."

Nasmith: "Students' Cotton Spinning."

Hooper: "Hand Loom Weaving."

Brooks: "Cotton."

Wilkinson: "The Story of the Cotton Plant."

McLaren: "Wool Spinning."

American Woolen Company: "From Wool to Cloth."

Chittick: "Silk Manufacturing and Its Problems."

Bennet: "Cotton Glossary."

Bennet: "Woolen and Worsted Glossary."

American Silk Company: "Glossary of Silk Terms."

Kastanek: "Manual of Weave Construction."

Watson: "Textile Design and Color."

Watson: "Advanced Textile Design."

Pellew: "Dyes and Dyeing."

DRESSMAKING

DESIGN

Dow: "Composition."

Ross: "A Theory of Pure Design."

Ross: "On Drawing and Painting."

COLOR

Munsell: "A Color Notation."

TECHNIQUE

Woolman: "A Sewing Course."

Butterick Publishing Co.: "The Dressmaker."

Baldt: " Clothing for Women."

LACE

Sharp: "Point and Pillow Lace."
Palliser: "History of Lace."

EMBROIDERY

Day: "Art in Needlework."
Christie: "Embroidery and Tapestry Weaving."
"D. M. C. Encyclopedia of Needlework."

INDEX

Accuracy—
 in designing, 296.
 in technique, 156.
Alterations—
 foundation skirt, 207, 208.
 in commercial patterns, 239, 240.
 kimono-waist, 237, 238, 265–267.
 shirt-waist, 183, 241–244.
 shirt-waist sleeve, 189, 242.
 skirt, 247–249.
 tight-fitting sleeve, 230, 246, 247.
 tight-fitting waist, 244–246.
 tight-fitting waist and collar, 223.
Angle-stripper, 51.
Apotygma, 6.
Appearance of hand-loom, 68–71.
Appreciation—
 development, 250, 251.
 necessary in designing, 250.
Armseye—
 basting sleeve to, shirt-waist, 188, 189, 331; tight-fitting, 229.
 covering padded sleeve at, 292.
 darting, 222.
 facing, 431.
 finishing, in evening-waist lining, 372; in guimpe, 352; in semifitting lining, 359, 360; in shirt-waist, 334, 342, 343; in tight-fitting lining, 365.
 lines of, matched in basting—
 in shirt-waist, 181, 328; in tight-fitting waist, 219, 220.
 locating, in designing kimono-waist, 266; in shirt-waist, 183; in tight-fitting waist, 221.
 marking—
 by colored basting, in dress-form cover, 291, 292; in draped lining, 299; in guimpe, 347; in shirt-waist, 180, 181, 327; in tight-fitting waist, 219–223.
 by tracing, in designing yokes, 264; in shirt-waist, 180, 326; in tight-fitting waist, 219.
 regulation measure of, in shirt-waist, 174; in shirt-waist sleeve, 184; in tight-fitting sleeve, 224; in tight-fitting waist, 209.
 removing fulness at, in draping kimono, 302.

 seam allowances for, in shirt-waist, 180, 299, 322; in tight-fitting waist, 217, 218.
 sleeve-fitting dependent on, 189, 229.
 spreading shoulder seams at, in designing collars, 264.
 taking measure of, 169.
 testing in commercial patterns, in shirt-waist, 241, 242; in tight-fitting waist, 244.
Arrowhead tacks—
 making by more complicated method, 447–449, 450.
 making by simplest method, 446, 447.
 making of design, 446.
 methods of making, 446, 447.
 variations, 449, 450.
Artificial silk, 116, 117.
Automatic feed, 50.

Basquine, 19.
Basting—
 collars, 220, 351.
 cotton used for, 159, 160.
 darts, 204, 205, 387.
 linings, 357.
 plackets in skirts, 205.
 seams, general rules for, 422.
 shirt-waists, 181, 327–333.
 shirt-waist sleeves, 188.
 skirts, 384–388.
 tight-fitting sleeves, 228, 229.
 tight-fitting waists, 223.
Batten, 68.
Bar tacks, making, 446.
Belts—
 fastenings in foundation skirts or linings, 406, 407.
 making and attaching in foundation skirts or linings, 387, 405, 406.
 making and attaching in kimono-waists, 236.
 making and attaching in semifitting linings, 358, 359.
 making and attaching in shirt-waists, 181, 182, 183, 329, 336.
 making and attaching in skirts, 205, 206, 208, 388, 389, 404–415.
 making and attaching in tight-fitting linings, 364, 365.
 making in lingerie dresses, 408, 409.

use in foundation skirts or linings, 405.
width in finishing skirts at waist line, 407.
Bertha, 45.
Bias bindings—
simulated fold, 434, 435.
true bias, 433, 434.
use for edge finishes, 433–435.
Bias edges, basting, 204.
Bias facings—
for foundation skirts or linings, 388.
Bias folds—
attaching, 433, 434.
cutting and making, 433.
on scalloped edges, 434.
use in joining ruffles to foundation skirts or linings, 419, 420.
Binding—
continuous, for bound buttonholes, 441, 442.
for tailor buttonhole, 444.
in two sections, for bound buttonholes, 442, 443.
use on seam edges, 423.
Bindings, use in skirts, 419.
Bisymmetric line arrangement—
in design of costume, 256.
Bleaching, 117.
Bleaching, scouring, and dyeing, 117–119.
Bliaud, 12–14.
Block-printing—
by hand, 139.
by machine, 139.
Bobbin, 56, 70.
Bodice, in historic costume, 20, 21, 22, 24, 25, 27, 28, 29, 32, 33, 35, 39, 42.
Boning—
seams of tight-fitting lining, 361–363, 364.
Bound buttonholes—
binding material, 441, 442, 443.
finishing, 445.
marking, 440, 441.
methods of making—
continuous binding, 441, 442.
two sections of binding, 442, 443.
reinforcing material, 440.
size, 440.
use for fastenings, 440–443, 445.
Box plaits—
making, in shirt-waist, 317, 318.
Bradford system—
doubling and drawing, 92, 93.
gilling, 92.
spinning, 93.
Breaker, 52.
Burr guards, 51.
Burr-picking, 94.

Bustle, in historic costume, 47.
Buttonholes—
making in non-tailored waists, 346.
making in tailored waists, 345, 346.
Buttons and buttonholes—
use for fastenings, 440.

Cap spinning, 66.
Carding—
cotton, 53.
hand, 49, 50.
machine, 50–83.
process of, 48–53.
wool, 50–53.
Carding-machines—
for cotton, 53.
for wool, 50–53.
Cases for embroidery silks, 453.
Centre-front decoration—
designing on skirt pattern, 271, 272.
Chemise, in historic costume, 14, 19, 37.
Chiton, 6, 7.
Circular flounces—
designing on skirt pattern, 286.
joining to foundation skirts or linings, 420.
use in foundation skirts or linings, 420.
Circular skirts—
cut with four gores, 380.
cut with two gores, 379.
designing on skirt pattern, 285, 286.
Classes of fibres, 76.
Classification of weaves, 129.
Cloth-beam, 68.
Clothing, 50.
Coiffure à la Fontanges, 27, 28.
Cold-water retting, 111.
Collars—
alteration of pattern, 223.
attaching to guimpe, 351, 352.
attaching to semifitting lining, 360.
basting for fitting, 220.
basting in guimpes, 351.
basting for tracing, 219.
boning in guimpes, 351.
cutting in guimpes, 348.
cutting in material, 218.
decoration in shirt-waist making, 322.
designing on shirt-waist pattern, 264.
drafting pattern, 215, 216.
draping pattern in guimpes, 349, 350.
fastenings in guimpe, 352.
finishing top in guimpe, 351, 352.
finishing in tight-fitting lining, 367, 368.
fitting, 222, 223.
making for dress-form cover, 291.
making in guimpes, 349–351.
making in tight-fitting linings, 367.
making pattern for, 217–224.

marking pattern—
 in cloth, 219.
 in paper, 218.
measures, how taken, 168, 169.
padding for dress-form cover, 292.
placing on material, 218.
rebasting pattern, 223.
refitting pattern, 223.
regulation measures, 209.
seam allowances for, 217, 218.
taking measures for, 168, 169.
testing draft, 217.
Collars and collar-bands—
 basting in shirt-waists, 331, 332.
 making in shirt-waists, 332, 336–338.
 placing and cutting in shirt-waists, 324, 325.
 seam allowances for, 322.
Collar-bands—
 buttonholes, 345.
 placing and cutting, 325.
Colonjal loom, 68.
Color in costume—
 choice, 258, 259.
 combinations, 258, 259.
 in relation to eve~ ..._,
 in relation to hair, 259.
 in relation to light, 259.
 in relation to personality, 259.
 in relation to skin, 259.
Color in materials—
 difference in, in cutting, 163, 164.
Commercial patterns—
 makes, 239.
 measures, 239, 240.
 preliminary directions for use—
 cutting, 240, 241; fitting, 239; placing, 239, 240; reading directions, 239; testing, 239, 240.
 shirt-waist, directions for use, 241–244.
 shirt-waist, fitting, 242–244.
 shirt-waist, purchase, 241.
 shirt-waist, testing, 241, 242.
 shirt-waist sleeve, directions for use, 242.
 shirt-waist sleeve, testing, 242.
 skirt, fitting, 247–249.
 skirt, purchase, 247.
 skirt, testing, 247–249.
 special directions for use, 241–249.
 tight-fitting sleeve, testing, 246, 247.
 tight-fitting waist, directions for use, 244–247.
 tight-fitting waist, fitting, 247.
 tight-fitting waist, purchase, 244.
 tight-fitting waist, testing, 244–246.
 use, 239.
Comparison of fibres, 123–126.
Condenser, 53.
Consulate, fashions of the, 38, 39.

Cordings—
 attaching, 436–438.
 making, 435, 436.
 use to finish hems, 438.
 use to finish skirt edges, 437.
 use to join sleeves and cuffs, 437, 438.
Cordings and pipings—
 use as edge finishes, 435.
 use in skirts, 419.
Corset, 19, 37.
Costume—
 accessories for use in design, 261.
 bisymmetric line arrangement in design, 256.
 choice of colors, 258, 259.
 Egyptian, 3–5.
 eighteenth century, 28–39.
 factors important in choice of design, 254, 255.
 good proportion, 255, 256.
 Greek, 5–8.
 harmony of line in design, 256.
 historic development, 1–48.
 lines in opposition in design, 256, 257.
 lines in subordination in design, 257.
 lines in transition in design, 257.
 nineteenth century, 39–47.
 of Gauls, Gallo-Franks, early Franks, and French through Middle Ages, 10–18.
 purpose, 252.
 repetition of lines in design, 256.
 rhythmic arrangement of lines in design, 256.
 Roman, 9, 10.
 seventeenth century, 23–28.
 simplicity in construction, 157.
 simplicity in design, 255.
 sixteenth century, 18–23.
 space relation in design, 256, 257, 258.
 texture of fabric in design, 259, 260, 261.
 unity of design, 255.
Costume books, securing, 252.
Costume prints—
 collection for use in designing, 251.
 securing, 251.
Cotte, 14, 16, 20.
Cotton—
 colors for use in basting, 160.
 for basting, 159, 160.
 processes of manufacture—
 baling, 77
 carding, 79.
 combing, 79, 80.
 doubling and drawing, 80.
 drawing and twisting, 80, 81.
 field picking, 77.
 finishing:
 (a) regular processes:
 bleaching, dyeing, or printing, 83.

calendering, 83.
inspecting and marking for repairs, 82.
repairing, 82
singeing, 83.
spraying, 83
starching, 82.
(*b*) special processes, 83, 84.
ginning, 77.
opening, 78.
picking, 78, 79.
spinning, 81.
twisting, 81.
weaving, 81. 82.
weighing, 77.
texture of, 259. 260.
Cotton, processes of manufacture for, 76–84.
Cotton carding, 53.
Creel feed, 52.
Critical faculty—
how secured, 251, 252.
important factor in original designing, 250.
Crampton's mule, 60, 61.
Crow tacks, making of, 450, 451.
Cuffs—
buttonholes, 345, 346.
decoration in shirt-waist making, 322.
folding material for, 341.
making and attaching in tailored shirt-sleeve, 340–342.
making in non-tailored or fancy sleeve, 344, 345.
placing and cutting for shirt-waist, 325, 326.
seam allowances, 322, 325, 341.
stiffening for, 326, 340, 341.
styles in non-tailored or fancy sleeve, 344. 345.
use of striped material, 325, 326.
Cylinders, 50, 51, 52.

Darts—
basting, 204, 205, 387.
direction at hip of four-gore skirt, 196.
in armseye of tight-fitting waist, 221, 222.
in five-gore skirt design, 272.
in folds of net in V-shaped neck line, 370, 371.
marking, 202.
position in fitting skirts, 206, 207.
to remove fulness in foundation-skirt draft, 195, 196.
to remove fulness in four-gore skirt, 198.
to remove fulness in five-gore skirt, 198.
to remove fulness in seven-gore skirt, 200.
to remove fulness in skirts, 386, 387.
Decoration—
kinds in shirt-waists, 318.
of cuff in shirt-waist making, 322.
of sleeve in shirt-waist making, 322.
of waist in shirt-waist making, 318–321.
Decorative methods of finishing—
plaits, stitching, buttons, etc., 446–451.
use of arrowhead tacks, 446–450.
use of bar tacks, 446.
use of crow tacks, 450, 451.
Decorative ways of securing fulness, 445, 446.
Design by—
warp printing, 128, 129.
weaves, 129–139.
yarn, 127, 128.
Design—
choice for costume, 252.
choice in relation to design, 155, 156.
in textiles—
structural, 126–139.
surface, 139–141.
of costume—
determined by textile, 155, 156.
with color, 139, 140.
by hand:
block-printing, 139.
stencilling, 139.
by machine:
block-printing, 139.
machine printing, 140.
without color, 140, 141.
moiréing, 141.
on plain weave, 140.
on pile weave, 140, 141.
Designing—
flat-paper work, 262–288.
handling materials, 294, 295.
illustrative materials, 251, 252.
important factors, 296, 297.
kimono-waist, 265–267, 301–303.
linings, 298–301.
mousquetaire sleeve, 309, 310.
necessary elements involved, 250–261.
on dress-form, 289–303.
shirt-waist decoration, 301.
shirt-waists in flat paper, 262–267.
shirt-waist sleeves on padded form, 305, 306.
skirts in flat paper, 270–288.
skirts on dress-form, 310–312.
sleeves in flat paper, 268–270.
sleeves on form and stiff-paper pattern, 303–310.
suggestive problems, 297–312.
technique based on, 289.

tight-fitting sleeves, 309, 310.
 lined, 309; unlined, 309, 310.
 tight-fitting-sleeve linings, 306–309.
Development of spinning-machine, 57–67.
Dew retting, 111.
Directory, fashions of the, 37, 38.
Distaff, 54.
Dobby, 73.
Doffer, 51, 53.
Doffer comb, 51.
Doric chiton, 6.
Drafting—
 basis for designing, 262.
 general construction lines, 172, 173.
 kinds of garments—
 foundation skirt, 190–195.
 kimono-waist, 230.
 shirt-waist, 174–179.
 shirt-waist sleeve, 184–187.
 tight-fitting sleeve, 224–227.
 tight-fitting waist and collar, 209–216.
 practicability, 173.
 regulation measures—
 foundation skirt, 190; kimono-waist, 230; shirt-waist, 174; shirt-waist sleeve, 184; tight-fitting sleeve, 224; tight-fitting waist and collar, 209.
 taking measures for, 166–170.
 testing—
 in kimono, 234, 235; in shirt-waist, 179; in shirt-waist sleeve, 187; in skirt, 195, 196, 200–202; in tight-fitting sleeve, 227; in tight-fitting waist, 217.
 tools, 172.
 use—
 for designing, 262, 265, 268, 270, 271, 289, 303, 304.
 for securing patterns, 315, 354, 355, 373, 374.
Drafting system—
 advantages, 172.
 garments included, 172.
 order of procedure, 174.
Draped skirts—
 how made, 374, 375.
 materials for, 375.
Draped waists, style of, 313, 314.
Draping on dress-form. *See* Designing.
Drawing, 54.
Drawing-off rolls, 51.
Dress-form—
 designing on, 289–303.
 preparation for draping, 289–293.
 technique, 294.
Dress-form cover—
 preparation, 290–293; collar, 291, 292; skirt, 292, 293; sleeve, 292; waist, 290, 291, 292.

"Dressmaking-sewing," definition of term, 156.
Drop-box, 71.
Drying material after shrinking, 161.
Dyeing, 117–119.

Early hand weaving, 67, 68.
Edge finishes, 430–438.
 bias bindings, 433–435.
 cordings and pipings, 435–438.
 facings, 431, 432.
 hems, 430, 431.
 linings for drapery, 432.
 machine hemstitching, 438.
 rolling and whipping, 438.
Egyptian costume, 3–5.
Eighteenth-century, costume, 28–39.
Elastic—
 use in evening-waist linings, 370–372.
Embroidery, 451–485.
 color in, 451, 452.
 design in, 451, 452.
 materials—
 kinds, 453, 454.
 preparation of for smocking, 478, 479.
 patterns for, 452.
 ribbons for, 477.
 stitches, 454–485.
 beading-stitch, 460.
 bullion stitch, 466, 467.
 chain-stitch, 457, 458; in smocking, 484.
 coral stitch, 462, 463.
 couching, 467–469.
 brick, 468, 469.
 plain, 468.
 puffy, 468.
 twisted, 469.
 fagoting, 471–476.
 Bermuda, 472, 473.
 Cuban, 475, 476.
 French, 473–475.
 straight, 472.
 by use of Indian herring-bone stitch, 472.
 by use of plain herring-bone stitch, 472.
 feather-chain stitch, 459, 460.
 feather-stitch, 460–462.
 use in smocking, 484.
 use with lazy daisy, 459.
 French knots, 465, 466.
 use in smocking, 484.
 use with lazy daisy, 459.
 German knot stitch, 471.
 herring-bone stitch, 464, 465.
 use in fagoting, 472.
 Indian herring-bone, 465.
 use in fagoting, 472.
 interlacing stitch, 469, 470.

lazy-daisy stitch, 459.
 use in smocking, 484.
magic chain-stitch, 458.
oriental stitch, 463.
outline stitch, 456, 457.
 use in smocking, 479, 480.
Portuguese laid work, 456, 457.
rococo or ribbon embroidery, 476–478.
running stitch, 454–456.
 in Portuguese laid work, 456.
satin stitch, 463, 464.
 use in padding, 464.
seed stitch, 470, 471.
smocking—
 preparation of material, 478, 479.
 stitches, 479–485.
 cable, 481, 482.
 diamond, 482.
 plain smocking, 483, 484.
 rope, 479–481.
 Van Dyke, 483.
 use of feather-stitching and chain-stitching, 484.
 use of French knots and flowers, 484, 485.
 wide chain-stitch, 458, 459.
tools, 452, 453.
 cases for silks, 453, frames, 453; needles, 453.
use in finishing hems, 430, 431.
Emery, 158.
Empire, fashions of the, 39–41.
Evening-waist linings—
 cut to extend to bust line, finishing, 371, 372.
 cut to extend over shoulder, finishing, 369–371.
 designing on dress-form, 300, 301.
 making and finishing, 369–372.
 pattern, how secured, 355, 356.

Fabrics—
 general comparison, 142, 143.
 testing for fibres and finish, 145–153.
 testing for strength and color, 143–153.
 tests, 141–153.
Facings—
 attaching to foundation skirts or linings, 407.
 fasteners for in foundation skirts or linings, 407.
 for irregular-shaped pieces, 432.
 for scalloped edges, 432.
 making and attaching to edges, 431, 432.
 preparing for foundation skirts or linings, 407.
 use for edge finishes, 431, 432.
 use in skirts, 418.

Fagoting—
 use in finishing hems, 430, 431.
 use in finishing seams, 430.
Fancy, 51.
Fancy hems, making in skirts, 418.
Fastenings, 438–445.
 belt for foundation skirt or linings, 406, 407.
 bound buttonholes, 440–443, 445.
 buttons and buttonholes, 440.
 guimpes, 352.
 hooks and eyes, 439.
 hooks and loops, 439.
 hooks and peets, 439.
 importance of, 439.
 kinds of, 438.
 plackets in tailored skirts, 400, 401.
 semifitting linings, 358.
 semi-tailored skirts, 404.
 separate skirts, 413.
 snaps for, 439, 440.
 standing belt of skirts, 388.
 tailor buttonholes, 443–445.
 tight-fitting lining, 364.
Featherbone—
 preparing and attaching, 363
Feed—
 automatic, 50.
 creel, 52.
 traverse, 52.
Feeding the fibre, 52.
Feeling—
 necessary in designing, 250.
Fell seam—
 attaching sleeve to semifitting lining, 359.
 attaching tailored sleeve to waist, 343.
 making and use, 424, 425.
 use in semifitting lining, 357, 358.
 use in shirt-waists, 335.
 use in skirts, 393.
Fibre—
 feeding the, 52; removing the, 52, 53.
Fibres—
 classes, 76; comparison of, 123–126; substitutes for, 150; testing for cotton, 145; for linen, 152, 153; for silk, 149–151; for wool, 146–148.
Fichu, in historic costume, 11, 35, 36, 40, 47.
Final processes necessary for both woolen and worsted—
 burling, 97.
 fulling, 97.
 gigging and shearing, 98.
 inspecting, 99.
 mending, 97.
 perching or inspecting, 96.
 steaming, 98.
 tentering, 99.

twisting, 95.
washing, 98.
weaving, 96.
Finish—
 testing for—
 cotton, 145, 146.
 linen, 153.
 silk, 151, 152.
 wool, 148, 149.
Finisher, 52.
Finishes for bottom line of foundation skirts or linings, kinds, 419, 420.
Finishes for bottom line of skirts, kinds, 415.
Finishes for edges, 430–438.
Finishes for seams, 421–430.
Finishing bottom line of skirts, tunics, etc., 415–420.
Finishing bottoms of waists—
 in shirt-waists, 336.
 in tight-fitting linings, 365.
Finishing—
 by decorative methods, 446–451.
 guimpes, 351, 352.
 linings, 357–370.
 evening-waist, 369–372; girdles, 372; semifitting, 357–360; tight-fitting, 360–369; princess, 372.
 shirt-waists, 333–346.
 skirts, 389–420.
 waist lines in skirts, 404–415.
Finishing processes usual for woolen, 99, 100; worsted, 99.
Finishings—
 choice of, 421.
 kinds of, 421.
Fitting—
 commercial patterns, 240, 242–249.
 shirt-waist, 242–244.
 tight-fitting waist, 247.
 skirt, 247–249.
 general rules, 165.
 guimpes, 351.
 kimono-waist, 236, 237
 linings, 357.
 shirt-waist sleeves, 188.
 shirt-waists, 181–183, 332, 333.
 skirts, 205–207, 388, 389.
 tight-fitting sleeves, 229, 230.
 tight-fitting waists, 220–223.
Five-gore skirts, how cut, 380.
Flaring or full skirts, how cut, 378.
Flat-paper work. *See* Pattern-designing.
Fly-shuttle, 71.
Flyer, 56, 57.
Flyer spinning, 66, 67.
Foundation—
 cutting away in guimpe, 351.
 draping in guimpe, 347, 348.

Foundation skirts or linings—
 attaching belt, 406.
 attaching facing, 407.
 circular flounces in finishing, 420.
 cutting and finishing, 419, 420.
 fastenings for belt, 406, 407.
 fastenings for facing, 407.
 finishes for bottom, 419, 420.
 finishing waist line, 387, 388, 405–407.
 how made, 373.
 making belt, 405, 406.
 making placket, 395, 396.
 materials, 373.
 placing plackets, 395.
 preparing facing, 407.
 use of bias fold in joining ruffles, 419, 420.
 use of tucks in joining ruffles, 419, 420.
Four-gore division—
 use in designing, 272.
Four-gore skirts, how cut, 379, 380.
Frames, for embroidery, 453.
French seam—
 joining sleeve to semifitting lining, 359.
 making, 425, 426.
 semifitting lining, 357.
 use, 425.
 use in skirts, 392.
 use in shirt-waists, 335.
French system, back-washing—
 doubling and drawing, 93, 94.
 gilling, 93.
 spinning, 94.
Fulness—
 removing in skirt hems, 417, 418.
 securing, 445, 446.

Garde corps, 15.
Gathered skirts—
 designing on skirt pattern, 282–285.
 how cut, 378.
 methods of procedure, 282.
 placing on material, 382.
Gibson plait—
 designing on shirt-waist pattern, 263.
Girdle, in historic costume, 8, 9, 10, 11, 14, 16, 18, 21, 31, 37.
Girdles—
 finishing edges, 372.
 pattern, how secured, 355, 356.
Good quality in material, requisites for, 121–123.
Gore divisions—
 arrangement in skirts, 378–380.
 circular skirts with four, 380.
 circular skirts with two, 379.
 for dress-form cover, 293.
 in foundation-skirt pattern, 196–200.
 peg-top skirts, 379.

skirts with five, 380.
skirts with six, 380.
skirts with seven, 380.
straight skirts with four, 379, 380.
straight skirts with two, 379.
Gores—
 five-gore division of skirt, 198.
 four-gore division of skirt, 196–198.
 seven-gore division of skirt, 200.
 six-gore division of skirt, 198.
 two-gore division of skirt, 200.
 marking, 203, 204.
 placing on material, 203, 380–382.
 testing, 200–202.
 trueing lines of, 202.
Gores, plain—
 basting for fitting, 204, 384, 385.
Gores with tucks or plaits—
 basting for fitting, 385.
Grain of material, 348.
 importance in dressmaking, 161; in
 skirt cutting, 375.
 importance in designing, 252, 296.
 in arranging folds in designing, 296,
 297.
Greek costume, 5–8; return to, 37.
Guimpes—
 attaching collar to, 351, 352.
 cutting collar, 348.
 draping foundation, 347, 348.
 fastenings, 352.
 finishing, 351, 352.
 finishing armseye, 352.
 fitting, 351.
 general method of making, 347.
 making collar, 349–351.
 making sleeve, 352.
 purpose, 346, 347.
 seams, 351.
 stretching yoke, 348, 349.

Hair. *See* Head-dress.
Hand carding, 49, 50.
Hand-looms—
 preparation of warp and threading,
 73–75.
 process of operating, 70, 71.
Hand weaving, 67, 68.
 early appearance of hand-loom, 68–
 71.
 inventions in—
 drop-box, 71.
 fly-shuttle, 71.
Hanging material after shrinking, 161.
Harness, 69.
Harness-loom, 71, 72.
 attachments—
 Dobby, 73.
 Head-motion, 73.
 lappet, 73.
 swivel, 73.

Head-dress in historic costume, 5, 8, 10,
 14, 16, 17, 18, 21, 23, 25, 27, 28, 30,
 33, 34, 38, 39, 43, 44, 45.
Head-motion, 73.
Heddle, 68.
Hemp, 116.
Hems—
 as finishes for edges, 430, 431.
 finish in shirt-waist, 317, 318.
 finished with cording, 438.
 finished with embroidery, 430, 431.
 finished with fagoting, 430, 431.
 finished with hemstitching, 430.
 for skirts, 415–418.
 fancy, 418; plain, 416–418.
 turning in skirts, 386.
Hemstitched seam—
 use in shirt-waists, 335.
 use in skirts, 394.
Hemstitching by hand—
 use in finishing hems, 430.
Hemstitching by machine, 335, 394, 419,
 438.
Hennin, 17, 18.
Himation, 6, 7.
Historic costume—
 use in designing, 251, 252.
Historic development of costume, 1–48.
Hooks and eyes—
 use for fastenings, 439.
Hooks and loops—
 use for fastenings, 439.
Hooks and peets—
 use for fastenings, 439.
Hoop, 28, 29, 32, 46, 47.
Houppelande, 17.

Illustrative material for designing—
 where found, 251, 252.
Imagination, stimulation, 252.
Individual—
 as important factor in choice of cos-
 tume, 254.
Inventions in hand weaving—
 drop-box, 71.
 fly-shuttle, 71.
Inverted plaits—
 basting in skirts, 385, 386.
 designing on skirt pattern, 274–277.
 at centre-back seam, 275.
 between any other two gores, 275–
 277.
Ionic chiton, 6.
Iron—
 use in pressing after shrinking, 161;
 in pressing, 162, 163; in sponging,
 162.

Jack-spool, 53.
Jacquard loom, 72.
Jersey wheel, 55, 56.

Jewelry. *See* Jewels.
Jewelry in historic costume, 8, 10, 21, 26, 30, 32, 33, 37, 39.
Jute, 116.

Kimono-waists—
altering pattern, 237, 238.
basting for fitting, 235, 236.
basting for tracing, 235.
belt, making and attaching, 236.
cutting in material, 235.
designing on dress-form, 301–303.
designing on shirt-waist pattern, 265–267.
drafting pattern, 230–234.
fitting, 236.
fulness at waist line regulated in fitting, 236.
gathering for fitting, 236.
making pattern, 234–238.
marking pattern in cloth, 235; in paper, 235.
neck line, direction in fitting, 237.
placing pattern on material, 235.
preparation for fitting, 236.
rebasting pattern, 238.
refitting pattern, 238.
regulation measures for, 230.
seam allowances for, 235.
shoulder in fitting, 237.
sleeve in fitting, 237.
taking measures for, 166–169.
testing draft, 234, 235.
underarm, in fitting, 237.

La Belle Poule, 34.
Lace bands—
at shoulders of evening-waist lining, 371; on girdle, 372.
Lace beading—
used in evening-waist linings, 369, 370, 371.
Lapped seam—
making, 426.
use in skirts, 393, 426.
Lappet, 73.
Lathe, 68.
Lay, 68.
Lease-rods, 70.
Linen—
processes for short fibre or tow, 114, 115.
processes for true or line fibre, 110–114.
texture, 260.
Linings—
basting for fitting, 357.
choice of, 352, 353.
cutting in material, 356.
designing, on dress-form, 298–301.

evening-waist, 300, 301; shirt-waist, 298–300; tight-fitting, 301.
fitted sleeve linings, designing, 306–309.
fitting, 357.
materials, 353, 354.
making and finishing, 357–372.
marking for basting, 356.
patterns, how secured, 354–356.
placing on material, 356.
seam allowances, 356.
styles of, 352.
use in skirts, 419.
use of for edge finishes, 432.
Lingerie dresses—
making and attaching belts of, 408, 409.
Lingerie skirts—
how made, 374.
joining to waists, 415.
materials for, 374.
Line—
harmony of in design of costume, 256.
repetition of in design of costume, 256.
Lines in opposition—
illustration of in costume, 256, 257.
in design of costume, 256, 257.
Lines in subordination—
in design of costume, 257.
Lines in transition—
illustration of in costume, 257.
in design of costume, 257.
Loom—
hand or Colonial, 68–71.
power, 71–73.
Louis XIV, fashions of the period of, 25–29, 31, 32.

Machine carding, 50–53.
Machine hemstitching—
use for edge finishes, 438.
use in shirt-waists, 335.
use in skirts, 394, 419.
Machine printing, 140.
Maintenon, Madame de, 27.
Making and finishing—
evening-waist linings, 369–372.
linings, 357–372.
shirt-waists, 333–346.
skirts, 389–420.
Manufacture of textiles, 48–119.
Marie Antoinette, 32.
Marking—
bound buttonholes, 440, 441.
linings for basting, 356.
methods of, 164, 165.
shirt-waists for basting, 326, 327.
skirts for basting, 382, 383.
with cotton, 159.
with silk, 159, 160.

with tailor basting, 165.
with tailor's chalk, 159, 165.
with tracing-wheel, 159, 164.
Materials—
choice in relation to design, 155, 156.
difference in color in cutting, 163, 164.
folds in designing, on the bias, 297; on crosswise thread, 297; on lengthwise thread, 296.
for draped skirts, 375.
for foundation skirts or linings, 373.
for guimpes, 346.
for lingerie skirts, 374.
for non-tailored or fancy waists, 315.
for semifitting linings, 353.
for sleeves in semifitting lining, 359.
for tailored and semi-tailored skirts, 374.
for tailored shirt-waists, 315.
for tight-fitting linings, 354.
general rules for cutting, 163, 164.
handling in designing, 294, 295.
kinds for designing, 297, 298, 305.
kinds for embroidery, 453, 454.
nap in cutting, 164.
preparation for cutting shirt-waists, 316–322.
preparation for smocking, 478, 479.
preparation, 160–163.
pressing, 162, 163; shrinking, 160, 161; sponging, 161, 162.
removing selvage, 316, 321.
requisites for good quality in, 121–123.
Measures—
how taken, 165–170.
regulation—
foundation skirt, 190.
kimono-waist, 230.
shirt-waist, 174.
shirt-waist sleeve, 184.
tight-fitting sleeve, 224.
tight-fitting waist and collar, 209.
Method of making weaves—
double cloth, 136.
figure, 135.
gauge, 138, 139.
lappet and swivel, 138.
leno, 139.
pile, 136, 137.
plain, 129–132.
satin, 133–135.
twill, 132, 133.
Mineral fibres, 116.
Mirror velvet, making of, 163.
use in designing, 295.
Modern types of spinning-machines—
mules—
woolen, 62.
worsted, 63, 64.

upright spinning-frames—
cap spinning, 66.
flyer spinning, 66, 67.
ring spinning, 65.
Moiréing, 141.
Mousequetaire sleeve—
designing on stiff-paper sleeve, 309, 310.
Mules, 62–64.

Neck—
finishing at normal neck line with standing collar, 365–368.
finishing in semifitting lining, 360.
finishing in tight-fitting linings, 365–371.
finishing shaped line in tight-fitting lining, 368.
Needles—
for basting, 158.
for dressmaking, 158.
for embroidery, 453.
for fagoting, 472, 473, 475.
for pinning, 160.
for sewing, 158.
Net—
stretching on stiff-paper collar, 350, 351.
use in guimpes, 347, 348.
Nineteenth-century costume, 39–47.
Noble comb, 90, 91.
Non-tailored or fancy waists—
general style of, 315.
materials for, 315.

Old costumes, records, 251, 252.
Openings—
at centre back in shirt-waists, 317.
at centre or side front in shirt-waists, 317, 318, 319, 320.
fastenings in shirt-waists, 345, 346.
finishing in kimono, 302.
finishing in semifitting linings, 358.
finishing in tight-fitting linings, 363, 364.
making in shirt-waists, 316–318.
marking lengthwise centre in shirt-waists, 316.
Ornaments, 4, 5, 8, 10, 16, 23, 25.
Overcasting—
use on seam edges, 423.

Padded sleeve—
preparing, 304.
use for shirt-waist-sleeve designing, 305, 306.
Palatine, 26.
Palla, 9.
Panels, joining in skirts, 386.
Panier in historic costume, 28, 29, 32, 33, 35, 36, 37.

Panne velvet, cutting, 163.
Pattern-designing, 262–288.
 shirt-waist designs, 262–267.
 skirt designs, 270–288.
 sleeve designs, 268–270.
Pattern-making—
 altering—
 foundation skirt, 207, 208.
 kimono-waist, 237, 238.
 shirt-waist, 183.
 shirt-waist sleeve, 189.
 tight-fitting sleeve, 230.
 tight-fitting waist and collar, 223.
 basting—
 foundation skirt, 204.
 kimono-waist, 235, 236.
 shirt-waist, 181.
 shirt-waist sleeve, 188.
 tight-fitting sleeve, 228, 229.
 tight-fitting waist and collar, 219, 220.
 collar, draping, 349, 350.
 cutting—
 foundation skirt, 202, 203.
 kimono-waist, 235.
 shirt-waist, 180.
 shirt-waist sleeve, 188
 tight-fitting sleeve, 228.
 tight-fitting waist and collar, 218.
 fitting—
 foundation skirt, 205–207.
 kimono-waist, 236, 237.
 shirt-waist, 181–183.
 shirt-waist sleeve, 188, 189.
 tight-fitting sleeve, 229, 230.
 tight-fitting waist and collar, 220–223.
 marking the cloth—
 foundation skirt, 203, 204.
 kimono-waist, 235.
 shirt-waist, 180, 181.
 shirt-waist sleeve, 188.
 tight-fitting sleeve, 228.
 tight-fitting waist and collar, 218, 219.
 marking the paper—
 foundation skirt, 202.
 kimono-waist, 235.
 shirt-waist, 180.
 shirt-waist sleeve, 187, 188.
 tight-fitting sleeve, 227, 228.
 tight-fitting waist and collar, 217, 218.
 placing on material—
 foundation skirt, 202, 203.
 kimono-waist, 235.
 shirt-waist, 180.
 shirt-waist sleeve, 188.
 tight-fitting sleeve, 228.
 tight-fitting waist and collar, 218.

rebasting—
 foundation skirt, 208.
 kimono-waist, 238.
 shirt-waist, 183.
 shirt-waist sleeve, 189.
 tight-fitting sleeve, 230.
 tight-fitting waist and collar, 223.
refitting—
 foundation skirt, 208.
 kimono-waist, 238.
 shirt-waist, 183, 184.
 shirt-waist sleeve, 189.
 tight-fitting sleeve, 230.
 tight-fitting waist and collar, 223.
seam allowances—
 foundation skirt, 202, 203.
 kimono-waist, 235.
 shirt-waist, 179, 180.
 shirt-waist sleeve, 187, 188.
 tight-fitting sleeve, 227, 228.
 tight-fitting waist and collar, 217, 218.
testing drafts—
 foundation skirt, 195, 196, 200, 201.
 kimono-waist, 234.
 shirt-waist, 179.
 shirt-waist sleeve, 187.
 tight-fitting sleeve, 227.
 tight-fitting waist and collar, 217.
three methods, 239.
Patterns—
 commercial—
 careful reading of, 239.
 cutting and placing, 240.
 different makes of, 239.
 fitting of, 240; shirt-waist, 242, 243; tight-fitting waist, 247; skirt, 247–249.
 marking, 241.
 testing of, 239, 240; shirt-waist, 241, 242; shirt-waist sleeve, 242; tight-fitting waist, 244–246; tight-fitting sleeve, 246, 247; skirt, 247–249.
 designed, 297–312.
 kimono-waist, 301–303; linings, 298–301; shirt-waists, 301; skirts, 310–312; sleeves, 303–310.
 drafted, 174–234.
 foundation skirt, 190–195; kimono-waist, 230–234; shirt-waist, 174–179; shirt-waist sleeve, 184–187; tight-fitting sleeve, 224–227; tight-fitting waist and collar, 209–216.
 flat-paper, 262–286.
 shirt-waist, 262–267; skirts, 270–288; sleeves, 268–270.
 kinds for embroidery, 452.

Pattern-weaving, 72.
Peg-top skirts, how cut, 379.
Pelerine, 26.
Peplum, 24.
Pile weave, design on, 140, 141.
Pincushions, 159.
Pinning seams, general rules, 422.
Pins, choice, 158.
Pipings, use, 438.
Placing and cutting—
 linings, 356.
 shirt-waist, 323–326.
 collar and collar-band, 324, 325;
 cuffs, 325, 326; sleeve, 325;
 sleeve placket, 326; waist, 324;
 yoke, 324.
 skirts, 377–382.
Plackets—
 choice of finish in skirts, 395.
 fasteners in semi-tailored and fancy
 skirts, 404.
 fasteners in tailored skirts, 400, 401.
 finishing in semi-tailored and fancy
 skirts, 401–404.
 finishing in tailored skirts, 399–401.
 length in shirt-waists, 339.
 length in skirts, 397.
 making in bias edges, 403, 404.
 making in foundation skirts or li-
 nings, 395, 396.
 making in non-tailored or fancy
 sleeve, 343, 344.
 making in skirt seam finished with
 tuck, 397–401.
 making in straight or nearly straight
 edges, 402, 403.
 making in tailored shirt-sleeve, 339,
 340.
 making in tailored skirts, 396.
 making left side in tailored skirts,
 399.
 making right side in tailored skirts,
 398, 399.
 placing in foundation skirts or li-
 nings, 395.
 placing in tailored skirts, 395, 396.
 planning and making in skirts, 394–
 404.
 seam allowances, 323.
 stitching in tailored skirts, 400.
Placket pieces—
 placing and cutting for shirt-waist,
 326.
Plain harness-loom, 71–73.
Plain hems—
 making in skirts, 416–418.
 removing fulness, 417, 418.
Plain hems with one turning—
 making and finishing, 416–418.
Plain hems with two turnings—
 making, 416.

Plain seams—
 binding edges, 423.
 finishes for right side, 392, 424.
 finishes for wrong side, 390–392, 423,
 424.
 for attaching tailored sleeve to waist,
 342, 343.
 for semifitting linings, 358.
 making, 422, 423.
 making in skirts, 390, 391.
 notching edges, 422, 423.
 overcasting edges, 423.
 turning in edges—
 closed seam, 424; open seam, 423,
 424.
 use, 422.
 use in shirt-waists, 334, 335.
Plaited skirts—
 designing on shirt pattern, 277–282.
 how cut, 378.
 methods of procedure in designing,
 278–282.
 placing on material, 382.
Polonaise, 31.
Pompadour, Madame, 31.
Power-looms—
 Jacquard, 72.
 plain harness, 71–73.
 preparation of warp and threading
 for, 75, 76.
 use, 71–76.
Preliminary processes necessary for
 worsted and woolen, 85, 86.
Preparation of shoddy—
 carbonizing, 102.
 dusting, 102.
 oiling, 102.
 picking, 102.
 sorting, 101.
 washing, 101.
Preparation of warp and threading for
 hand and power looms, 73–76.
Pressing seams, general rules, 422.
Pressing materials—
 after shrinking, 161; for sponging,
 161, 162; general method of, 162,
 163; silk, 163; velvet, 163.
Princess lining—
 finishing, 372.
 pattern, how secured, 356.
Printing—
 block, 139.
 machine, 140.
 roller, 140.
Proportion in costume, 255, 256.

Ramie, 115.
Raw silk—
 processes for—
 reeling, 104, 105.

throwing—
kinds of thread used in, 106.
operations included in, 106, 107.
Redingote in historic costume, 40.
Reed, 69.
Regency, fashions of, 29, 30.
Regulation measures, 174, 184, 190, 209, 224, 230.
Reinforcements for fitted linings—
cutting and tracing, 356.
Reinforcements for waist line in separate skirts, 410, 411.
Relation of lines of draft to lines of figure taught by fitting pattern, 262.
Renaissance, fashions of, 18–23.
Repetition of line—
illustration of in costume, 256.
in design of costume, 256.
Republic, fashions of the period of, 46.
Restoration, fashions of, 41–44.
Retting—
cold-water, 111.
dew, 111.
Revolution, fashions of, 36, 37.
Rhythm in design of costume, 256.
Rhythmic arrangement of line—
illustration of in architecture, 256.
Ribbons—
for embroidery, 477.
used in evening-waist linings, 369, 370, 371, 372.
used in girdles, 372.
Right dress, 252.
Ring spinning, 65.
Rock (*see* Distaff), 54.
Roller-drawing, 60.
Roller-printing, 140.
Rolling and whipping—
use for edge finishes, 438.
use in skirts, 419.
Roman costume, 9, 10; return to, 37.
Romantic period, fashions of, 44–46.
Roving, 53.
Ruff, 21, 22, 23, 24, 39.

Sandals, 4, 8, 9, 10.
Saxony wheel, 56, 57.
Scalloped edges—
bias folds, 434.
facings, 432.
Scissors, 158.
Scouring, 94, 117.
Seam allowances—
for collars, 217, 218, 322.
for cuffs, 322.
for kimono-waist, 235.
for linings, 356.
for shirt-waists, 179, 180, 322, 323.
for shirt-waist sleeves, 187, 188.
for skirts, 202, 376, 377.

for tight-fitting sleeve, 227, 228.
for tight-fitting waists, 217, 218.
Seam finishes, 421–430.
fell, 424, 425; finished with *entre-deux*, 428, 429; French, 425, 426; lapped, 426; plain, 422–424; slot, 427; strapped, 427; welt, 425.
Seam finished with *entre-deux*—
making and use, 428, 429.
use in shirt-waists, 335.
use in skirts, 392, 393.
Seams—
basting, 422.
basting for placket in skirts, 398.
finishing in guimpes, 351, 352.
finishing in tight-fitting linings, 360–363.
for making semifitting linings, 357, 358.
general rules for making, 422.
pinning, 422.
pressing, 422.
stitching, 422.
stitching and finishing for skirts, 390–394.
Seams finished with fagoting, 430.
Seams finished with machine hem-stitching—
making and use, 429, 430.
Second Empire, fashions of, 46, 47.
Securing pattern—
of evening-waist linings, 355, 356.
of girdles for linings, 355.
of princess lining, 356.
of semifitting lining, 355.
of shirt-waist, 315, 316.
of skirts, 376.
of tight-fitting lining, 355.
Semifitting linings—
attaching belt, 359.
attaching collar, 360.
designing on dress-form, 298–300.
fastenings, 358.
finishing armseye, 359, 360.
finishing neck line, 360.
finishing openings, 358.
finishing waist line, 358, 359.
how cut, 353.
making and attaching sleeves, 359, 360.
making and finishing, 357–360.
making belt, 358.
materials, 353.
pattern, how secured, 355.
seams, 357, 358.
Semifitting waists—
style, 313.
Semi-tailored skirts—
making plackets, 401–404.
Sequence in technique, 156.
Seven-gore skirt, how cut, 380.

Seventeenth-century costume, 23–28.
Sewing-boxes, 157.
Sewing-machines, 157.
Shaped neck line without collar—
finishing in shirt-waist, 338.
Shedding, definition of, 67.
Shirring—
use for securing fulness, 445.
Shirt-waists—
alteration of pattern, 183.
armseye line in fitting, 183.
basting for fitting, 181, 327–333.
basting for tracing, 180, 181.
belt, attaching, 182, 336.
belt, making, 181, 329.
box plaits, making, 317, 318.
buttonholes in non-tailored, 346.
buttonholes in tailored, 345, 346.
centre-back openings, 317.
centre or side-front openings, 317, 318.
collar-band—
attaching, 184.
making, 184.
collar line, direction in fitting, 182, 183.
cutting in material, 180, 323–326.
decoration, 318–322.
designing in flat-paper work, 262–267.
collars, 264; Gibson plait, 263; kimono-waist, 265–267; tucks, 262, 263; yokes, 263, 264.
designing on dress-form, 301.
drafting pattern, 174–179.
finishing bottoms, 336.
finishing shaped neck line, 338.
fitting, 181–183, 332, 333.
fitting in commercial pattern, 242–244.
fulness at waist line regulated in fitting, 182.
gathering for fitting, 181.
hems, making, 317, 318.
lace insets, 316.
making, general directions, 314–346.
making back, with centre front or back opening, 321.
making front, with centre-back opening, 321.
making front, with centre-front opening, 319–321.
making and attaching belts, 329, 336.
making and attaching collars and collar-bands, 332, 336–338.
making and attaching sleeves, 338–345.
making and attaching yokes, 338.
making and finishing, 333–346.
making pattern, 179–184.
marking for basting, 326, 327.

marking lengthwise centre of opening finish, 316.
marking pattern—
in cloth, 180, 181; in paper, 180.
materials, 315.
non-tailored or fancy, 315.
non-tailored sleeve, making and finishing, 343–345.
openings, making, 316–318.
pattern, how secured, 315, 316.
placing on material, 180, 323–326.
preparation for fitting, 181.
preparation of material for cutting, 316–322.
purchase of commercial pattern, 241.
rebasting pattern, 183.
refitting pattern, 183, 184.
regulation measures, 174.
seam allowances, 179, 180, 322, 323.
seams—
kinds, 334; making, 334, 335.
shoulder in fitting, 182, 183.
shoulder seams in basting, 181.
style, 313.
tailored, 314, 315.
tailored sleeve, making and finishing, 338–343.
taking of measures, 166–169.
testing draft, 179.
testing in commercial patterns, 241, 242.
tucks, making, 319, 320, 321.
types, 314, 315.
Shirt-waist lining. *See* Semifitting lining.
Shirt-waist sleeves—
altering pattern, 189.
basting for fitting, 188.
basting to waist, 188, 189.
cutting in material, 188.
designing in flat-paper work, 268.
designing on padded sleeve, 305, 306.
drafting pattern, 184–187.
fit dependent on armseye line, 188.
fitting, 188.
gathering for fitting, 188.
making pattern, 187–189.
marking pattern—
in cloth, 188; in paper, 187, 188.
pinning to waist, 188, 189.
placing on material, 188.
placket, position, 188.
preparation for fitting, 188, 189.
rebasting pattern, 189.
refitting pattern, 189.
regulation measures, 184.
seam allowances, 187, 188.
size at hand, regulation measure, 184.
taking measures, 169.
testing draft, 187.
testing in commercial patterns, 242.

Shoddy—
 definition of, 101.
 preparation of, 101–103.
Short fibre or tow, processes for, 114, 115.
Shoulder straps—
 in evening-waist lining, 371.
Shrinking—
 fulness in skirt hems, 417, 418.
Shrinking materials—
 drying afterward, 161; hanging afterward, 161; in sponging, 161; method of, 161; necessity for, 160, 161; pressing afterward, 161.
Shuttle, 68, 70.
Side plaits—
 basting in skirts, 385.
 designing on skirt pattern, 277.
Silhouette—
 importance in costume, 254.
Silk—
 artificial, 116, 117.
 processes for raw, 104–106.
 processes for spun or waste, 106–108.
 processes for both raw and spun, 108–110.
Silks—
 basting, 160; pinning, 160; pressing, 163.
 texture, 260.
Silkworm, 103, 104.
Simplicity—
 in construction of costume, 157.
 in design of costume, 255.
Simulated bias folds—
 making of, 434, 435.
Six-gore division, use in designing, 272.
Six-gore skirts, how cut, 380.
Sixteenth-century costume, 18–23.
Sizing—
 removal by shrinking, 160.
Skirt in historic costume, 12, 13, 17, 19, 20, 22, 24, 25, 26, 29, 31, 32, 33, 35, 37, 39, 42, 43, 44, 46, 47.
Skirt-rules and squares, 160.
Skirts—
 alteration of pattern, 207, 208.
 arranging fulness at waist line, 386, 387.
 arrangement of gore divisions, 378–380.
 attaching of belt, 404–415.
 attaching yokes and decorative pieces, 387.
 basting—
 for fitting, 204, 205; darts, 204, 205; gores, 204; plackets, 205; seams, 204.
 basting for fitting, 384–388.
 basting for tracing, 203, 204.

belt—
 attaching, 206.
 making, 205, 206, 387, 388.
bias edges—
 basting for fitting, 204.
bias facing, 388.
bindings at edges, 419.
bottom line—
 position in fitting, 207.
 testing, 200.
circular, 379, 380.
cordings and pipings at edges, 419.
cutting in material, 202–204, 377–382.
darts—
 basting for fitting, 204, 205.
 marking, 203, 204.
 opening for alterations, 208.
 position in fitting, 206.
designing in flat-paper work, 270–288.
 centre-front decoration, 271, 272; circular flounces, 286; circular skirts, 285, 286; four and six gore divisions, 272; gathered skirts, 282–285; inverted plaits, 275–277; plaited skirts, 277–282; side plaits, 277; triple skirts, 286–288; tucks, 272–274; tunics, 285, 286.
designing on dress-form, 310–312.
 circular, 311; straight, 311.
different ways of cutting, 377, 378.
division into gores, 196–200.
drafting of pattern, 190–195.
facing at edges, 418.
fastenings for belts, 388.
finishes for bottom, 415–419.
finishing at waist, 404–415.
finishing at waist line, 387, 388.
fitting, 205–207, 388, 389.
fitting in commercial pattern, 247–249.
five-gore division, 198.
flaring or full, how cut, 378.
four-gore division, 196–198.
 use in fitting, 205.
gathered—
 designing on pattern, 282–285.
 how cut, 378.
 methods of procedure, 282.
 placing on material, 382.
gore divisions for dress-form cover, 293.
gores—
 basting for fitting, 204.
 marking, 203, 204.
 placing, 203.
 testing, 200–202.
 trueing lines of, 202.
hems, 415–418.
 turning, 386.

hem allowance in pattern, 203.
hip line—
 marking, 203, 204.
 position in fitting, 206, 207.
 testing, 195, 200.
hip measure, augmented for close-fitting skirt, 190.
joining panels, 386.
lengths—
 testing foundation pattern, 195.
linings in finishing, 419.
machine hemstitching at edges, 419.
making and finishing, 389–420.
making for dress-form cover, 292, 293.
making patterns for, 195–208.
marking for basting, 382, 383.
marking pattern, 202, 203, 204.
 in cloth, 203, 204; in paper, 202.
measures, how taken, 169, 170.
methods of procedure in designing on, 270, 271.
peg-top, how cut, 379.
placing of gores or lengths on material, 380.
placing on material, 202–204, 377–382.
plackets—
 basting for fitting, 205.
 planning and making, 394–404.
 position, 205.
pattern, how secured, 376.
plaited, how cut, 378.
preparation for dress-form cover, 292, 293.
preparation for finishing bottom line, 415.
preparation for finishing at waist line, 404, 405.
preparation for fitting, 205, 206, 388, 389.
purchase of commercial pattern, 247.
rebasting pattern, 208.
refitting pattern, 208.
regulation measures, 190.
rehanging, 207.
rolling and whipping edges, 419.
seam allowances, 202, 203, 376, 377.
seams—
 basting for fitting, 204.
 stitching and finishing, 390–394.
seam-lines, marking, 203, 204.
seven-gore division, 200.
six-gore division, 198.
 use in fitting, 205.
straight, 379, 380.
straight, how cut, 378.
taking measures, 169, 170.
testing draft, 200.
testing foundation pattern, 195, 196.
testing in commercial pattern, 247–249.

two-gore division, 200.
 use in fitting, 205.
types, 373.
waist line—
 marking, 203, 204.
 testing foundation pattern, 195, 196, 200.
Skirts attached to waists—
 attaching belt, 408, 409, 415.
 decorative finishes for waist line, 414, 415.
 finishing waist line, 407, 414, 415.
 making belt, 408, 409, 414.
 non-decorative finishes for waist line, 408, 409.
Skirts, separate—
 attaching belt, 409, 412, 413, 414.
 decorative finishes for waist line, 409–414.
 fasteners, 413.
 finishing waist line, 407, 409–414.
 non-decorative finishes for waist line, 409.
 making belt, 409, 412.
 reinforcement for waist line, 410–411.
 stitching waist line, 411–414.
Skirts with four gores—
 circular, how cut, 380.
 straight, how cut, 379, 380.
Skirts with five gores, how cut, 379.
Skirts with seven gores, how cut, 380.
Skirts with six gores, how cut, 380.
Skirts with two gores—
 circular, how cut, 379.
 straight, how cut, 378.
Sleeves—
 attaching in semifitting linings, 359, 360.
 basting in shirt-waist, 330, 331.
 decoration in shirt-waist making, 322.
 designing on sleeve form, 305, 306.
 designing on stiff-paper sleeve, 306–310.
 gathering in shirt-waist, 331.
 making and finishing in guimpe, 352.
 material in semifitting lining, 359.
 measures, how taken, 169.
 methods of procedure in designing, 303, 304.
 use padded sleeve, 303, 304.
 use stiff-paper sleeve, 303, 304.
 placing and cutting for shirt-waist, 325.
Sleeves, non-tailored or fancy—
 making cuffs, 344, 345.
 making placket, 343, 344.
 planning, 343.
Sleeves, tailored—
 attaching cuffs, 341, 342.
 attaching to waist, 342, 343.

making cuffs, 340, 341.
making placket, 339, 340.
making seam, 340.
planning, 338, 339.
Sliver, 49, 50, 51, 53.
Slot seam—
in centre front of skirt, 272.
making, 427.
use, 393, 427.
Smocking—
use for securing fulness, 446.
Snaps (ball and socket)—
use for fastenings, 439, 440.
Space relation—
illustration in costume, 257.
illustration in Greek costume, 258.
in design of costume, 256, 257, 258.
Spencer, 39, 40.
Spindles, 54.
Spinning—
cap, 66.
definition of, 54.
flyer, 66, 67.
hand, 54, 55.
machine, 57–67.
process of, 54–67.
ring, 65.
Spinning-jenny, 58, 59.
Spinning-machines—
Crompton's mule, 60, 61.
development of, 57–67.
modern types of, 61–67.
spinning-jenny, 58, 59.
water-frame, 59, 60.
Spinning-wheels—
introduction of, 55.
Jersey, 55, 56.
Saxony, 56, 57.
Sponging materials, 161, 162.
Spun glass, 117.
Spun or waste silk—
processes for—
beating and opening, 107.
boiling and schapping, 106.
combing, 107.
conditioning, 107.
doubling and drawing, 108.
gassing, 108.
inspecting and cleaning, 107.
mixing, 106.
preparing and drawing, 108.
slubbing, 106.
spinning, 108.
Square neck line—
finish of in evening-waist linings, 370–372.
Standards for judging textiles, 120–123.
Standing collars—
finishing in shirt-waists, 337, 338.
placing and cutting, 324, 325.
Stays, 39.

Stencilling, 139.
Stiff-paper collar pattern—
making, 350.
stretching of net, 350, 351.
Stiff-paper sleeve pattern—
preparing, 304.
use, 306–310.
Stitching—
decorative finish for plain seam, 424.
seams, general rules, 422.
Stockings, 32.
Stola, 9.
Straight of material—
in placing commercial patterns, 240.
Straight skirts—
cut with four gores, 379, 380.
cut with two gores, 379.
Straight, narrow skirts—
how cut, 378.
Strapped seam—
making, 427, 428.
use in skirts, 393, 394, 427.
Stripper, 50.
angle, 51.
Structural design, 126–139.
Substitute fibres, 150.
Substitutes used in manufacture of wool—
cotton, 100, 101.
wool, 101–103.
Surcot, 14, 15, 16.
Surface design, 139–141.
Swivel, 73.
System or sequence in technique, 156.

Taffeta silks—
basting and pinning, 160.
Tape-measures, selection of, 159.
Tailor basting—
for marking, 165.
method of making, 165.
Tailor buttonholes—
finishing, 445.
making, 444, 445.
preparation, 443, 444.
use for fastenings, 443–445.
Tailor's chalk, use, 159, 165.
Tailored and semi-tailored skirts—
how made, 374.
materials, 374.
Tailored shirt-waists—
general style, 314, 315.
materials, 315.
Tailored skirts—
placing of plackets, 396.
Taking measures, 165–170.
Tape—
use in outlining design on dress-form, 297.
Tape-measure, use in designing, 296.
Technique, essentials, 156, 157.

Temple, 70.
Testing patterns—
 commercial, general directions, 239, 240.
Tests for fabrics, 141–153.
Tests (in fabrics)—
 for color, 144, 145.
 for fibres and finish, 145–153.
 for strength, 143, 144.
Textiles—
 collection for use in designing, 251, 252.
 definition of, 48.
 determine design of costume, 155, 156.
 manufacture of, 48–119.
Textile design—
 structural, 126–139.
 surface, 139–141.
Textile fabrics, standards for judging, 120–123.
Textile manufacture, 48–119.
Texture—
 contrasts in, 260, 261.
 definition, 259.
 in costume, 259–261.
 in cottons, 259, 260.
 in linens, 260.
 in silks, 260.
 in wools, 260.
 relation to color, 259.
Thimbles, 158.
Throwing silk—
 kinds of thread used in—
 organzine, 105.
 singles, 105.
 tram, 105.
 twist, 105.
 operations included in—
 doubling and finishing, 106.
 drying, 106.
 washing or soaking, 105.
 winding, 106.
Tight-fitting linings—
 attaching belt, 364, 365.
 designing on dress-form, 301.
 fastenings, 364.
 finishing armseye, 365.
 finishing at normal neck line with collar, 365–368.
 finishing bottom, 365.
 finishing neck or top line, 365–372.
 finishing openings, 363, 364.
 finishing seams—
 boning, 361–363; finishing edges, 361; stitching, 360, 361.
 finishing shaped neck line, 368.
 finishing yoke, 367, 368.
 kinds, 353, 354.
 making and finishing, 360–372.
 making belt, 364.
 making yoke, 365–368.

 materials, 354.
 pattern, how secured, 355.
 reinforcements, 356.
Tight-fitting sleeves—
 altering pattern, 230.
 basting for fitting, 228, 229.
 basting to waist, 229.
 cutting in material, 228.
 designing on stiff-paper sleeve, 309, 310.
 designing in flat-paper work, 268–270.
 drafting pattern, 224–227.
 fit determined by armseye line, 229.
 fitting, 229, 230.
 gathering for fitting, 229.
 making pattern, 227–230.
 making for dress-form cover, 292.
 marking for gathering, 227, 228.
 marking for joining seams, 228.
 marking pattern—
 in cloth, 228; in paper, 227, 228.
 padding for dress-form cover, 292.
 pinning to waist, 229.
 placing on material, 228.
 preparation for fitting, 229.
 rebasting pattern, 230.
 refitting pattern, 230.
 regulation measures, 224.
 seam allowances, 227, 228.
 taking measures, 169.
 testing draft, 227.
 testing in commercial pattern, 246, 247.
Tight-fitting-sleeve linings—
 designing on stiff paper, 306–309.
 cap, 308, 309; long sleeve, 306–308; short sleeve, 308.
Tight-fitting waists—
 altering pattern, 223.
 armseye line in fitting, 221, 222.
 basting for fitting, 219, 220.
 basting for tracing, 219.
 centre-front seam in fitting, 221.
 collar, direction in fitting, 222, 223.
 cutting in material, 218.
 darts at armseye to remove fulness, 222.
 drafting pattern, 209–215.
 fitting, 220–223.
 fitting in commercial pattern, 247.
 making for dress-form cover, 290, 291.
 making pattern, 217–224.
 marking pattern—
 in cloth, 218, 219; in paper, 217, 218.
 method of procedure in fitting seams, 220, 221.
 neck line—
 direction in fitting, 222.
 notching seams for fitting, 220.
 padding for dress-form cover, 291, 292.

pinning in place for fitting, 220.
placing on material, 218.
purchase of commercial pattern, 244.
rebasting pattern, 223.
refitting pattern, 223, 224.
regulation measures, 209.
seam allowances, 217, 218.
shoulders in fitting, 221.
style, 313, 314.
taking measures, 166–169.
testing in commercial pattern, 244–247.
testing draft, 217.
Tools—
 for use in drafting, 172.
 for use in dressmaking, 157–160.
 for use in embroidery, 452, 453.
Tow, processes, 114, 115.
Tracing-wheel—
 selection, 159.
 use in marking, 164.
Traverse feed, 52.
Treadles, 69.
Triple skirts—
 designing on skirt pattern, 286–288.
True or line fibre—
 processes for—
 breaking, 111.
 doubling and drawing, 112, 113.
 drying, 111.
 finishing, 114.
 gilling, 112.
 hackling, 111.
 retting, 111.
 rippling, 110.
 spinning, 113.
 twisting, 113.
 weaving, 114.
Trumpet, 51.
Tucked or corded shirring—
 use for securing fulness, 445.
Tucks—
 basting in skirts, 385.
 basting in skirt seam for placket, 398.
 designing on shirt-waist pattern, 262, 263.
 designing on skirt pattern, 272–274.
 making in front of shirt-waist, 319, 320, 321.
 use in joining ruffles to foundation skirts or linings, 419, 420.
 use, lengthwise, for securing fulness, 445.
Tunic, 9, 10, 11, 12, 14.
Tunics—
 designing on skirt pattern, 285, 286.
Turning in edges—
 use in finishing seams, 423, 424.
Turnover collars—
 finishing in shirt-waists, 338.
 placing and cutting, 321.

Twizzle, 66.
Two-gore skirts, how cut, 379.

Unity in design of costume, 255.
Upright spinning-frames, 64–67.

Velvet—
 basting, 160.
 mirror velvet made from, 163
 pressing, 163.
 nap—
 in cutting, 163.
 in pressing, 163.
 use in designing, 295.
Vertugale, 19.
V-shaped neck line—
 finish of in evening-waist linings, 369–372.

Waist line—
 arranging fulness in skirts, 386, 387.
 decorative finishes in skirts attached to waists, 414, 415.
 decorative finishes in separate skirts, 409–414.
 finishing in foundation skirts or linings, 405–407.
 finishing in semifitting linings, 358, 359.
 finishing in separate skirts, 407, 409–414.
 finishing in skirts, 387, 388.
 finishing in skirts attached to waists, 408, 409, 414, 415.
 non-decorative finishes in separate skirts, 409.
 non-decorative finishes in skirts attached to waists, 408, 409.
Waists—
 basting in shirt-waist, 328, 329.
 measures, how taken, 166–169.
 placing in shirt-waist, 324.
 types, 313, 314.
Warp—
 preparation of and threading for hand and power looms, 73–76.
Warp-beam, 68.
Warp printing, design by, 128, 129.
Waste silk. *See* spun or waste silk.
Waste wool—
 dusting, 103.
 removing burrs, 103.
Water-frame, 59, 60.
Watteau fashions, 15, 30, 32, 35.
Weaves—
 basket, 130.
 classification, 129.
 design, 129.
 double cloth, 136.
 double pile, 137, 138.
 figure, 135.

filling pile, 137.
gauze, 138, 139.
lappet and swivel, 138.
leno, 139.
method of making, 129–139.
pile, 136, 137.
plain, 129–132.
satin, 133–135.
twill, 132, 133.
Weaving—
hand, 67–71.
machine, 71–76.
pattern, 72.
Weighting (in silk), 150.
Welt seams—
for attaching tailored sleeve to waist, 342.
making, 425.
use, 425.
in shirt-waists, 335.
in skirts, 393.
Whalebone—
preparing and attaching of, 361–363.
Whorl, 54.
Wool, 84, 85.
processes of manufacture, 85–103.
substitutes used in manufacture, 100–103.
Wool carding, 50–53.
Wool extract, 101.
Woolen—
special processes—
burr picking, 94.
carding, 95.
drying, 94.
mixing, 94.
scouring, 94.
spinning, 95.
usual finishing processes, 99, 100.
Woolen and worsted—
final processes, 95–99.
Woolen mule, 62.

Wools—
texture, 260.
Worsted—
special processes—
blending or mixing, 86.
carding—
cards, 88.
preparers, 89.
preparing, 88.
combing, 90.
drying, 88.
dusting, 86, 87.
gilling, 89.
oiling, 88.
scouring, 87.
spinning—
Bradford system, 92, 93.
French system, 93, 94.
usual finishing processes, 99.
Worsted mule, 63, 64.
Worsted and woolen—
preliminary processes, 85, 86.

Yoke lining—
making in tight-fitting lining, 365–367.
Yokes and decorative pieces—
attaching in skirts, 387.
Yokes—
basting in shirt-waists, 329, 330.
lined, 329, 330; unlined, 329.
designing on shirt-waist pattern, 263, 264.
finishing in guimpes, 351, 352.
finishing in shirt-waists, 338.
finishing in tight-fitting lining, 365–367.
placing and cutting for shirt-waist, 324.
seam allowances, 322.
stretching in guimpes, 348, 340.

L

Lightning Source UK Ltd.
Milton Keynes UK
UKHW020634071222
413510UK00004B/46